DURHAM COUNTY COUNCIL
Cultural Services

Please return or renew this item by the last date shown.
Fines will be charged if the book is kept after this date.
Thank you for using *your* library

 100% recycled paper.

In Pursuit of
THE RIGHT TO
SELF-DETERMINATION

Collected Papers & Proceedings of the

First International Conference
on the Right to Self-determination
& the United Nations

GENEVA 2000

editors

Y. N. Kly
D. Kly

CLARITY PRESS, INC.

© 2001 Clarity Press, Inc.

ISBN: 0-932863-32-9

Cataloguing in Publication Data:

International Conference on the Right to Self-Determination
 & the United Nations (1st: 2000 : Geneva, Switzerland)
 In pursuit of the right to self-determination :
 collected papers & proceedings of the First
 International Conference on the Right to
 Self-Determination & the United Nations " Geneva 2000 /
 edited by Y. N. Kly & Diana Kly ; preface by Richard
 Falk. -- 1st ed.
 p. cm.
 Includes bibliographical references and index.
 ISBN: 00-932863-32-9

 1. Ethnic relations--Congresses.
 2. Self-determination, National--Congresses. 3. Human
 rights--Congresses. 4. Race relations--Congresses.
 I. Kly, Yussuf Naim, 1935-; II. Kly, Diana, 1945-.

 JC312.I58 2000 323.1'1
 QB101-200323

Table of Contents

Preface

Richard Falk

No question in international law and morality is as contested as fixing *limits* on the right of self-determination. Not only is this issue controversial in the extreme, but its resolution bears directly on many of the bloodiest and persistent struggles that presently beset every region of the planet, and bring intense suffering and continuous frustration to millions of peoples. At stake, as well, is whether the criteria relied upon to clarify the right of self-determination are to be determined in a top-down manner through the mechanisms of statism and geopolitics or by a bottom-up approach that exhibits the vitality and potency of emergent trends favoring the extension of democratic practices and the deepening of human rights.

At stake is whether the criteria relied upon to clarify the right of self-determination are to be determined in a top-down manner through the mechanisms of statism and geopolitics or by a bottom-up approach that exhibits the vitality and potency of emergent trends favoring the extension of democratic practices and the deepening of human rights.

In essence, the outcome of these struggles will shape whether our era lives up to the emancipatory potential implicit in the legal, moral, and political promise of self-determination to "the peoples" of the world. Or fails to do so, and retreats into the rigidities of processing self-determination claims by reference to the territorial nationalism and status quo compulsions of most existing sovereign states. In such circumstances, states will continue to rely upon force and intimidation to impose order on disaffected minorities and entrapped "nations." By tradition and past practice, states regard the maintenance of their territorial unity and ethnic/linguistic/religious hierarchies as justifying whatever measure of coercion and abuse is deemed necessary to keep the "peace." And what is more disturbing is that despite the widespread affirmation of human rights, including the right of self-determination, statist violence and brutality to sustain unity will, under most circumstances, be treated as "natural" and even "justifiable" within the arenas of the organized international community. Only in exceptional circumstances where strategic interests or special considerations are strongly felt by hegemonic actors would international support be given to post-colonial secessionist claims. What support is forthcoming is rooted in the ethical expectations of civil society that can be mobilized to a degree by appeals to sympathy, especially if presented by the media ("the CNN factor"), and by the efforts of charismatic leaders (The Dalai Lama).

The evolution of the right of self-determination has been one of the great normative narratives of the past century. It started after World War I, as might be expected, with a Eurocentric focus, specifically the challenge of dealing with the political fate of the distinct peoples formerly encompassed by the collapsing Ottoman

Empire, and to a lesser extent, the Austro-Hungarian Empire. It was part of the visionary contributions of Woodrow Wilson, who despite a deep seated conservatism seemed to have an uncontrollable tendency to give credibility to normative ideas that contained implications that carried far, far beyond his intentions. When articulating the right of self-determination, Wilson clearly did not want to undermine colonial rule to any degree, and had no interest whatsoever in inspiring nationalist movements of liberation around the world. It is ironic that Lenin's endorsement of self-determination at about the same time as Wilson's did have a definite expansive intention that stressed an anti-colonial agenda, and yet had little subsequent impact on the world political consciousness. Leaving aside issues of paternity, what is most relevant here is to understand that ideas create a trajectory of significance based on their overall historical resonance, and this was emphatically the case with self-determination. Ever since the words of self-determination left the lips of Woodrow Wilson, the wider meaning of the words has excited the moral, political, and legal imagination of oppressed peoples around the world. Self-determination even now, decades later, still seems to be a Pandora's Box that no one knows how to close, and despite concerted efforts there is little likelihood that the box will be closed anytime soon.

With the help of the historical convulsions associated with World War II, including its ideological outcome, the politics of self-determination were embraced by the anti-colonial movement, and given increasing aid and comfort by the United Nations, especially the General Assembly. The dismantling of the European colonial empires was undoubtedly the greatest normative achievement of the late twentieth century, but its outcome was flawed in several respects that have generated a post-colonial self-determination agenda. Some struggles for independence were deformed or left without an acceptable closure, inflicting great suffering on such peoples as the Palestinians, the Kashmiris, the Tibetans, and the Tamils of Sri Lanka, and fueling ongoing conflicts. Others took place in a manner that entrapped "nations" within the "new states." The complicity of the leaders of the anti-colonial movements is both understandable, and responsible for much of the anguish and conflict that has ensued. The decision of colonialists and their opponents to accept colonial boundaries as authoritative, regardless of ethnic-linguistic patterns of habitation and without any effort to secure the consent of affected peoples, virtually ensured that varying degrees of resistance would mount over time. Such a prospect was strengthened by the degree that the elites who dominated most post-colonial states were themselves of a given ethnic identity, and variously discriminated against those with a different identity. It is important to recall that world order was in an ultra-statist phase during the 1960s and 1970s, the peak period of decolonization. There was no serious consideration of alternatives to the territorial state as independent political actor. Further, a related assumption was made that the most viable and legitimate modern states were of a secular character that did not base its structures of governance upon ethno/linguistic/religious characteristics. Such a secular creed did not offset the existential realities of pervasive ethnic domination and oppression that emerged in the aftermath of colonialism, and was indeed partly a legacy of colonial practices associated with "divide and rule" that accentuated fissures within territorial boundaries. Of course, this prevailing Westphalian climate of opinion

could not eliminate feelings of discontent, but by and large the post-colonial state was accepted by public opinion as the inevitable and most desirable sequel to the colonial state. Such a transition, without territorial adjustment, was so widely endorsed and so rarely challenged because of fears than any other approach would have a fragmenting impact on existing political communities and lead to an endless series of violent conflicts by secessionist minorities. This statist dynamic was also reinforced by cold war rivalries that induced the opposing superpowers to invest heavily in the state-building processes in the hopes of securing friendly Third World governments and avoiding defections to the enemy camp.

Another factor was the absence of a human rights movement that affirmed group rights and an expansive view of the right of self-determination. There was no organized civil society initiative promoting the humane idea that the right of self-determination could not be *reduced* to obtaining political independence and achieving statehood coterminus with the prior colonial boundaries, that the scope of the right had to be adjusted in light of the will of the inhabitants, including their insistence on various degrees of autonomy, or even independence.

Two important challenges to this view of the scope of self-determination emerged. The first was associated with indigenous peoples who became organized on a transnational level, and asserted their status as sovereign nations seeking to sustain a traditional way of life on traditional lands. This movement continues, and has benefited from the auspices of the United Nations, especially the Informal Working Group on Indigenous Populations that met annually in Geneva starting in the early 1980s, and produced in 1996 after a long process a document entitled the United Nations Declaration on the Rights of Indigenous People. As Ms. Erica-Irene A. Daes, the chair of the Forum throughout most of this period, points out in her contribution to this volume, the Declaration resulted from the most participatory process that has ever existed in the history of the human rights movement. The representatives of indigenous peoples were insistent on claiming for themselves a right of self-determination, which has stalled the acceptance of the Declaration by the UN System. The scope of the claim is not specified, but its assertion has been regarded by governmental representatives as threatening the stability of a statist conception of world order.

The second change is on the level of practice associated with a variety of territorial adjustments that followed upon the end of the cold war. The West was not opposed to the collapse of the Soviet Union, and the emergence of independent states in place of the Soviet republics, particularly with respect to the Baltic States that the Soviet Union had annexed after World War II. The far more traumatic breakup of Yugoslavia cast much deeper doubt on the limited scope of the right of self-determination. Yugoslavia, as the sole remaining European state with a Communist ideology, was widely perceived as an anachronism in the Europe of the 1990s, and the prospect of its replacement by market-oriented constitutional governments was viewed with favor, despite its state-shattering impacts and the resulting warfare. Indeed, the Serb attempt to use coercive means to preserve the unity of Yugoslavia, which was the normal Westphalian response to secessionist movements, was widely condemned from the outset. This process of censure was made easier because of the extreme brutality of Serb tactics, culminating in an

explicit avowal of "ethnic cleansing" by the leading Serb military commander in Bosnia. What emerges after the cold war is an opportunistic and pragmatic view of claims to self-determination, with little geopolitical attention being devoted to the relative merits of these claims from the perspective of justice.

The challenge now confronting the people of the world is to find a fairer way to address the range of self-determination claims. Such fairness would need to treat the process of adjudicating self-determination claims as falling to a greater extent within the domain of law and morality, rather than as presently being mainly sorted out in accordance with geopolitical priorities. More than any recent occasion the First International Conference on the Right to Self-determination & the United Nations, held in Geneva during the millennial year 2000, dramatized the range of claims and the severity of suffering associated with their denial under a variety of statist and geopolitical pretexts. Such a conference made a truly historical contribution by signaling to the world that it would be a cruel hoax to close the book on self-determination claims just because the process of decolonization has been substantially, yet not totally, completed. As well, the conference clarified the extent to which certain forms of decolonization can perpetuate, or even intensify, the ordeal of a previously colonized people. Such has clearly been the case in relation to Ireland, Kashmir, and Palestine to name but three prominent

This Conference made a truly historical contribution by signaling to the world that it would be a cruel hoax to close the book on self-determination claims.

instances. What might be described as "the imperial guidance" of decolonization also greatly complicated the struggle of the Kurdish people for their right of self-determination. In this regard the Geneva conference underscored the need and responsibility of the international community, both organized within the UN System and informal as represented by the initiatives and organs of global civil society, to pursue the rights of vulnerable and oppressed peoples whose identities and destinies are being warped by current patterns of statist control. This post-colonial agenda of self-determination also needs to be incorporated within the broader human rights movement that continues, with a few exceptions, to reduce human rights to the rights of the individual.

Happily, this volume preserves and extends the proceedings of the conference. It vividly sets forth in a series of deeply felt formulations from the perspective of the victims of current arrangements who also have academic or career credentials, a wide range of unsatisfied and highly deserving claims of self-determination in the world. Such claims have received scant attention despite the severe denials of rights involved, and in the face of the clearly expressed aspirations of the peoples involved. The powers that be seek to render such claims as are articulated in the chapters of this book as invisible to the wider world. Publication of this volume, then, can be seen as itself being an act of resistance, as a victory for the politics of visibility, but in a struggle that will need to be waged for decades, if not longer.

Beyond this affirmation, *In Pursuit of the Right to Self-determination* takes the position that the implementation of the right of self-determination should be handled by giving the United Nations more responsibility in assessing claims and their fulfillment. The proposal of the volume to establish a High Commissioner of

In Pursuit of the Right to Self-determination

Self-Determination and to create a Commission of Self-Determination is a credible way of bringing greater fairness into the process of responding to claims associated with *collective* as distinct from individual rights.

Of course, participants in a conference of this sort are not naïve enough to expect that in the present climate of opinion the UN would be able to take on the self-determination challenge in the manner advocated by the contributors assembled by IHRAAM and ICHR. Indeed, their personal testimony bears witness to the extent to which such activist intellectuals as here represented have experienced years of frustration and disappointment, responding to an official language of concern about oppression and the denial of basic rights, yet turning a blind eye to some of the most blatant instances of the collective abuse of peoples. Despite such past discouragement there is alive a sense that it would be a defeat to accept this experience, and that the struggle is itself worthwhile, and produces gains.

In this regard it is notable that even in the current reactionary global climate, breakthroughs are possible, and should not be ruled out. In this regard it is important to take note of the formation of the Permanent Forum on Indigenous Issues that will function as a subsidiary organ of the Economic and Social Council. The leading states in the UN, and many of the lesser ones as well, are quite content to operate within the present post-colonial framework of denial, altered from time to time to serve geopolitical goals of the sort that existed at the end of the cold war. The demand for a more equitable approach to the administration of self-determination claims must be directed mainly to global civil society at this point and to those few government who are attracted by the symbolism and substance of "human security" as the foundation for their engagement with the world. As with decolonization, the next stage in the unfolding, unfinished journey of the right of self-determination will involve many forms of struggle in a variety of arenas. Yet, can any serious student of history doubt that the logic of democratic governance and the realization of a human rights ethos depends on implementing the right of self-determination whenever a "people" is entrapped within oppressive circumstance and clearly manifest the will to exercise freedom over their own destiny. As many of the authors here underscore, self-determination does not necessarily entail secession, but can be realized in a number of ways that impart autonomy, self-administration, collective dignity. Secession cannot be ruled out in circumstances where the denial of human rights is severe and persistent, and where the overwhelming sentiment of a distinct people is so directed.

There are no easy answers to the puzzles associated with balancing claims of self-determination against claims of established political communities to sustain their territorial and political identity. Of course, the establishment of highly democratic structures of governance at all levels of political interaction would mitigate many claims of self-determination. That is, there are two promising complementary ways to address the challenge of self-determination: the first is to provide a systematic way to evaluate claims and arrange for their satisfaction; the second is to create conditions that make the assertion of such claims less necessary and their satisfaction less disruptive- democracy, human rights, and participation in regional organizations can have a nullifying effect on self-determination claims.

What makes *In Pursuit of the Right to Self-determination* so valuable is that it approaches these issues as moral and legal questions, and as prime matters of concern for civil society. This contrasts with a still prevailing tendency to view the issue of self-determination through a statist prism that insists on resolving claims one by one, and in light of political considerations.

As a first step, the voices to heed are those of the claimants, not those of their governmental interlocutors. As a second step, the need is to construct a self-determination regime that operates to the extent possible in accordance with the Rule of Law, treating equals equally. Such a regime is best situated within the United Nations, with as much independence as possible. Until the time when this can happen, the torch of post-colonial self-determination must and will be carried primarily by the transnational forces of civil society. These forces can build a climate of opinion that shifts the political calculus in favor of particular claimants, as occurred in the course of the anti-apartheid campaign waged so successfully on the global level. Given the structures of the world, it is not possible to anticipate the full realization of such a people-oriented approach. It is not prudent to push Russia too far on Chechnya or China on Tibet, or rather, pushing is fine, and might even help to alleviate the situation, and produce some sort of peace process. But what cannot be undertaken save in the rarest of situations is a militarist approach to the denial of self-determination claims of the sort that was relied upon with some success to advance the Albanian Kosovars on the path of self-determination. For many reasons, a nonviolent, yet militant, approach to justifiable self-determination is to be greatly preferred.

Editors' Note

As many do in the face of momentous events, it is tempting to abandon all efforts to capture the First International Conference on the Right to Self-determination & the United Nations with the words: "You had to be there." Present in the Zurich Room of the Forum Park Hotel in Geneva were not only UN experts, distinguished scholars, members of government and minority members of various parliaments, but also representatives of NGOs from all corners of the world concerned with the struggle of internal nations for self-determination.

Organized by the International Human Rights Association of American Minorities (IHRAAM), an international NGO in Consultative Status with the United Nations and the International Council for Human Rights (ICHR), this very unique conference connected the detached analysis and concerns of internationally recognized scholars, members of governments and UN officials to the pressing concerns of those whose nations seek to exercise the right to self-determination as a means of external or internal societal development, thus increasing the understanding and appreciation of all concerned of the difficulties and potentials involved. Many of the groups thus obliquely represented were ro some degree engaged in civil conflict; many suffered from historical and longstanding human rights grievances committed against their people of a severity almost incomprehensible to persons living in nations at peace. Some represented well-organized struggles with long familiarity with the issues surrounding self-determination, while others, still on the threshold of discovery, were swept out of their isolation by the realization that so many diverse groups – European, Indigenous, African, Asian — experienced the kind of difficulties and outrages which they had thought unique to themselves.

This conference fostered the realization that the issue of self-determination concerns not merely the relation of internal nationalities to the dominant groups within their own states but their relation to the international system itself. In an international system essentially defined by states, where many multinational states themselves have primarily addressed and reflected the needs and views of the dominant groups within them, the distress of disempowered internal groups – over 2,000 nationalities squeezed into 192 states – takes on a scale and significance worthy of recognition as one of the more serious global problems of our time – on a par with the issues so hotly debated surrounding globalization and the Bretton Woods institutions. Clearly, an international confluence organized by these groups themselves to address their needs and how the UN might respond was in the cards, yet all were almost incredulous that it had actually come about. "Historic!" was the word that passed from mouth to mouth.

Prior to the Conference, copies of the paper "Towards a Mechanism for the Realization of the Right to Self-determination," prepared by André Frankovitz, Executive Director of the Human Rights Council of Australia, were distributed by e-mail, at the Conference itself, and posted on the Conference website. Delegates were requested to familiarize themselves with this paper as a starting point for further deliberations as to what role the UN should play in relation to self-determination, and whether there was a need for a UN mechanism in order for it to fulfill such a role.

The Conference began on Friday evening almost in an atmosphere almost of jubilation as delegates gathered, ate together by candlelight, then listened to the stirring speeches of the Opening Plenary Session. The two days that followed were "very strenuous" as Daniel Atchebro of the UN Office on Racism diplomatically put it. The first day called for the deliberation of five themes, but one panel had to be deferred to the following day. The order of the themes was shuffled due to the need to meet the schedules of two prominent speakers who had to depart early. There were misunderstandings as to the reason for the changes; concerns that some groups were gaining more conference speaking time than others; disagreements among individuals and groups over past history as well as interpretations of international law. One of the more remarkable exchanges was that between Karen Parker, an international lawyer who has often represented the claims of internal nations through Congressional testimony, studies and UN intervention, and George Reid, who presently serves as Deputy Speaker in the Scottish Parliament, but had a long history of work with the International Red Cross responding to conflict situations, on whether, under humanitarian law, groups undergoing long and continuous grievous human rights violations had the right to engage in armed conflict in defense of their right to self-determination. Another occurred between Rt. Honourable Gerald Kaufman, Member of Parliament of the United Kingdom and Dr. Y. N. Kly, Chair of IHRAAM, on whether African Americans as a group had been consulted within a context acceptable to international law and agreed to policies of assimilation as practiced in the state in which they live. Towards the close of the conference, many delegates had still not been heard, and the floor was re-opened in order to accommodate them, so that all who attended might have the opportunity to speak.

Three speakers who were unable to attend in person managed to address the Conference nonetheless, thanks to the modern technology of the global village. Conference Guest of Honor Yasin Malik spoke to a hushed assembly directly from Kashmir by means of long distance telephone, as did Jamil Al Amin (former Black Panther, Rap Brown) by video.

Many groups sought Conference endorsement for resolutions specific to their own situations, while others who represented governmental bodies advised that they were not empowered to endorse such specific situations and would have to dissociate themselves from the Conference, were such resolutions passed. Rather than pressing for individual claims, the delegates chose to unite around the common interest, and passed the Conference resolutions calling for the UN to create new mechanisms to adjudicate or arbitrate claims to the right to self-determination without a single dissenting voice.

In order to achieve a peaceful, democratic, human-centered and sustainable systemic development, a strong UN intervention in this process of nations and groups renegotiating their socio-political and geo-political relations is necessary. The words of Ali Shariati express this effort in metaphor:

> The unconscious appearance of the dawn, without volition or sensibility, is flawed... The poet seeks a dawn which, like a resolute hero rises from behind the horizon... and slits the black throat of the night by *intention*... nature does not offer such a dawn.

Notes on the Compilation

The compilation of the Conference papers has been a major task. The editors drew on papers which had been deposited with Conference officials, as well as on video-tapes of the sessions – some 12 in all covering the three day period – which were re-taped onto 4 tapes, which then had to be converted into North American format and transcribed.

In compiling these papers, the editors sought to restore some degree of balance in the representation of the groups in attendance, which has required the elimination of some papers which addressed the same situation. In ordering the presentations, we have restored the order of speakers as listed on the Conference brochure. The placement of interventions was somewhat more problematic. Many were not delivered at the time of the theme they referred to, and many did not refer to any specific theme in particular. Many concerned more than one situation. Accordingly, we placed the numerous interventions in a unit following the presentations of the speakers rather than under the various themes which they may have concerned.

The presentations made by Dr. Robert Brock and by his wife, Mickie were not made available for publication, and are not included here. It is also a great disappointment that the closing summation delivered by George Reid, Deputy Speaker of the Scottish Parliament, was not captured on videotape, and is therefore not included. We also regret that no photo of Mme. Daes, who contributed so much to this conference, was available for inclusion in the photo section to follow.

Acknowledgements

Special appreciation is extended to Colin McNaughton, Conference Operations Manager; Diana James, Publicity Director; interns Amy Quark and Nicole Eddy, who also assisted in transcription of some of the Conference tapes; Dr. Bailee Muhammad Shoaib, President of ICHR, and Mr. Shakil Ameir, who taped the Conference proceedings and provided photographs of same.

CONFERENCE SPONSORS

International Human Rights Association of American Minorities (IHRAAM)

http://www.ihraam.org

IHRAAM is an international NGO in consultative status with the United Nations. It serves as an umbrella organization to facilitate and coordinate the efforts of individuals, minorities and community organizations to gain access to international law and its enforcement mechanisms.

*[Left: Dr. Y. N. Kly, Chair of IHRAAM with Mrs. Marilyn Preston Killingham.
Dr. Kly is wearing an honorary gift presented to the Conference Sponsors by M. Udhaya Bhanu of Dr. Ambedkar Advocates Association for Human Rights.]*

International Council on Human Rights (ICHR)

ICHR is an international NGO committed to providing assistance to the United Nations and its affiliated bodies in the promotion and observance of the Universal Declaration of Human Rights, and to work for fundamental freedoms and peace.

[Left: Barrister Majid Tramboo, Executive Director, ICHR and Member of the IHRAAM Directorate.]

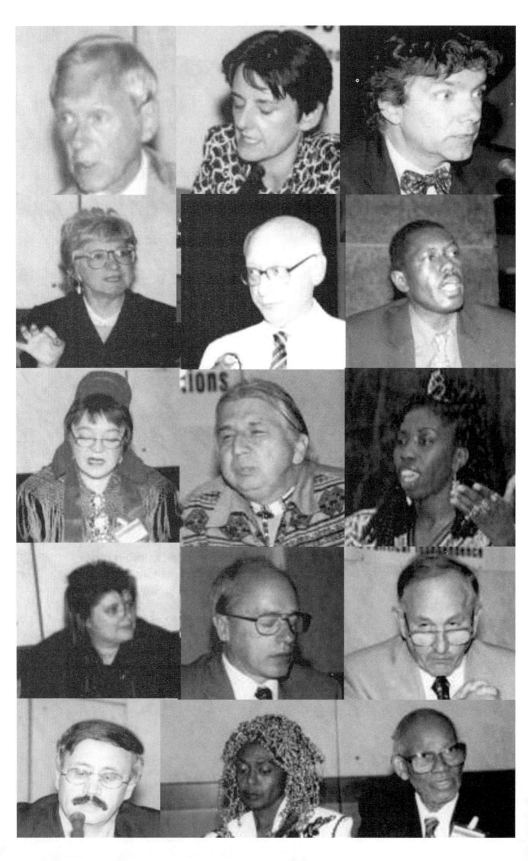

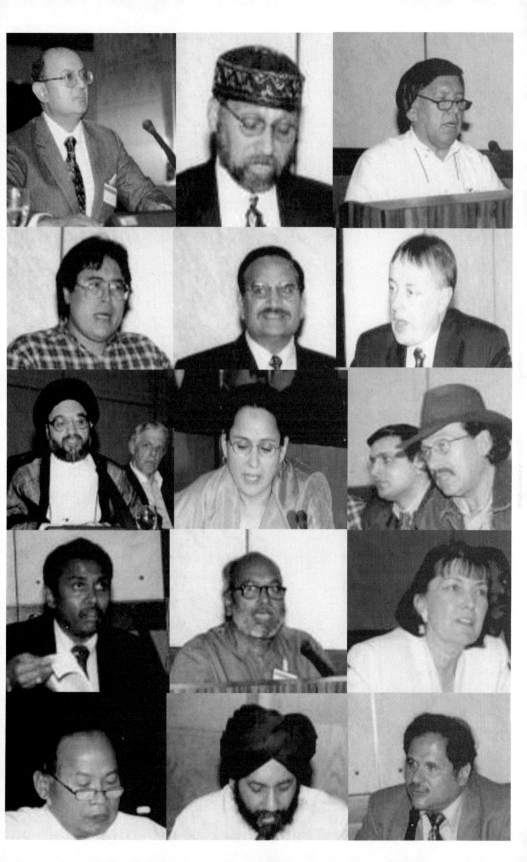

Towards a Mechanism for the Realization of the Right to Self-determination*

André Frankovits

INTRODUCTION

This paper proposes a mechanism for the realization of the right to self-determination.

It recommends:

The establishment of a Self-determination Commission comprising representatives of the UN memberStates;

The establishment of an office of a High Commissioner for Self-determination;

The appointment of an Expert Group on Self-determination to serve as an advisory body to the Commission.

The words 'self-determination' immediately conjure up the notion of a territory seceding from another and sounds an echo of the struggles of the 1940s and 1950s by the former colonies to achieve independence. In discussions of how an ethnic or political group can achieve self-determination, such terms as autonomy or self-regulation are used to broaden the definition and to avoid implications of secession and the breakdown of the nation state. The paper will attempt to show that self-determination can cover a range of concepts from outright secession through means of popular participation to federalism and local domestic autonomy, and that the term is firmly grounded in the international human rights framework.

The paper will argue that there is a pressing need for a mechanism for the achievement of self-determination and that this needs to be anchored in the United Nations system not only because the human rights framework provides a universal one agreed to in principle by the international community but also because it is a

*This paper was recommended to attendees as pre-conference reading, to serve as a stimulus indicating systemic possibilities towards which participants might direct their thoughts. The paper was originally prepared by André Frankovits for Senator Vicki Bourne, Australian Democrats Senator for New South Wales, in August, 1996.

feature of modern-day post-Cold War conflicts which create an unacceptable threat to peace and security. Since the UN Charter is based on the maintenance of peace and security and the realization of human rights, it is within the UN system that the quest for self-determination must be pursued.

It is within the UN system that the quest for self-determination must be pursued.

HISTORICAL BACKGROUND

The words "self-determination" were included in the founding documents at the time of the creation of the United Nations following the horrors of the Second World War. The words appear in the UN Charter as an enunciated principle rather than as a designated right and — in a not too subtle allusion to the American Declaration of Independence which served as an inspiration to the Charter — the concept is tied to the notion that "peoples" have equal rights.

The inclusion of the term self-determination arose from pressure from the territories under the colonial domination of European powers and from other First World States without colonies whose economic and strategic interests would benefit from independence for the old colonies. Self-determination was thought of from the outset by the UN member states as a descriptive term applying to the process of decolonization.

From some perspectives the decolonization process has been one of the outstanding successes of the United Nations machinery. If one looks purely in numerical terms, the history of decolonization is an impressive one. In 1948 among the original fifty-one countries in the UN only three had recently emerged from colonial rule. Less than twenty years later, in 1965, out of a total of one hundred and nineteen members, fifty had only recently been colonies while another twenty had been former colonies and another six had emerged from under foreign tutelage.[1]

The entire process of decolonization was not all smooth sailing. There were many instances when those states still intent on holding on to their colonies put up a strong resistance against having their dominions stripped from them but the calls for independence — in many cases accompanied with well-motivated insurgent movements — brought home to the international community the importance of achieving self-determination in order to ensure peace and security.

Indeed the motivation for decolonization did not stem merely from concerns about justice but from the realization that the instability created by peoples seeking their independence from colonial occupation could easily lead to conflict and undermine peace and security and the strategic balance between the countries of east and west.

Such instability is once again threatening world peace and security in the post-Cold War period in which long-repressed nationalist sentiments as well as discriminated-against minorities are calling for self-determination.

The forums initially available to the anti-colonialist forces were the UN General Assembly and its Fourth Committee — the so-called Decolonization Committee — the Security Council itself and the Trusteeship Council.

The Trusteeship Council was established by virtue of Article 88 of the UN Charter. Half of its members were the administering powers of the Trust Territories and it is not surprising therefore that unanimity over the process and pace of the granting of independence would be slow. Not only did the administering powers

use stalling tactics to delay progress but they would also exert influence on the other members of the Council. Thus only three or four of the members at any one time would be actively pressuring for progress in the granting of independence to individual colonies.

The Trusteeship Council itself had only limited powers: its main activity was the issuing of questionnaires concerning the political, economic, social and administrative advancement attained within each territory. This information was supposed to provide the framework for an annual report submitted by each administering power. The Council also sought to augment its information by asking to send missions to the relevant territory but this was at the mercy of the administering powers which were often reluctant to cooperate over requests for such missions.[2]

With the odds stacked against any progress through the Trusteeship Council, it was not unexpected that the Fourth Committee of the UN General Assembly with delegates from all the member States repeatedly expressed its impatience with the decolonization process and began to seek to carry out fact-finding missions itself.

As well, anti-colonial sentiments were more prevalent in the General Assembly than in the Security Council, given that it was in the Assembly where the former colonies had the numbers.

In 1960, the UN General Assembly adopted the Declaration on the Granting of Independence to Colonial Countries and Peoples and this reflects the growing impatience of a majority of the member States. The Declaration lays out the aspirations and expectations of the international community in the face of the slowing down of the progress towards decolonization. It proclaims the right to self-determination which was subsequently incorporated into the preambles to the International Covenant on Economic, Social and Cultural Rights and the International Covenant on Civil and Political Rights.

In a move parallel to the interpretation by States of the Declaration on the Right to Development in more recent times, the drafters of the Declaration on the Granting of Independence to Colonial Countries and Peoples seriously limited their definition of self-determination. Just as many UN member States have behaved as if the Right to Development refers to national development alone and downplayed the people-focus of development, so the definition of self-determination is qualified by a major caveat in the 1960 Declaration:

> Any attempt aimed at the partial or total disruption of the national unity
> and the territorial integrity of a country is incompatible with the purposes
> and principlesof the Charter of the United Nations.

This formulation is aimed at preventing any definition of self-determination that is not based on the gaining of independence of the former colonies of the European powers and to exclude any other definition. It also shifts the focus away from the rights of peoples and communities to those of governments.

The irony is that as far back as 1955 when the UN was trying to draft a right to self-determination, one delegate suggested six categories in which the right would apply:

1. Peoples which constitute independent and sovereign States.
2. Peoples of States which had lost their independence and sovereignty
and wish to regain it.

3. Peoples which although constituted in independent sovereign States are prevented by their own dictatorial governments from exercising their right to self-determination.

4. Peoples who form part of a independent and sovereign State, but consider themselves absolutely different from the other elements in the country and wish to set up a separate State.

5. Peoples constituting States which were formerly or nominally independent and sovereign but whose independence and independence were forcibly controlled by another State.

6. Non self-governing peoples whose territories were administered by the so-called colonial powers.[3]

Philip Alston points out that these well-meaning definitions would inevitably antagonize States that would see most of them as a threat to their national cohesion and accordingly lead to the rejection of any suggestion for their incorporation in the declaration. As he puts it,

This was put forward, as I understand it, in good faith by someone who wanted the right to self-determination to be recognized. But it seems to me to be the best possible summary of all the reasons why governments would not have been prepared to accept such a right.[4]

In any event, the UN recognized three types of situations in which the right to self-determination is applicable. The first is of course that of colonial peoples to self-determination. Next is when a State falls under the foreign domination of another power as this is seen as a violation of the right to self-determination. The third situation covers racist domination and has only been applied in Southern Africa.[5]

The 1960 Declaration on the Granting of Independence to Colonial Countries and Peoples proposed a Committee to oversee the decolonization process. Originally constituted of seventeen members, the Committee was increased to twenty-four in 1962 and was henceforth known as the Committee of Twenty-Four. The significant difference from the Trusteeship Council was that the Committee of Twenty-Four was no longer dominated by the administering powers and that its secretariat was involved on a more independent basis in the preparation of the agenda and documentation of the Committee.

The secretariat would provide papers assessing not only the civil and political situation in the territory under question but also economic, social and cultural factors and the performance of the administering powers in relation to these.

The Committee was far more assertive in the face of resistance from the colonial powers and the proceedings were often characterized by denunciation and recrimination. The Soviet Union, intent on creating trouble for the European Powers, encouraged an antagonistic relationship between the Committee and the colonial powers. The Committee thus invited petitions from the independence movements in the administered territories and sought to conduct fact-finding missions which would often be refused. The Committee would also seek to have Security Council involvement, arguing that some of the insurgencies were a threat to peace and security.

The main criticism of the Committee of Twenty-Four focussed on the adversarial nature of its processes and on its attempted political manipulation by the Soviet union. In a sense this was also the measure of its success since it managed to maintain a high international profile for the issue of decolonization particularly during those periods of the year that the mechanisms of the United Nations faded from the gaze of the media. As Luard has said in his history of the UN,

> The most visible effort of the Committee was that UN pressures were maintained even in periods when the Assembly was not meeting and were exerted in a rather more publicized form than before.[6]

The Fourth Committee by contrast, comprising as it did representatives of all the Member States of the UN,was in a sense more democratic and less open to political manipulation. Given the increasing representation in the UN by the former colonies, the activism of this Committee increased under the goading of the morecampaigning Committee of Twenty-Four to the extent of itself calling for access for fact-finding missions. It also had the advantage of benefiting from the greater media attention given to a full committee of the General Assembly. To quote Luard again,

> The Fourth Committee of the Assembly, though it became in time almost as radical [as the Committee of Twenty-Four], was probably more influential, because it was recognized as more representative, and because its debates were more highly publicized.[7]

If it is accepted that the decolonization process was a relatively successful one then a number of factors can be identified that contributed to this success:

> The inclusion of all UN member States through their participation in the General Assembly and its Committees conferred the legitimacy needed for sufficient pressure to be placed on the colonial powers to want to achieve a resolution of the problems that confronted the administered territories.

> This was aided by assessments that at least some of the independence struggles could prove a threat to world peace and security particularly in the context of the Cold War.

> The involvement or possible involvement of all the member States tended to mitigate the possibility of overly aggressive conflict in the debates around decolonization.

> The fact that the decolonization process was taking place at UN Headquarters and thus in the shadow of the Security Council, meant that the political dimension of the decolonization process could not be overlooked and added to the urgency of the calls for independence.

> The debates taking place in the Committees and in the General Assembly itself meant that there was constant and continuing public scrutiny of the process with the consequent increased media attention.

DEFINITIONS OF SELF-DETERMINATION

The great independence struggles following the Second World generally resulted in successful outcomes as evidenced by the rapid increase in the number of UN member states – with the exception of some notorious cases such as the territories of East Timor and West Papua. In almost all cases of successful decolonization the newly independent States have been strong defenders of the pre-colonial boundaries established by the colonizers. The rationale for this position for both the emerging nations and the former colonial powers was based on pragmatism.

The reasoning behind this principle (the sanctity of borders) was quite clear; without it, the newly decolonised states would be condemned to fight each other over the unrealistic borders established by the haphazard nature of the conquests of the colonisers. In the Burkina Faso and Mali (Frontier Dispute) case of 1986, the International Court of Justice held that the principles of *uti possidetis* "is a general principle, which is logically connected with the phenomenon of the obtaining of independence, wherever it occurs"[8]

The principle re-affirmed by the International Court has however been applied quite selectively and inconsistently. For example, the principle was used to recognize the former federated states of Yugoslavia such as Croatia and Slovenia but was not applied to the former province of Kosovo. The old colonial borders took little account of the ethnic divisions that have now become an intrinsic aspect of so many bloody conflicts in Europe and Africa.

What could be categorized as the old Soviet colonial system is a case in point. The imposed borders of the fifteen former Soviet republics have been maintained with the fall of the Union but the consequent lifting of the heavy hand of the state apparatus has resulted in calls for self-determination from ethnic minorities in Georgia, Uzbekistan, Tajikistan and Armenia, to name but a few. The existing minorities in these newly independent states are entitled to some form of self-determination and have a legitimate claim for the retention of their culture. The denial of these has lead to the civil conflicts we see on our TV screens virtually every night.

The principle of the sanctity of borders was reinforced through such instruments as the 1970 Declaration on Principles of International Law concerning Friendly Relations and Cooperation among States. This declaration served to preserve the former boundaries and underpinned the claims of States that internal conflicts are exclusively an issue of domestic jurisdiction and not subject to international scrutiny. In this doctrine any expression of concern by the international community can be construed as interference in the affairs of States and an infringement of national sovereignty.

The Declaration on Friendly Relations makes clear that self-determination may stop short of territorial separation, and provides for acts of self-determination arising from an act of free choice that does not necessarily involve secession.

Yet the Declaration itself makes clear that self-determination may stop short of territorial separation. It makes provision for acts of self-determination arising from an act of free choice that does not necessarily involve secession:

... The establishment of a sovereign and independent State, the free association or integration with an independent State or the emergence into any other political status freely determined by a people constitute modes of implementing the right to self-determination by that people. Ian Brownlie points out that there already exists a range of options in the realization of the right to self-determination. He describes how trusteeships — of which there are only a very few remaining examples — represent one form of autonomy providing that it is established with the consent of the people under trusteeship. While trusteeship is related to a presumed transition to independence, it is possible to envisage an act of free choice which will lead to a different relationship to the State administering the trust territory. He describes a number of examples:

... there are a variety of other models, including that of 'Associated State' (as in the case of the Cook Islands and New Zealand), the regional autonomy of Austrians in the South Tyrol, the Cyprus Constitution of 1960, and the various arrangements within the Swiss and other federal constitutions.[9]

Frederick Kirgis Jr goes further in listing what he calls the 'numerous faces' of self-determination. While pointing out that the legal nature of some of these can be questioned, he notes that there are degrees of claims just as there are degrees of self-determination and argues that the legitimacy of each claim is proportional to the level of democratic participation allowed by the government concerned. This argument is based on both pragmatism and empirical observation. For example, a claim for secession will not be supported by the international community if it is made within a representative democracy whereas there is likely to be more support if the claim is lodged where the government is extremely unrepresentative and where there is a high degree of destabilization brought about by the conflict with the claimants.

Kirgis lists the following 'faces' of self-determination:

Decolonization is the most obvious and well-accepted manifestation of the right to self-determination.

The process is incomplete most obviously in East Timor and is now very much in question in West Papua where the Act of Free Choice was certainly not free with little choosing allowed by the peoples of this former Dutch Colony.

The people within a defined territory may elect to remain dependent through an act or plebiscite as was the case with Puerto Rico deciding to remain a dependency of the United States.

A referendum in the former Czechoslovakia decided peacefully on its dissolution into two independent states. A similar act of self-

determination won Eritrea its independence from Ethiopia following the fall of the Mengistu regime.

The international community eventually recognized the right of East Pakistan to secede and become Bangladesh. That act recognized the arbitrary nature of the former colonial power's partition of its former colonies.

Tibet was invaded in 1949 by Chinese forces and annexed by the Chinese authorities as a part of China. It is clear that the Tibetan people do not want to remain a part of China and that their cultural and ethnic identity is under attack from the Chinese authorities. There is no indication as yet that any of the member states of the UN are prepared to take up the cause of the self-determination of Tibet.

Germany is an example of two territories agreeing to become one and has some lessons for the two Koreas both of whose state policies call for reunification.

The limited autonomy, short of secession, for groups defined territorially or by common ethnic, religious and linguistic bonds is exemplified by the relationship of some Pacific Island States to Australia and New Zealand.

The Inuit of Canada have been granted self-determination within a larger political entity and minority groups elsewhere including those in Australia are pointing to this example as a model.

The draft Declaration on the Rights of Indigenous People, while using the language of the accepted international human rights instruments, elaborates on aspects of self-determination that clarify the specifics of the obligations to and entitlements of indigenous people. It is no surprise that the wording therein has proved so controversial and is having such a difficult passage through the UN. It is worth quoting from this draft Declaration for the echoes of the terms of the debate on self-determination that started at the beginning of the twentieth century:

> Indigenous peoples have the right to self-determination. By virtue of that right they freely determine their political status and freely pursue their economic, social and cultural development. (Article 3) Indigenous peoples have the right to maintain and strengthen their distinct political, economic, social and cultural characteristics, as well as their legal systems, while retaining their rights to participate fully, if they so chose, in the political, economic, social and cultural life of the State. (Article 4)

> Indigenous peoples, as a specific form of exercising their right to self-determination, have the right to autonomy or self-government in matters relating to their internal and local affairs, including culture, religion, education, information, media, health, housing, employment, social welfare, economic activities, land and resources management, environment and entry by non-members, as well as ways and means for financing these autonomous functions. (Article 31)[10]

Even if the Declaration is adopted, it may not have very much impact on the practices of many UN states. It is after all in the developed world that indigenous people have won acceptance of their rights while in the developing world their voices have been muted. In the words of Michael Ong,

> Indigenous minorities [he is speaking about Asia] share several commonalities. They are, in the overwhelming majority of cases, demographically insignificant and thus politically ineffectual. They also exist on the periphery of their country's economy and have often become the primary targets of domination and subjugation by the more powerful, including the government, resulting in their assimilation. [11]

Yet the accommodation reached by the indigenous populations with their governments in countries like Sweden, Canada, Australia and New Zealand demonstrate that the nexus between self-determination and independence or secession can be broken and provide an example for other claimants.

> The internal self-determination freedom to choose one's form of government, or even more sharply, the right to a democratic form of government.[12]

The last case is about the democratic process. People ought to be free to choose whatever form of government is most appropriate to them but a more important point highlighted by this last case is that self-determination is and must remain an ongoing process. A single act of self-determination is meaningless if it does not alter the situation of the people concerned in any meaningful manner. There are too many instances of such a single act leading to a deterioration in the protection of human rights supposedly endorsed by that single act.

Dr Peter Wilenski, the former Permanent Head to the UN and an ardent proponent of UN reforms in a speech to the General Assembly highlighted this dimension to the nature of self-determination. Self-determination is not simply a single definitive act. In a view shared by many of his colleagues, Wilenski explains that the notion of popular participation is intrinsic to the notion of self-determination:

In Pursuit of the Right to Self-determination

Realisation of the right to self-determination is not limited in time to the process of decolonisation nor is it accomplished solely by a single act or exercise. Rather, it entails the continuing right of all peoples and individuals within each nation State to participate fully in the political process by which they are governed. Clearly, enhancing popular participation in this decision-making is an important factor in realising the right to self-determination. It is evident that, even in some countries which are formally fully democratic, structural and procedural barriers exist which inhibit the full democratic participation of particular popular groups. [13]

This notion of continuing process and of popular participation is especially relevant to the self-determination of indigenous populations whether defined within a given territory or within a 'larger political entity'.

IS A SELF-DETERMINATION MECHANISM FEASIBLE?

Many of the current threats to international peace and security stem from the struggles of various minorities to claim their right to self-determination. Wherever one looks, such claims are creating the sorts of tensions which have a major impact on the good relations between states.

The status of East Timor remains – in the words of President Suharto – the stone in the shoe of the relations between Indonesia and Portugal, Australia, the Netherlands and the US. The suppression of Tibetan culture has most recently lead to a breakdown in cordial relations between China and its trading partners, Germany and the United Kingdom. The failure to recognize the popular will in Burma has resulted in threats of economic sanctions from the European Community. The attempted wiping out of the Christian minority in the southern Sudan is giving rise to grave concerns about relations between Sudan and its African neighbours. The aspirations of the indigenous people of Mindanao threaten the prospects for a trade triangle between the Philippines, Brunei and Indonesia. The survival of the Palestinian people is the basis for a possible conflagration in the Middle East. The subjugation of the citizens of Chechnya may provide the kindling for a resurrection of a totalitarian military regime in Russia.

In most of these cases attempts are under way to try to resolve the conflict either through the good auspices of the UN Secretary-General as in the case of East Timor, by governments themselves as in Mindanao, through international mediation as in Palestine or by using the suasion of regional bodies such as ASEAN in Burma or the OAS in Sudan. The fact remains that each time a new situation develops, a considerable time is expanded internationally or within the state on trying to develop a process appropriate to the specific disagreement — and the lack of success in finding either a rapprochement between the parties or a solution to the problems remains notoriously elusive.

The legacy of the Declaration on Principles of International Law concerning Friendly Relations and Cooperation among States is invoked in the refusal of many of the respective states to countenance any external involvement in the resolution of disputes. It is argued that the insistence on the supremacy of national sovereignty

in such disputes arise from fear of the disintegration of the state. This gives rise to an increased focus on the inviolability of national boundaries and the categorising of attempts by the international community to assist as an unwarranted interference in their internal affairs.

In a certain sense this approach to conflicts arising from the claims of ethnic or other minorities parallels that by those governments accused of abuses of human rights.

Prior to the early 1990s at least, the standard reaction of these governments to criticism by the UN or its member States of the violations of rights was that this constituted an interference in their internal affairs – this response was particularly and understandably strongest in those cases in which the threat of some kind of sanction would be made against the offending state.

In the lead up to and at the second UN Conference on Human Rights held in Vienna in 1993 this position lost its legitimacy following the re-affirmation by governments and non-governmental organizations alike that human rights were the legitimate concern of the international community. Through the work of human rights organization such as Amnesty International and Human Right Watch and their emphasis on inalienable rights and a focus on the victims of the denial of these rights, it is less common for governments to use domestic jurisdiction as a defence for their abuses.

While there are still governments that reject criticism of their human rights records as an unjustified intrusion in their domestic affairs, this is becoming rare and the new defence of abuses now centres on claims that the realization of human rights varies according to the cultural context in which it is situated and on the economic and social status achieved by each country. In general most governments now acknowledge the essential role played by the UN human rights mechanisms in the protection of the inalienable rights of their citizens.[14]

In the light of this acknowledgment and the increasing awareness by the international community of the costs associated with the struggles for self-determination and their possible impact on a globalizing world, the time is ripe for addressing the issue of self-determination more directly than in the past and from a different perspective than that of the UN Commission on Human Rights.

Such private bodies as the Canberra Commission on Nuclear Disarmament can have considerable moral force and add to any existing momentum for change. However, like the Peace Tribunals of the 1970s, they lack the legitimacy provided by apolitical governmental support in the UN. There is thus a need for the establishment of a body similar to the Decolonization Committee but with a wider mandate to explore the realization of all aspects of the right to self-determination.

> **The time is ripe for addressing the issue of self-determination more directly than in the past and from a different perspective than that of the UN Commission on Human Rights.**

In a paper delivered to the International Peace Research Association Conference in 1992, Herb Feith and Alan Smith proposed a new UN process for the evaluation of self-determination claims. They also allowed for the range of possible definitions of self-determination outlined above. However they focused more on how these would

In Pursuit of the Right to Self-determination

be assessed and described a three-step procedure which they point out has similarities to the processes adopted by the former League of Nations to protect minorities.

The first step is the registering of claims to self-determination with an organ of the UN. This is followed by an evaluation of the legitimacy of the claim and whether there is a prima facie case made out for self-determination. If the case is deemed legitimate, the UN organ charged with the evaluation refers the case to the Security Council which in turn endows its authority to negotiations between claimant and the State concerned.

Feith and Smith suggest that the organ that would be charged with registering and evaluating claims could be either the Human Rights Commission or its Sub-Commission for the Prevention of Discrimination and Protection of Minorities, or the Decolonization Committee but they also issue a warning about the "ideological baggage from past debates" of these UN bodies.

The process they propose for the evaluation of a prima facie case is based on identifying at the outset the goals of a claim rather than focussing on the nature of the outcome (secession etc). The conditions for assessing these would encompass,

an analysis of the nature of the dispute between the state and the claimant;

the level of support from civil society in the affected territory;

the historical basis for the claim;

the actual or potential presence of an institutional entity able to administer the claim;

the existence of any abuse of human rights leading to the claim.

These factors may serve to establish a bona fide claim. There is also a need however to establish whether any proposed process towards self-determination will actually benefit the population making the claim and protect the legitimate interests of the state in question. In other words, "the international community can demand observance by the claimant of peaceful settlement of outstanding disputes with the states involved and acknowledgment of the rights of new minorities" created in the self-determination process.[15]

Thus additional considerations must feature in the assessment of the legitimacy of claims. These might include the provision of protection or compensation to those adversely affected by fulfilment of the claim, whether individuals, groups or the state. For example, if a claim is based on greater political autonomy some kind of guarantee must be provided for the protection of the rights of minorities within the newly autonomous entity. Only if this is present should the claim be accepted.

Important also then is the need for the possibility of follow-up after a claim has been "settled". As Wilenski points out, the right to self-determination is an ongoing process and there should also be a guarantee from the parties to the claim that there is a commitment to the ongoing process.

As for the process of involvement of the Security Council in the negotiations over self-determination, Feith and Smith take the UN Commission on Indonesia as their model. In this each disputant independently chose a member state for a small commission and the two parties together agreed on a third state to form a tri-partite commission.

A PERMANENT SELF-DETERMINATION COMMISSION

The proposal to divide the processing of claims for self-determination into three steps has an initial appeal.

First is the registering of claims with a designated body. Then comes an assessment of the legitimacy of a claim by using a set of predetermined criteria. Finally, the claim is processed by a body designated by the Security Council.

There are drawbacks to the creation of separate commissions for each claim to self-determination. The Security Council does not have an outstanding record of impartiality in its votes over issues of international peace and security. While the veto has been exercised less frequently recently, the permanent members of the Council have applied it in a clearly political manner. As well, with the prospect of a process of democratization of the Security Council, it is increasingly likely that the new members as well as the permanent members will be involved in claims themselves and will be in a position to prove obstructive to the establishment of commissions that they will perceive as potentially declaring against them.

On the other hand it is important to ground a Self-determination Commission in the UN system in New York. The experience of the Decolonization Committee is a valuable one. The new Commission would be made up of representatives of the member states of the UN and report directly to the General Assembly. It would thus be advisory to the Security Council and be in an ideal position to forewarn of claims which are a danger to international peace and security.

There might be a temptation to convert the Decolonization Committee to fill the functions of a proposed Self-determination Commission. This should be resisted. That Committee is too closely associated with the decolonization process and will inevitably be forced to view self-determination through the prism of a search for independence and secession. It is also bound up with the history of decolonization and, as Feith and Smith point out about the Commission on Human Rights and its Sub-commission, carry the political baggage of past differences.

EXPERT GROUP ON SELF-DETERMINATION

The complexities of the issues around the right to self-determination creates a major challenge for those involved in the realization of that right. The usual practice for a UN commission is the allocation of a secretariat (unfortunately mostly underfunded) charged with servicing the UN-appointed organ. As has been argued above, there is a level of urgency in addressing the numerous claims for self-determination around the world. Yet the relevant literature is scattered and contradictory.

There is clearly a need for the development of a body of expertise focussing on the realization of the right to self-determination, for the compilation of lessons from past experience and the establishment of an organ able to explore the varieties of claims to self-determination. It is proposed therefore to recruit an Expert Group on Self-determination.

The group would consist of individuals with a high reputation and experience in a number of fields. Such a group would include:

a human rights expert able to evaluate claims based on persistent discrimination and who would have a thorough knowledge of the UN human rights system,

a diplomat experienced in negotiation and conflict resolution,

a UN staff member familiar with the processes at the UN Secretariat and at the General Assembly, someone from the indigenous sector familiar with the procedures at the Sub-Commission and with indigenous claims to self-determination,

a demographer able to assess the context in which claims arise,

a sociologist who could advise on the outcomes of various forms of autonomy ranging to territorial independence,

an international jurist who could draft terms of agreement acceptable to the parties to a claim.

This list is not exhaustive. The function of this group of experts would be initially to develop a proposal for the registration of claims, for assessing the legitimacy of claims and mechanisms needed to resolve the claims.

Initially funded by sponsoring governments, it would produce a comprehensive report and recommendations for further action. Its most important task would be to then apply the recommendations to a small number of carefully selected cases with a view to develop a body of experience leading to a more concrete proposal to set up the Commission on Self-determination itself.

Once the latter has been agreed and established the Expert Group would act as an advisory body to the Commission.

A HIGH COMMISSIONER FOR SELF-DETERMINATION

The international human rights movement in 1993 during the lead up to the UN World Conference on Human Rights, resurrected the proposal to establish an office of a High Commissioner for Human Rights. The rationale for such a post was based on a perceived need to invest credibility in the UN human rights system, to provide for effective human rights diplomacy and to bring a semblance of order into the complicated human rights machinery of the UN.

It was thought that a person who had expertise and an impeccable reputation in the human rights field would be able to emulate the role of the High Commissioner for Refugees and enable high level discussions with state representatives on human rights matters. Such a person would be in a position to integrate the work of the treaty bodies and generate greater cohesiveness and coordination in their respective areas of concerns. The office would also serve as a liaison between the UN human rights activities based in Geneva and the General Assembly in New York and serve to regularize the work the Centre for Human Rights.

The proposal was accepted at the Vienna Conference and included in the Program of Action. After lengthy debate the General Assembly approved the

establishment of the office of the High Commissioner and Jose Ayala-Lasso was appointed soon after as the first High Commissioner. This appointment has resulted in recommendations for human rights monitors in Rwanda, an increase in the provision of advisory services on human rights and numerous meetings between the High Commissioner and government officials in countries with human rights problems.

There has been some criticism about the performance of the office to date. For example it has been suggested that the High Commissioner has not succeeded in integrating the treaty bodies in his diplomatic activities and that in some cases he has undermined their work by not coordinating visits adequately. Concerns have also been expressed that reliance on advisory services and their promotion waters down any criticism and condemnation of human rights abuses by various relevant parties.

These criticisms may be justified but the fact remains that the high profile of the High Commissioner and his diplomatic background has opened doors which used to be firmly shut. Governments that used to be firmly opposed to any dialogue on human rights have welcomed the High Commissioner and, while the provision of advisory services may be seen as the softest option, the very process of identifying areas of international cooperation will lead to some improvements in the promotion of a rights culture in the affected countries.

The search for a mechanism to improve the observance of human rights parallels the situation in regards to efforts to engage governments in discussions on the right to self-determination. Similarities include the following issues:

> The stability of states is being challenged by ethnic, racial and other minority groups whose rights are under threat;

> States are fearful that they will surrender their sovereignty if they accept to consider the concept of self-determination;

> States perceive that their integrity is under challenge in any talk of self-determination;

> There is concern in the international community about the outcomes of a failure to resolve these conflicts;

> The current mechanisms of the UN are not adequately equipped to address the question of self-determination;

> Certain of the conflicts impact on international peace and security.

As described throughout this paper, there is likely to be continuing opposition by states to the rapid development of a mechanism to address self-determination. Yet the establishment of the office High Commissioner for Human Rights provides an example of the potential for moving the debate forward when the international community is faced with some intractable problems whose resolution will prove beneficial to many parties.

The first step needed is to find credible state sponsors for the proposal to establish an office of the High Commissioner for Self-determination. As outlined above, the mandate of the Expert Group on self-determination will include investigation of the process needed, the qualifications and the responsibilities of the proposed High Commissioner for Self-determination. Without pre-empting this work by the Expert Group, certain criterion spring immediately to mind. The High

Commissioner will need to have acquired a high profile in the international community and have had experience in conflict-resolution and international diplomacy. She/he will not be associated with a current or past conflict over autonomy or self-determination and will be — and will be seen to be — independent of any geo-political grouping or political alignment. Another prerequisite is a thorough knowledge of the United Nations system including the human rights system and a commitment to the promotion and protection of all rights.

The office of the High Commissioner would be located in New York to stress the relationship it will need to develop with the UN Security Council and the General Assembly. The office would be responsible to the Self-determination Commission and take its direction from it. It would not be responsible for research or the evaluation of the legitimacy of claims to self-determination but instead act as the senior diplomatic representative for the Commission and be accountable to it.

It would facilitate dialogue sponsored by the Self-determination Commission between the various parties. It would ensure that ongoing discussions take place. The High Commissioner would act as the Chair for these discussions as and if it is necessary. She/he would also prepare reports to the Commission on progress and present these reports at appropriate forums.

STRATEGY FOR SETTING UP
A SELF-DETERMINATION COMMISSION

The development of a strategy to bring about the establishment of a proposed UN mechanism for the settling of claims to self-determination is dependent on the willingness of a number of governments to sponsor an approach which will lead to the establishment of such a mechanism. Ideally this sponsorship will come from the developing as well as the developed world and not be restricted to the European democracies. However, the initiative will in all likelihood come foremost from neutral states in Europe and organizations such as the OAU, the OAS and the Commonwealth Secretariat that will act as initiators and honest brokers in the process.

Such a strategy might have the following components:

A coordinated lobbying effort in the UN to gain acceptance of the notion of a Self-determination Commission.

A lobbying effort to gain acceptance of the notion of the establishment of an office of the High Commissioner for Self-Determination.

The provision of funding for the setting up of an expert group on self-determination. This group would have the mandate to:

establish a process for assessing the legitimacy of claims;

choose three current instances where there exists claims to self-determination. These would be judicially selected to be representative but with a reasonable chance of being resolved;

research past efforts to resolve each claim and consult with all the parties involved so far;

seek cooperation with the relevant parties as test cases;

apply the test of legitimacy to the three cases;

produce a comprehensive report on the findings.

Under the auspices of the sponsoring states the group of experts would convene a series of conferences with the involved parties and begin negotiations over the settling of the claims.

The sponsoring states will support the holding of a major international conference to debate the outcomes of the efforts of the expert group in the three cases.

Once these initiatives have been completed it should be possible to recruit additional support from the UN member states.

The first practical step in the creation of a mechanism for the realization of the right to self-determination is for its sponsors to agree to undertake to implement the strategy and to find the funds to achieve its component aspects.

ENDNOTES

[1] Evan D Luard, *A History of the UN* Vol 2, St Martins Press, 1989.

[2] *Ibid.*

[3] Philip Alston, The Right to Self Determination in International Law, in a paper delivered at the "New Dimensions of the Right to Self-Determination: Its implications for the World and Australia in the 1990s" Seminar organized by the Human Rights Council of Australia, 1 September 1992.

[4] *Ibid.*

[5] *Ibid.*

[6] Evan D Luard, *op cit.*

[7] *Ibid.*

[8] Roland Rich, Problems of Self-determination in Central and Eastern Europe, in a paper delivered at the "New Dimensions of the Right to Self-Determination: Its implications for the World and Australia in the 1990s" Seminar organized by the Human Rights Council of Australia, 1 September 1992.

[9] Ian Brownlie, Rights of Peoples in International Law in *The Rights of Peoples*, James Crawford, ed, Oxford 1988.

[10] Draft Declaration on the Right of Indigenous People; Sub-Commission on Prevention and Protection of Minorities, Forty-sixth session.

[11] Michael Ong, The Asian Context, presentation to the "New Dimensions of the Right to Self-Determination" Seminar, *op cit.*

[12] Adapted from Frederick Kirgis Jr, The Degrees of Self-determination in the United Nations Era, *American Journal of International Law* 1994.

[13] Speech to the 44th Session of the UN General Assembly, 1992.

[14] Most of the debates on the legitimacy of international attention on human rights focus on the civil and political rights. Indeed in many such situations human rights are equated with civil and political rights. The question of the realization of economic, social and cultural rights is only now being addressed by some UN member states, human rights lawyers and by sectors of civil society.

[15] Herb Feith and Alan Smith in Self-determination in the 1990s: the need for UN guidelines and machinery to resolve ethno-nationalist conflicts, presented to the International Peace Research Association, Kyoto 1992.

The Scottish Route Towards Self-determination

George Reid

How pleasant it is to be in Geneva to bring the best wishes of the Scottish Parliament, the newest parliament of the European Union representing one of the oldest nations, to this important conference on the interrelationship of minorities' rights, human rights and self-determination. I spoke at the beginning in Gaelic for two reasons: first, any citizen of the monoglot British State, who is schooled in the indigenous language of his country, can reasonably claim to be a member himself of a minority group; second, because I have been asked to speak on short notice on the Scottish Parliament and the route of the Scottish people to self-determination. I regret in this respect that Yasin Malik from Kashmir is not here tonight if, as reported, he has been refused travel documents by the Indian Authority. I do regret that, as pluralism or opinion is a basic human right, as is freedom of movement

I am here at this conference wearing two hats. During my time in this Conference in Geneva, I was also to be the Rapporteur of the closing session, reflecting on the fifteen years I have spent with the International Red Cross and, through the British, with the United Nations, working in dozens of conflict and war-torn zones where the key factor was the rights of minority groups. That has been particularly true, as you will hear on Sunday, in Eastern and Central Europe following the implosion of Communism; I shall certainly deal with what the United Nations has or has not done in this field and also comment on the overwhelming emphasis inside the United Nations on the rights of states. Further, I shall wonder why the melting pot model of the United States — where everyone has human rights, but minorities are not specified within that particular framework — has not played particularly well in large parts of the world. I shall question why, within the United Nations system, special rights have been granted to women, to persons with disabilities and children, but there has been little comment on the rights of minorities. I think this is important because somewhere between 15-20% of the global population today are members of minority groups inside multinational states.

Today, on short notice, I was asked to speak about Scotland, which is part of the Fourth World (the stateless nations) and the Scottish route towards self-government.

In April 1707, in the capitol city of Edinburgh, the old Scottish parliament which had been convening since the 13th century, met for the last time following the decision to merge the sovereignty of the Scots with the English people into a new Union of Great Britain. Battles in the churches then broke out, the mob rioted in the streets of Edinburgh and other Scots towns, and a new tune played on the belfries: "Why am I sad on my wedding day?" The Chancellor of Zurich, the presiding officer then of the Scots Parliament, said "There's one end to one old song."

In July of last year, the Scots Parliament, after one of the longest recesses in parliamentary history, reconvened again in Edinburgh and Scotland started to sing a new song. Here's just a little picture of that day, if anyone knows the topography of Edinburgh: the Royal Mile — one mile of road — connects the ancient castle at the top of the hill with the Palace of Holyrood (the old palace of the Scots king and her majesty, Queen Elizabeth) at the bottom. In the courtyard of Holyrood Palace, "God Save the Queen" was played but not in the streets of Edinburgh. The crown of Scotland, the oldest crown jewels of Europe because we hid it during the revolution and dug it up later, dropped down from the castle to the streets. But it was not placed on the head of the monarch as had happened in Westminster, but placed in the well of the Parliament, representing the sovereignty of the people. This is well-established in Scots law. In the streets, there were no flunkies, no coaches but the children of Scotland, the disabled of Scotland, the masses of Scotland, the miners of Scotland, the fishermen and the whole community of Scotland in a celebration of a practical nature. The defining moment in the Parliament itself was the song, "A Man's a Man for A' That:"

> A prince can mak a belted knight,
> A marquis, duke, and a' that;
> But an honest man's aboon his might,
> Guid faith, he maunna fa' that!
> For a'that, and a' that;
> Their dignities, and a' that;
> The pith o'sense and price o'worth,
> Are higher rank than a' that.
>
> Then let us pray that come it may__
> As come it will for a'that –
> That sense and worth, o'er a' the earth,
> May bear the gree, and a' that.
> For a' that, and a' that,
> It's coming yet, for a' that,
> That man to man, the warld o'er,
> Shall brothers be for a'that!

It was my job to encourage the Duke of Edinburgh and Prince Charles to sing along with that. I tried. The Duke of Edinburgh did recognize the origin of that particular song. It is, of course, a radical Jacobin song dating back to the French Revolution, which recognized the equality and dignity of nations and peoples on

God's earth, and as the French Ambassador said afterward, it was much more a Scandinavian day than a British day.

Now, what I would like to do in terms of Scotland and the Fourth World, is to touch on four points. I think it is important to give you a very brief sketch of the history because otherwise you will not understand the context. I would like to describe the process of a people without their own self-governing institutions to having a parliament, and why it happened. I will touch briefly on the powers and procedures of the Parliament and then lastly, within the framework of Scot society, on some of the lessons we have learned which might be of an advantage to other minorities. So firstly, we Scots have had our share of aggression, attempts at assimilation and at ethnic cleansing, as have many groups represented around this table. We also, within the British imperial phase of our history, have done the same to others.

It was very strange to come to this part of Geneva. We are in the commune of Saconnex. The word "Saconnex" is immediately intelligible to any Gaelic speaker. In a very strange way, the people from the Irish delegation and ourselves from Scotland started here some four or five thousand years ago, because this was the heartland of the Scottish and Irish people before we were driven west by incoming forces. During the early years of history of the Christian era in Scotland and Ireland, when Christianity failed throughout most of Europe, we in both Scotland and Ireland were the light in the darkness, the Christian people of the Catholic Church, who came back to Switzerland, Germany and northern Italy and re-Christanized a land that had become heathenized.

In terms of Scotland, we have been within the same boundaries as a people for almost 1200 years. We were unified in 854 and then subject, like many small peoples — many around this table — to the inroads of English imperialism, or what Scottish writers refer to as " being in bed with an elephant" — as is the situation of any small people who have to cope with the demands of a much bigger nation — 500 thousand of us to 55 million of them. During the Middle Ages, Scotland fought for her independence. Many of you will have seen movies on Robert Wallace such as *Braveheart*. This is perhaps a Hollywood version of Scottish history, but it did contain some basic truths. In 1314, there was a final battle for Scots' freedom, which we won; unlike the other minority peoples in the British Isles – shared islands — we have never been conquered because we won our freedom in 1314. Going back to the Declaration of Arbroath in 1328, which followed that, a fundamental one to the Scots people, for all those who suffered indignity and oppression, the words the Scottish people at Arbroath used were: "As long as one hundred of us remain alive, we shall never ever submit to British domination. For glory, nor for riches, nor honor can be fought, but for freedom which no good man ever gives up but with his life." What is important about that is that the Declaration of Arbroath itself was the founding document for the American Declaration of Independence. If you look at the resolution passed in the Senate two years ago, it does recognize the vast importance of the input of the Scots' belief in the democracy of the people and the sovereignty of the people. Of course, the reality was that nine of the signatures on the Declaration of Independence of the United States were of Scots origin. Picture a small country tossed backward and forward, allied with France. Here in Geneva,

John Knox rallied the doctrines of Presbyterianism. During the revolution, Scotland became cut from its Catholic Celtic roots and had Presbyterianism forms of government adopted throughout the country. One of the benefits of that is that all Scots, from the 16th century onwards, have public education.

In the 1700s, Scots tried to establish an overseas empire. It failed, the economy failed, union followed, there was a rebellion against that, the Jacobites, and then we came to a period of ethnic cleansing. Then, World Wars with many Scots killed, the economy in crisis, no more empire, Mrs. Thatcher. During the 100 years up to the arrival of the Scots Party, there were 26 Home Rule bills in the British House of Commons, all supported by Scots demanding, "give us our Parliament back", who were voted down by the English majority. The Labor party was founded with its second objective of restoring parliament to Scotland, after the proper treatment of the working class in the U.K (who were going through a period of unionism). The Scottish National Party floundered as a movement on the issue, and increasingly took a political attitude because we realized that only by going to the polls and threatening other parties, could we make more political progress. Mrs. Thatcher felt that under no circumstances would Scotland have a parliament. On the departure of Mrs. Thatcher, the Labor Party permitted a referendum on a Scots Parliament, which was approved by an overwhelming number of Scottish voters.

It's more than that. I suggest three basic thoughts as to how this process came about. The first one is the effects of globalization: the need to belong somewhere, as the world enters an era of rapid ITC development; the pull upwards to larger economic groupings; and the need to feel roots and identity, and push downwards to local roots. Throughout the European Union, the same factors which applied to Scotland are applying to Catalonia, Basque Country, to Flanders, and were in existence and are undoubtedly in part to come in northeastern and central Europe.

There is a need to define this relationship, which is not the nation state of the 19th century, but rather viewed within the world of globalization. "Service your own people and serve them as is best." As an example, we now have 129 members, 73 elected, the first half of those in single ballot constituencies, and 56 elected on a balancing list. The Scots' list, unlike that of Westminster, is proportional.

The Labor party is the biggest party, the Scottish National, my party, is the official opposition, and the Conservatives and Liberals are very much the smaller third and fourth parties. There are three independents, including one who is closest to the Trotskyite view. I sat on the Commission appointed by the Labor government to decide what the practices and procedure of the parliament would be. Now this is important because here you are moving from a referendum stage to the institutions you set up. In a very Scots way, we decided to build a parliament around three key principles: the first principle was accessibility – the people must have access to the institution; the second principle is accountability — the people must know what the Parliament has done and where the money has been spent; and the third principle was equal opportunities — that all minorities, whether it be minorities of race, gender or physical disabilities, should have a positive agenda of equal opportunities. The fourth and the last principle is that power should be shared between the people, the Parliament and the executive, which is the government. It is this bond which functions very much in the committees who are close to the

people. Sixteen committees exist throughout the country, so it is not a Parliament which belongs to Edinburgh, it is a Parliament which belongs to the towns, the villages, and the rural communities throughout the country. In terms of access, the galleries of the Parliament are full at all times. Scots no longer have to travel 500 miles to London to lobby for their interests. I do advise you to look at the website (www.scottish.parliament.uk); you will find the most friendly interactive and accessible website in the world, where everything that is decided in that Parliament – be it in committee or be it in plenary — is available for you to print up by the next morning in the privacy of your home or office.

If you take accountability — all sessions are open. You can print everything from the website. We have one of the most rigorous audit systems practiced in the west, which is now the subject of some interest and advisement on procedures for the European Union. In terms of equal opportunities, 40% of the Parliament members are women, which is the second highest in the European Union. I have to say that I have found the culture of parliament where women are present to be distinctly less aggressive and more concerned with pragmatic solutions to problems than some others I have been in. Take the simple issue of prayer. In Westminster, only the Church of England can pray in the parliament – not that they do. In the Scottish Parliament, we decided to welcome everybody. In a country with a tiny Muslim segment of the population, we now have Muslims praying in parliament, Jews praying in parliament, Buddhists praying, and even atheists making statements.

In terms of petitions, any person in Scotland can petition the Parliament and the petition must be acknowledged within four working days. So if you are a small group with a grievance — be it in the Highlands, or a university group concerning drugs, or a gay or bisexual group — you will have a response from that Parliament within four working days that says "we're studying it," and an answer within 41 working days. Again, this is a parliament which is close to the people. What is important is the building of trust with the people. Six hundred voluntary organizations, trade unions and churches exist in Scotland. They were widely consulted during the pre-legislative stages of the legislation, so they could input their thoughts. They also provided expert witnesses on the committees; again, this is building a civic society.

If you look at the process, what happened in Scotland is not the end of the story. I am not saying that Scotland will be granted independence — I think it may be likely, but I question what independence actually means. I think that this must be something some of the more strongly developed groups here will reflect on in the next two or three days. Certainly, the view of the unionist parties who are the majority in the government, is that the position of Scotland is much stronger within the United Kingdom, stronger in terms of the United Nations, stronger in terms of NATO and the European Union. The position of the nationalists is that nobody can set patterns for the march of liberation.

Scotland is a rich country but not yet a rich society. You must remember the uniqueness of Scotland. We have something like 60% of the oil and gas reserves in the European Union. By OECD figures, we are the seventh richest country in the world; Britain is the seventeenth and we are slightly ahead of Denmark. The nationalists will say that only we can control our own resources and determine what is a rich society. This is echoed among some of the indigenous groups around

the table. In terms of separation, which I know will come up during the course of our discussions, I think Scotland's position is quite unique because in 1707, it represented the union between two sovereign parts, so there is no question of separation or independence, or of Scotland going its own way. So, under the Vienna Convention on State Succession, there will be two successor states: one is Scotland and the other, the rest of the United Kingdom, within the European Union. It may not be like that, because if you go to Catalonia, to the Basque country or Flanders, you will find people talking about a two-tier Europe, where there is no hierarchy between the community and state, and a certain number of powers are passed up to the European levels: foreign policy, defense, and so forth. All subsidiaries should be dealt with by the community as a natural repository, and in that respect, as I said in conversation with our friends from the Bloc Quebeçois, we have some affinity because it is a community we can go to and share our identity. I found it significant that Gerald Fitzergerald came from Ireland to a university in my constituency a few years ago and he said: "Only by submerging our sovereignty as Irish men or women in the widest sovereignty of the European Union did we paradoxically find at last true freedom from Britain."

So what are the lessons? If you look at the headlines in the paper today, there are more bombings in San Sebastian from the ETA, killings in Sri Lanka, bombings in the metro in Moscow, and so on. Yet we in Scotland achieved all of this without any single person even getting a bloody nose. We must ask why that should be? Personally, I think it is because over 1200 years, a sense of common identity has been formed, so that no one has any doubts who they are. That sense of identity has been strengthened significantly by separate institutions. We have always had a totally separate system of law and always had a separate system of education. If you like, Scots of my generation form a Mafia – we went to the same schools, the same universities – not the English universities. We had in place in Scotland, prior to the Scots Parliament, 8,000-9,000 civil servants well trained to do the job so that all that happened was they simply moved from the authority of Westminster to the subsidiary authority of the Scottish Parliament.

The third strength that I think is important to this seminar is the strength of Scottish civil society, which is like that of Scandinavia. Two out of three Scots volunteer for non-paid activities, whether it be the tribunals, churches, or a voluntary agency. These were the bodies that during the Thatcher years held a candle, a light in the darkness, for the Scots Parliament to be formed. These committees are extraordinarily strong and work in partnership with Parliament. Without them, we would be a much-impoverished society. In the years that I worked in Eastern Europe, particularly in the Caucasus in 1988 and 1989, I found that the implosion of communism had left a surge of nationalism back to the security of the tribe. The same people coming out of the party offices were being shouted down by the ruled and going back preserving themselves as the national salvation front. But the problem was that there was no strength of a civic society, no middleman, no democratic structures that can sustain a civic society. I think that if one moves to self-government, one must think of that nexus as well.

Lastly, I bring you the thought that nationalism should be inclusive. We have all lived through a period of *jus sanguinus*, those of us who are Scots or Irish or whatever. We lived with the idea of the English *jus solus*, or those involved in the

country should inherit nationality. I think in the post-nationalist phase, we should go further, and certainly we have done in Scotland. Anyone regardless of race or color who wants to live in and contribute to and be part of society can rightly call themselves a Scot, man or woman. One of the greatest groups in the Scottish National Party are Asian Scots. These are people from Pakistan or Bangladesh who have decided to live in Scotland. Forty to fifty nationalities live in Scotland who have decided support the cause of Scottish independence. This is a major breakthrough in terms of our society because there were times when Scottish Presbyterians reacted very bitterly to the immigration of Irish workers, and the Catholic and Presbyterian church had daggers drawn. It is only over the last 30-40 years that this has started. The big difference is in people making common cause.

There is a Scots phrase that "we do not own the land, the land owns us". There is a fundamental truth here, especially for all of us around the table, that the basic ingredient which makes us who are, is our relationship with the land we live in. This has been a particular problem in Scotland where 800 people have owned 80% of the land. We are taking the first tentative steps now in the Scots Parliament to give it back to the people: access to all, so that you can't say that "this is private" so others cannot walk there. In small local communities throughout the state, it is now required that the first options on purchase should go to the local community, staked by state money. The community can then apply to purchase land as a foundation or trust, where they themselves are their own tenants.

The United Nations has not been very clear in the past as to what is a community, and what is self-determination. I hope that we will look at one or two of the ways minority issues have been handled by the United Nations. The United Nations was formed in 1945, '46 and '47 with much emphasis on the American model of the melting pot, human rights in the 50's and 60's, where people could be equal — but separately. Then there was the ex-colonial period, where state-building and lines drawn by colonial masters on the map were formed into new states. As tribes were separated from their national lands, people could not migrate as they did in the past, and much money was spent on bringing together a nation which had no historical or geographical entity in itself. Now today, in the age of globalization and consolidation of regional groupings, of ITC, we find the state simultaneously too big for citizens at the grass root level and too small to tackle the macroeconomic issues.

Today, in the age of globalization and consolidation of regional groupings, of ITC, we find the state simultaneously too big for citizens at the grass root level and too small to tackle the macroeconomic issues.

I leave you again with the thoughts of the Declaration of Arbroath, which speaks immensely of our history: " Not of glory, nor riches did we fight but only for liberty, which no good man gives up without his life. For liberty above all permits us to live in the past of our ancestors, to have respect for ourselves and culture, which we inherited, and which makes us what we are." The brave United Nations wants a just world, where all are equal in dignity and rights. For that world to happen, minorities must have equality and dignity in their rights as well. I look forward very much in the next few days as to how this Conference debates these particular issues; how the United Nations relates to the resolutions of this Conference; and how they take the principles of minority rights and self-determination of minorities further forward.

Exploring the Concept of the Right to Self-determination in International Law & the Role of the UN

Y. N. Kly

I take this opportunity to welcome you all to the First International Conference on the Right to Self-Determination and the United Nations, co-sponsored by IHRAAM and the ICHR. This is essentially an educational conference designed to explore the significance of the right to self-determination in international law and the role of the UN.

Before I begin, I would like to give special thanks to Attorney Majid Tramboo, IHRAAM's European Director as well as Chair of the ICHR, co-sponsor of this Conference and general mover and shaker, to Colin McNaughton, our Operations Director, to my wife Diana Kly, our Program Director, to Diana James, our Press Relations Officer, and to the two interns who have volunteered their services, Amy Quark and Nicole Eddy, and to all who participated in the organization of this Conference.

Dear friends and colleagues, I would like to begin the exploration with a few thoughts. If each tomorrow was another world wherein no meaning or significance over time could be assigned to actual historical acts or events, most of today's socio-economic problems and bloody but low-intensity conflicts would either be dismissed as transitional or could be demonstrated to have been resolved simply by linguistic re-definition. Many have attempted to resolve the problem of maldevelopment caused by the policies of neo-colonialism by such a redefinition, revisioning this ongoing historical reality now as the emerging developmental opportunities afforded by globalization. Despite this new articulation, the result nonetheless belies the new language used to describe it: an increasing gap between the haves and have-nots, famine, disease, increasing international criminal activities, civil conflicts, and low intensity warfare, etc. We witness, in short, nothing less than the creation of environments ripe for Samuel Huntington's clash of civilizations and Robert Kaplan's "coming anarchy."

Similarly, today we are encouraged to believe that globalisation has replaced the logic of the struggle for national identity and self-determination, that the logic

of the global market renders this struggle meaningless and backward. At the same time that this is being told to us, the world is awash in civil conflicts and low intensity warfare. Why is this so? In situations of minority oppression, racism and discrimination is usually given by states as the reason for the maldevelopment of such nondominant nations relative to dominant nations in multinational states, and the solution voiced by many governments is simply non-discrimination, as politically defined by the state concerned. There is little or no comment on the need for or type of institutional changes and special measures or self-determination as is sought in the African American, Dalit and indigenous situation, or the demand for political independence as may be required in the Kashmiri dilemma. There is no *mechanism* to assure that the international legal concept of non-discrimination in relation to minorities is in effect or effectively addresses the problem. In this vacuum, we see the need for a role that only the UN can play.

Many multinational states wishfully take great pride in their melting-pot assimilationist policies or traditions as proof of their commitment to non-discrimination – as politically defined by them. But there can be a gross contradiction between non-discrimination as politically defined by most states, and melting pot policies or traditions which may often serve as a linguistic euphemism and cover for what can in reality be more accurately defined as the forced assimilation of nations, minorities and indigenous peoples, and the resultant retardation of their socio-economic and cultural development. Where the resistance of a nation, such as the Kashmiri nation, is strong, non-discrimination and majority rule can even become a cover for ethnocide, ethnic cleansing, or genocide.

Where minority resistance is limited, such as in the situation of the African Americans, Dalits and indigenous peoples, melting pot policies themselves, when enforced by government in conjunction with societal institutions, may become a chief reason for institutional and systemic racial discrimination. As a matter of fact, the advocacy by government of policies of the melting pot in relation to national minorities, i.e. indigenous peoples, "involuntary immigrants" (the terminology currently in UN usage to describe the African population in the Diaspora), etc., automatically promotes and necessitates racial or ethnic discrimi-nation. This is true if for no other reason than that in order to force or pressure a minority to assimilate into some sector, particularly the lower caste or underclass, of the dominant majority, the culture of the minority has to be re-identified as that of the dominant group's lower caste or underclass, and by this means be devalued in the cultural mindset not only of the dominant group, but often of the minority itself as well, leading to its being distorted, shattered, exploited or destroyed. This leaves such groups open to an almost unlimited assault on their human dignity, values, community cohesion and economic independence, reducing the individual member of such groups to a state of almost complete dependency in all societal sectors, where his/her success is measured in terms of majority-dominated processes and norms.

> **Melting pot policies may often serve as a cover for what can in reality be more accurately defined as the forced assimilation of nations, minorities and indigenous peoples, and the resultant retardation of their socio-economic and cultural development.**

Honored guests, in order to explore this concept of self-determination in international law as a possible response, it will be helpful for us to make a quick review of the following:

1) The importance of the concept of self-determination
2) The history of this concept
3) Its philosophical origins
4) Criteria for the evaluation of its implementation
5) Evaluation of non-material criteria

IMPORTANCE OF THE CONCEPT

The importance of this concept is evident when we remember that in the early 21st Century, major wars, economic crises, floods of refugees, human rights violations of all types, and the wasteful expenditure of resources on weapons purchases, are the result not of conflicts between states, but of civil conflicts (popularly referred to as low-intensity warfare [LIC]), usually involving national groups vs. the state in which they live. Among the many indicators of this devastation is the fact that during the period 1998 through 2000, there were at least 33 states involved in serious civil conflict related to the search for or prevention of some form of self-determination, which led to their deployment of child soldiers in significant numbers.[1]

Another important factor about present day civil conflicts as it relates to the search for or prevention of some form of self-determination: they are increasingly causing more socio-economic destruction and loss of lives among civilian populations, than government infrastructure and soldiers.[2] The damages, in places like Kashmir, are spoken of not only in terms of lives lost in combat, but also in terms of widespread rape, the death of women and children, etc.. Quite contrary to the earlier Clausewitz concept of war, the line between civilians, soldiers and governments is disappearing, and violations of the most fundamental humanitarian law are likely to increase in these types of conflicts, insofar as well-equipped armies find it increasingly difficult to prevail in low-intensity civil conflicts without attacking the civilian population and its service and survival socio-economic infrastructures.[3]

HISTORY OF THE CONCEPT OF SELF-DETERMINATION

The principle of self-determination and equal rights of peoples made its appearance in the Friendly Relations Declaration (General Assembly Resolution 2625(XXV), which drew no objection from any member state, and was adopted by consensus.[4] It is on this basis that the International Court of Justice (ICJ) felt entitled to give its blessing to self-determination as a legal right (see ICJ judgments in relation to Namibia/South Africa,[5] Western Sahara[6]).

Until this occurrence, it was generally felt that international law could not take sides in internal conflicts which call into question the legitimacy of the exercise of state jurisdiction in relation to its nationals, and that the principle embedded in the decisions reached in relation to the Friendly Relations Declaration could be applied only to colonial people or the territory of colonial people.[7]

However, these notions were superseded by the emergence of the individuals and groups as subjects of international law and the coming into force of the two international covenants, both of which contain, in their first articles, the right to

self-determination. When a state attempted to invoke the superceded interpretation that self-determination in these covenants was to be understood solely as a right of "peoples under foreign domination," this interpretation was not accepted by the other states, and the Human Rights Committee upheld the vast majority in confirming that the meaning of Article 1 of both Covenants is to be derived from a literal meaning of the provision, namely that self-determination is a right of all peoples.[8] What was not specified was the circumstances or the degree of gravity required to give rise to a right to self-determination.

As the noted international legal scholar, ChristianTomuschat,[9] observed:

> With the emergence of international human rights law, in particular, the traditional picture has changed dramatically. The consolidation of this new branch of international law amounts to a general recognition that States [whose legal existence is based in international law] are not objectives in and by themselves and that, conversely, their finality is to discharge a task incumbent upon them in the service of their citizens. In other words...[t]heir jurisdiction, even their existence, is not exempt from challenge, even on a legal plane. Rather, they have a specific *raison d'etre*. If they fundamentally fail to live up to their essential commitments, they begin to lose their legitimacy.[10]

It is obvious that any State is under a basic obligation to protect the life and the physical integrity of its citizens. Therefore, if a State machinery turns itself into an apparatus of terror which persecutes specific groups of the population, those groups [or the members of those groups] cannot be held obligated to remain loyally under the jurisdiction of that State. Genocide is the ultimate of all international crimes. Any government that engages in genocide forfeits its right to expect and require obedience from the citizens it is targeting.[11] If international law is to remain faithful to its own premises, it must give the actual victims a remedy enabling them to live in dignity.

On the one hand, the concept of the right to self-determination in international law recognizes the importance of respect for the jurisdiction of all states in relation to their citizens. However, on the other hand, it also recognizes that all states are under a basic obligation to protect the life and the physical integrity of their citizens.

A new era in popular understanding of self-determination and its effect on the exercise of state jurisdiction over its citizens has begun.[12] By legitimizing the right of a group to demand the right to self-determination and thereby indirectly question the legitimacy of state's exercise of its jurisdiction in relation to those it claims as its citizens, the right to self-determination in international law is being viewed by many scholars as a tool for remedying unjust and nonfunctional historical "fait accompli" and amending the criteria for the internationalization and legal elaboration of a global social contract.[13]

PHILOSOPHIC ORIGINS IN WESTERN THOUGHT

a) Social contract theory in its day represented the dominant opinions of scholars about the conditions by which government should legally and morally exercise continued jurisdiction over its citizens.

b) This was the "raison d'etat' for the constitutions of the European nation-states emerging from the Peace of Westphalia.

c) Even while the law of conquest remained intact, the assumption of a social contract as manifested by the constitution of each state served to politically legitimize states' jurisdiction in relation to their citizens.

d) The preparation of constitutions (in the context of social contract philosophy) was the customary practice of states of that period and thus has become a part of international customary law.

e) Thus, unlike this customary international law that was animated by social contract theory and practice in the form of constitutions, which sets broad philosophical responsibilities of states to its citizens as the basis for moral jurisdiction, the concept of the right to self-determination in international law, building on this general philosophy of state responsibility, has moved today towards codification of international human rights and humanitarian law and the creation of international courts and tribunals, etc. to encourage state accountability.

f) Social contract theory and the concept of the right to self-determination in international law are most similar in that they both are directly or indirectly concerned with issues surrounding the legitimacy of state exercise of its jurisdiction in relation to those it designates as citizens.

g) The right to self-determination in international law can be considered an international legal elaboration of a collective social contract criteria.

h) If so, then there is sufficient reason to assume that its suggested implementation would animate human-centered democratic development.

i) Although today international law (*lex lata*) requires the parties demanding the implementation of any aspect of self-determination to do so on the basis of the state's demonstrated inability or unwillingness to protect, provide for or promote the human rights of the group concerned, and wherein the demand for self-determination is the last available option that the group has to achieve their human rights, the historical circumstance leading to the acquisition by the state of its claim to jurisdiction (was there a treaty, social contract, conquest, etc.) may have an important influence on group acceptance of the type and degree of self-determination that will be demanded.

In our Conference reading paper, it is suggested that the UN establish a Self-determination Commission comprising representatives of the UN member states; an Office of a High Commissioner for Self-determination; and appoint an Expert Group on Self-determination to serve as an advisory body to the Commission. This

recommendation assumes that the concept of self-determination in international law is desirable for promoting human-centered democratic development. Thus, we turn to the essential issues.

ESSENTIAL ISSUES

1) Is the concept of the right to self-determination in international law both practically and theoretically applicable to the resolution of real world conflicts in such a manner as to animate human-centered democratic development?

2) Does the concept of the right to self-determination in international law represent the beginning of the international legal elaboration of a social contract criteria for defining the moral/legal limitations of the legitimacy of states' exercise of jurisdiction in relation to those designated as citizens?

CRITERIA FOR DECIDING

We suggest that three criteria could be used in responding to the essential issues when applied in real world conflicts. Does the concept of self-determination in international law serve to: prevent, discontinue and restore? Only the non-material aspects of restoration will raise some important problems as to finding the indicators. However, applying the same international legal reparations practice and advocacy principles used in relation to assessing non-material damages,[14] we might review the following criteria after the implementation of the concept of the right to self-determination in order to determine :

(a) Was there cessation of continuing human rights violations;
(b) Was there verification of the facts and full and public disclosure of the truth
(c) Was there a declaratory judgment in favor of the victim
(d) Was there an apology, including public acknowledgment of the facts and acceptance of responsibility
(e) Were the persons responsible for the violations brought to justice, etc.[15]

CONCLUSION

Even recent history clearly indicates that policies of forced assimilation lead to maldevelopment, which lead to protest, and eventually the rejection of state jurisdiction or the demand for political independence, which in turn may animate ethnic cleansing, genocide, war, greater ethnic/racial discrimination (such as segregation, apartheid), etc. Both voluntary assimilation (fusion) and appropriate development occur best where equal status socio-political and economic interdependency between groups is provided for in an environment of consociated, human-centered democracy.

We suggest that what this Conference should seek to address, is what over-sight role the UN should play, and whether there is a need for new UN mechanisms in order for it to fulfil this role.

ENDNOTES

[1] Regions in conflict in 1998, 1999, or 2000 and the number of Soldiers under age 18:Afghanistan (100,000), Algeria (100), Angola (7,000),Bangladesh (100), Burundi (8,000), Cambodia (7,000), Chad (unknown), Chechnya (1,000), Colombia (19,000), East Timor (1,000), Eritrea (100), Ethiopia (unknown),Guatemala (1,000), Guinea-Bissau (50), Honduras (1,000), Kashmir (100), Kenya (none), Kosovo (100), Kurdistan (3,000), Lebanon (100), Liberia (12,800), Mexico (1,000), Myanmar (50,000), Palestine (1,000), Peru (2,100), Philippines (1,000), Rwanda (20,000), Sierra Leone (5,000), Somalia (1,000), Sri Lanka (1,000), Sudan (25,000), Tajikistan (100), Uganda (8,000) LEADING SMALL ARMS SUPPLIERS: Belgium, Brazil, Bulgaria, China, France, Germany, Israel, Italy, Russia, South Africa, UK and US

[2] See Walter Clemen and David Singer, "The Human Cost of War," *Scientific American*, June 2000, pp. 56-57.

[3] See Martin L. Van Creveld, *The Transformation of Warfare*, Free Press, 1991. Note also the bombing of radio stations, electric plants, etc. by NATO in its war against Yugoslavia and the almost perverse misuse of the long-held concept in the Geneva Conventions of collateral damage, the destruction of the Chechen capitol of Grozny and treatment of its civilians by the new Russian republic, etc. The physical and economic damages caused by such conflicts are well documented in the literature. However, scholars are beginning to document some of the more invisible societal wounds among civilians resulting from such LIC as compared with traditional wars: serious mental illness, psychiatric incapacitation, serious family conflict, clinical depression/PTSD, fear of government, vigilantism to seek justice/revenge, physical and mental exhaustion, demoralization, etc. See Richard Mollica, mental health medical researcher, in "Invisible Wounds," a study of the results of LIC in Oragobel, Kosovo, Oct. 28, 1998, in Neil G. Boothley and Christine M. Knudean, *Children of the Gun.*

[4] Only South Africa raised objections against the legitimacy of state jurisdiction connected with self-determination, as well as against the paragraph which requires that a State possess a government representing the whole people. General Assembly Official Records, 25th Session, Sixth Committee, 1184th meeting, 28 September 1970, p. 42, para. 15.

[5] *International Court of Justice Reports* 1971, pp. 16, 31.

[6] *International Court of Justice Reports* 1975, pp. 12, 31-33.

[7] Multilateral Treaties Deposited with the Secretary-General. Status as at 31 December 1990, UN doc. ST/LEG/SER.E/9, p. 122. Christian Tomuschat, in "Self-Determination in a Post-Colonial World," in *The Modern Law of Self-Determination*, Martinus Nijhoff, Dordrecht, 1993, argues that since its adoption in the UN Charter, it was widely recognized that the term "self-determination," contrary to the present popular belief, referred to all peoples, not simply to colonial peoples.

[8] Adopted in 1984, see Report of the Human Rights Committee, General Assembly Official Records, 39th Session, Suppl. No. 40 (A/39/40), p. 142.

[9] See Tomuschat, *supra.* Footnote 7, p. 9.

[10] Tomuschat agrees with Buchheit, see note 7, p. 217, who "seeks to maintain the underlying force of the self-determination principle and yet minimize the dangers to international peace and security."

[11] The Universal Declaration of Human Rights of 1948 provides in its third preambular paragraph: "Whereas it is essential, if man is not to be compelled to have recourse, as a last resort, to rebellion against tyranny and oppression, that human rights should be protected by the rule of law." See also C. Tomuschat, "The Right of Resistance and Human Rights," in: UNESCO (ed.), *Violations of Human Rights: Possible Rights of Recourse and Forms of Resistance*, 1984, pp. 13, 22.

[12] See Tomuschat, *supra.*, footnote 6.

[13] Note the promotion of the right to self-determination in international law by such international organizations as the UN Working Group on Minorities, the ICJ, the OSCE, the UN Sub-Commission, the EU and HR Tribunals of the EU, and scholars such as Asbjorne Eide, Christian Tomuschat, Otto Kimminich, Gudmundur Alfredsson, Patrick Thornberry, Hurst Hannum, Alphonso Martinez, Arend Lijphart, Halperin & Scheffer, Alexis Heraclides, etc.

[14] See Theo van Boven, "Study concerning the right to restitution, compensation and rehabilitation for victims of gross violations of human rights and fundamental freedoms, Final Report," UN Doc E/CN.4/Sub.2/1993/8.

[15] *Ibid.*

Striving for Self-determination for Indigenous Peoples

Erica-Irene A. Daes

It is both a great honor and a considerable challenge for me to speak to this august First International Conference on the Right to Self-determination and the UN. The title of my contribution will be: "Striving for Self-determination for Indigenous Peoples: Article 3 of the draft UN Declaration on the Rights of Indigenous Peoples".

At the outset, I would like to extend my earnest congratulations to the leadership of the International Human Rights Association of American Minorities for organizing this important Conference.

I. SOME CONSIDERATIONS CONCERNING THE RIGHT TO SELF-DETERMINATION IN GENERAL

At its inception, the Charter clearly did not include any general "right to self-determination."

The principle of "equal rights and self-determination of peoples", with all its ambiguity, is referred to only twice in the United Nations Charter. The development of friendly relations among nations, based on respect for the principle of equal rights and self-determination of peoples, is listed as one of the purposes of the United Nations.[1] In addition, the Charter makes preambular mention of the principle of self-determination before enumerating several goals which the Organization "shall promote" in various fields, including economics, education, culture and human rights.[2]

On the basis of reasonable textual construction, the conclusion should be that self-determination, in contrast to sovereignty and all that flows from it, was not originally perceived as an *operative* principle of the Charter; accordingly, the principle of self-determination was one of the *desiderata* of the Charter rather than a legal right that could be invoked as such. The proclamation by the United Nations General Assembly of the historic Declaration on the Granting of Independence to Colonial Countries and Peoples[3] (hereinafter Declaration of Granting of Independence) was clearly the beginning of a revolutionary process within the United Nations and represented, by its terms, an attempt to supplement the above-mentioned relevant provisions of the Charter.[4] The Declaration of Granting of

Independence expressly provides that "all peoples have the right to self-determination. By virtue of that right they freely determine their political status and freely pursue their economic, social and cultural development."[5] The Declaration of Independence is essentially a political document with questionable legal authority, but it has formed the cornerstone of what may be called the new United Nations law of self-determination.[6] Nowadays, it is almost impossible to deny that the right to self-determination has attained true legal status consistent with a realistic interpretation of the practice of the political organs of the United Nations.[7]

Nowadays, it is almost impossible to deny that the right to self-determination has attained true legal status consistent with a realistic interpretation of the practice of the political organs of the United Nations.

Further, although (resolution 1960/1541) provides that integration and free association are ways in which *a peoples' right to self-determination* may be exercised, a great number of states, fearing secession, do not accept that indigenous peoples qualify for decolonization.[8] Indigenous peoples are systematically opposing the assumption that they are not entitled to the same rights as other *"peoples"*. According to them, this is a racist policy and practice. The right to self-determination was further limited by the Declaration of Principles of International Law concerning Friendly Relations and Cooperation among States in Accordance with the Charter of the United Nations (hereinafter Declaration on Friendly Relations), which provides that: *"States enjoying full sovereignty and independence, and possessed of a government effectively representing the whole of their population, shall be considered to be conducting themselves in conformity with the principle of equal rights and self-determination of peoples as regards that population." It further notes that nothing in the relevant paragraphs of the Declaration shall be construed as authorizing any action which would impair, totally or in part, the territorial integrity or political unity of such States."[9]* The Declaration on Friendly Relations provides also that *"only when all peaceful means of achieving self-determination have failed should other measures be adopted"*. *The basic objective of the above-mentioned Declaration was to discourage session.*

In addition to the above-mentioned international instruments, the right to self-determination was reaffirmed by the Helsinki Final Act of the Conference on Security and Cooperation in Europe (1975) which under the Heading of *"Equal Rights and Self-determination of Peoples"*, states that: *"The participating States will respect the equal rights of peoples and their right to self-determination, acting at all times in conformity with the purposes and the principles of the Charter of the United Nations and with the relevant norms of international law, including those relating to territorial integrity of States."[10]*

Here again the question arises. Upon whom is the right to self-determination conferred? The answer given in identical terms in all the above-mentioned international instruments, is as simple in formulation as it is chimerical in fact. All these instruments stipulate: *"all peoples have the right to self-determination."* Nevertheless, the context in which the universal goal is declared demonstrates an intention to confine the right to self-determination to the peoples who are still "dependent" and those subjected to "alien subjugation, domination, and exploitation." No specific reference has been made to indigenous peoples.

In Pursuit of the Right to Self-determination

By virtue of the right to self-determination, both of the International Covenant on Civil and Political Rights and the International Covenant on Economic, Social and Cultural Rights provide in their common Article 1(1):

All peoples have the right of self-determination. By virtue of that right they freely determine their political status and freely pursue their economic, social and cultural development.[11]

According to the Covenants, the right to self-determination is intimately linked with what has come to be termed permanent sovereignty over natural wealth and resources.

Attempts to recognize indigenous communities and nations as "PEOPLES" within the framework of the contemporary international law began during the negotiations and elaboration of ILO Convention (No. 169/1989) concerning Indigenous and Tribal Peoples in Independent Countries. When indigenous participants in the aforesaid negotiations insisted on references to the terms "peoples" and "self-determination," a political deadlock ensued, which blocked the adoption of the relevant text and posed a threat of suspension of the meetings. After two years of hard work, the negotiating committee agreed to the use of the term *"peoples,"* subject to a clarification that it was not intended to convey any general implications under international law. The negotiating committee felt that the ILO lacks competence to interpret Article 1 of the Charter and referred this question to the Working Group on Indigenous Populations and its parent bodies.

Whether a group of persons is a *"people"* for the purpose of self-determination depends, in my view, on the extent to which the group making a claim shares ethnic, religious, linguistic or cultural bonds, although the absence or weakness of one of these bonds or criteria need not invalidate the claim. The substantive standards should weigh up to the extent to which members within the group perceive the group's identity as distinct from the identities of other groups.

A very bitter struggle for the term "peoples" took place at the United Nations World Conference on Human Rights held in Vienna on 1993. Indigenous Organizations had initially viewed the Conference with skepticism. However, many representatives of indigenous non-governmental organizations in consultative status with ECOSOC took active part in the drafting Committees for the final text of the Vienna Declaration and Programme of Action. They met with the President of the Conference and certain Government representatives. In my speech at the opening of the Conference, an appeal was made to the governments to recognize indigenous peoples as *"peoples"*. The representatives of the Australian Government also made a plea for acceptance of indigenous peoples' demands, including the term "peoples" i.e. people with an "s". *Australia's proposal was supported by a number of Latin American and European States. Only* Burundi, India and France explicitly opposed the "s". Unfortunately, the proposal for consensus on the "s" was rejected. Nevertheless, some indigenous peoples felt that at the World Conference, they moved to the realization of their aspirations and objectives to be recognized by the United Nations system as *"peoples"*. Subsequently, the criteria for the peoples who have the right to exercise their

right to self-determination remained unchanged in the Vienna Declaration and the relevant Programme of Action.

2. A CONCISE OVERVIEW OF THE UNITED NATIONS DRAFT DECLARATION ONTHE RIGHTS OF INDIGENOUS PEOPLES

The United Nations Working Group on Indigenous Populations had decided, at its third session in 1985, to proceed, as a first important step, with the elaboration of a draft declaration on indigenous rights for an eventual adoption and proclamation by the United Nations General Assembly.[12] In pursuance of this decision, the Working Group had in 1985 provisionally adopted a set of fourteen draft principles referring to the protection of the rights of indigenous peoples, elaborated by the present author.

In order to further facilitate this process, the Working Group on Indigenous Populations, in 1987, recommended that I as Chairperson Rapporteur of this Working Group, be entrusted with the preparation of a working paper containing a full set of preambular paragraphs and principles for insertion into the draft declaration. The recommendation was subsequently approved by the parent bodies of the Working Group, namely the Sub-Commission[13] on Promotion and Protection of Human Rights (at that time called the Sub-Commission on Prevention of Discrimination and Protection of Minorities, hereinafter "Sub-Commission"), the Commission on Human Rights (hereinafter "Commission") and the Economic and Social Council (hereinafter ECOSOC).

The working paper, which I elaborated, containing the first draft Declaration on Indigenous Rights,[14] attempted to cover all the substantive issues brought to the attention of the Working Group under its mandate: the review of developments and the standard-setting.

In addition to the above-mentioned principles already adopted, the sources for preparing *the first draft Declaration consisted of certain principles and data* of international human rights instruments, the recommendations made by the Special Rapporteur, Mr. J. Martinez Cobo, in his monumental *"Study on the Problem of Discrimination against Indigenous Populations",*[15] *and the many constructive proposals made in the course of the Group's sessions by indigenous and governmental representatives. The guidelines for the setting of international standards in the field of human rights as laid down by the relevant General Assembly resolution 41/20 of 4 Dec. 1966*[16] *had also to be taken into account. Accordingly, the above-mentioned draft did not deal and was not intended to deal with rights more extensively covered in existing or upcoming instruments.*

In my introductory statement on the aforesaid draft before the Sub-Commission, I stated, *inter alia,* that one should not lose sight of the most significant features of the draft. Those crucial issues included the use of the term *"indigenous peoples"* rather than indigenous populations," the combination of individual and collective rights, including the right to self-determination, with a special emphasis on the latter as an inherent and essential element of indigenous rights; the effective protection of indigenous identities as manifested in cultures, languages, religions, traditions and customs; the introduction of indigenous autonomy with meaningful functions and powers; the reaffirmation of land and resources rights; and the

absence of a definition of beneficiaries which I personally considered unnecessary for the adoption and proper application of the Declaration. Governments and Indigenous Peoples, as well as inter-governmental and non-governmental organizations were invited to submit written comments and suggestions on the draft Declaration, prior to the seventh session of the Working Group. At that time, there could possibly be a new draft, which we wanted to elaborate and to present to the Working Group, taking into account the opinions, comments and information received. I also expressed the hope and expectation that agreement could be reached between all the parties concerned at the Working Group level before the text was to be submitted through its parent bodies to the General Assembly.[17]

A number of speakers reiterated the point made at previous sessions that the final draft of the Declaration ought to be broad enough to encompass the conditions and needs of indigenous peoples on a universal basis. One governmental observer referred to the difficulty of reconciling not only different factual situations of indigenous peoples throughout the world but also their many different legal systems. Members of the Working Group, myself among them, and representatives of Indigenous Peoples and Governments, pointed out that the draft declaration should be realistic and acceptable to all the parties involved to the greatest degree possible.[18]

The first revised text of the draft Declaration was submitted at the seventh session of the Working Group. The revision which I made was based[19] on the various written comments received from both Governments and Indigenous Peoples. However, the text represented a draft instrument in its early stages intended for facilitating the Working Group's task and was still very much open to amendments and additions. In the ensuing debate, delegations and in particular indigenous peoples' representatives made general comments on the draft text as well as specific comments on the articles of the draft declaration.[20] The members of the Working Group as well as many Indigenous and Governments participants expressed their firm opinion that the above-mentioned draft represented an important step forward.[21] In addition, I was also requested by the Sub-Commission and the Commission on Human Rights to prepare an extensive analytical commentary on the articles of the draft Declaration. This working paper was prepared based on my first revised text, the reports of the informal working groups established temporarily by my relevant decision in order to accelerate the preparatory work on the draft declaration, the significant and fruitful debate of the eighth session of the Working Group, written observations and proposed amendments and relevant existing international instruments. This working paper was prepared[22] and relevant constructive discussions took place during the seventh and eighth sessions of the Working Group, and some suggestions, additions and modifications to the first revised text had been submitted by Indigenous Peoples, representatives of observer Governments, United Nations bodies, specialized agencies and non-governmental organizations concerned. Accordingly, I had prepared a second revised text and presented it at the tenth session of the Working Group.

At its eleventh session, the Working Group started the second reading of the draft Declaration on the basis of a new second revised text of the draft declaration.[23] At the fourth meeting of the eleventh session of the Working Group, the United Nations Good Will Ambassador, Ms. Rigoberta Menchu Tum addressed the meeting and stated, *inter alia*, that the draft declaration would have to be an instrument

which facilitated the struggle of all indigenous peoples. Thus far, the drafting procedure had shown considerable progress but before the Declaration could be enshrined within the framework of international instruments, gaps needed to be filled. It was essential that the draft not be viewed as a threat to Governments or a source of friction, but as a mechanism which would eliminate conflict in the future.[24]

> **It was essential that the draft not be viewed as a threat to Governments or a source of friction, but as a mechanism which would eliminate conflict in the future.**

Some representatives of Governments pointed out that the draft declaration in its present form did not contain a definition of "indigenous peoples". In particular, the representative of the observer Government of Japan expressed the concern that this might give rise to subjective interpretations as to which groups were entitled to the rights contained in the draft Declaration.[25] In this respect, I replied that, for the purposes of the draft Declaration, the working definition of "indigenous peoples" contained in the above-mentioned study by Martinez Cobo should be applied.[26]

During the discussion at the aforesaid meeting, a number of questions proved to be of particular importance to the participants. Many representatives of indigenous peoples and governmental observers expressed their views on the issues of "self-determination", on the implications of using or not using the term "indigenous peoples", and of "collective rights" and "land rights". The majority of the governmental observers expressed reservations on the issue of "self-determination". The observer for Canada emphasized that his country supported the principle that indigenous people qualified for the right of self-determination in international law on the same basis as a non-indigenous people. In all other cases, "self-determination" of indigenous people had to be granted within the framework of existing nation-states. The observer for Finland stated that his country was in favor of the use of the concept of self-determination in the draft Declaration. The observer for Denmark stated that the exercise of the right of self-determination was a precondition for any full realization of human rights for indigenous peoples...[27]

At the same meeting, two steps were taken on the basis of a proposal I made, toward a compromise. The principle of the draft Declaration regarding self-determination was redrafted in order to stress constitutional reform rather than secession.[28] The proposal was accompanied by a note[29] explaining that, "instead of focusing on the right to form new States when existing Governments fail", the proposal promotes the negotiation of arrangements to strengthen States and make them truly representative, democratic, liberal and inclusive," without foreclosing secession as a last resort. Although the observer of Australia shared my views and optimism that a "balanced" consensus text could be devised, indigenous representatives were adamant on the issue of self-determination. By the second day of the session, the task of the Working Group could be characterized as expressing the *"essential aspirations"* of indigenous peoples.[30]

Finally, I and the other members of the Working Group acceded to the requests of the participants, mainly the indigenous representatives, and adopted unanimously as article 3 of the draft Declaration, the following text that quotes common Article 1(1) of the two International Human Rights Covenants without any change or qualification, except for changing the opening word "all" to "Indigenous":

> Indigenous peoples have the right of self-determination. By virtue of that right, they freely determine their political status and freely pursue their economic, social and cultural development.[31]

The decision received spontaneous expressions of enthusiasm by indigenous participants and a conciliatory response from many of the governments.

It should be once more underlined that no other United Nations human rights instrument was prepared with so much direct involvement and active and constructive participation of its intended beneficiaries.[32]

No other United Nations human rights instrument was prepared with so much direct involvement and active and constructive participation of its intended beneficiaries.

On this basis, *the final version of the draft "United Nations Declaration on the Rights of Indigenous Peoples"[33] was prepared with the active participation by all members of the Working Group* and with its approval by the representatives of the words "indigenous peoples," was duly submitted to the Sub-Commission.[34]

After an attentive consideration of the revised draft Declaration, during which no amendments or further revision were proposed, the Sub-Commission submitted it to the Commission on Human Rights for further action. The Commission established an open-ended inter-sessional working group with the sole purpose of elaborating a draft Declaration, taking into consideration the draft submitted by the Sub-Commission contained in the annex to resolution 1994/45 of 26 August 1994 of the Sub-Commission, entitled "Draft United Nations Declaration on the Rights of Indigenous Peoples", for further consideration and adoption by the General Assembly *within the International Decade of the World's Indigenous People.[35]*

It should be also noted that the draft declaration as agreed upon by the Members of the Working Group was sent to the competent United Nations team for a technical review.[36]

Unfortunately, the draft Declaration is still pending before the inter-sessional Working Group of the Commission for the purpose of further elaborating a draft declaration in accordance with operative paragraph 5 of General Assembly resolution 49/214 of 23 December 1994.[37] In spite of the six annual meetings of the Working Group of the Commission, no substantive progress has been made. This constitutes a source for disappointment and even bitterness for myself along with the indigenous peoples of the world community, as well as for certain Governments, which sincerely seek the adoption and proclamation by the General Assembly of this history United Nations instrument, which will, inter alia, contribute to a genuine reconciliation between the world's indigenous peoples and Governments.

It should be reaffirmed that the completion of the work of the draft Declaration at the level of the Working Group on Indigenous Populations and the Sub-Commission constitutes the most important development within the framework of the United Nations system concerning the protection of the basic rights and fundamental freedoms of the world's Indigenous Peoples.

The draft Declaration is not a short or simple document, but long and complicated, as befits the complexity of the subject matter. It may not – and probably could not – fully reflect the concerns of every indigenous people or national

government. Nevertheless, it reflects the essential concerns of indigenous peoples as a whole, in the understanding that indigenous peoples, in the manner of all nations and other peoples, vary greatly even among themselves. In this context, specific reference is made to the right of self-determination, not because it is a right of indigenousness, but as a right of peoples, a right of which indigenous peoples cannot be denied. It was in this spirit that I, in my capacity as Chairperson-Rapporteur and the members of the Working Group on Indigenous Populations and all other participants, especially the representatives of the world's indigenous peoples agreed upon, to adopt Article 3 of the draft Declaration in its present wording.[38]

3. THE SPIRIT AND THE LETTER OF THE DRAFT DECLARATION

Sixteen years have already elapsed since I, as the principal drafter, and the other members of the Working Group began the drafting of the Declaration, and seven years have passed since the drafting was completed at the level of the Working Group. Indeed, it has been more than twenty-three years since world attention was initially drawn to the demands of indigenous peoples for recognition of their right to self-determination at an international non-governmental Conference at Geneva on the Indigenous Peoples of the Americas.

Through all these years, governments have remained skeptical on the right to self-determination of indigenous peoples. There have been some exceptions, but a majority of governments has continued to express *fear and uncertainty* about self-determination, in particular about Article 3 of the draft Declaration. This fear and uncertainty by the governments on this important and multifarious point has been the main factor delaying the completion of the elaboration of the draft Declaration as a whole at the level of the *ad hoc* Working Group of the Commission.

The unjustified fears of a number of governments, most of them from Asia, have prevented the United nations system from devoting serious attention to studying the practical applications of the right to self-determination – for example, through national, regional and international workshops, or through field missions to countries which have taken important steps to empower indigenous peoples. Without further work of technical nature at the national, regional and international levels, we can not develop an understanding of the concrete implications of the right to self-determination. Also, without a better understanding of the meaning of the concept of self-determination in actual practice, in turn we cannot alleviate the fears of governments. It is a vicious circle, perpetuated by fear and ignorance.

It should be underlined that *the spirit of the draft Declaration and the fundamental condition for realizing the right of self-determination in practice is trust between peoples.* Trust is impossible without cooperation, dialogue and respect. Governments have nothing to fear from indigenous peoples; they can learn to respect and trust.

The fundamental condition for realizing the right of self-determination in practice is trust between peoples. Trust is impossible without cooperation, dialogue and respect.

In my view, it is very important to think of self-determination *as a process.* *The process of achieving self-determination is endless.* This is true of *all* peoples

– not only indigenous peoples. Social and economic conditions are ever-changing in our complex world, as are the cultures and aspirations of all peoples. For different peoples to be able to live together peacefully, without exploitation or domination – whether it is within the same state or in two neighboring states – they must continually renegotiate the terms of their relationships. There are far too many tragic examples, even here in Europe, where a failure to attain self-determination as part of a living, growing relationship between peoples has resulted in oppression and violence.

It is useful to make an attempt to examine how the concept of *self-determination* has been explained in many different languages. Thus, the words most frequently used to translate *self-determination* have the meaning of *freedom, integrity and respect*. In other words, *self-determination* means the freedom for indigenous peoples to live well, to live according to their own values and beliefs, and to be respected by their non-indigenous neighbors.

The Mohawk legal scholar Patricia Monture has written extensively about the ideas *of law and justice in culture*. She has translated the Mohawk words for law and justice as *"living together nicely"*. The freedom of people to "live together nicely", as they understand this to be, is what could also be conceived as the true spirit of self-determination.[39]

The protection of this freedom unquestionably involves some kind of collective political identity for indigenous nations and peoples, i.e. it requires official recognition of their representatives and institutions. However, the underlying goal of self-determination for most indigenous peoples *has not* been the acquisition of institutional power. Rather their goal has been achieving the freedom to live well and humanly – and to determine what it means to live humanly. In my view, no Government has grounds for fearing that.

Indeed, it is important that we must try to guard against a kind of false consciousness with respect to achieving the true spirit of indigenous self-determination. It is entirely possible for a State to recognize indigenous peoples' right to self-government, and to delegate various administrative tasks and responsibilities to indigenous communities – including perhaps even some limited authority to legislate upon purely local or internal matters – and yet, despite all of this, the spirit of the right to self-determination has not been fulfilled. The true test of self-determination is not whether indigenous peoples have their own institutions, legislative authorities, laws, police and judges. The true test of self-determination, it should be emphasized, is whether indigenous peoples themselves actually feel that they have choices about their way of life.

The existence of a genuine right to self-determination cannot be only determined from the outward form of indigenous peoples' self-governing or administrative institutions. The true test is a more subjective one, which must be addressed by the indigenous people themselves. In other words, the amount of power and money transferred to indigenous institutions is not a measure of self-determination. The indigenous peoples must feel secure in their right to make choices for themselves – to live well and humanly in their own ways.

In this respect, it should be added that it is precisely because indigenous peoples do *not* seek, and will not be able to acquire a great deal of physical and economic *power, that new forms of international cooperation are needed to guarantee the security and rights of indigenous peoples*. If we are genuinely

committed to conserving the world's cultural diversity, we must accept responsibility for establishing an international regime in which small nations and peaceable peoples can survive. A world system dominated by power and wealth is incompatible with culture diversity. Peoples who must fight continually for their subsistence and existence are never truly free to develop their distinctive cultures.

We live in a world of economic globalization in which the power of transnational corporations often dwarfs the power of States.

Many Governments are overwhelmed by market forces. Acting alone, they can be ineffective at regulating corporate ventures and in protecting indigenous peoples from destructive projects. There is an urgent need to develop *new international legal machinery to extend the power of States to defend their citizens and their environment against irresponsible transboundary corporate activities*, including in particular corporate activities that disrupt, displace and destroy indigenous peoples.

There are some of my views concerning the spirit of self-determination in terms of achieving the real goals of indigenous peoples themselves, rather than merely creating the appearance of indigenous self-government or local administration.

In addition, a brief reference should be made to two other important elements of the true spirit of self-determination: *land and mutual respect.*

In my opinion, a fundamental aspect of the true spirit of self-determination is respect for the land,[40] *without which indigenous peoples cannot fully enjoy their cultural freedom or cultural integrity.*

As I have repeatedly explained in my capacity as Special Rapporteur on the Protection of the Heritage of Indigenous People,[41] *land is not only an economic resource for indigenous peoples. Land is also the people's library, laboratory and university; land is the repository of all history and scientific knowledge. All that an indigenous people have been, and all that they know about living well and humanly, is embedded in their land and in the stories associated with every feature of the land.*

Naturally, indigenous peoples need land to provide both subsistence and meet their physical needs. However, their cultural integrity and cultural development also depend fundamentally on their continuing right to determine their relationship with everything in their territories including landforms, water, animals and plants. An indigenous people could become wealthy from Government transfer payments or from the development or sale of forests and minerals, and still lack genuine self-determination if the land and natural resources are no longer under their meaningful control. The alienation of an indigenous people from their land can never be adequately compensated. For this reason, issues relating to land cannot properly be separated from political discussions of self-government. This has, of course, been a matter of some sensitivity mainly in the Nordic context.

Indigenous peoples have argued persistently that relationships to land or territories are at the heart of their distinct cultures. In this connection, it should be said that human ecology and geography are intrinsic components of indigenous peoples' conceptions of living well and living humanly. It is therefore inconceivable that an indigenous people could attain self-determination if it is detached from its ancestral territory, or if it has no real choices in the disposition of its territory.

In Pursuit of the Right to Self-determination

There is one more fundamental condition, at least in the long term, for achieving the spirit as well as the letter of self-determination. This condition is *mutual respect*. As North American Indians and Aboriginal Australians have recently experienced, in the wake of changes in the political philosophies of their national Governments, self-determination is never secure if it depends entirely on legislation and high-level political decision-making. Whatever may be given by one Prime Minister or political party can be taken away by the next. Even constitutions can be changed. The only real security for self-determination lies in improving social relationships between indigenous peoples and their non-indigenous neighbors. Changes at the grassroots – that is, in the ways indigenous people and their neighbors perceive each other and interact as individual human beings – must take place before indigenous peoples can enjoy real freedom.

In this regard, reference can be made to the notion of a *"culture of human rights"*, which has been promoted mainly by UNESCO and other Human-Rights bodies of the United Nations system for more than a decade. In my view, a culture of human rights begins with basic respect for the existence and the identity of our own neighbors – regardless of their ethnicity, nationality, religion, color or culture. This is the foundation upon which the complete range of human rights and fundamental freedoms can begin to be realized. This is not a reference to fear of the law or the state, or the philosophical ideals of human rights, but of respect for the value and humanity of the person who lives next door or a few miles down the road.

When indigenous peoples speak in their own languages about self-determination in terms of *respect*, this is what they mean. Indigenous peoples are calling upon the leaders of Governments to set an example by treating the leaders and the elders of indigenous peoples with the full respect and dignity of fellow humans who can be trusted. This is so simple, but it has been very elusive.

How can the leaders (elders and Chiefs) of indigenous peoples and States build trust and respect? We must return to the concept of self-determination as a process. As in the case of peace-building and disarmament, there is a preliminary need for confidence-building, through a gradual process of cooperation and collaboration. In other words, self-determination can never be defined in the abstract. It can only arise out of a process of sincere engagement. A good faith process can eventually result in a practical arrangement, specific to the country and the people, while consultations or negotiations in bad faith will most certainly deepen the divisions between States and Indigenous Peoples, and diminish the possibilities of peaceful solutions.

In Europe, we should understand this very clearly. The growth of the European Union has been a very gradual process of building trust, of accommodation and of compromise. Over time, sovereignty and historical differences have grown less problematic, and confidence in the possibility of living well together has grown. Our experiences in constructing a new Europe offer sound insights for States that are uncertain or fearful of constructing new relationships with indigenous peoples. Defining the specific modalities for the exercise of self-determination is far less important than beginning to talk and getting to know one another. Speaking with good hearts and with a willingness to earn trust is more important, in truth, than the letter of the law.

It is my sincere hope that this presentation and analysis of some concepts and key elements of the true spirit, meaning and scope of the draft Declaration will effectively contribute to the alleviation of the fears of Governments, to the revocation of their reservations and to the development of a constructive dialogue based in good will, good faith, trust and understanding between the indigenous peoples and Governments. All these developments will contribute to a prompt adoption and proclamation of the draft Declaration by the United Nations General Assembly.

ENDNOTES

[1] UN Charter Article 1.1.

[2] *Ibid.*, Article 55.

[3] Declaration on the Granting of Independence to Colonial Countries and Peoples, UN GA Res. GAOR, 15th sess., Supp. No. 16, at 66, UN Doc. A/4684/1961.

[4] C. Tomuschat, "Self-determination in a Post-Colonial World", in C. Tomuschat, ed., *Modern Law of Self-determination*, Kluwer Academic Publishers, the Netherlands, 1993, p. 2.

[5] Principle 2 of the Declaration of Independence, in *Human Rights: A Compilation of International Instruments*, UN publication, Sales No. E.88.XIV.1, p. 48.

[6] E-I.A. Daes, "Some Considerations on the Right of Indigenous Peoples to Self-determination," *Transnational Law and Contemporary Problems* (TLCPA), Journal of the University of Iowa College of Law, Symposium Contemporary Perspectives on Self-determination and Indigenous Peoples' Rights, Vol. 3, Number 1, Spring 1993, p.3.

[7] On the importance of UN practice in the development of international law, see R. Higgins, *The Development of International Law Through the Political Organs of the United Nations,* 1969, 1-10.

[8] R.L Barsh, "Indigenous Peoples in the 1990s: From Object to Subject of International Law?", *Harvard Human Rights Journal*, p. 35.

[9] Declaration on Friendly Relations, UN GA Res. 1970/2025, GAOR, 25 sess., Supp. No. 28, at 121.

[10] Final Act of the Conference on Security and Cooperation in Europe, adopted Aug. 1, 1975, Dept. St. Publ. No. 8826, reprinted in 14 I.L.M. 1292.

[11] For the text of the Covenants, see *Human Rights: A Compilation of International Instruments*, UN publ., op. cit., pp. 7-42.

[12] UN Doc. E/CN.4/Sub.2/1985/22, Annex II, UN Doc. E/CN.4/Sub.2/1987, Annex II and UN Doc. E/CN.4/Sub.2/1988/24/24, August 1988, p. 17.

[13] Sub-Commission on Prevention of Discrimination and Protection of Minorities Resolution 1987/16, the Commission on Human Rights Resolution 11988/49 and Economic and Social Council Resolution 1988/36.

[14] UN Doc. E/CN.4/Sub.2/1988/25, Annex II.

[15] J.R. Martinez-Cobo, Study of the Problem of Discrimination Against Indigenous Populations.

[16] UN Gen. Ass. Resolution 41/120 of 4 December, 1986.

[17] UN Doc. Report of the Working Group on Indigenous Populations on its sixth session, E/CN.4/Sub.2/1988/24 of 24 August 1988, pp. 17-18.

[18] *Ibid.*, pp. 18 and 19.

[19] UN Doc. E/CN.4/Sub.2/1989/33.

[20] UN Doc. E/CN.4/Sub.2/1989/36 of 25 August 1989, p. 16.

[21] *Ibid.* p. 16. As Glenn T. Morris wrote: "Despite these shortcomings, Daes' draft declaration provides an important step in the long, often tedious, process of transforming international legal standards...", "International Law and Politics: Toward a Right to Self-determination for Indigenous Peoples," in M. Annette James, ed., *The State of Native America*, South End Press, 1992, p. 77.

[22] Report of the Working Group on Indigenous Populations on its tenth session, UN Doc. E/CN.4/Sub.2/1991/36.

[23] Report of the Working Group on Indigenous Populations on its eleventh session, UN Doc. E/CN.4/Sub.2/1992/33. In this respect, see also G. Alfredsson, "The Right to Self-determination and Indigenous Peoples", in *Modern Law of Self-determination, op. cit.*, pp. 41-54.

[24] UN Doc. Report of the Working Group on Indigenous Populations on its eleventh session, E/CN.4/Sub.2/1993/29 of 23 August 1993, p. 15.

[25] *Ibid.*, p. 15.

[26] *Op. cit.* UN Doc E/CN.4/Sub.2/1983/21/Add 8, paras. 362-381. In connection with the meaning of the concept/term "indigenous people", see E-I. A. Daes, Working paper on the concept of "indigenous people", UN. Doc. E/CN.4/Sub.2/AC.4/1996/2, also, among others, B. Kingsbury, "'Indigenous Peoples' in International Law: A Constructivist Approach to the Asian Controversy", in *AJIL*, Vol. 92:414, 1998.

[27] UN Doc. E/CN.4/Sub.2/1993/29, p. 16.

[28] The following was the relevant compromise proposal made by the present author: "Indigenous peoples have the right to self-determination, in accordance with international law, subject to the same criteria and limitations as apply to other peoples in accordance with the Charter of the United Nations. By virtue of this, they have the right, *inter alia*, to negotiate and agree upon their role in the conduct of public affairs, their distinct responsibilities and the means by which they manage their own interests." E-I.A. Daes, Explanatory note concerning the draft declaration on the rights of indigenous peoples, E/CN.4/Sub.2/1993/26/Add.1, p. 3.

[29] *Ibid*, pp. 1-8.

[30] R.L. Barsh, *op. cit.*, pp. 52-54.

[31] The text of the two International Covenants on Human Rights is contained in *Human Rights: A Compilation of International Instruments, op. cit.* For a comprehensive analysis of Article 1 of the Covenant on Civil and Political Rights, see M. Schleinin, "The Right to Self-determination under the Covenant on Civil and Political Rights," in Pekka Aikio and Martin Scheinin, eds., *Operationalizing the Right of Indigenous Peoples to Self-determination*, Institute for Human Rights, Abo Akademi University, Turku/Abo 2000, pp. 179-199.

[32] E-I. A. Daes, "Equality of Indigenous Peoples Under the Auspices of the United Nations Draft Declaration on the Rights of Indigenous Peoples," *St. Thomas Law Review*, Special edition of the Symposium, Tribal Sovereignty: Back to the Future?, Vol. 7, Summer 1995, p. 494.

[33] For the final and full text of the draft United Nations Declaration on Indigenous Rights, see *Ibid.* UN Doc. E/CN.4/Sub.2/1993/29, pp. 50-60.

[34] Sub-Commission's Resolution 1993/46, UN Doc. E/CN.4/Sub.2/1993/45, pp. 95-96. Also Sub-Commission's Resolution 1995/38, UN Doc. E/CN.4/Sub.2/1995/51, pp. 89-91.

[35] Commission on Human Rights' Resolution 1995/32 of 3rd March 1995.

[36] UN Doc. E/CN.4/Sub.2/1994/2/Add. 1 of 20 April 1994, Technical review of the UN draft declaration on the rights of indigenous peoples as agreed upon by the members of the Working Group on Indigenous Populations.

[37] UN Doc. E/CN.4/1994/L.11/Add 2. Commission on Human Rights' resolution 1995/32.

[38] *Ibid.*

[39] According to Prof. Douglas Sanders, "self-determination for indigenous peoples is assumed to mean a degree of autonomy involving cultural, economic and political rights within the structures of recognized states". D. Sanders, The UN Working Group on Indigenous Populations, *Human Rights Quarterly*, vol. 11, Number 3, August 1989, pp. 429-430. For the content and significance of the right to self-determination for indigenous peoples, see the important and comprehensive article, "The Right of Self-determination and Its Significance to the Survival of Indigenous Peoples" by the Grand Chief of the Crees of Quebec, in *Operationalizing the Right of Indigenous Peoples to Self-determination, op. cit.*, pp. 155-177.

[40] E-I. Daes, Indigenous Peoples and their Relationship to Land, Final Report on the Working paper on Indigenous Peoples and their Relationship to Land, UN Doc. E/CN.4/Sub.2/2000/.

[41] E-I.A. Daes, Protection of the Heritage of Indigenous People, Study Series 10, UN publ., UN, New York and Geneva, 1997, pp. 1-23.

Understanding Self-determination: The Basics

Karen Parker

DEFINITION OF SELF-DETERMINATION

The right to self-determination, a fundamental principle of human rights law,[1] is an individual and collective right to "freely determine ... political status and [to] freely pursue ... economic, social and cultural development."[2] The principle of self-determination is generally linked to the de-colonization process that took place after the promulgation of the United Nations Charter of 1945.[3] Of course, the obligation to respect the principle of self-determination is a prominent feature of the Charter, appearing, *inter alia*, in both the Preamble to the Charter and in Article 1.

The International Court of Justice refers to the right to self-determination as a right held by people rather than a right held by governments alone.[4] The two important United Nations studies on the right to self-determination set out factors of a people that give rise to possession of the right to self-determination: a history of independence or self-rule in an identifiable territory, a distinct culture, and a will and capability to regain self-governance.[5]

The right to self-determination is indisputably a norm of *jus cogens*.[6] *Jus cogens* norms are the highest rules of international law and they must be strictly obeyed at all times. Both the International Court of Justice and the Inter-American Commission on Human Rights of the Organization of American States have ruled on cases in a way that supports the view that the principle of self-determination also has the legal status of *erga omnes*.[7] The term "*erga omnes*" means "flowing to all." Accordingly, *ergas omnes* obligations of a State are owed to the international community as a whole: when a principle achieves the status of *erga omnes* the rest of the international community is under a mandatory duty to respect it in all circumstances in their relations with each other.

Unfortunately, when we review situations invoking the principle of self-determination, we encounter what we must call the politics of avoidance: the principle of self-determination has been reduced to a weapon of political rhetoric. The international community, therefore, has abandoned *people* who have the claim to the principle of self-determination. We must insist that the international community address those situations invoking the right to self-determination in the proper, legal way.

THE DE-COLONIZATION MANDATE

As a result of the de-colonization mandate, two types of situations emerged: situations I call "perfect de-colonization" and those that I call "imperfect de-colonization". The principle of self-determination arises in the de-colonization process because in a colonial regime the people of the area are not in control of their own governance. In these situations there is another sovereign, an illegitimate one, exercising control. De-colonization, then, is a remedy to address the legal need to remove that illegitimate power.

A. Perfect de-colonization

In a perfect de-colonization process, the colonial power leaves and restores full sovereignty to the people in the territory. In these situations, the people have their own State and have full control of their contemporary affairs, with a seat in the United Nations and all other attributes of a State in international law. There are either no component parts of the State that would have the right to self-determination in their own right or if there are such component parts, the State has voluntarily become a working multi-group State. Some de-colonization that took place after the UN Charter can be viewed as "perfect." This is not to declare that all States that were former colonial States have a "perfect" current government or that a particular government in any of these States fully respects human rights. However, the issue of self-determination no longer arises in these countries.

B. Imperfect de-colonization

Imperfect de-colonization occurs when there is an absence of restoration of full governance to a people having the right to self-determination. There are several types of imperfect de-colonization. In one scenario, separate States conquered by a colonial power were amalgamated into what the colonial powers frequently referred to as a "unitary" state — a kind of forced marriage between the two or more formerly separate States. The people of these States usually have different languages, ethnicities, religions or cultures. At the termination of the colonial regime, the colonial power may simply turn over power to one of the groups and leave the other group or groups essentially entrapped in the new de-colonized State. The entrapped group may resist this, and may seek to restore its pre-colonial sovereignty.

In another scenario, these different groups may decide to continue as a unitary State, but with an agreement (usually through the de-colonization instrument or national constitution) that if it does not work out, then the component parts would go back to their pre-colonial status of independent units. This is what I call a "we'll give it a try" abrogation of full independence by usually the smaller group or groups with clear op-out rights (a fall-back position) if the "unitary" system set up by colonial power fails to afford them full rights. However, when a component part seeks to opt-out, the dominant power refuses.

In yet another scenario, one State may forcibly annex a former colonial people, but either the affected peoples, the international community or both do not recognize this as a legal annexation. The international community may have even mandated certain procedures, as yet unrealized, by which the affected people are to indicate their choice regarding self-determination rights.

In a fourth scenario, there may be a situation where a small component part of a colonially-created "unitary" State agreed to continue the unitary State but with no particular "op-out" agreements signed. Rather, there were either verbal or negotiated written agreements about how the rights of the smaller (or in some situations, weaker) group would be protected in the combined State. However, the smaller or weaker group then experiences severe curtailments of their rights over a long period of time by the dominant group and may lose the ability to protect its rights by peaceful means.

CASE STUDIES

Burma[8]

I will begin with the de-colonization process in British Burma. The 1947 Constitution of Burma, which was to be the constitution following the de-colonization process, had "opt-out" clauses regarding the many different people of the territory occupied by Great Britain. In other words, the groups that were put under "unitary" rule by the British would have the right to say they do not want to continue being united to the other groups in post-colonial Burma. This is the classic "we will give it try" scenario, with the protection of legal instruments to enforce the "opt out" rights.

The 1947 Constitution in Burma had a ten-year trial period, so theoretically a group couldn't have opted out until 1957. However, in the intervening years between 1947 and 1957, the Burmese, the majority in that area, seized power and the other ethnic nationalities that were part of the union of Burma began to suffer. Even worse, the Burmese government unilaterally extinguished the opt-out rights under the 1947 Constitution. Many people think the situation of human rights in Burma, under serious review by the United Nations Commission on Human Rights for many years, relates to the Burman[9] military regime against Daw Aung Sang Suu Kyi's ethnically Burman party and her supporters. Unfortunately, the situation is far more complex than that — the majority of the more serious human rights violations have occurred in the context of conflicts between the Burman army against the military forces of the other ethnic nationalities that were given the right to cede in the 1947 Constitution: the Karen, the Karenni, the Mon, the Shan and others. In fact some of those groups cast a leery eye at any Burman political party: they say that even if Daw Aung San Sui Kyi's party takes over, the relationship between that essentially Burman party and the other ethnic nationalities is not certain. In particular, some groups are unsure as to whether they will then be able to exercise their op-out rights conferred under the 1947 Constitution.

The Moluccas[10]

A second situation is that of the Moluccas. This situation arose in the area of the Netherlands East Indies. I use that term rather than Indonesia because the term Indonesia is a term invented at the time of the de-colonization process – there was not a State called Indonesia prior to 1949. Whereas the British were mainly behind the scenes during the 1947 constitutional process in Burma, the Netherlands authorities had their hands in very heavily throughout the de-colonization process of the Netherlands East Indies.

In Pursuit of the Right to Self-determination

The Netherlands, as had Great Britain, amalgamated many unrelated nations and placed them under the colonially-imposed "unitary" state system — under one rule.

At the time of de-colonization, there was great difficulty in reaching an agreement as to what should happen to all of those formerly independent island nations. The strongest and most populous group was the Javanese, centered in Jakarta although also located elsewhere in the islands. The Javanese became the bargaining power. So through the Netherlands and the Javanese and with the cooperation of the United Nations at that time, Indonesia was to come into being. The de-colonization instrument, called the Round Table Conference Agreements of 1949, was between the Netherlands, the Javanese-Indonesian leadership and the United Nations.[11] The new State to be formed from the Netherlands East Indies was to be called the United States of Indonesia and was to be made up of the Javanese islands to be grouped as "the Republic of Indonesia" and other co-equal "republics." The Moluccas was to be part of the Republic of East Indonesia.

The Round Table Conference Agreement had several "opt-out" provisions offering provisions for both internal and external choices. For example, the populations of territories were to be given a plebiscite to determine "whether they shall form a separate component state."[12] The second "opt-out" provision allowed states that did not ratify the constitution to negotiate with either the United States of Indonesia or the Netherlands for a "special relationship."[13] Thus, the de-colonization instrument itself for the Netherlands East Indies gives the Moluccas the legal right to secede.

Immediately following the turning over of power, the Javanese began to forcibly incorporate the component parts into the Republic of Indonesia (the Javanese stronghold) rather than implement any plebiscites. Additionally, the Javanese made clear they would not allow component parts to "opt-out" entirely. With increasing Javanese pressure on the Moluccas, the Moluccas responded by invoking Article 2.2: on April 25, 1950 the Moluccan leadership declared the independent state of the Republic of South Moluccas. However, the Javanese strongly opposed this, and invaded the Moluccas. Sadly, at that same time, the Moluccan forces were seriously depleted because the Netherlands had transported 4,000 Moluccan troops and their families to the Netherlands. The Moluccan forces had been part of the Netherlands forces in the East Indies (the KNIL) and were transported with them to the Netherlands. The Moluccan people were left without defenders against the Javanese army.

At the time, the United Nations Commission for Indonesia took up the Moluccan case. But even so, it became apparent that the politics of the United Nations seemed to change. It is difficult to assess what occurred, in part because, as I discovered in researching the Security Council and United Nations Commission for Indonesia of that era, most of the documents are still embargoed. Researchers cannot even look at them. What is obvious is that a deal was made probably behind the scenes, because in the end, the United Nations did not insist on the removal of the Javanese from the Moluccas and the Commission for Indonesia quietly ceased to exist in about 1955.

As you know, many other component parts of the former Netherlands East Indies share with the Moluccas a continuing (and indeed worsening) period with

rampant and violent attacks by the Indonesian Army and government-supported paramilitary groups as well as continuing violations of human rights. This is truly a crisis of self-determination, affecting especially the Moluccas, Acheh, and West Papua.

Kashmir[14]

The next situation I want to present is Kashmir – an "imperfect" de-colonization process in which the United Nations also got involved. The United Nations interest in the situation of Kashmir began in 1947-1948 during the de-colonization process of the British Empire in south Asia. The leaders of what became Pakistan and India reached an agreement with the British that the people of Kashmir would decide their own disposition. Prime Minister Nehru (India) had gone on record publicly saying that the disposition of the Kashmir people will be up to them.[15] Due to a great deal of turmoil in the area, including a full-fledged revolt in Kashmir against the British-imposed maharajah, the United Nations began formally to address Kashmir in 1948. That year, the Security Council established the United Nations Commission on India and Pakistan, which, in addition to the Security Council itself, adopted resolutions mandating that the final disposition of Kashmir was to be via a plebiscite carried out under the auspices of the United Nations.[16]

The Indian government backed up its earlier promises that the Kashmiri people would decide the future of Kashmir when it supported the plebiscite under the auspices of the United Nations. The Security Council resolutions cited above indicating United Nations action to settle the Kashmir question were all supported by India as were resolutions of the United Nations Commission for India and Pakistan. For example, on January 5, 1949, India agreed to a Commission resolution stating:

> The question of the accession of the State of Jammu and Kashmir to India or Pakistan will be decided through the democratic method of a free and impartial plebiscite.[17]

However, before such a plebiscite could take place, the armed forces of India seized much of Kashmir under the pretext of coming to aid the British maharajah who was attempting to quell the Kashmiris' revolt against him. The maharajah obtained India's military help in exchange for an Instrument of Accession giving Kashmir to India.[18] Since that time, India has maintained control of what must be called Indian-occupied Kashmir, and continually refers to Kashmir as an integral part of India. India supports this view in part because of Indian-managed elections taking place in Kashmir. However, the United Nations Security Council has repeatedly rejected this argument by stating that such unilateral acts do not constitute the free exercise of the will of the Kashmiri people: only a plebiscite carried out by the United Nations would be valid.[19]

Unfortunately, the plebiscite has still not occurred. By the mid-1950s, the Cold War deepened and the alliances in the region fell under different spheres of influence in that Cold War. The United Nations Security Council and the Commission had established a plebiscite administration under the authority of the President of the Security Council, and both directly with the President of the Security Council

and the Commission on India and Pakistan, a series of plebiscite administrators were unable to secure a situation on the ground so that a plebiscite could take place. The last plebiscite administrator finished his term somewhere between 1955-1956.

Today we find that the disposition of Kashmir has not been legally decided. It is not an integral part of any country and yet we have the failure today of the realization of the expression of self-determination of the Kashmir people. The Kashmiri people are involved in a brutal war in Jammu and Kashmir – what I call the Kashmiri War – in which 5-700,000 Indian troops are present in the area carrying out military actions against civilians and Kashmiri military forces alike. In the course of that armed conflict, the Indian forces have engaged in grave breaches of the Geneva Conventions and the general laws and customs of war. Rapes, disappearances, summary execution, torture and disappearances related to the conflict are nearly everyday events in Indian-occupied Kashmir.

Even without the United Nations recognition of the Kashmiris' right to self-determination, the Kashmir claim is exceptionally strong and so makes a good case study from this perspective. The area had a long history of self-governance pre-dating the colonial period.[20] The territory of Kashmir has been clearly defined for centuries.[21] Kashmiri people speak Kashmiri, which, while enjoying Sanskrit as a root language as do all Indo-European languages, is clearly a separate language from either Hindi or Urdu.[22] The Kashmiri culture is similarly distinct from other cultures in the area in all respects — folklore, dress, traditions, and cuisine. Even everyday artifacts such as cooking pots and jewelry have the unique Kashmiri style.[23]

Most important to a claim to self-determination, the Kashmiri people have a current strong common aspiration for re-establishment of self rule. The Kashmiri people resisted the British, and maintained a degree of autonomy throughout British rule. In 1931, a major uprising of Kashmiris against the British and the British-imposed maharajah was brutally put down. But the "Quit Kashmir" campaign against the maharajah continued into 1946, when the Azad Kashmir movement gained momentum. During the breakup of British India, the Azad military forces began armed attacks against the forces of the maharajah — prompting the accession to India in exchange for Indian military protection.[24] Resistance to India has continued unabated throughout Indian occupation, with major uprisings in 1953, 1964 and continuing essentially unabated since 1988.

While resistance to India has played a major role in Kashmiri events, there is also forward-looking political leadership with a clear will and capability to carry on the governance of an independent Kashmir. There are a number of political parties in Kashmir that have been active for some time, even though at great risk. Many of the leaders of these parties have spent time in Indian jails, some for many years, merely because of their political views on Kashmir. In 1993 most of the Kashmiri political parties joined together to form the All-Parties Hurriyet Conference (APHC).

Since its formation, the APHC has sent leaders around Kashmir and around the world to forward dialogue, peaceful resolution of the Kashmiri war, and realization

of the United Nations resolutions for a plebiscite of the Kashmiri people. Leaders and representatives of the APHC have regularly attended United Nations human rights sessions, special conferences and the General Assembly.

I also encourage people to investigate the situation in the Punjab in India as well. I am less an expert on the situation there. However, as part of the de-colonization processes, there have been a number of agreements, well before the British left, between the Punjabi leadership, the British and others with promises and agreements which have not been met, that are a factor in the disturbances and the question in the Punjab. Although it is different from the Kashmir question with the distinct Security Council resolution and obligation of the International community to carry out a plebiscite in Kashmir, it may be that final resolution to the difficulties in the Punjab will have to incorporate some form of self-determination in that region.

Tibet[25]

I want to very briefly discuss Tibet. The Tibet situation represents a post-Charter annexation because China seized independent Tibet in 1949-1950. Rather than a de-colonization, the international community was faced with a new colonization. For Tibet, of course, now the issue is de-colonization. The early documents of the United Nations on that question indicate the right to self-determination of the Tibetan people: quite obviously the international community had to recognize China's post-Charter military seizure as illegal.[26] The situation in Tibet is still not resolved and the Tibetan people still have the right to self-determination, and have the right to their governance and culture.

Unfortunately, China is sending large numbers of non-Tibetan people into Tibet. Rather than ethnic cleansing, China is engaging in ethnic dilution. This is a violation of Article 49 of the Fourth Geneva Convention. This is where the government of China does the most damage to Tibetans and their culture, because in many parts of Tibet, Tibetans are now in the minority. This becomes a very serious situation in the realization of self-determination. If you think for a moment of what Madame Daes said in her paper about a middle ground self-determination, where there is some agreement that the indigenous peoples' question should not be handled in terms of absolute sovereignty, China seeks to dilute Tibetans with others, so that if forced into any de-colonization process, the Tibetan question might be viewed as an indigenous question rather than one involving full restoration of sovereignty. This "trick" is used elsewhere by other governments and has been especially rampant in the Moluccas where the Indonesian authorities have for may years sent Javanese "settlers" into Moluccan territory.

Sri Lanka[27]

The situation in Sri Lanka, for many years now engulfed by armed conflict between the Sinhala-controlled government and the Tamil people, must be understood in terms of an "imperfect" de-colonization process by the British. Once again, two distinct countries – in this case the Tamil nation and the Sinhala nation – were amalgamated under "unitary" rule by the colonizers.

The Sinhala and the Tamil people in the island of Ceylon are as distinct as, say, the Finns and Italians. The colonizers understood this clearly. The first colonial

power on the island, Portugal, was only able to conquer the Tamil country more than 100 years after it conquered the Sinhalese one. In 1621, the Portuguese captured the Tamil king Sankili and killed him. The Dutch took over the island from the Portuguese, and apparently were able to exercise some loose governance over the Tamil areas but mostly ruled from the Sinhalese lands. When the British came, they were able to establish a unitary rule. This was not without protest from Britain's own early administrators, as the first of them said, and I paraphrase here, "I do not know how we are going to do this — these people are really different," recognizing that in this case, the forced marriage of unitary rule would never work.[28] And in fact during the British administration, the two peoples were probably less amalgamated than in other areas where the British created "unitary" states: there was clearly a governance recognizing the very different natures of these people.

In the de-colonization process in Sri-Lanka, there was an attempt between the Tamil and Sinhala leadership to try out a post-colonial unitary state despite the historic situation of the two countries. In the first two constitutions, there was an agreement between the majority Sinhalese people and the numerically fewer Tamil people for a government structure that would guarantee that the Tamil people would not become fatally submerged under the Sinhala. So there was an attempt to avoid submersion in the language of the Constitution of 1947. Before the ink was dry, the Sinhala leadership began to violate the terms. There were a number of subsequent agreements between the Tamil and Sinhala leadership to re-negotiate on various occasions, beginning even as early as 1950 and 1951. However major pacts between Tamil leadership and Sinhalese leadership that allowed the rights of the Tamil people and the rights of the Sinhalese people to be dually respected in a jointly run island also failed.[29] In evaluating this situation, then, in light of the right of self-determination, we can see that this was an "imperfect" de-colonization process. The attempts to negotiate and re-negotiate to try to keep open ways to guarantee rights for the Tamil people failed for nearly 30 years, at which point the combined Tamil leadership said that "unitary" rule was no longer an option.[30] Since 1982, a war has ensued defending that right of the Tamil people to self-determination.

Western Sahara

One last situation I want to bring up, that of Western Sahara, brings up an extremely important point that I will not be able fully to elaborate here, but that nonetheless helps us in some comparisons between "peoples" – people with a legal right to full sovereignty — and "indigenous peoples" – people with a right to internal self-determination and local rule but not *full* sovereignty. The International Court of Justice, in its decision on the Western Sahara in 1975, ruled that if there is land that in fact no one has ever claimed, it is opened for grabs. Such land is called "terra nullius" – empty land. But if any land has had a population on it, that land belonged to that population and is not open for grabs. This question arose in the de-colonization process of Western Sahara because Morocco attempted to claim that prior to becoming a colony of Spain, Western Sahara has been "empty" except for a few nomadic Moroccans. The Court, however, found the Saharans to be a distinct people who historically populated that land.

When we realize that the international community, however, did not require the colonizers of the lands of the American and Oceanic peoples to return those lands with full sovereignty, there appears to be a clear violation of the principle enunciated by the Court in the Western Sahara case. The sad fact is, that due to a legal principle usually referred to as "impossibility" — the European people were not obliged to cede land and power back to the American Indian and Oceanic peoples. Impossibility in those situations was in part related to the sheer numbers of colonizers,[31] in part to the scale of "colonial" enterprises, and in part to the perceived idea that the Indigenous Peoples were not capable of taking over governance of the countries in their current state. Yet the numbers factor was a direct result of massive killing of the original people by the colonizers and their armies. So, in fact, the international community rewarded genocide by letting the colonizers and heirs to colonizers remain in full control. One wonders if the current schemes of both ethnic cleansing and ethnic dilution rampant today results from some perceived expectation by the perpetrators that the doctrine of "impossibility" may be applied to them and they will become the sole sovereign.

FINAL REMARKS

Most of you are aware of the facts set out in the above outlined situations where people have the right to self-determination but have not yet realized it. In these countries there are conflicts — I do not just mean verbal ones but armed ones. Unfortunately, many of the states involved in attempting to militarily obliterate the peoples with valid self-determination claims try to reduce these conflicts to "terrorism". So depending on which side of the fence you are on, group A is either a terrorist or a freedom fighter. Some of these regimes' friends either acquiesce or actively support this erroneous assertion. Apart from the mud-slinging, the tragedy is that states are in open violation of their *jus cogens* and *erga omnes* obligations to defend the principle of self-determination. And also, very sadly, not enough people know sufficiently both the law of self-determination and the law of armed conflict to properly redirect the dialogue. The defenders of self-determination are in a very vulnerable position, charged with terrorism. The supporters of the groups fighting for the realization of national liberation may also be labeled or unduly burdened by laws against terrorism at the extremely serious expense of not only human rights but rights under the Geneva Conventions, other treaties and customary laws of armed conflict.

ENDNOTES

[1] The Universal Declaration of Human Rights provides that "the will of the people shall be the basis of the authority of government." Universal Declaration of Human Rights, G.A. Res. 217A (III)(1948), Art. 21; The International Covenant of Civil and Political Rights (ICCPR), *in force* Mar. 23. 1976, 999 U.N.T.S. 171, Art. 1; The International Covenant on Economic, Social and Cultural Rights (ICESCR), *in force* Jan. 3, 1976, 999 U.N.T.S. 3, Art. 1.
2ICCPR, Art.1; ICESCR, Art. 1; *see also* Karen Parker & Lyn Neylon, *Jus Cogens: Compelling the Law of Human Rights*, 12 Hastings Int. & Comp. L. Rev. 411, 440 (1989), drawing on discussion of the right to self-determination in A. Critescu, *The Right to Self-determination*, U.N. Doc. E/CN.4/Sub.2/404/Rev. 1, U.N. Sales No. E.80.XIV.3 (1980) and H. Gros Espiell,

In Pursuit of the Right to Self-determination

The Right to Self-Determination, U.N. Doc. E/CN.4/Sub.2/405/Rev.1, U.N. Sales No. E.79.XIV.5 (1980).

[3] This paper does not address the issue of the right to self-determination of Indigenous Peoples and is not meant to deny application of self-determination rights to Indigenous Peoples. Please refer to the paper of Mme Erica-Irene Daes in this document for discussion of Indigenous Peoples and self-determination.

[4] Western Sahara Case, 1975 International Court of Justice 12, 31.

[5] Gros Espiell, *op.cit.* and Critescu, *op. cit.* Critescu defines "people" as denoting a "social entity possessing a clear identity and its own characteristics" (op. cit. at p. 41) and implying a "relationship to territory" (*id.*).

[6] H. Gros Espiell, *op. cit.* at p. 12:"[N]o one can challenge the fact that, in light of contemporary international realities, the principle of self-determination necessarily possesses the character of *jus cogens..*" Gros Espiell cites numerous references in United Nations documents referring to the right to self-determination as *jus cogens. Id.*, at pp. 11-13. *See also Legal Consequences for States of the Continued Presence of South Africa in Namibia (S.W.Africa)* 1971 International Court of Justice 16, 89-90 (Ammoun, J., separate opinion)(recognizes *jus cogens* nature of self-determination); I. Brownlie, *Principles of Public International Law* 83, (3d ed. 1979)(argues that combatants fighting for realization of self-determination should be granted a higher status under armed conflict law due to application of *jus cogens* to the principle of self-determination); *See also* Karen Parker & Lyn Neylon, *op. cit.* at 440-41 (discusses, with many references, self-determination as *jus cogens* right).

[7] While not using the precise term as it did in an earlier case (Barcelona Traction, Light and Power Co. (Belg. v. Spain) 1970 International Court of Justice 3, 32), many consider the language of the Nicaragua Case reflective of both a *jus cogens* and *erga omnes* duty to respect the principle of self-determination. See The Nicaragua Case (Nicar. v. United States) 1986 International Court of Justice 14. The Inter-American Commission was explicit regarding the *erga omnes* duties of all states to guarantee civil and political rights. Inter-American Commission on Human Rights, Organization of American States, Press Communique no. 13/93 (May25, 1993).

[8] Please also see Human Rights in Burma, Hearings on Burma before the Subcomm. On For. Ops. Of the Senate Appropriations Comm., 104 Cong., 1st Session (1995)(Statement of Karen Parker); Human Rights in Burma, Hearing on Burma before the Subcomm. On Asian and Pacific Affairs of the House Comm. on For. Affairs, 103rd Cong. 1st Session (1993)(Statement of Karen Parker).

[9] I use the term "Burman" to refer to people who are ethnically Burman rather that the term "Burmese" – which refers to people who reside in Burma who may be either Burman or one of the other ethnic nationalities.

[10] Also see Karen Parker, *Republik Maluku: The Case for Self-Determination*, (IED/HLP 1996).

[11] The United Nations involvement began with the establishment of Committee of Good Offices on the Indonesian Question of the Security Council in 1947. In 1949 this Committee ceased when the Security Council established the United Nations Commission for Indonesia. These bodies were constant participators in the de-colonization process.

[12] Round Table Conference Agreement, Article 2.1 of the Third Agreement (Transitional Measure).

[13] *Idem*, Article 2.2. The two "opt-out" measures were incorporated under pressure from the authorities of the Netherlands.

[14] Please see Karen Parker, *The Kashmiri War: Human Rights and Humanitarian Law*, (IED/HLP 1996).

[15] For example, in a 3 November 1947 radio broadcast, Mr. Nehru stated: "We have declared that the fate of Kashmir is ultimately to be decided by its people. That pledge we give not only to the people of Kashmir but to the world. We will not and cannot back out of it."

[16] *See, especially* Security Council resolutions 39 (1948), 47 (1948), 80 (1950), 91 (1951) and 96 (1951).

[17] Resolution of the United Nations Commission for India and Pakistan, adopted on 5 January 1949, reprinted in UN Doc. S/1196 of 10 January 1949.

[18] An interesting side note to this involves this Instrument of Accession, supposedly signed by the Maharajah Hari Singh and Lord Mountbatten, and rumoured to be missing from the Indian state archives. News reports indicate that the United States, other western and some Arab states wished to view the text because of serious questions of its validity. See, for example, "Instrument of Accession to India missing from state archives", PTI News (New Delhi), 1 September 1995.

[19] *See, for example,* Security Council resolution 122 of 24 January 1957. India had claimed that the Kashmiri people accepted secession to India because a Kashmiri Constituent Assembly approved it in 1956. However, that assembly was chosen by India and does not meet requirements of a plebiscite as expressed in Security Council resolution 122. As states Rapporteur Gros Espiell: "A people under colonial and alien domination is unable to express its will freely in a consultation, plebiscite or referendum organized exclusively by the colonial and alien power." H. Gros Espiell, *op cit.* at p. 11.

[20] Kashmir successfully regained independence when overrun by Alexander's Empire in the 3rd century B.C. and the Moghul Empire of the 16th and 17th centuries.

[21] Historic Kashmir comprises about 84,000 square miles, making it somewhat larger that the United Kingdom. Its current population is about 12 million.

[22] Spoken Kashmiri also draws on the Persian and Arabic languages. Written Kashmiri uses a variation of Urdu script.

[23] Even fabrics, embroidery and carpets have uniquely Kashmiri designs. My organization's delegates to the area report that recognition of the distinct culture of Kashmir is unanimous in India. Unfortunately, this recognition is in the negative in that every-day Indians show great prejudice against anything Kashmiri. Our delegates confirm the Indian mind-set that Kashmiri people, their culture, cuisine, indeed everything about Kashmiris is inferior. But in these displays, they clearly indicate that Kashmiri is *not* Indian.

[24] Kashmiri self-determination is also defended by the principle that the determination of the political future of a colonized people made either by the colonial power itself or a "ruler" established by the colonial power is repugnant to the process of de-colonization and the principle of self-determination. I would challenge the legitimacy of an instrument of accession of Kashmir to India if in fact one were to be found. This rejection of "determination by colonial power" seems to be the guiding principle of the Security Council in its dealing with Kashmir. It is also clearly behind the fact that the government of Spain sought advice from the International Court of Justice on the question of to whom should Spain hand over power when they left the Spanish Sahara. See The Western Sahara Case, 1975 Int'l Court of Justice 12.

[25] Please see Report [on Tibet] of the Secretary-General, U.N. Doc. E/CN.4/Sub.2/37, which includes my submission regarding self-determination and Tibet.

[26] *See especially* General Assembly resolutions 1353 (1959); 1514 (1960) and 1723 (1961).

[27] Please see the following written statements submitted to the United Nations by International Educational Development/Humanitarian Law Project: Self-Determination, E/CN.4/1998/89; The Situation in Sri Lanka, E/CN.4/Sub.2/1995/17; E/CN.4/1994/37.

[28] In 1799 Sir Hugh Cleghorn, the first Colonial Secretary, wrote what has become known as the "Cleghorn Minute": "Two different nations, from very ancient period, have divided between them the possession of the island. . . These two nations differ entirely in their religions, language and manners."

[29] The major pacts were the Bandaranaike-Chelvanayagam Pact of 1957 and the Senanayake-Chelvanayagam Pact of 1965.

[30] The Vaddukkoddai Declaration of 1976 marks a clean rupture from any further attempts by the Tamil leadership to negotiate a dual state. The Declaration calls upon all Tamils to work for the sovereignty of Tamil Eelam.

[31] Note that some of the colonizers were actually "break-away" colonizers – people who had rejected their original sovereign in favor of self-rule in the "former" colony.

Self-determination & Democracy: Canada's *Clarity Act* & Quebec's *Fundamental Rights Bill* in Collision

Daniel Turp

The subject of peoples' right to self-determination fascinates me. As student, professor and researcher I have devoted many papers, theses and articles to this question and am, in fact, compiling them in a work that should come out this fall entitled *Essays on Quebec's Right to Self-Determination*.

However, as a member of Parliament — which I have been since June 2, 1997 representing the riding of Beauharnois-Salaberry in the House of Commons in Canada — I try to give this right meaning and practical application in the case of Quebec, in particular. As the representative of the Bloc Quebecois, a political party with 44 of the 75 members of the House of Commons from Quebec and therefore with two thirds of the seats set aside for Quebec, I work to achieve Quebec's sovereignty. Accordingly, in the case of concern to me, the right to self-determination is the essence of the claim to political independence, more so than minority rights, the other theme selected for consideration by the participants at this conference.

Indeed, while Quebecers once considered themselves part of a French-Canadian minority within Canada, a very clear majority of them today consider themselves a majority within Quebec and call themselves a people, a nation. And it is as a people, a nation, that they contemplate their future in Canada, or, as in my case, as a sovereign and independent country.

This future has been hotly debated from the time of the "Quiet Revolution" — *circa* 1960 — right up to the present, 40 years later, with unflagging intensity. A democratic intensity, I should perhaps add, because these debates have taken place within the context of referendums, general elections, discussions and parliamentary commissions and in the many other places where the options of both sides may be expressed.

Recent events have, however, tarnished the democratic lustre of the political debate in Canada and Quebec. In its desire to give effect to an advisory opinion by the Supreme Court of Canada in the *Reference re Secession of Quebec*, the Parliament of Canada passed the *Clarity Act* on June 29, 2000 casting a pall on Canadian democracy. This federal initiative, which I and my Bloc Quebecois colleagues fought with vigour and conviction, struck a chord with the Government of Quebec, which considered it necessary to reply with a bill entitled *An Act Respecting the Fundamental Rights and Prerogatives of the Québec People and of the Québec State*. Two laws, a federal one, in force, a Quebec one, to be adopted in the fall, placing Canada and Quebec more than ever before on a course where not only ideas but interests will collide.

THE *CLARITY ACT* AND QUEBEC: IDEAS IN COLLISION

While Quebec and Canada have been locked in a political and constitutional debate for several decades, the debate may be said to have taken place in a context of understanding and mutual respect. Until quite recently, both sides in the debate appear to have agreed to certain rules.

Accordingly, it seemed that Quebec was free to determine its political and constitutional future and to consult the people of Quebec on this future. Two referendums, one held on May 20, 1980, the other on October 30, 1995 and both held with the involvement of the federal government and its ministers, supported this view and gave Quebecers the opportunity to express their opinion on the appropriateness of Quebec's becoming sovereign. I should no doubt add that another referendum on constitutional reform contained in the *Charlottetown Accord* was organized on October 26, 1992 under the aegis of the Quebec *Referendum Act* and also gave Quebecers the opportunity to decide whether the proposed reform was desirable for Quebec. In all three instances, Quebecers rejected the changes with respect to Quebec's status and jurisdiction put to them and thus helped maintain, indeed aggravate, the constitutional impasse. While the majorities in the 1980 and 1992 referendums were relatively slim — with less than 10% separating the two sides in both instances — the majority in the 1995 referendum was infinitesimal, with the victorious NO side coming out ahead with a mere 54,288 votes of the 4,671,008 votes cast and the YES side obtaining 49.52% of valid ballots cast.

This slim victory by the NO in the 1995 referendum seems to have caused a significant shift in attitude among certain federalists, especially those in power in Ottawa. Accordingly, after passing measures to implement certain proposals for renewing the Canadian federation, which failed to meet Quebec's expectations, be it a motion by Parliament on the distinct society or a *Constitutional Amendments Act*, the federal government formulated what today may be called Plan B, intended to hobble the sovereignist movement in Quebec.

This plan B found expression in the request for an advisory opinion by the Supreme Court of Canada on the issue of Quebec's secession. Claiming the need for clarification on the position of international law and Canadian constitutional law on the issue of secession, the Government of Canada put three questions on Quebec's right to unilateral secession to Canada's final court of appeal, one of which referred to the right of peoples to self-determination and which is appended

along with the summary of the response by the Court (Annex 1). These questions were severely criticized by the former head of the International Law Commission of the United Nations in a legal opinion sought by the *amicus curiae* of the Court. Alain Pellet stated:

> [trans] I am profoundly distressed and upset by the partisan manner in which the questions are put and I take the liberty of suggesting that a court of justice has the duty to react to what appears to be a blatant attempt at political manipulation.

However, as Lucien Bouchard, the Premier of Quebec, has recently said, the Court appeared to have smelled a trap. Contrary to all expectations and as constitutional experts would point out, the Court refused to answer YES or NO to the questions put to it. And, rather than simply deny Quebec's right to declare independence unilaterally and state that international law on the self-determination of peoples did not recognize the right to unilateral secession, it noted that the federal and provincial governments had a constitutional and mandatory duty to negotiate should Quebec choose sovereignty. It also considered the question of the international community's recognition of Quebec's sovereignty, linking the two questions. It said :

Canada's Supreme Court noted that the federal and provincial governments had a constitutional and mandatory duty to negotiate should Quebec choose sovereignty.

> The corollary of a legitimate attempt by one participant in Confederation to seek an amendment to the Constitution is an obligation on all parties to come to the negotiating table. The clear repudiation by the people of Quebec of the existing constitutional order would confer legitimacy on demands for secession, and place an obligation on the other provinces and the federal government to acknowledge and respect that expression of democratic will by entering into negotiations and conducting them in accordance with the underlying constitutional principles already discussed. (§88)

The opinion of the Supreme Court hurt the federalists especially because it recognized that Quebec could turn to the international community if Canadian governments failed in their obligation to negotiate in good faith. The Court said:

> To the extent that a breach of the constitutional duty to negotiate in accordance with the principles described above undermines the legitimacy of a party's actions, it may have important ramifications at the international level. Thus, a failure of the duty to undertake negotiations and pursue them according to constitutional principles may undermine that government's claim to legitimacy which is generally a precondition for recognition by the international community. Conversely, violations of those principles by the federal or other provincial governments responding to the request for secession may

undermine their legitimacy. Thus, a Quebec that had negotiated in conformity with constitutional principles and values in the face of unreasonable intransigence on the part of other participants at the federal or provincial level would be more likely to be recognized than a Quebec which did not itself act according to constitutional principles in the negotiation process. Both the legality of the acts of the parties to the negotiation process under Canadian law, and the perceived legitimacy of such action, would be important considerations in the recognition process. In this way, the adherence of the parties to the obligation to negotiate would be evaluated in an indirect manner on the international plane. (§103)

In an effort to revive its plan B and despite the lack of public support for a hard line against Quebec, the federal government initiated proceedings that would provide Canada with an *Act to Give Effect to the Requirement for Clarity as Set Out in the Opinion of the Supreme Court of Canada in the Quebec Secession Reference* (Bill C-20)(Annex 3) but that in reality was intended to neutralize, indeed circumvent, the obligation to negotiate set out in the opinion.

And so the *Clarity Act* was born. Tabled on December 13 in the House of Commons, it was debated in conditions unworthy of a parliamentary democracy in which the government repeatedly invoked closure in order to ensure quick passage of this bill through the legislative committee struck for the purposes of the bill and through the House of Commons itself. It was passed on March 15 by a vote of 208 to 55, including 47 nay votes from among the 73 Quebec members present at the time of the vote (64% of Quebec's representation). The bill was subsequently examined by the Senate of Canada and passed on June 29, despite strong opposition, especially by senators from Quebec. It received royal assent from the Governor General the same day.

The *Clarity Act* attempts essentially to define the wording of the question in a future referendum on Quebec's sovereignty and to determine the majority threshold that would allow the Canadian government to shirk its obligation to negotiate. By doing so, it collides headlong with ideas that have prevailed for decades and guaranteed the Quebec nation a freedom the government is now trying to take away.

It had long ago been agreed that Quebecers could organize referendums on their future through their National Assembly. In the organization of these referendums, Quebec's elected representatives would decide the wording of the referendum question. This notion was destroyed by the *Clarity Act*, which will give the House of Commons the power to determine the clarity of the question. This House of Commons – where only 25% of the members are from Quebec (75 of 301) – is to be given, in the name of clarity, the right to reject a question formulated by a democratic institution in Quebec, the National Assembly of Quebec. And yet this Quebec institution is the seat of the sovereignty of the people of Quebec, and their elected representatives exercise this sovereignty on their behalf.

The idea that a referendum is won with a majority of 50 per cent plus one of the valid votes cast seemed also to have prevailed in all referendums organized with respect to the political and constitutional future in Quebec and Canada. Here too,

ideas are in collision, since the intent of the *Clarity Act* is to give the House of Commons the power to decide that a majority of 50 per cent plus one of valid votes cast is not enough to oblige the federal political player to assume its constitutional and mandatory duty to negotiate. On this point, the collision is all the more real and the undemocratic nature of the bill all the more obvious in the light of Canadian practice on the subject of majority rule. All referendums in Canada have been held on the basis of majority rule, and Newfoundland joined Confederation with 52% of the valid votes cast. All referendums on Quebec's and Canada's political and constitutional future — on sovereignty-association of 1980, on the *Charlottetown Accord* in 1992 or on sovereignty and partnership in 1995 — were all governed by majority rule of 50% of the valid votes cast.

To cast doubt on the rule of 50 per cent plus one is also to contravene the fundamental principle of the equality of voters. The vote of some must have the same value as the vote of others. This is a matter of equity and justice the Supreme Court of Canada recognized in its 1991 decision on electoral boundaries in Saskatchewan: "...dilution of one citizen's vote as compared with another's should not be countenanced."

The three parties represented in the Quebec National Assembly, the Parti Québécois, the Quebec Liberal Party and the Action démocratique du Québec, all rejected the *Clarity Act*, as did a very clear majority of the federal members for Quebec, as mentioned earlier. Hence, nearly two thirds of the Quebec members of Parliament in attendance during the vote at third reading on March 15, 2000 voted against Bill C-20, including the 44 members of the Bloc Quebecois on whose behalf I prepared a solemn declaration entitled "Québec is free, the Québec nation is sovereign" (Annex 3). Civil society, through the voices of unions, student associations women's groups and community groups is also nearly unanimous in its rejection of this law. Few groups in Quebec supported this federal initiative.

Bill C-20 breaks the democratic tradition in Canada that, up to now, had taken into account Quebec's desire to freely decide its future. Bill C-20 breaks the democratic tradition in Canada that, up to now, had taken into account Quebec's desire to freely decide its future. It cannot be ignored. It is no credit to a country that boasts of itself in international circles as a model of democracy and the best country in the world. Canada's aboriginal nations know this not to be true as do its poor children, whose defence the UN has taken up.

Quebec appears today to be the victim of a country described as unique by its ability to recognize its own divisibility, when, in actual fact, its *Clarity Act* is intended to confront what the Minister of Intergovernmental Affairs, Stéphane Dion, calls "any threat of separation" and "to guarantee the unity of Canada", according to Prime Minister Jean Chrétien.

This sort of attitude is not going to deny Quebec its right to self-determination. Every ten years or so, it seems that Quebec has to reaffirm its freedom to determine its political status. In 1980, the Premier of Quebec, René Lévesque, noted in the days after the May 20 referendum that "[trans] the recognition of this right [to self-determination] [was] the most important outcome of the Quebec referendum". Another Premier of Quebec, Robert Bourassa, said on June 22, 1990 that "[trans] no

matter what is said or done, Quebec is now and will always be a distinct society, free and the master of its destiny and its development." In 2000, the Government of Quebec took a solemn stand on the *Clarity Act* by tabling in turn *An Act Respecting the Fundamental Rights and Prerogatives of the Québec People and of the Québec State*, setting a collision course with the interests of Canada.

THE *FUNDAMENTAL RIGHTS ACT* AND CANADA: INTERESTS IN COLLISION

In reaction to such a serious threat to the freedom of the people of Quebec to determine their future, the Government of Quebec tabled on December 15, 1999, two days after the tabling of the *Clarity Bill*, a bill entitled *An Act respecting the fundamental rights and prerogatives of the Québec people and of the Québec State* (Bill 99)(Annex 4). With this bill, the government called on the National Assembly of Quebec to reaffirm Quebec's freedom to determine its future and to adopt measures to establish this freedom on solid legal grounds.

The Quebec *Fundamental Rights Bill* was debated at length in the National Assembly and in its Committee on Institutions. A number of amendments were made to it as the result of proposals by individuals and groups that testified before the committee. Passed on second reading on May 30, 2000 by a vote of 65 to 38, the bill received the support of the members of the Parti Québécois and the Action démocratique du Québec. Despite an attempt to achieve a consensus, the members of the Liberal Party of Quebec have not yet supported the bill, preferring that the National Assembly pass a solemn declaration. The Bill will be further examined during the fall session of the National Assembly and will most probably be adopted before the end of the year.

The *Fundamental Rights Bill* has a much broader scope than the *Clarity Act* and was described by the Premier of Quebec as a charter of collective rights for Quebec. As such, it is in collision not only with the *Clarity Act* but with the vision of Canada held by its leaders and the interests they appear to promote.

One of the dominant features of the *Fundamental Rights Bill* is its unreserved affirmation of the existence of the Quebec people and its establishment in law of this affirmation. Thus the first chapter of the act affirms, as no Quebec legislation has ever done, the concept of a Quebec people. This affirmation was necessitated by Canada's inability to recognize the existence of the people of Quebec. After consistently refusing to consider that Quebecers constituted a nation, a people, the attempt to affirm the existence of a "distinct society" in Quebec was also challenged by the rest of Canada and its representatives.

The affirmation of the existence of the people of Quebec is therefore necessary in this context and permits the bill to enshrine the right to self-determination and the right to choose a political system and a legal status for Quebec. Thus, section 4 of the *Fundamental Rights Bill* provides clearly that "[w]hen the Québec people is consulted by way of a referendum under the Referendum Act, the winning option is the option that obtains a majority of the valid votes cast, namely fifty percent of the valid votes cast plus one."

Section 5 of the *Fundamental Rights Bill* rightly provides that the Quebec state derives its legitimacy from the will of the people inhabiting its territory and

contains an affirmation fully consistent with the third paragraph of article 21 of the *Universal Declaration of Human Rights*, which provides that "[t]he will of the people shall be the basis of the authority of government".

The subsequent reference to the fact that the will of the people is expressed through the election of members to the National Assembly by universal suffrage, by secret ballot, under the one person, one vote system, pursuant to the *Election Act* and through referendums held pursuant to the *Referendum Act* is also consistent with the requirements of this international instrument and sets out the two Quebec laws whose democratic nature is incontrovertible.

The objective of protecting Quebec's internal and international jurisdictions is apparent in the other sections of chapter II of the bill and is set to collide with the interests of the federal government, which has tried to progressively expand its jurisdiction. Accordingly, section 6 of the *Fundamental Rights Bill* states that "[t]he Québec State is sovereign in the areas assigned to its jurisdiction by laws and constitutional conventions." There are recent examples to support the argument that Quebec's jurisdiction has been infringed by federal authorities, whether it be in the case of the millennium scholarship institution or of the passage, without Quebec's approval, of a framework agreement on Canada's social union.

This sort of attitude reflects an increasingly obvious desire on the part of these authorities to assume a determinant role in all spheres of activity and to use their spending power to this end. Quebec has consistently disputed the exercise of this power, but its pleas have been ignored. Accordingly, the government decided to remind Parliament and the Government of Canada of Quebec's profound commitment to its areas of jurisdiction and to their integrity and of its intention to resist any attempt to further usurp these areas that were given to Quebec by law and constitutional convention.

In addition, Quebec's exercise of international jurisdiction has consistently been disputed by the federal government of Canada, and here again the differing interests of Canada and Quebec collide. Arguing that only the federal government had international jurisdiction as granted by royal prerogative, successive Canadian governments have rejected the doctrine formulated in 1965 by minister Paul Gérin-Lajoie to the effect that Quebec could extend its internal jurisdiction internationally. Under these conditions, the principle enshrined in the first paragraph of section 7 of the *Fundamental Rights Bill* whereby "[t]he Québec State is free to adhere to any treaty, convention or international agreement in matters under its constitutional jurisdiction" and "[t]he Québec State is not bound by any treaty, convention, agreement or Act in the areas under its jurisdiction unless it has formally adhered to it by a decision of the National Assembly or the Government, subject to the applicable legislative provisions."

In its application as well to the question of international representation, the Gérin-Lajoie doctrine was also rejected by the Government of Canada and has been the source of considerable conflict between Canadian and Quebec government officials. Whether it concerned participation in international forums on cultural diversity or in meetings between representatives of Quebec with heads of state or foreign governments (e.g. Bouchard-Zedillo) or the refusal to give Quebec its proper place in the context of the Free Trade Area of the Americas (FTAA), the doctrine of

the federal government's monopoly over foreign policy has caused considerable and ongoing conflict. Accordingly, the Government of Quebec wanted to affirm in the third paragraph of section 7 of Bill 99 that Quebec "may, in areas under its jurisdiction, transact with foreign states and ensure its representation outside Quebec." In this era of globalization, such an affirmation seems all the more compelling in the light of what the Quebec Minister for Canadian Intergovernmental Affairs,, Joseph Facal, called a "Canadian federal deficit", which aims to prevent Quebec from reaching out as it will onto the international scene.

Added following the hearings of the National Assembly's Committee on Institutions, section 8 of the *Fundamental Rights Bill* reiterates Quebec's jurisdiction over issues of language and provides that French is the official language of Quebec. The Quebec state must promote the quality and influence of French in a spirit of fairness and open-mindedness, respectful of the long-established rights of Quebec's anglophone community. The act provides that "[t]he status of the French language in Québec and the related duties and obligations are established by the Charter of the French language." This desire to preserve and promote Quebec's French language also conflicts with another desire, that of the federal government to promote two official languages in Canada and thus to have the Canadian identity of new immigrants overshadow their Quebec identity.

In the chapter on the territory of Quebec, the National Assembly of Quebec reaffirmed that "[t]he territory of Québec and its boundaries cannot be altered except with the consent of the National Assembly." This provision is intended to ensure that the existing boundaries of Quebec are respected and maintained and to counter the partitionist reveries in subsection 3(2) of the *Clarity Act*. This provision is intended primarily to temper and limit the right of the Quebec people to choose their political future and status freely. Quebec's territorial integrity, the intangibility of its borders and the rule of law form the cornerstone of a very broad consensus emerging in Quebec.

The *Fundamental Rights Bill* assures the Abenaki, Algonquin, Attikamek, Cree, Huron, Innu, Malecite, Micmac, Mohawk, Naskapi and Inuit Nations of a rightful place and sets forth, in the fifth clause of the preamble, the principles associated with the recognition of the aboriginal nations including their right to autonomy within Quebec. In addition, in sections 11 and 12 of the act, the National Assembly recognizes, in exercising its constitutional jurisdiction, the existing rights — aboriginal and treaty — of the aboriginal nations of Quebec, and the government undertakes to promote the establishment and maintenance of harmonious relations with these nations and to foster their development and improvement of their economic, social and cultural conditions.

On all these matters, the *Fundamental Rights Bill* and the *Clarity Act* differ in their concepts of the future. However, with the final provision of the *Fundamental Rights Bill*, the collision becomes headlong. Section 13 of this act provides that "[n]o other parliament or government may reduce the powers, authority, sovereignty or legitimacy of the National Assembly, or impose constraint on the democratic will of the Québec people to determine its own future."

This provision is fundamental and is designed to nullify any effect of the *Clarity Act* on Quebec. It must also be seen as a stand taken against any power this

law might give the House of Commons to decide on the clarity of a measure of the National Assembly and specifically the clarity of a question selected by a motion of the National Assembly. It also nullifies the effect of any measure by the House of Commons to determine the clarity of the result of a referendum and the votes cast by Quebec electors.

In this pivotal year 2000, the right of peoples and nations to self-determination remains as relevant as ever. It underlies claims to autonomy and independence and the calls for freedom heard on every continent. This right rests on the guarantee of rights to national and ethnic, cultural or religious minorities and on the recognition of the right of peoples and nations to political independence.

So long as governments and international institutions continue to question the right to self-determination and refuse to give it effect, they exacerbate conflicts and promote neither political harmony nor cultural diversity. However, their democratization is essential and cannot be achieved at a cost to the minorities, peoples and nations that fashion this international system and give meaning to the concept of international community. This democratization must, however, be based on principles that neither threaten freedom nor impose trusteeship regimes on minorities, peoples or nations. It must never be based on the principles that gave rise to the *Clarity Act* recently enacted by the House of Commons of Canada, which represents the antithesis of the process of democratization that springs from true recognition of the right to self-determination. This democratization must be based on a real desire to recognize minorities, peoples and nations and an absence of meddling in the process of determining their political and constitutional future.

Like the Martin Ennals Symposium on Self-Determination held in Saskatoon in 1993, in which I was a participant, this conference may help give the right to self-determination the letters patent it deserves and permit it to give rise to creative personal and territorial sovereignty sharing formulae. As I did at the earlier conference, I will continue to argue, as do the Scots and the Palestinians, to give but two examples, in favour of such creative formulae. These formulae must be found in my corner of the world too so that Quebec, Canada and the aboriginal nations within them may take charge of their economic, social and cultural development freely and contribute in their own way to the enrichment of humanity's common heritage.

ANNEX I

Re Reference re secession of Quebec (excerpts from the summary)

IN THE MATTER OF Section 53 of the *Supreme Court Act*, R.S.C., 1985, c. S-26;

AND IN THE MATTER OF a Reference by the Governor in Council concerning certain questions relating to the secession of Quebec from Canada, as set out in Order in Council P.C. 1996-1497, dated the 30th day of September, 1996
Indexed as: *Reference re Secession of Quebec*

Present: Lamer C.J. and L'Heureux-Dubé, Gonthier, Cory, McLachlin, Iacobucci, Major, Bastarache and Binnie JJ.

Pursuant to s. 53 of the *Supreme Court Act*, the Governor in Council referred the following questions to this Court:

Question 1: Under the Constitution of Canada, can the National Assembly, legislature or government of Quebec effect the secession of Quebec from Canada unilaterally?

Question 2: Does international law give the National Assembly, legislature or government of Quebec the right to effect the secession of Quebec from Canada unilaterally? In this regard, is there a right to self-determination under international law that would give the National Assembly, legislature or government of Quebec the right to effect the secession of Quebec from Canada unilaterally?

Question 3: In the event of a conflict between domestic and international law on the right of the National Assembly, legislature or government of Quebec to effect the secession of Quebec from Canada unilaterally, which would take precedence in Canada?

(3) Question 2

The Court was also required to consider whether a right to unilateral secession exists under international law. Some supporting an affirmative answer did so on the basis of the recognized right to self-determination that belongs to all "peoples". Although much of the Quebec population certainly shares many of the characteristics of a people, it is not necessary to decide the "people" issue because, whatever may be the correct determination of this issue in the context of Quebec, a right to secession only arises under the principle of self-determination of people at international law where "a people" is governed as part of a colonial empire; where "a people" is subject to alien subjugation, domination or exploitation; and possibly where "a people" is denied any meaningful exercise of its right to self-determination within the state of which it forms a part. In other circumstances, peoples are expected to achieve self-determination within the framework of their existing state. A state whose government represents the whole of the people or peoples resident within its territory, on a basis of equality and without discrimination, and respects the principles of self-determination in its internal arrangements, is entitled to maintain its territorial integrity under international law and to have that territorial integrity recognized by other states. Quebec does not meet the threshold of a colonial people or an oppressed people, nor can it be suggested that Quebecers have been denied meaningful access to government to pursue their political, economic, cultural and social development. In the circumstances, the "National Assembly, the legislature or the government of Quebec" do not enjoy a right at international law to effect the secession of Quebec from Canada unilaterally.

Although there is no right, under the Constitution or at international law, to unilateral secession, the possibility of an unconstitutional declaration of secession leading to a *de facto* secession is not ruled out. The ultimate success of such a secession would be dependent on recognition by the international community, which is likely to consider the legality and legitimacy of secession having regard to, amongst other facts, the conduct of Quebec and Canada, in determining whether to grant or withhold recognition. Even if granted, such recognition would not, however, provide any retroactive justification for the act of secession, either under the Constitution of Canada or at international law.

ANNEX 2
Bill C-20

An act to give effect to the requirement for clarity as set out in the opinion of the
supreme court of Canada in THE QUÉBEC SECESSION REFERENCE
As passed by the House of Commons of Canada on March 15th, 2000
and by the Senate on June 29th 2000
Assented to by the Governor-General on June 29th, 2000
An act to give effect to the requirement for clarity as set out in the opinion of the
Supreme Court of Canada in the Québec secession Reference

WHEREAS the Supreme Court of Canada has confirmed that there is no right, under
international law or under the Constitution of Canada, for the National Assembly, legislature
or government of Quebec to effect the secession of Quebec from Canada unilaterally;

WHEREAS any proposal relating to the break-up of a democratic state is a matter of the
utmost gravity and is of fundamental importance to all of its citizens;

WHEREAS the government of any province of Canada is entitled to consult its population
by referendum on any issue and is entitled to formulate the wording of its referendum
question;

WHEREAS the Supreme Court of Canada has determined that the result of a referendum on
the secession of a province from Canada must be free of ambiguity both in terms of the
question asked and in terms of the support it achieves if that result is to be taken as an
expression of the democratic will that would give rise to an obligation to enter into negotiations
that might lead to secession;

WHEREAS the Supreme Court of Canada has stated that democracy means more than
simple majority rule, that a clear majority in favour of secession would be required to create
an obligation to negotiate secession, and that a qualitative evaluation is required to determine
whether a clear majority in favour of secession exists in the circumstances;

WHEREAS the Supreme Court of Canada has confirmed that, in Canada, the secession of a
province, to be lawful, would require an amendment to the Constitution of Canada, that such
an amendment would perforce require negotiations in relation to secession involving at least
the governments of all of the provinces and the Government of Canada, and that those
negotiations would be governed by the principles of federalism, democracy, constitutionalism
and the rule of law, and the protection of minorities;

WHEREAS, in light of the finding by the Supreme Court of Canada that it would be for
elected representatives to determine what constitutes a clear question and what constitutes
a clear majority in a referendum held in a province on secession, the House of Commons, as
the only political institution elected to represent all Canadians, has an important role in
identifying what constitutes a clear question and a clear majority sufficient for the Government
of Canada to enter into negotiations in relation to the secession of a province from Canada;

And WHEREAS it is incumbent on the Government of Canada not to enter into negotiations
that might lead to the secession of a province from Canada, and that could consequently
entail the termination of citizenship and other rights that Canadian citizens resident in the
province enjoy as full participants in Canada, unless the population of that province has
clearly expressed its democratic will that the province secede from Canada;

Now, Therefore, Her Majesty, by and with the advice and consent of the Senate and
House of Commons of Canada, enacts as follows:

1. (1) The House of Commons shall, within thirty days after the government of a province tables in its legislative assembly or otherwise officially releases the question that it intends to submit to its voters in a referendum relating to the proposed secession of the province from Canada, consider the question and, by resolution, set out its determination on whether the question is clear.

(2) Where the thirty days referred to in subsection (1) occur, in whole or in part, during a general election of members to serve in the House of Commons, the thirty days shall be extended by an additional forty days.

(3) In considering the clarity of a referendum question, the House of Commons shall consider whether the question would result in a clear expression of the will of the population of a province on whether the province should cease to be part of Canada and become an independent state.

(4) For the purpose of subsection (3), a clear expression of the will of the population of a province that the province cease to be part of Canada could not result from

(a) a referendum question that merely focuses on a mandate to negotiate without soliciting a direct expression of the will of the population of that province on whether the province should cease to be part of Canada; or

(b) a referendum question that envisages other possibilities in addition to the secession of the province from Canada, such as economic or political arrangements with Canada, that obscure a direct expression of the will of the population of that province on whether the province should cease to be part of Canada.

(5) In considering the clarity of a referendum question, the House of Commons shall take into account the views of all political parties represented in the legislative assembly of the province whose government is proposing the referendum on secession, any formal statements or resolutions by the government or legislative assembly of any province or territory of Canada, any formal statements or resolutions by the Senate, any formal statements or resolutions by the representatives of the Aboriginal peoples of Canada, especially those in the province whose government is proposing the referendum on secession, and any other views it considers to be relevant.

(6) The Government of Canada shall not enter into negotiations on the terms on which a province might cease to be part of Canada if the House of Commons determines, pursuant to this section, that a referendum question is not clear and, for that reason, would not result in a clear expression of the will of the population of that province on whether the province should cease to be part of Canada.

2. (1) Where the government of a province, following a referendum relating to the secession of the province from Canada, seeks to enter into negotiations on the terms on which that province might cease to be part of Canada, the House of Commons shall, except where it has determined pursuant to section 1 that a referendum question is not clear, consider and, by resolution, set out its determination on whether, in the circumstances, there has been a clear expression of a will by a clear majority of the population of that province that the province cease to be part of Canada.

(2) In considering whether there has been a clear expression of a will by a clear majority of the population of a province that the province cease to be part of Canada, the House of Commons shall take into account

(a) the size of the majority of valid votes cast in favour of the secessionist option;

(b) the percentage of eligible voters voting in the referendum; and

(c) any other matters or circumstances it considers to be relevant.

(3) In considering whether there has been a clear expression of a will by a clear majority of the population of a province that the province cease to be part of Canada, the House of Commons shall take into account the views of all political parties represented in the legislative assembly of the province whose government proposed the referendum on secession, any formal statements or resolutions by the government or legislative assembly of any province or territory of Canada, any formal statements or resolutions by the Senate, any formal statements or resolutions by the representatives of the Aboriginal peoples of Canada, especially those in the province whose government proposed the referendum on secession, and any other views it considers to be relevant.

(4) The Government of Canada shall not enter into negotiations on the terms on which a province might cease to be part of Canada unless the House of Commons determines, pursuant to this section, that there has been a clear expression of a will by a clear majority of the population of that province that the province cease to be part of Canada.

3. (1) It is recognized that there is no right under the Constitution of Canada to effect the secession of a province from Canada unilaterally and that, therefore, an amendment to the Constitution of Canada would be required for any province to secede from Canada, which in turn would require negotiations involving at least the governments of all of the provinces and the Government of Canada.

(2) No Minister of the Crown shall propose a constitutional amendment to effect the secession of a province from Canada unless the Government of Canada has addressed, in its negotiations, the terms of secession that are relevant in the circumstances, including the division of assets and liabilities, any changes to the borders of the province, the rights, interests and territorial claims of the Aboriginal peoples of Canada, and the protection of minority rights.

ANNEX 3

QUÉBEC IS FREE,
THE QUÉBEC NATION IS SOVEREIGN

Solemn Declaration drafted by

Daniel TURP
MP for Beauharnois-Salaberry
Bloc Québécois Critic for Intergovernmental Affairs

and read during the Special General Council Meeting of the Bloc Québécois
in Ottawa on March 16, 2000

We, of the Bloc Québécois,
through our democratically elected representatives in the Canadian Parliament;

We, of the Bloc Québécois,
who detain within the Canadian Parliament the majority of seats from Québec;

We, of the Bloc Québécois,
who defend the interests of Québec and its democracy;

We, of the Bloc Québécois,
affirm that Bill C-20 is undemocratic and deprived of any legitimacy on the territory of Québec;

We, of the Bloc Québécois,
affirm that the undemocratic process which led to the adoption of Bill C-20 has confirmed its illegitimate character;

We, of the Bloc Québécois,

accuse the Prime Minister of Canada Jean Chrétien of usurping the freedom of Québec to choose its collective destiny;

We, of the Bloc Québécois,
accuse the architect of Plan B, the minister for Intergovernmental Affairs Stéphane Dion, of wanting to imprison Québec within Canada;

We, of the Bloc Québécois,
deplore the fact that the majority of the members of Parliament from the rest of Canada made common cause with Jean Chrétien and Stéphane Dion to restrict the freedom of the Québec nation;

We, of the Bloc Québécois,
realize that the adoption of the Bill C-20 is part of an history which has seen several other attempts to limit the freedom of Québec;

We, of the Bloc Québécois,
reaffirm our allegiance to Québec and to its interests;

We of the, Bloc Québécois,
recognise that the sovereignty of the Québec nation belongs to its citizens and is exercised through their National Assembly;

We, of the Bloc Québécois,
remind that Québec is a land of pride, fraternity, tolerance and justice;

We, of the Bloc Québécois,
affirm that the most precious collective good for Quebeckers is their freedom and that no authority, and notably the Canadian Parliament, will deprive their nation of its right to choose its collective destiny;

We of the, Bloc Québécois,
recall that the *Universal Declaration of Human Rights*, adopted by the United Nations General Assembly, declares that the will of the people is the basis of the authority of government;

We, of the Bloc Québécois,
believe that our struggle will serve future generations and preserve the territory of their freedom and culture;

We, of the Bloc Québécois,
affirm that the Québec nation is not subservient to any other nation, and will never be;

We, of Bloc Québécois,
are committed to continue our struggle for the freedom of Québec to decide democratically of its future and to determine freely its political status;

We, of the Bloc Québécois,
invite all democrats of Québec, Canada and of the international community to join with the Québec nation in its struggle to safeguard its sovereignty and freddom;

We, of the Bloc Québécois,
affirm that the Québec nation is sovereign;

We, of the Bloc Québécois,
affirm that Québec is free.

ANNEX 4

BILL 99
AN ACT RESPECTING THE EXERCISE OF THE FUNDAMENTAL RIGHTS AND
PREROGATIVES OF THE QUÉBEC PEOPLE AND THE QUÉBEC STATE

As adopted on second reading by the National Assembly of Québec on May 30th 2000

An Act respecting the exercise of the Fundamental Rights and Prerogatives of the Québec People and the Québec State

WHEREAS the Québec people, in the majority French-speaking, possesses specific characteristics and a deep-rooted historical continuity in a territory over which it exercises its rights through a modern national state, having a government, a national assembly and impartial and independent courts of justice ;

WHEREAS the constitutional foundation of the Québec State has been enriched over the years by the passage of fundamental laws and the creation of democratic institutions specific to Québec ;

WHEREAS Québec entered the Canadian federation in 1867 ;

WHEREAS Québec is firmly committed to respecting human rights and freedoms ;

WHEREAS the Abenaki, Algonquin, Attikamek, Cree, Huron, Innu, Malecite, Micmac, Mohawk, Naskapi and Inuit Nations exist within Québec, and whereas the principles associated with that recognition were set out in the resolution adopted by the National Assembly on 20 March 1985, in particular their right to autonomy within Québec ;

WHEREAS there exists a Québec English-speaking community that enjoys long-established rights ;

WHEREAS Québec recognizes the contribution made by Quebecers of all origins to its development ;

WHEREAS the National Assembly is composed of Members elected by universal suffrage by the Québec people and derives its legitimacy from the Québec people in that it is the only legislative body exclusively representing the Québec people ;

WHEREAS it is incumbent upon the National Assembly, as the guardian of the historical and inalienable rights and powers of the Québec people, to defend the Québec people against any attempt to despoil it of those rights or powers or to undermine them ;

WHEREAS the National Assembly has never adhered to the Constitution Act, 1982, which was enacted despite its opposition ;

WHEREAS Québec is facing actions by the federal government, including a legislative initiative, that challenge the legitimacy, integrity and valid operation of its national democratic institutions ;

WHEREAS it is necessary to reaffirm the fundamental principle that the Québec people is free to take charge of its own destiny, determine its political status and pursue its economic, social and cultural development ;

WHEREAS this principle has applied on several occasions in the past, notably in the referendums held in 1980, 1992 and 1995 ;

WHEREAS the Supreme Court of Canada rendered an advisory opinion on 20 August 1998, and considering the recognition by the Government of Québec of its political importance;

WHEREAS it is necessary to reaffirm the collective attainments of the Québec people, the responsibilities of the Québec State and the rights and prerogatives of the National Assembly with respect to all matters affecting the future of the Québec people ;

THE PARLIAMENT OF QUÉBEC ENACTS AS FOLLOWS :

CHAPTER I

THE QUÉBEC PEOPLE

1. The right of the Québec people to self-determination is founded in fact and in law. The Québec people is the holder of rights that are universally recognized under the principle of equal rights and self-determination of peoples.

2. The Québec people has the inalienable right to freely decide the political regime and legal status of Québec.

3. The Québec people, acting through its own political institutions, shall determine alone the mode of exercise of its right to choose the political regime and legal status of Québec.

No condition or mode of exercise of that right, in particular the consultation of the Québec people by way of a referendum, shall have effect unless determined in accordance with the first paragraph.

4. When the Québec people is consulted by way of a referendum under the Referendum Act, the winning option is the option that obtains a majority of the valid votes cast, namely fifty percent of the valid votes cast plus one.

CHAPTER II

THE QUÉBEC STATE

5. The Québec State derives its legitimacy from the will of the people inhabiting its territory.

The will of the people is expressed through the election of Members to the National Assembly by universal suffrage, by secret ballot under the one person, one vote system pursuant to the Election Act, and through referendums held pursuant to the Referendum Act.

Qualification as an elector is governed by the provisions of the Election Act.

6. The Québec State is sovereign in the areas assigned to its jurisdiction within the scope of constitutional laws and conventions.

The Québec State also holds, on behalf of the Québec people, any right established to its advantage pursuant to a constitutional convention or obligation.

It is the duty of the Government to uphold the exercise and defend the integrity of those prerogatives, at all times and in all places, including on the international scene.

7. The Québec State is free to consent to be bound by any treaty, convention or international agreement in matters under its constitutional jurisdiction.

No treaty, convention or agreement in the areas under its jurisdiction may be binding on the Québec State unless the consent of the Québec State to be bound has been formally expressed by the National Assembly or the Government, subject to the applicable legislative provisions.

The Québec State may, in the areas under its jurisdiction, establish and maintain relations with foreign States and international organizations and ensure its representation outside Québec.

8. The French language is the official language of Québec.

The Québec State must promote the quality and influence of the French language.

The Québec State shall pursue those objectives in a spirit of fairness and open-mindedness, respectful of the long-established rights of Québec's English-speaking community.

The status of the French language in Québec, and the related duties and obligations, are established by the Charter of the French language.

CHAPTER III

THE TERRITORY OF QUÉBEC

9. The territory of Québec and its boundaries cannot be altered except with the consent of the National Assembly.

The Government must ensure that the territorial integrity of Québec is maintained and respected.

10. The Québec State exercises, throughout the territory of Québec and on behalf of the Québec people, all the powers relating to its jurisdiction and to the Québec public domain.

The State may develop and administer the territory of Québec and, more specifically, delegate authority to administer the territory to local or regional mandated entities, as provided by law. The State shall encourage local and regional communities to take responsibility for their development.

CHAPTER IV

THE ABORIGINAL NATIONS OF QUÉBEC

11. In exercising its constitutional jurisdiction, the Québec State recognizes the existing aboriginal and treaty rights of the aboriginal nations of Québec.

12. The Government undertakes to promote the establishment and maintenance of harmonious relations with the aboriginal nations, and to foster their development and an improvement in their economic, social and cultural conditions.

CHAPTER V

FINAL PROVISIONS

13. No other parliament or government may reduce the powers, authority, sovereignty or legitimacy of the National Assembly, or impose constraint on the democratic will of the Québec people to determine its own future.

14. This Act comes into force on (*insert here the date of assent to this Act*).

Self-determination – People, Territory, Nationalism & Human rights: Thoughts on the Situation of South Moluccans, Roma & Sinti

Suzette Bronkhorst

Looking at some descriptions of self-determination:

Self-determination is the foundation for any concept related to nation-building. It is a collective consciousness developed by a people with a common design for establishing or furthering future self-government.

and:

Self-determination is the right of a people or ethnic group to choose its own government, form of state and rank in the row of nations. Without qualification, this term includes all forms of self-determination, whether it be external, internal, corporate or cultural self-determination. Another definition of self-determination is: All people, including people with disabilities, have the right to determine their futures.

We are dealing with two kinds of self-determination here. One says: you and me, we have much the same culture, background and/or religion, we are being oppressed by nation X which colonized us a 100 years ago, let's fight for our freedom and right to self-determination, in other words, have our own nation. Then there is the one that says: we have much the same culture, background and/or religion, we want our rights, we want to determine our own destiny without making territorial claims.

The first kind of self-determination mostly has to do with native inhabitants of a country justifiably claiming their country back, as colonialism is supposedly a thing from the past. Let's have a look at this kind of right to self-determination by using an example from the Netherlands.

In Pursuit of the Right to Self-determination

In the Netherlands, we have 'those South Moluccans' as the former inhabitants of the Moluccan Islands are called. The Moluccan Islands used to be, with Indonesia, part of the Dutch colonial empire. During the Second World War, the Japanese occupied the Indonesian islands, including the Moluccans. After the war, in which the majority of the males of the Moluccan Islands served in the Royal Dutch Indies Army, the Indonesians fought a bloody guerrilla war to get their independence. The Netherlands brought in waves and waves of fresh soldiers but could not get the upper hand. This period, which is euphemistically referred to as 'policing actions' in Dutch history books, was an interesting and much covered-up affair. Even today, former Dutch soldier and human rights activist Poncke Prins is not allowed to return to the Netherlands because he is a traitor. (Of course, his present activities against the Indonesian government are viewed and recognized as legitimate human rights actions).

After four years of fighting, the Dutch government, under strong pressure from the United Nations, agreed to return sovereignty to the people of Indonesia. Meanwhile, the Moluccan people were expecting the return of their independence as well, as had been promised by the Dutch government for their having served in the Dutch army. Agreements were signed in 1949 which were to settle the handing over of power to the new state, the United States of Indonesia, which provided mechanisms for the various areas to choose or opt out of, the new Indonesia. The Agreements granted the Moluccan people the right to determine their ultimate sovereignty: they were to have a choice whether to join the new state of Indonesia, or to re-establish their historic independent status.

The Agreements were violated within a year of signing. In response, the Moluccan people severed ties with Indonesia.[1] On April 25, 1950, they declared the Republik Maluku Selatan (South Moluccas Republic), comprising the historic islands of the Moluccan people: Amboina, Buru, Ceram and the adjoining islands. At this time, the United States of Indonesia did not yet formally exist, only becoming fully independent on August 17, 1950. Indonesian forces initially invaded the islands on July 13, 1950 and occupied the Moluccan islands, which they viewed as being 'part of Indonesia'. They conveniently forgot that the Moluccans had been independent until 1605 when the Dutch conquered the islands. Goodbye old oppressors; hello, new ones.

The Indonesian government accused the Moluccan people of 'collaboration with the Dutch Empire against the Indonesian Freedom movement.' Those Moluccans who were employed in the Royal Dutch Indies Army (KNIL) claimed their right to be 'repatriated' to the 'home country.' Others followed, and a 'Moluccan Government in Exile' was formed in the Netherlands. The South Moluccans, as they became known in the Netherlands, were not treated well there. Instead of being given a hero's return – they were, after all, part of the Dutch army and had fought for the Kingdom – they were largely ignored. They were put in temporary housing (as they were to return soon to the Moluccan Islands) such as old army camps and barracks, and in one case, an old nazi-built concentration camp. This was hardly a fitting response by the Dutch government to soldiers who had been officially part of their own army, their brothers and sisters who fought on their side.

The South Moluccans were separated from the rest of Dutch society, although they seemed to be happy enough living among each other in their 'temporary' housing (the last camp was forcibly cleared of its last inhabitants in the '80's). After the South Moluccans were housed in 'normal' houses, they were still kept together – segregated, in my view – in neighborhoods of just a few towns, mainly in the north of Holland. They suffered many difficulties. The European Dutch did not really understand who they were ("some kind of Indonesians…") or what they had been through. The history books only referred to them in passing, and those Dutch who knew the facts were rather unwilling to talk about the 'Indonesian matter' and the 'policing actions'. The Moluccan people had trouble recuperating years of back wages still owed to them by the Dutch government – the same Dutch government which promised them, year after year, that they would put the matter of self-determination for the Moluccan Islands on the political agenda again. Nothing came of it; every cautious mention of the Moluccan matter was squashed by the Indonesian government, who questioned how the former Dutch occupiers dared to meddle in internal Indonesian matters.

In the years after the Indonesians occupied the Moluccan Islands, they tried to weaken Moluccan culture by integrating large numbers of non-Moluccan Indonesians, mainly from Java, into Moluccan society. To this day, the Moluccans are an oppressed people, and to this day, the oppression and violence continues, also in a new form: religious violence – Christians on the one hand, Muslims (a lot of them originally Javanese) on the other, and a rather dubious role for the Indonesian army.

In Holland, meanwhile, Moluccan youth in the seventies, out of anger that the Dutch government did nothing to help them realize their dream – the return to a free republic of South Maluku – hijacked a train in one place, and kidnapped school kids in the Netherlands in another place. Both actions were swiftly ended by the Dutch authorities. Some of the hijackers were killed, and the rest received heavy jail sentences. There was little understanding in the Netherlands for these deeds. 'What do these people want, anyway?' was the most commonly-heard remark. It was all very hard to fathom for most of the Dutch. "We gave them hospitality here and see how they abuse it!" The fact that the Dutch treated the Moluccans, their proud Royal Dutch Indies Army soldiers, as lepers all these years was never mentioned.

This was the first time I was confronted with the matter of territorial self-determination.

In my mind, it is a clear case: the Indonesian Government should give the Moluccan Islands back (easy for me to say, living halfway around the world), the Dutch Government should do their utmost to help them obtain their objective, and pay reparations to those of her citizens of Moluccan descent who want to go back to the Moluccan Islands to start a new life or to live the last years of their lives there.

Most conflicts born out of the right to determine one's own life and future are not so simple.

If you want territory, sometimes you will have to fight those who think they have the same rights, or worse, better rights than you. We have only to think of Bosnia and more recently Kosovo, where self-determination and the fight against

oppression led to the slippery slope of extreme nationalism and xenophobia. Look at Spain where the so-called Basque Liberation Army ETA, a terror group which the Basque people themselves think does not represent them, kills people claiming that they want self-determination for the Basques.

And let's not forget the struggle for self-determination that leads to terrorizing others who want no part of it. The extreme right Afrikaner vryheidsfront want self-determination, the right to govern themselves. Should they be allowed this, bearing in mind that their striving for self-determination is just a way to create apartheid anew in parts of South Africa? Yes, ethics and self-determination are sometimes at odds with each other. And sometimes people who fight for self-determination go hand in hand with fascist organizations or are fascist, or promoting racial hatred.

Of course, there are enough examples of successful self-determination. Decolonized African states are self-determining states. Or are they? On a very sour note, I have to say that with the total debt the so-called third world has to the western world, and the way the western countries keep the third world on a leash with this fact, those countries only determine their own fate to a certain extent. Mostly, it is determined by the old colonizing countries in a very brutal sense: will we let you die of famine now or somewhat later because we still have some uses for you?

What do you call a person who sees his neighbor suffering, hungry and sick, but who wants his interest from the loan he gave to the neighbor? You don't call him a man, he is a beast.

To me, if you talk about self-determination, the economic aspects are very important. Maybe the UN references to self-determination should be amended with this line:

> Self-determination is also the right of a people or ethnic group not to starve because a nation or other nations choose to use economic methods to prevent this people's right to self-determination by keeping it undernourished and thus incapacitated.

Now I want to take a look at the other kind of right to self-determination, when a group aims for non-territorial self-determination.

Let's talk about self-determination versus assimilation first. When you prepare a salad, you want the different ingredients to keep their individual identity, their taste. Nobody puts all ingredients in a blender to create a perfect mixture. For some reason, when we talk about human beings, it all changes.

Assimilation means the loss of your own culture. Becoming part of a melting pot rather than a salad bowl.

"Resistance is futile. We will assimilate you," the Borg out of the SF series Star Trek are saying. "You will be Borg, you will become part of the collective, and the collective is one." Why is that bad? Very simple. To assimilate means to be as similar to the dominant group as you possibly can be, to act similar, to become similar.

In the western world, this means: act white. Assimilation means the loss of your own culture. Becoming part of a melting pot rather than a salad bowl. What is so difficult about allowing people to have their own (cultural) identity, living according to their own guidelines within a region or state?

Once again, I have an example for you, wandering people who have no territory and claim none, but who are a people nonetheless: the Roma and Sinti. Language studies suggest that Roma and Sinti are of Indian descent and migrated westward from northwest India in the eleventh century. By 1500, Roma lived throughout Europe, becoming indispensable suppliers of diverse services such as music, entertainment, fortune-telling, metalworking, horse dealing, woodworking, sieve making, basketry and seasonal agricultural work.[2] Only the Roma alone are right now estimated as a rapidly growing group of between 8 and 10 million people. Roma and Sinti are under heavy attack in the countries where they are living. Discrimination against them is on the rise. In order to claim self-determination, should they go back to India? Surely, based on being a culturally or ethnically identifiable group, they have a right to be recognized as peoples – they who have no homeland, or who left a homeland so long ago that it is quite forgotten and thoughts of claiming it are unthinkable – not that anyone would ever give it. But the Roma and Sinti are a non-territorial people who do not claim a country; they claim the right of travelers and the right to be treated as human beings. Foremost these days, they want to be left alone. In other words, they want the right not to be discriminated against. Part of self-determination is having your own schools, houses, facilities and so forth. In the case of the Roma, as has been done in other regions, self-determination has been used as a racist tool, to in fact segregate communities from the rest of society, while giving them inferior education and facilities. In order to achieve true self-determination, first racism and prejudices against Roma will have to be fought. A number one priority for Roma and Sinti in Europe is equal treatment under the law, and an end to prejudices against them.

Conclusions. I have talked about two kinds of self-determination. The example of my fellow Dutchmen, the Moluccans. Their situation seems quite hopeless, but yet... I have talked about regions where self-determination is already a fact, regions where it went rather well, and where it is one big disaster. I have shared with you my ideas about economics, debt and self-determination, and last but not least, I have talked about the Roma and Sinti, peoples who do not connect self-determination with territorial rights.

My conclusions are quite simple. I have none, but I have hope. As migration throughout the world intensifies, mixing of peoples intensifies, and the world gets smaller and smaller. Through the use of modern technology, the whole issue of self-determination may become less important because we will have found ways to identify with being human first, and part of one of the groups within humanity, second. These groups do not necessarily have to be ethnic or political groups; they might be communities with common interests. I do think that we have to work on equal rights and equal resources for all humans first. If we get that right, or even just improve on the present situation, we can start dreaming about a world where self-determination is a natural thing for every man and woman.

ENDNOTES

[1] *REPUBLIK MALUKU: The Case for Self-determination.* Briefing Paper of the Humanitarian Law Project, International Educational Development and Association of Humanitarian Lawyers. Prepared by Karen Parker, J.D.

[2] Carol Silverman, *Persecution and Politicization: Roma of Eastern Europe*, Duke University Press, 1996.

BIBLIOGRAPHY

Lucassen, Leo (1990). *En men noemde hen Zigeuners...De gaschiedenis van Kalderasch, Ursari. Lowara en Sinti in Nederland (1750-1944)*, Stichting beheer ILSF/SDU Uitgeverj, Amksterdam/ .'s-Gravenhage.

Het Konikrijk der Nederlanden in de tweede wereldoorlog (1986). Deel 11c Nederlands-Indie III, Staatsuitgeverji, 's-Gravenhage.

Peterse, Leon en Petri Joke (1995). *Oost-Indonesie*, Uitgeverij Gottmer/H.J.W. Becht.

The Right to Self-determination: Reviewing the Anomalies

Gerald Kaufman

Before we can address ourselves to the theme of this session — the relationship between politics of forced assimilation and racism, ethnocide and armed conflict in the context of denial of just demands for self-determination — we have to ask ourselves other questions. We have to ask ourselves: what is a just demand for self-determination? There are many thousands of ethnic groups in the world in the diversity of the human race. How many of them want self-determination? How many of them have just demands for self-determination. Again, if we are talking about the denial of minority rights, we have to ask ourselves: what is a denial of minority rights. Everyone of us is a minority of one;.. it may be that we want rights that the rest of our community may not grant us. On the other hand, it may be said that religious and cultural groups have got a sense of identity which can lead to the demand for formal rights and for denial of these rights.

Now in various ways, we are testing it. We heard Mr. Reid describe yesterday afternoon what has taken place in the United Kingdom in terms of devolution of power from the Westminster government. And in a community with a unitary democracy, like the United Kingdom which is four countries with one parliament which evolved separate Assemblies, you can test what the demand is. Regarding Scotland, to which Mr. Reid referred, what happened in our last elections in Britain was that the party that wanted devolution of power from London to Edinburgh beat the party that wanted total independence, and both of those parties beat the party that wanted neither devolution nor Scottish independence. So we had a test.

In Wales we had a test, too through a referendum, and the people who wanted devolution only just won the referendum. There was nearly half the Welsh voting population who actually wanted to be governed by London without any say of their own. In Northern Ireland, in the Parliamentary election — not the referendum two weeks after — the secessionists, the Sinn Fein, only got one third of the Catholic vote, and of course none of the Protestant vote. We have in our most southwesterly county in Britain, the county of Cornwall, a secessionist movement there called Mebyon Kernow, and they put candidates up in the last election, and got very few votes. So in a democracy, in a unitary democracy, a genuine democracy, you can test claims for self-determination or independence or devolution by vote. But there are not that many unitary democracies in the world, and indeed there are too few democracies of any kind in the world.

In Pursuit of the Right to Self-determination

If you are looking at demands and claims for self-determination in a federation or a union of states or a union of provinces, the validity of the demand or the claim for the demand or the rationale for the demand may be much less clear. We had another speaker from Canada yesterday who was listening with interest to the claims of indigenous peoples of Canada, for there are also people, descendants of the French colonists in Quebec, who have a secessionist movement, or an independence movement, or a self-determination movement, in one province in Canada, for which most of the other provinces in Canada have very little sympathy.

In a federation or a union of states such as the United States, the issue can be much less clear. Looking back on the United States' Civil War in which the North fought the South to free the black slaves in the South — that was not what the war was about at all, even though the consequence was the freeing of the slaves; the war was about states' rights in a country composed of states which very much value those rights — you have two minorities: the southern states , a minority which regarded themselves as being dictated to by the more powerful northern states, and then the blacks mainly in the southern states who felt, very rightly, that they were being oppressed, and regarded themselves as the oppressed minority. But of course the end of slavery in the US was not the end of racial discrimination in the US, and the battle for rights by the black minority in the US is still not over today. And it cannot be over. It is all too recently that black people in the United States won the right to serve as equals in the US armed forces to defend their own country. But most black people in the United States do not want a separate country of their own. They want integration into the society in the most genuine possible sense, and that kind of integration in a great democracy like the United States still does not exist.

I went to the United States as a Minister from the United Kingdom government, and I was asked to address a lunch at a club in New York, and it was only after the lunch had been completed that the people who had been organizing told me that it was a club that did not admit Jews. It is only forty years since the United States was willing to elect a Catholic for its President. Today, this very week, we have had what is regarded as a sensation, after 254 years of the existence of the United States — somebody is about to be nominated as a vice presidential candidate who is a Jew.

So the idea that it is only in countries without democracy that minorities are denied their rights is a false idea. And it is an idea which we who are fortunate enough to live in developed western democracies ought to remind ourselves of, continually. While we may criticize many other countries, and in my view justly criticize many other countries, for the denial of self-determination and denial of human rights, we ourselves in the most developed democracies have still not achieved all the ideals which we preach to the other countries. It's very important we do remember this.

When we are looking at claims for rights, we see that clashes arise between different groups of people, all of whom believe that they are right.

When we are looking at claims for rights, one of the things I have learned from my study of ancient Greek literature in school was that tragedy does not consist of a clash between right and wrong. Tragedy consists of a clash between different people or groups of people, all of whom believe that they are right.

If we look at the issue of Kashmir, which we have heard about from a number of delegates this afternoon and to which I have a personal commitment, as president in Britain of an organization called Justice for Jammu-Kashmir, we have three parties that are involved, all of whom believe that they are right. One or two or even three may turn out not to be right, but they all operate on the basis that they are right. The Indians claim — and they will cite all kinds of historical precedents for it — that Jammu-Kashmir is rightfully a state in the Indian union. They will also warn that were they to grant any kind of self-determination to the peoples of Jammu and Kashmir, that would have a deleterious effect on the integrity of India as a united country. Karen Parker mentioned today the issue of the Punjab, and while we have not heard from the Sikhs today concerning that part of the Punjab which is in India, and their feelings of oppression by India, it was a Sikh from the Punjab who assassinated Indira Gandhi. But there is the case put forward by many Sikhs — it is impossible to know, I will not say all for they have never had the right to state their view — that the Punjab should be an independent country, Kalistan, and not part of India. One of the apprehensions of India — I'm not saying it's a justified one — is that if they were to respond to the claims for self-determination and possibly independence for the Kashmiris, then the Sikhs in the Punjub would be next, and then finally Hyderabad and so on. I'm not saying that I agree with it, I'm simply saying that these are contentions put forward by India as part of the reason why they deny self-determination to the peoples of Jammu and Kashmir.

Pakistan, in saying that Jammu-Kashmir should not be part of India, does not say that Jammu-Kashmir should be an independent country. What they say is that Jammu and Kashmir should be part of Pakistan on the grounds that the largest number of people in that state are Muslims — the Kashmiris in the valley — and therefore they have an identity of culture and religion with Pakistan.. What the Kashmiris want, we've never been told, because they have never had a chance to say collectively what they want. The Indians state their point of view, as a country with a government. And Pakistan says what they want, as a country with a government. But the Kashmiris have never had the chance to vote, except in elections organized either by the Indians or the Pakistanis in the areas where they are respectively in control.

Now in the North, where China occupies more than 20% of Jammu and Kashmir, we have absolutely no idea what the people there would want, were they to be given the right to express themselves on the issue.

Should we get what is in the United Nations resolution — a plebiscite in Jammu and Kashmir — the predominant voters there will be the Muslims because they are the largest number. The next largest number will be the Hindus in Jammu. But as was pointed out yesterday in a very learned and instructive history of the Kashmir problem, up in the small state of Ladakh in the Himalayas, there are Buddhists — I've visited and talked with them — and nobody, neither the Muslim voters of Kashmir nor the Hindu voters of Jammu, will be able to take into account the interests of the Buddhists of Ladakh, who are very few, and who, from my conversations with their leaders, have just one objective in life: to stop being so incredibly poor. They are the poorest people in Jammu and Kashmir.

Then let us look at another area of contention today in which the majorities and minorities are saying they are being denied their rights: Cyprus, an independent

state, a member of both the United Nations and the Commonwealth, a third of which is being occupied illegally by a neighboring country, Turkey. Cyprus has gotten independence, and is therefore dominated by Greek Cypriots who are a majority there. But we don't know that that was what they really wanted, because the insurrectionist movement in Cyprus began originally not with a demand for independence but with a demand for union with Greece. Even if Cyprus is now an independent state, this is not what they originally sought. The Turkish Cypriots who occupy the northern third of the island roughly — we don't know what they want because again they have never been given the opportunity to say what they want – though we do know that they do not want to be dominated by the Greek Cypriots who are the majority on the island. We don't know if the Turkish Cypriots want a separate state which they claim to have or whether they want a confederation or whether they want a federation. What is perfectly clear is that although they are of Turkish origin and although there are 50,000 Turkish settlers on the island from the Turkish mainland, the one thing the Turkish Cypriots do not want is to be part of Turkey. But they have never been given a choice, and they are the minority.

We heard today about the situation in Western Sahara. Western Sahara used to be a Spanish colony, then the Spanish cleared out. The Moroccans moved in. The Moroccans claimed that Western Sahara is really part of Morocco. Although the religion is shared — they are all Muslims — the Sahrawi people say that they do not want to be part of Morocco. They want to have their own country, and have showed they do not want to live under Morocco by moving out in their tens of thousands to appalling unsanitary desert camps in Algeria, which I have visited. So the Sahrawis have never had a chance to say what they want. Although this is an issue in which the United States has involved itself very actively, passing Security Council resolutions demanding a plebiscite for the inhabitants of the Western Sahara, and even though the UN has sent troops out, including troops from my own country, whether we will ever get a plebiscite is open to doubt, because the Moroccans, who are not only being obstructive in holding the plebiscite, are also changing the electorate. Karen Parker earlier today spoke about the way in which the Chinese occupation of Tibet has changed it through what she called dilution. That same kind of dilution is going on in the Western Sahara. Many thousands of Moroccans have moved south into Western Sahara. One of the reasons no plebiscite has been held is because the United Nations is unable to compile a list of voters which is acceptable to both the Moroccans, who insist that all the Moroccans who live in the western Sahara should vote, and the Sahrawis, who say that only the Sahrawis or people of Sahara origin should vote

There are other issues which will need a much bigger campaign to restore, that we have heard about in the past few weeks. There's another coup, the second in recent years, in Fiji. In Fiji, you have indigenous Fijians, and you have the Indians who came south to trade and to better themselves, who now form the majority. Some Fijians say they are a minority who are being dominated electorally. The Indians say: "Everybody on the island is ready to share in the prosperity that we have brought, but they won't allow us to operate on the basis of our numbers." We have had several references yesterday and today to proportional representation. On the basis of proportional representation, the Indians would govern Fiji; they are the majority. How do you possibly resolve two rights of that kind — whether you

are the United Nations, whether you are the Commonwealth — Fiji keeps moving in and out of the Commonwealth, as it moves in and out of governments which it regards as lawful.

Again we have heard a great deal — and rightly so — about the problems in Sri Lanka, where I am again involved with Tamils in my constituency, and address Tamil Conferences. What is to happen in Sri Lanka if the Tamils prevail? Are they to run part of Sri Lanka or are they to have self-determination within Sri Lanka — and what is that self-determination to be? It is a very difficult question — except for the fact that the Tamils are fighting, which indicates that they have a case, or they believe they have a case, because you wouldn't risk your life and you wouldn't lose lives for something you didn't believe matters very much.

Although the problems have gone from the international headlines now, for a long time in Guyana there was a dispute, and it was a dispute of a remarkable nature, because it was between two peoples of different immigrant origin, each contesting the domination of the country. Now the original indigenous inhabitants of North America, of Australia and New Zealand and of other parts of other areas of the world, too, suffer from discrimination and domination, but are too few to go it alone. We will hear from our North American Native American speakers as to what they feel their countrymen will want, but to an outsider it is very difficult to see whether the separate territories would work.

The question then arises: what do you do? This conference is about the United Nations — we are all supporters of the United Nations, one of our speakers said he loved the United Nations, and certainly it is far better to have it than not to have it — but the United Nations has passed resolutions on all kinds of situations. But not that many actually get implemented. The Security Council is there to organize and supervise the role, but if you look at Security Council Resolutions, by far the majority are not being implemented. You look at the last ten years of Security Council resolutions about Iraq following the Iraqi annexation of Kuwait more than ten years ago. A speaker talking about the Indian policy towards Kashmir asked for economic sanctions to be imposed on India – well, economic sanctions have been imposed on Iraq through the United Nations for ten years and the Iraqis ignore them all. So the question arises that if the writ of the United Nations does not run, what is to happen?

Now there was a very interesting discussion earlier today in the Opening Theme session about the use of force. Karen Parker talked about the right to use force and cited various documents in support of her contention. George Reid challenged that, and said there was not the right to force. Now that is a discussion with two sides, each of whom vary from the view of the other. But what is sure is that whether Karen Parker is right in saying that there is a right to use force or George Reid is right in saying that there is not, large numbers of minorities in all parts of the world have come to the view that there is a need to use force. They don't look at their right, they do not look at international documents, although I am very sure they are pleased to hear Karen Parker's documentation of what they are doing. What they are simply saying is that we have no other choice. Nobody is listening to us. Nobody is

Large numbers of minorities in all parts of the world have come to the view that there is a need to use force because they have no other choice.

giving us what we have the right to have, and the only way in which we can attract attention to our case is by using force. Because if you look at what is happening in the different parts of the world that I have mentioned, the Sahrawis know that they can't defeat Morocco, though they certainly have a huge accumulation out in the desert of Moroccan military equipment that they have captured. I don't believe the Tamils would claim they could defeat the official government forces of Sri Lanka. The various forces in Kashmir know they can't defeat the Indian forces which different estimates vary at between half a million and three quarters of a million. They know they can't win militarily, but they do it all the same because it is their only way.

I hate violence, I'm sure everybody in this room hates violence. I have a reverence for Parliament. Parliament means talking, from the French word, to talk. In democracies, we are committed to solving our differences by talking rather than by physical conflict. But I have to say, not because I support that, but simply looking at it from the point of view of experience and observation, that only that, in reality, whether forceful or otherwise, seems to bring about change or to accelerate change.

In the United States, black people were oppressed — I'm not saying they're not oppressed now, but they were oppressed in utterly intolerable degrees — until they began civil disobedience campaigns. And it was not blacks voting in elections, and heaven knows it was difficult enough for them to vote, that brought about any kind of progress towards civil rights. It was the civil disobedience campaign.

In India now — I look at India as a huge country which denies rights to many of its inhabitants. Remember, India was a British dependency for over 200 years. It was only through civil disobedience of a peaceful kind originated by Gandhi or by the more forceful kind, that they won their independence. Pakistan came about because the Pakistanis actively demonstrated that they would not be part of the secular Indian country.

Kenya achieved its independence not by rational argument but because there was a dreadful terrorist movement which did unspeakable things. That is why we have the phrase, the Mau-Mau oath, because the Mau-Mau oath was taken in blood. As a result of what happened in Kenya, as a result of the achievement of independence for Kenya, there was a triggering off of decolonisation throughout Africa: in Guinea the beginning with the British colonies, then including the French, the Portuguese, the Belgians, the Spanish, etc. It wasn't argument and persuasion of the colonial powers that brought about their removal. It was insurrection, murder, and terrorism. Even today I was talking to a delegate who comes from Zanzibar who is still not satisfied that there is an independent country called Tanzania. As someone coming from Zanzibar, he still does not believe that the right to self-determination has been completed. In Cyprus, it was the terrorists who made the British feel that it was not worthwhile to stay.

You have extraordinary case of Palestine. The British occupied Palestine after the First World War. The Jews decided that they wanted an independent state. There was a very civilized Jewish political movement which went nowhere. It was only when two terrorist groups, both of whose leaders later became Prime Ministers of Israel, made life for British soldiers utterly impossible with murder and booby

traps and the rest, that Britain decided that it had to get out. So the Israelis won control of their country through terrorism, though they would deny that that's a fact. But when they achieved control of their country, then they began to dominate the Palestinian Arabs whose existence as a nation was totally denied. It was only when the Palestinian Arabs began resisting forcefully, and particularly with the *intifada*, that you got an independence movement that the world was willing to listen to, and which has made progress, though not yet sufficient progress.

If the Kashmir problem is solved, as I am hopeful it will be, it will be not because India suddenly decided to be nice, and that it would be a good idea to be friendly, but because insurgents within the valley of Kashmir have triggered off a chain reaction which has led to a nuclear standoff between India and Pakistan, and therefore started to frighten the rest of the world. It isn't human rights violations in Kashmir which will have done it — it is the fact that turbulence triggered off insurgence which finally made the world realize that a solution to the Kashmiri problem is necessary at all. But what is comforting is that if violence brings issues to a head, it is in the end, talk, that brings about the solutions.

While the United Nations is not always around, as for example in Northern Ireland as our friends have shown in their submission to the United Nations, the United Nations is often involved. Israel exists because of a resolution passed in 1947 by the UN General Assembly, not the Security Council. Namibia, whose independence celebrations I was privileged to attend, exists because of, was created by, the United Nations. I was there when Perez de Cuellar pronounced independence. He was due to declare it at midnight and because he didn't have a chairman as disciplined as yours, he went over eight minutes, and so forever, Namibia will have lost eight minutes of independence. And there is a UN demand for a plebiscite in Western Sahara.

It is certainly true that UN involvement in human rights has led too often to insufficient implementation but that is because human beings are extremely fallible people. If they were not, then we would have no problems. One of the things that irritates me when I read of some particular atrocity that may have taken place anywhere in the world, is when people then say that those responsible behaved like animals. In fact, animals do not behave like this. Only human beings treat each other as slaves, as inferiors. And that is what this conference is about: this conference is about trying to bring international law and regulation into disputes which are often irrational and in my view, this conference would be a success if it contributed to persuading human beings to behave like human beings.

An Indigenous Understanding of Self-determination

Kenneth Deer

The right of self-determination is, of course, one that Indigenous Peoples have been fighting for, for a number of years. It is something that numerous international jurists and people involved in legal areas have been discussing through numerous debates, because some people have been contending that Indigenous Peoples do not have the right to self-determination. That opinion is changing. But it hasn't been changing very easily.

When I began my involvement in international activities, coming to the United Nations in 1987 and attending the Working Group on Indigenous Populations, we were talking about the Draft Declaration and the rights of Indigenous Peoples. But there was no article in the Draft Declaration at that time that recognized the right to self-determination for Indigenous People; human rights experts at the United Nations didn't believe that this right existed.

It took us a number of years before they were convinced by Indigenous Peoples that we do have a right to self-determination. Finally in 1993, they approved Article 3 recognizing that Indigenous Peoples do have a right to self-determination. However, just because a group of human rights experts have now agreed that we have the right to self-determination, that doesn't mean that the United Nations itself believes that we have the right to self-determination. The Sub-Commission on the Elimination of Racism and the Protection of Minorities has approved the Declaration in its current context. But the UN Commission on Human Rights, which is controlled by governments, has created a Working Group on the Draft Declaration which has been in existence since 1995. Every year, for two weeks, we debate the Draft Declaration, and in those weeks, we devote two days to debating the right to self-determination, pitting Indigenous Peoples, our representatives, lawyers, jurists, and sovereignists against many governments who are resisting the whole idea that Indigenous Peoples have the right to self-determination.

One of the arguments that governments give is that Indigenous Peoples did not understand the concept of the right to self-determination at the time of the European contact, particularly in the Americas, Australia and New Zealand. Of course, we protest that vigorously. We knew all about concepts of nations. We even formed federations of nations such as the Six Nations Iroquois Confederacy in North America.

We believe the whole idea that Indigenous Peoples do not have the right to self-determination is race-based. I'll give you the example of our own people, the

Mohawk, who live in the northeastern part of North America. We had treaties with the incoming Europeans, and the first treaty that we made was not with the British or the French but with the Dutch. (I was talking to a Dutch person earlier yesterday — I was wondering about how the Dutch dealt with the South Moluccans. We had a very different relationship with the Dutch in North America.) As Mohawk people interacting with Europeans, we knew that they would not be returning to Europe and that they would be here for a long time. So we had to make an agreement with them. This agreement is called the Treaty of Fort Orange. It was signed in 1634.

In our tradition, this treaty was represented by a wampum belt called the Two Row Wampum. This belt was made up of two purple strips on a white background. One row of purple represented the Mohawk people with their laws and their spirituality, in their canoe, and the other row represented the Dutch in their ship with sails, with their people and their laws and their religion. The white background represented the river of life. The Mohawk people and the Dutch people went down that river of life parallel to each other, neither one of them interfering with the navigation of the other peoples' vessel. There's no border to the wampum, just long strings indicating that life goes on forever. There's no end to it. So this was how the Mohawks recognized and understood the right to self-determination of the Dutch people. And at the same time it indicated that we expected that the Dutch would understand that we have the same right to self-determination. This was in the year 1634. We're not talking 50 years ago, but almost 400 years ago. This shows you the wisdom of our people at that time. We recognized everybody's right to existence; we recognized the right to self-determination, though we didn't use the word because the word "self-determination" didn't exist back then. But this, of course, is what it was.

We recognized that self-determination is not held in isolation; there is no absolute self-determination. It is shared with your neighbour. It follows the relationship you make with the people who live next to you. Self-determination means living side by side. We didn't want Dutch people coming into our communities and passing judgment on our people just like they didn't want Mohawks going into Dutch communities and passing judgment on them. We knew that we had to live side by side, and we knew that we had to have agreements and understanding when we had conflicts with one another. So we knew in order for us to survive and in order for the Dutch to survive, we had to learn how to co-exist.

Self-determination is not held in isolation; there is no absolute self-determination. It is shared with your neighbour. It follows the relationship you make with the people who live next to you.

This Two Row Wampum has applications anywhere in the world. We can apply this in Palestine, in Kosovo, in any conflict area in the world right now, this kind of relationship, this way of living side by side. Well, of course, in North America, somebody violated this wampum and it wasn't us.

After the Dutch left, we kept this concept of coexistence. We lived by this concept with the French when there was a French regime in North America and also during the British involvement in North America. This was the attitude that we had with the British and the French. We didn't consider ourselves subjects; we were partners, people who lived side-by-side. Then, when the 13 colonies separated

from Great Britain, we also had this kind of relationship with the 13 colonies. Then later on, when Canada separated from Great Britain and became independent, we also had the same attitude toward our relations with Canada. And now Quebec wants to separate from Canada, and we can also have the same kind of concept concerning relations in a separate Quebec.

It is our experience that Europeans keep separating, but we have learned how to live with them. But the Europeans have not learned this concept. They have not fundamentally accepted the concept of living side by side, and developing cooperatively.

Today, the governments in the United Nations are trying to say that we don't understand the concept of self-determination, that Indigenous People were primitive and didn't understand what human rights were or what the rights of our people were. We have a very clear idea of who we are, of what rights are, of what land is, and of what resources on that land meant. We have a very clear idea of the relationship we have with the land, which is something they will never understand. They thought European kings had divine rights, the divine right to conquer, to take the land in North America, and that the Indigenous Peoples who lived here, who were put here by the Creator, didn't have these divine rights. Today in Canada, there are Mohawks that don't own a single square inch of land in Canada, and yet every square inch is called "Crown lands." Still today, Canada claims the idea that the European crown has somehow acquired our land.

The whole idea that Indigenous Peoples don't have the right to self-determination is racially based, and it is ingrained into the very fabric of the legislation, the laws and all the institutions of the Americas and other parts of the world.

We had quite a dispute in the United Nations — the United Nations thought that Indigenous rights were the same as minority rights, and we had to go through very large battles to convince the United Nations that Indigenous rights were different from minority rights. Hence we have the Draft Declaration on the Right to Self-determination of Indigenous Peoples, in which the right to self-determination is a fundamental principle.

Without the right to self-determination, all the other rights have no grounding.

Without the right to self-determination, all the other rights have no grounding. There is no basis for any other right in the Draft Declaration. The right to self-determination in that Declaration is vital for the continued survival of Indigenous Peoples in the world.

I was really very curious to hear in Mr. Turp's earlier presentation about how Quebec has a right to self-determination. I am very curious to hear how Quebec has a right to self-determination and yet Canada and others deny our right to self-determination. Is the right to self-determination racially based? Is it held only by white Europeans and their descendants? Because I think that if anybody has the right to self-determination, it is the Indigenous Peoples of the Americas. The Europeans and their descendants, meaning Quebec, can have all the minority rights they want but not self-determination.

We have the right to self-determination because we were there first. It's not as a right based on race; it's based on the fact that we are self-determining people before and since European contact.

Yeddy Wi: Gullah/Geechee Living Ways

Marquetta L. Goodwine*

> "When people live for years in freedom or within some sphere of influence, either in a feudal state or under colonial domination; and when their own lands — even if they become French speaking, like the country of the colonizer — are nevertheless as different from France in their customs, nature and climate as Africa is from Europe: then it is natural that such people should return to their roots, should investigate their past, and delving into that past, should enter upon a passionate quest for traces of those beings and those things that have guided their destiny."
>
> *Camara Laye, "Guardian of the Word"*

Since the time when chattel slavery was a law of the land and way of life in America, people have come from the north and other parts of the world to the Sea Islands of the south east coast of the United States. When they came, they heard the enslaved Africans speaking in a different tongue which they thought was a dialect or a "broken" form of the English language. Some were appalled by this manner of presentation that the people had. Edward King wrote: "The lowland Negro of SC has a barbaric dialect. The English words seem to tumble all at once from his mouth, and to get sadly mixed whenever he endeavors to speak."[1]

However, even with such remarks, there were those that enjoyed the rhythm with which these words "tumbled out." Thus, they came and wrote down the words that they could make out as the enslaved Africans recounted stories or sang upon the plantations. The rhythmic tones that rang out from the fields, the creeks, and the praise houses such as "Michael Row the Boat Ashore," "Cum By Ya," "Motherless Child," "Wade in the Water," "Great Getting Up Morning," "Go Down, Moses," "O, Freedom," and countless others, have been written down in the language of the visitors. They have been documented in English with the words written down in different places as best as they could have been understood by the English-speaking visitors. Had Gullahs and Geechees recorded them in writing the

* Marquetta L. Goodwine spoke to the Conference by means of video-tape. This is her written address.

titles would read more like, "Een da Great Gettin' Up Mawnin'," "Go Doung, Moses," etc. These songs were written down because of their beauty and their tone. They have been spread throughout the United States and the world and have come to be known as "the spirituals" or the "Negro spirituals." These came from the spirits and souls of the enslaved Africans as they worked or even looked out for others that may have been leaving the plantation. These who were the enslaved and their descendants are the people now called "Gullah and Geechee."

Due to their language and their mannerisms, the Gullahs and Geechees were not understood during their enslavement nor after slavery officially ended in the United States. Thus, they were consistently told that the way they were speaking was backwards and ignorant. They were taught that to get anywhere in life, they would need to learn "proper" English and may have had to endure corporal punishment to insure that they did. They were told to stop believing in backwards ignorant practices, rituals, and customs.

The problem that existed then unfortunately continues to exist. The problem lies within the definition of "customs." In the 1991 Edition of *The New Webster's Comprehensive Dictionary of the English Language*, the word "custom" is defined as "a generally accepted practice or habit, convention, the dictates of custom." Another definition as it applies to law states it is "a long-established practice having the force of law." In both cases, these definitions would probably match what most people have come to consider as customs.

However, it has to first be established who is in control of acceptability and who is in control of law. Given the fact that there was a Black majority in South Carolina during the plantation /chattel slavery era, the enslaved Africans of the Sea Islands were generally autonomous on the islands. In many cases, the Anglo "slaveowners" lived on the mainland just across rivers or creeks from the islands on which the Africans harvested cotton, rice, indigo, and other crops. There were often "drivers" instead of European overseers in place as well. These were men of African descent that made sure that the work was done and tried to insure that people did not run away or begin insurrections. Thus, how things were going to be done was generally in the hands of the enslaved even though there were other laws "on the books" to govern the institution of slavery.

As a result of the isolation of the Gullah and Geechee people from many mainland and/or Anglo ways, there were things that they were "accustomed to" and that they saw as "correct" or "acceptable" within the community that they were able to establish in spite of their being in bondage. These were not seen in the same manner on the mainland or within mainstream society. This Gullah/Geechee community had different nuances from island to island and plantation to plantation, but had the same foundation in the Sea Islands of "the Carolinas" and later spread to the areas that are now called Georgia and northern Florida.

With the migration (forced and chosen) of Gullah and Geechee people, the mores or "customs" of these communities have spread into other parts of the African American community at large. Many individuals still journey to the Sea Islands in search of the Gullah and Geechee people. They want to experience and record their ways. Many often come seeking ONE village where they can find the Gullah people since, as Twining and Baird wrote:

Among the Afro-American groups in North America, the culture of the Sea Islands is that most closely related to certain African cultures. On the Sea Islands, moreover, there are family and culture patterns that relate to areas along the African cultural continuum between Africa and the Americas, including Afro-North American, Afro-Caribbean and Afro-South American, as well as continental African societies.[2]

They do not realize that the "village" is and has been a community that is much larger than one town, one plantation, or one island. It is the chain of islands and the Lowcountry cities at the tip of the mainland that hold the heritage of the Gullahs and Geechees in each piece of soil, water, marsh, and Spanish moss. It is even in the boards, bricks, and tabby of the historic buildings that were built by Gullah and Geechee hands. It is in the rice that is eaten daily and the wild indigo that still grows in back yards in the Lowcountry.

What is most overlooked when people seek out the story of the Gullah people is one of the central components in how the language, crafts, trades, religious and healing practices, cooking traditions, and more were passed on and how and where they continue to exist. This component is one of the most prominent and readily identifiable aspects of this continuum in the Gullah community – the "family compound." As a means to protect various cultural elements and to provide safety for their families, this living pattern (which is also found all along the West African coast) involves the elder member of a family having a house in the middle and the children flanking this house on either side in a semi-circular pattern. The grandchildren align themselves around their parents' homes as they are old enough to have land provided to them for their families to reside on.

Twining and Baird even go on to write:

> Like the Caribbean Island societies which have strong African compon-
> ents, the Sea Island families and culture constitute a mixture of African
> and European cultural elements which supply variety to the modes of
> life and expression of the people. This culture complete with its own
> Creole language, folklore and social institutions, is predominantly oral/
> aural in its communication... The family is the single most important
> organizing principle in the Sea Islands...[3]

Bearing in mind the importance of keeping the family together, "freedmen"(the term given to enslaved Africans after chattle slavery officially ended in the United States with the signing of the Emancipation Proclaimation) were elated when the news of William Tecumseh Sherman's Special Field Order Number 15 was made known. In it he stated:

Sherman's Special Field Order Number 15 assigned a land area in the United States to the sole and exclusive management of the freed people themselves.

> I. The islands from Charleston, south, the abandoned rice fields along
> the rivers for thirty miles back from the sea, and the country bordering
> the St. John's River, Florida, are reserved and set apart for the settlement
> of the negroes *[sic]* now made free by acts of war and the proclamation
> of the President of the United States.

II. At Beaufort, Hilton Head, Savannah, Fernandina, St. Augustine, and Jacksonville, the blacks may remain in their chosen or accustomed vocations, but on the islands, and in the settlements hereafter to be established, no white person whatever, unless military officers and soldiers, detailed for duty, will be permitted to reside; and the sole and exclusive management of affairs will be left to the freed people themselves, subject only to the United States military authority and the acts of Congress...

The field order also went on to outline the parameters of the distribution of plots which stated that "each family shall have a plot of not more than forty (40) acres of tillable ground..." This tillable ground was fertile ground on which to harvest crops to sustain the people that dwelled there.

However, this field order was rescinded after the assassination of Abraham Lincoln. Many "freedmen" were still able to "officially" obtain deeds. At auctions of the land which had been confiscated when the Union forces arrived in what was called "the Port Royal region," previously enslaved Africans began purchasing tracts of land on which they had already been working and raising their families. Prior to the start of the Civil War, the task system structure of many plantations on the Sea Islands allowed even enslaved African people to have tracts of land which they worked for themselves to feed their families from. They often used the produce to barter for other goods. Thus, most considered these tracks to be their own. The areas in which they had already put their blood, sweat, and tears into for years were the tracks that most Gullah/Geechee bid on when they came up for sale.

Along with purchasing tracts of land, most Gullahs and Geechees sought to reclaim their own identities and to control their own names. Thus, many of them changed or added a last name of their own instead of bearing the name of the person that enslaved them. As Baird and Chuks-Orji point out:

In the African traditon, today as yesterday, a name is not a mere identification tag; it is a record of family and community history, a distinct personal reference, an indication of present status, and an enunciated promise of future accomplishment.

Your name amongst Gullah/Geechees represents a legacy which could mean that your word is accepted as a bond or the complete opposite. Just as with the various African ethnic groups that came together to form the Gullah/Geechee people, there is pride in what the group represents. Over 120 years later, numerous individuals that now reside on the mainland still send their children from cities to be reared or to spend summers on the property that has been in their families. They want to insure that they learn about their family and what it represents as well as about family traditions. This is an assurance that they will connect or reconnect to the land. Reconnecting to the land is an understanding of the entire history of the family and the community among Gullahs. Mamie G and Karen Fields summed up this occurrence by drawing upon a statement concerning villages among Kongo *[sic]* people:

For them, 'how this village was built' is both history and the material of individual identity. It is tied to locale and lineage, each encompassing past and present. Knowing how the village was built, how one belongs to it, and how one must therefore conduct oneself amount to the same thing.

With Gullah/Geechee people, there is a group consciousness that goes from one generation to another and from those who are now ancestors to the unborn. Branch took note that:

> The Sea Islands is an area where these ancestral patterns have been seen possibly more clearly than in other African American populations and therefore constitute a useful showcase through the study of which a fuller understanding of ... African world culture may be obtained. More particularly we can appreciate the lasting vigor, and the value of groups survival, of the African American family. An analysis of contemporary Gullah culture is very much needed. It is probably the most unique pattern of Black culture to be found anywhere.

This unique pattern is the center of survival for Gullah/Geechee people. The Gullah/Geechee people continue to strive to hold on to what fostered this pattern – their village, the Sea Islands – while also trying to get others to understand the community therein. As Clifford Geertz wrote, "Community is a culturally defined way of life." Yet, many come in and share in the Gullah/Geechee way of life through the courtesy of community members welcoming them in and they then want to be the ones to define for the Gullah/Geechee what their community should be. "Jus likka dem wha cum ya befo', peepol duh yeddy wi wod an' ting wile e set doung ya fuh a lee bit. E ain duh kno wha wi duh sey doe." In English, this would be "Just like those that came before, people hear our words and things while they are here for a short time. They do not understand what we are saying, though." Given this fact, the problem of collecting the words, documenting the ways, the crafts, the photos, etc. is that, more often than not, there is no clear understanding attached to them afterward. The establishment of the heritage of the Gullahs and Geechees and the preservation of that heritage has happened because of the methods that the Gullah and Geechee people established within their compounds. They found means to keep their culture and their ways alive.

Today they struggle in the face of not only "development" causing people to be more interested in relaxation and recreation than preservation, but also in the face of misunderstanding. Since it was misunderstood that when these African people were captured, they had skills and knowledge and were not simply ignorant people captured to be a labor force, it is not surprising to Gullahs and Geechees that unto this day, people feel that they need to come in and assist them. Just as the missionaries did during the Civil War, there are still those that feel they need to come into the Gullah/Geechee community and teach the people. However, the Gullahs and Geechees molded and maintained their story which they share with the world from beyond the family compound now. A mass of them are now "returning to their roots, investigating their past, and delving into that past, to enter upon a passionate

quest for traces of those beings and those things that have guided their destiny." There is a realization that:

> among the regular African American society, people don't even know us, that we still had our own distinct society. I don't know what they are looking for. I think they are looking for the quaint picture out of books... people walking around with baskets on their heads and standing out in fields. And they don't see it and they go. It is interesting to know that there are so many people and so many cultures all around and people don't understand the importance of preserving them. And it doesn't mean that there is anything wrong. That's nature, self preservation. And that's really what I want to do, is just I want people to share in our culture, but don't try to annihilate our culture and then celebrate it out of book! Instead of having pictures up about what we used to be, we should be here, living, breathing, showing you who we are, not what we used to be.
>
> <div align="center">****</div>
>
> I think that's why it is important that people around the world understand we are here, before we are eliminated by people with a mainstream mentality and people coming in with other cultural perceptions and trying to superimpose that on us.
>
> <div align="center">****</div>
>
> You understand that to survive here the way we do, that people did most of these interviews in English. That is our method of survival, to keep hidden the things that the other people don't relate to. Gullah language, certain Gullah traditions, or whatever. And so, I'm sure half the people here will keep on doing that. Just to survive.

The mechanism(s) of survival for Gullah/Geechee people has always been the continued "free determination of their own actions" which is one of the definitions of self-determination given in *Webster's Comprehensive Dictionary of the English Language*. As of July 2, 2000 when the Gullah/Geechee people decided to be officially recognized as a Nation with their own leader/spokesperson as the "head on the body" of the Gullah/Geechee Nation, they took the first step toward the other definition of self-determination — "the right of a people to decide its own form of government or political status." The Gullah/Geechee Nation now stands on the United Nations Declaration on the Rights of Persons Belonging to National or Ethnic, Religious and Linguistic Minorities (1992) and expect to have their rights recognized, adhered to, and protected as do all other people of the world. As people come into their community to see and to record, they prefer that the people understand that it is better to share. It is important to understand. Both of these come through communication at the center of which is the 'ritual' of communing. Communication requires speaking many times, but most of all it requires attention

and listening. Thus, in order to preserve the accuracy of the Gullah story and the richness of the Gullah/Geechee community for the centuries to come, the Gullah/ Geechee Nation now rings out with the statement "Hear Us!!!----Yeddy Wi!"

ENDNOTES

[1] Joyner, Charles, *Down by the Riverside*, p. 323.
[2] Twining and Baird, *Sea Island Roots*, p.VII
[3] *Supra.*, p. VII-VIII.

BIBLIOGRAPHY

Baird, Keith E. and Mary A. Twining, *Sea Island Roots*. Trenton, NJ: African World Press, 1991.

Branch, M M, *The water brought us: The story of the Gullah-speaking people*. New York, NY: Cobblehill Books, 1995.

Goodwine, Marquetta L., *The Legacy of Ibo Landing: Gullah Roots of African American Culture*. Atlanta, GA: Clarity Press, Inc., 1998.

Joyner, Charles, *Down by the Riverside*. Urbana, IL: University of Illinois Press Fields, 1985.

Vogel, Peggy "Biculturalism and Identity in Contemporary Gullah Families" February 25, 2000 Doctoral Thesis for Virginia Polytechnic Institute and State University Additional Resource Goodwine,

Self-determination & the Sami People

Ragnhild L. Nystad

The Samis are one nation living in four states, Finland, Norway, Russia and Sweden. We have inhabited this area long before the states were established, and we are an indigenous people. The Samis in Finland, Norway and Sweden have elected Sami assemblies, the Sami Parliament. The Russian Samis have not yet got their own Parliament. Even when we live in four states we have got the same culture, language (the Sami language) and the same organisations and institutions.

I would like to direct your attention to what the Sami Parliament in Norway considers to be the basis for claiming self-determination, then discuss our expectations in relation to the issue. The Sami Parliament in Norway has clear views on the right to self-determination, and I would like to focus on some of the principles which are fundamental in this context.

The right of the Sami people to self-determination must be based on the assumption that the Sami are a distinct people – an indigenous people attached to a particular geographical area. A people's right to self-determination is an internationally-recognised principle which member countries of the UN are obligated to promote and protect. Like indigenous peoples from all around the world, the Sami have claimed and continue to claim that the right to self-determination also applies to the indigenous peoples of the world, so it must be respected by the global community. Accordingly, one of the most basic tenets of the Sami is: "The Samis are a distinct people, meaning they have the right to self-determination."

This refers to a collective right to decide our own future. It is also an internationally recognised opinion that states should recognise peoples' demands for self-determination. The state is required to facilitate social and cultural development based on the people's own terms and conditions.

> **The right to self-determination has been contingent on the good will shown at any given time by states' current governments. The state policies end up being more random than binding.**

However, the situation for indigenous people the world over, is that most nation states have not recognised or imple-mented these rights. This makes the right to self-determination contingent on the good will shown at any given time by states' current governments. The state policies that have an impact on indigenous peoples end up being more random than binding. Nor have the states fully accepted this, not even the states established on the Sami territory.

It is imperative to establish that self-determination is something the Sami have as a people and as an indigenous people, basically in all areas of society, by virtue of our position as a distinct people.

Thus the states should enter into negotiations with the Sami people, represented through the Sami Parliament, regarding the various areas. Notwithstanding, it must be the Sami that determine the areas over which it may be expedient for them to have control. Thus, in terms of spheres of responsibility and influence, the demarcation line between the Sami and the Norwegian authorities should be arrived at through genuine negotiations and agreements. To accomplish that, however, it will be imperative to establish a common understanding of some *fundamental criteria* for working together.

Accordingly, the right to self-determination also entails the Sami's right to cede their right to make decisions. In other words, it is the Sami themselves, and not the state, that determine the areas of society over which the Sami people shall govern, control and administrate.

The right to self-determination also entails the Sami's right to cede their right to make decisions.

The Sami Parliament's scope of work, its challenges and its target areas in the years ahead must be viewed in the light of the right to self-determination and the material basis for the Sami culture.

The Sami community stands poised on the threshold of a recently initiated development phase in a number of key societal sectors. In fact, it is only recently that the Sami community has made sufficient progress to even begin this *development phase*. By way of contrast, the national community has completed its development and is currently in what might be called a *transition phase*. This is why comparisons should not be made between the Sami community and the national one when it comes to the distribution of resources. As you may know, The Sami Parliament in Norway is only in its third election period, meaning it is natural that the Sami's Parliament is just beginning the process of building up the Sami nation, a process that will take place on the Sami's terms and conditions.

The Sami are an indigenous people and they constitute a numerical minority of the country's population. This means that our future depends very much on the state recognising our fundamental rights.

Governmental measures instituted in relation to the Sami must be evaluated on the basis of the Sami's own needs and historical background. The relationship between the central state authorities and the Sami as a distinct people is not, as you know, first and foremost a question of welfare policy, social policy, regional development policy or industrial policy, although all these areas are important. The primary point at issue is the relationship between a state and an indigenous people, and how to organize an indigenous peoples' policy in which elements from the above-mentioned areas and others form parts of a larger whole.

It will be a major task to achieve mandatory negotiations between the Sami and the Norwegian authorities in cases where this, in the opinion of *the Sami,* is necessary. This obligation would entail more than merely consultations; it would have to be mutually binding.

In Pursuit of the Right to Self-determination

The rules of international law by which Norway is bound, and which impact the Sami's legal position, must be considered to be binding Norwegian law, at the same time as they ensure that national legal provisions are effective. In this context, I believe there is a need to update domestic law to bring it into line with legal trends in indigenous peoples' issues. In this connection, I want to draw your attention to the fact that the UN Committee on Human Rights, in October 1999 expects Norway to report on the Sami people's right to self-determination under article 1 of the International Covenant on Civil and Political Rights, including paragraph 2 of that article.

People's right of self-determination must apply equally to all peoples, including indigenous peoples, naturally. In this context, I refer, among other things, to the work on the United Nations' Declaration on the Rights of Indigenous Peoples.

By way of conclusion, I would add that the Sami people and our indigenous brothers and sisters around the world are undergoing an important process. We face a multitude of challenges and our rights will be key factors in how we deal with them. Firstly, we must obtain international acceptance for indigenous peoples' right to self-determination. After that, each individual indigenous people and each state must find solutions to the challenges inherent in self-determination their particular case.

Self-determination in relation to the principle: National Integrity of a State*

Joseph v. Komlóssy

I. FOREWORD

Before I start my presentation, I would like to say a few words about myself. I hope you will understand me if I say I am looking at the whole ethnic and national minority issue with the eyes of a person who – for several reasons – is personally strongly involved in this topic.

Once in a discussion among officials of the Council of Europe, delegates, and experts, during the introduction of the *Charter for Regional and Minority Languages* in Strasbourg in 1998, the chairman, Mr Fernando Albanese, responding to my intervention, said to me: "Mr Komlóssy, you are a maximalist!" My answer was: if I am a maximalist, then let me tell you my three good reasons for it.

First, my attitude is largely determined by the fact that I lived most of my lifetime in Switzerland, a country which has earned great worldwide respect for her direct democracy.

Second, I am an engineer by profession, accustomed to working with a reasonable margin of security.

And last but not least, I am a legal representative of minorities, which makes it ethically impossible for me to be a minimalist.

Consequently, I am always and stubbornly seeking for an equitable, just and lasting solution for ethnic or national minorities, for a solution which can provide them with the security in the long run to preserve and further develop their national identities.

II. INTRODUCTION

The Universal Declaration of Human Rights in 1948 was a big step; it was a good step in the right direction. Ever since, however, the Universal Declaration was only able to achieve the absolutely essential. The existence of the Document did not automatically provide the necessary guarantee of human rights to all its citizens

* The full title of this paper is "Self-determination in the framework of the International Convention on Civil and Political Rights and the Helsinki Final Act in relation to the principle: National Integrity of a State."

of the UN Member States. With specific regard to ethnic communities, the Declaration is far from ensuring equal conditions of life. Human rights for an ethnic community without adequate social, economic and cultural rights granted are *pro forma* commitments, in fact "words, words, mere words", lacking real substance and allowing collective discrimination.

It cannot be said that individual rights or subjective rights would do, because they accumulate into collective rights by themselves. No, a number of human rights can only provide the minority with security if they are being applied to the ethnic minority as a whole. It must be made clear: in several aspects of life, to provide only individual rights is not enough at all. Assuredly, it is a well known fact that many human rights can only be exercised collectively. Take only two fields as example: one is religion, the other includes the whole complex of educational rights in the mother tongue. In both cases, these human rights can only be exercised collectively.

Taking into consideration the fact that in Europe nowadays the bigger conflicts no longer take place between states, but inside the states themselves, then we ought to look for the reasons, and consequently, for possibilities for preventive measures to avoid ethnic tensions growing out of control.

At the same time, following the political changes in East and Central Europe in several countries, the process of democratisation has been accompanied ever more often by the demand to grant the right of self-determination to groups and to national minorities.

The topic of our Conference is self-determination and the United Nations.

After the experience gathered during the last two days I find it absolutely necessary to define what self-determination of an ethnic group or a national minority means. Furthermore, it is necessary to differentiate between *internal self-determination*, and *external self-determination.*

The definition of self-determination – in general – is very clearly described in the International Convention on Civil and Political Rights of the United Nations, and in No. VIII of the Helsinki Final Act. I will quote both of them below.

Internal self-determination does not affect the integrity of a State. In other words, internal self-determination does not aim at changing the internationally recognised border of a state.

The accomplishment of *internal self-determination* means that a numerous ethnic group or national minority, in order to safeguard its ethnic or national identity and to preserve its own national recourses within a clearly defined border of its settlement or settlements, decides to take its own affairs in its own hands. Accordingly, it establishes its own bodies and institutions in all fields: from local legislation through the issues of education to the management of local finances. All that is within the legal framework provided by the International Convention on Civil and Political Rights of the United Nation and the No. VIII of the Helsinki Final Act. Furthermore, it must be emphasized that it stays in full conformity with the principle of subsidiarity.

> **Internal self-determination permits a national minority to establish its own bodies and institutions in all fields: from local legislation through the issues of education to the management of local finances.**

Let me recall as a classical case, the creation of the Canton Jura in Switzerland. Several years of ethnic tension among the German speaking majority of the Canton Bern and the Francophone minority settlements in the North of the same canton resulted a dialog and finally, they came to a mutual agreement in 1976. A plebiscite took place in each community in the region. The outcome was the birth of the Canton Jura. It was promptly recognized by the over-whelming majority of the Swiss population, **In 1976 in Switzerland, a classical instance of internal self-determination was realised without casualties or notable material damage.** and the parliament of the Swiss Confederation. The Swiss peoples can be proud of the triumph of their democracy, because with the process which took place in time, it was possible to avoid ethnic tension growing out of control or in a worst case scenario, the secession of the French-speaking and Catholic population to France. Consequently in 1976 in Switzerland, a classical instance of internal self-determination was realised without casualties or notable material damage.

One result of the major political changes during the beginning of last decade in Central and Eastern Europe has been the creation of a number of new States. In one of the classically artificially created states, Yugoslavia, the exercising of peoples' rights to self-determination resulted in a tragic civil war among the *Brother Nations.*

The idea of self-determination of peoples as a part of a political peace program was launched by US President Woodrow Wilson in 1918, in the form of the famous Ten Points. According to point No. 10: *" The Peoples of Austria-Hungary must be given the right of Self-determination"*; further on: *"Peoples and provinces can not be transferred from one State supremacy to the other as pawns of a game."* The wise words of Wilson were overlooked. The exercise of the basic human right of self-determination by the great majority of cases for the nations of the losing powers after both World Wars was denied. Consequently, most of the newly created states in East and Central Europe had artificial borders. The imposed borders were drawn according to strategic military, economic and political reasons.

The ethnic situation or the cultural traditions of the region were considered very secondary, and were deliberately ignored. However, they could not be eliminated. As a consequence, after both World Wars, numerous national minorities were created encompassing millions of people; with them, not only were a high number of cases of ethnic tension created but in some instances, even ethnic cleansings in Europe were definitely pre-programmed.

At present, we have to live with these borders. We must try to make the best out of the given situation, whether we like it or not. Accordingly, let us see what are the legal frameworks to provide a reliable ethnic and national protection for those millions numbered as members of national minorities.

III INTERNATIONALLY VALID BASIS FOR
THE SELF-DETERMINATION OF PEOPLES

Among a number of internationally valid bases for the self-determination of peoples, I would like to refer to the following:

1. The International Convent on Civil and Political Rights, entered into force on 23 March 1976, in accordance with Article 49 of the Preamble.

In Pursuit of the Right to Self-determination

Article 1 General comment on its implementation

1. All peoples have the right of self-determination. By virtue of that right they freely determine their political status and freely pursue their economic, social and cultural development.

2. All peoples may, for their own ends, freely dispose of their natural wealth and resources without prejudice to any obligations arising out of international economic co-operation, based upon the principle of mutual benefit, and international law. In no case may a people be deprived of its own means of subsistence.

3. The States Parties to the present Covenant, including those having responsibility for the administration of Non-Self-Governing and Trust Territories, shall promote the realization of the right of self-determination, and shall respect that right, in conformity with the provisions of the Charter of the United Nations.

The right to self-determination of peoples (Art. 1) : 13/04/84. CCPR General comment 12. (General Comments)

General Comment 12 The right to self-determination of peoples (Article 1) (Twenty-first session, 1984)

1. In accordance with the purposes and principles of the Charter of the United Nations, article 1 of the International Covenant on Civil and Political Rights recognizes that all peoples have the right of self-determination. The right of self-determination is of particular importance because its realization is an essential condition for the effective guarantee and observance of individual human rights and for the promotion and strengthening of those rights. It is for that reason that States set forth the right of self-determination in a provision of positive law in both Covenants and placed this provision as article 1 apart from and before all of the other rights in the two Covenants.

6. Paragraph 3, in the Committee's opinion, is particularly important in that it imposes specific obligations on States parties, not only in relation to their own peoples but *vis-à-vis* all peoples which have not been able to exercise or have been deprived of the possibility of exercising their right to self-determination.

8. The Committee considers that history has proved that the realization of and respect for the right of self-determination of peoples contributes to the establishment of friendly relations and co-operation between States and to strengthening international peace and understanding.

2. Next, concerning OSCE member States, I would like to deal with the OSCE Final Act from Helsinki. It dates as far back as 1975.

VIII. Equal rights and self-determination of peoples

The participating States will respect the equal rights of peoples and their right to self-determination, acting at all times in conformity with the purposes and principles of the Charter of the United Nations and with the relevant norms of international law, including those relating to territorial integrity of States.

This paragraph makes it very clear that the Act speaks definitely of internal self-determination. Let us see further :

By virtue of the principle of equal rights and Self-determination of peoples, the peoples always have the right, in full freedom, t*o determine when and where, as they wish their internal and external political status, [italics added]* without external interference and to pursue, as they wish their political, economic social and cultural development.

The autonomy right of ethnic groups must be considered as the most essential part of rights to internal self-determination.

IV. THE DIFFERENT FORMS OF AUTONOMY:

The different forms of autonomy are the best means of preventive measures:

- by granting Territorial autonomy in time, it is possible to prevent ethnic tension from growing out of control
- by granting territorial autonomy in time, it is possible to prevent secession

Autonomy means an instrument for the protection of ethnic groups which, without prejudice to the territorial integrity of the States, shall guarantee the highest possible degree of internal self-determination and a corresponding minimum of dependence by the national minority. Autonomy is an instrument to protect ethnic groups from being outvoted by majority decision makers.

Autonomy guarantees the highest possible degree of internal self-determination and a corresponding minimum of dependence by the national minority.

The definition of the FUEN distinguishes three types of autonomy:
- Territorial autonomy
- Cultural autonomy
- Local autonomy or self administration

The particular situation of a certain group determines which form of autonomy could be suitable. In general, a group and their members shall have the right to autonomous legislative and executive power to conduct their own affairs, wherever possible, in the form of ***Territorial Autonomy.***

Safeguarding its own affairs shall take place through its own bodies for:
a. legislation
b. executive power, with corresponding administrative structure
c the administration of justice, providing that these are
responsible and reflect the composition of the population,
d. taking all finance maters in their own hands. Like collecting
taxes, financing their own projects, etc.
e. the matter of education

i. Territorial Autonomy

Territorial autonomy shall be comprised of all the powers which the ethnic groups consider necessary for conducting their own affairs and which shall be designated in national legislation as falling within the competence of the territorial autonomy. It is important to point out that a well-functioning local self-administration is just as advantageous for the majority as it is for the communities of the ethnic minorities. According to the highly respected Slovak political scientist, Professor Miroslav Kusy of Comenius University in Bratislava:

> Territorial autonomy does not have secession as its final aim... In its essence, autonomy means self-administration. This is equivalent to the decentralisation of power, i.e., to the delegation of powers to the lower of more local levels. This is exactly what Democracy is founded upon. Therefore territorial autonomy is something both the Slovak and the Hungarian regions are equally entitled to, because democracy is indivisible.

I completely agree with Mr. Kusy. Besides territorial autonomy, a cultural or local autonomy would provide the communities of autochthonous populations with sufficient power to safeguard their rights and institutions, which are indispensable for the maintaining of their identity.

ii. Cultural Autonomy

An ethnic group not forming the majority of the population in the areas where they are settled as well as an ethnic group which — for whatever reason — considers the establishment of territorial autonomy as unnecessary, shall have the right to cultural autonomy in the form of an organisation with public law status that they consider appropriate.

The organisation managing cultural autonomy should be an

association of individuals comprising persons belonging to the ethnic group and elected freely according to democratic principles.

iii. Local Autonomy or local self-administration

Ethnic groups not forming the majority of the population in the areas where they are settled, as well as persons belonging to ethnic groups who are settled away from those in isolated settlement, shall have the right of a *local self-administration, denominated local autonomy* — as is the case in Hungary concerning 13 ethnic minorities — within administrative units where they form the local majority of population, e.g. in individual districts or municipalities or administrative sub-units.

Self-determination, self-government, autonomy. There may be (and certainly is) disagreement as to the exact meaning and content of these concepts. However, what is really important, is the basic idea of intending to ensure stability and reconcile people with each other in a democratic, tolerant manner. The particular ways may be different, taking into account the local circumstances. Accordingly, Territorial Autonomy, Cultural Autonomy and Local Autonomy could be applied.

I am convinced: the just and lasting solution to the ethnic, national and religious minority questions of our world are the key to the stability in the world. That is why to seek an appropriate and viable solution to the ethnic and national minority question is a common task for all of us.

Structures of Governance Rights & A General Assembly of Nations

Françoise Jane Hampson

I need to explain my starting point before I look at ways in which the democratization of the United Nations system can be encouraged by means of reliance on certain principles of governments and issues of minority rights. In any kind of attempt to persuade states to do something, you need to be profoundly practical. You need to start from where they are now, if you want any chance of getting them to move in another direction. That means we need to understand where states are. We can't get them to accept the premise on which you wish to work. You've got to accept theirs. It is also a matter of not simply looking back; it is a matter principally (a point that Gerald Kaufman made) of looking forward. One reason for that is simply because something now is illegal does not mean it was illegal at the time it was committed, and so as far as legal obligations is concerned, more is gained by looking forward than looking back.

In terms of my starting point with regard to human rights law, human rights law is both an end in itself and a means to an end. When it is a means to an end, the end in question is promoting national, regional and international peace and security. Ultimately, unaddressed serious human rights violations will lead to threats to international peace and security. The significance of this link is that it should make internal human rights concerns a matter of concern and priority to the international community. If you are raising a serious human rights concern, it is not just a human rights issue; it is a peace and security issue. A peace and security issue in one state is very likely, if not addressed, peace and security issues in other states. A second starting point concerns the phrase, at least to a lawyer, self-determination. It has acquired a very particular feeling in the use of the phrase in international law and international practice. It means "the right of peoples in non self-governing territory or colony to independence". When a linked but not identical idea is being framed, I think it would be helpful to use another term if that were possible. I suspect that many states are alienated by the claim of minority groups to "self-determination" because I think this necessarily means what self-determination has come to mean. So I think it would be helpful if another term or phrase could be found. I shall be suggesting one which I don't think is necessarily good, but it is better than nothing at the end.

The idea the conference is looking at is the implication for structures of governance of the rights of certain types of minorities. I first think it is necessary to identify different possible types of minorities, I do not think this is an exhaustive list, but I am trying to advance an argument I think states may be open to. At this stage of the argument, minorities include: indigenous peoples, national minorities, ethnic\racial minorities, linguistic minorities and sexual minorities. Straight away, I want to distinguish the first group, indigenous peoples, for a variety of reasons, including a particular type of relationship to a particular land, a particular relationship to the environment and a particular social structure. Indigenous populations need a particular type of relationship with the authorities of the state, and that is currently being addressed. Whether it is being enforced is a separate question, but the special rights or whatever you are going to call them of indigenous peoples, is a matter of life concern and there is no prospect of minorities generally getting the same rights. It does not do indigenous groups any good for minorities to leap on their bandwagon. So I think it is more helpful not to include in this analysis what one could do for minority rights, with regard to the impact on systems of government, if indigenous peoples are set to one side of these focuses.

Similarly, I would like to distinguish the last group I suggested, and that is sexual minorities. Though they may need recognition as a group that is discriminated against, the protection of their rights does not have implications for the structure or organization of government.

So, what are the rights of the other type of groups I have identified, most notably, national minorities? There needs to be a couple of caveats about the concept of rights. If international law wills the end, it must also will the needs. In other words, if it not only fails to order the means but actually prohibits them, then it is most unlikely that what is at issue is a right. A second clarification is that just because a group does not have a right to something doesn't mean that they cannot be granted it. It may be morally desirable or it may be politically wise to support it.

If self-determination is understood as a right to independence, then national minorities do not have a right of self-determination according to international law, with one exception. The General Comment of the Human Rights Committee of article one of the International Covenant on Civil and Political Rights implies that if a minority of a certain type is denied the right to participate in public life, as a result of which the central authorities do not represent them, then they may have a right to self-determination. Let me give you examples of two extremes and then one which I think is more difficult. If a national minority group or members of it is persecuted on grounds of their political image, which they are expressing peacefully, then that would not be enough, according to the Human Right Committee, because there is no evidence that they are not participating in public life. If there is a situation where everybody in a state over the age of eighteen can vote except members of a national minority, then clearly the state can't claim to represent them, so in that situation it would appear to come within the General Comment.

What I think is more difficult, and this is the situation that currently exists in one country not far away, is if you are allowed to create a political party, but each time you create a political party to enable the expression of a particular view, those parties are being banned, is that enough to indicate that you can't participate in public life because you can't vote for a party you want to vote for? This is a

problem in South East Turkey, where DEP was the successor to a previous organization trying to represent the Kurdish viewpoint, and when that was banned, havoc has replaced it.

So I think there is an issue when it comes to political parties, but generally speaking with that exception aside, there is no right to independence for national minorities in international law. For example, international law actually opposes secession, by which I mean the breaking away by one bit of a sovereign state from that state. In other words, this does not apply to colonies. So international law opposes secession and prohibits assisting non-state fighters, except where fighting in the name of self-determination and that means in the context of a colony.

Bit that is in fact not an answer to the question. Members of minorities have rights. It is not clear if minorities as such have rights or if it is just members of minorities. That varies according to different texts. If minorities as such were to have rights, it does give rise to certain legal problems about how you test the joining and leaving of groups and who decides. But there are minority rights recognized in international law, in the International Covenant and in certain regional texts, and there are interesting developments in Europe in that regard. The nature of some of the alleged rights of members of minorities or minorities, can in fact only be fulfilled or fully be implemented if there are structural changes developed. For example, again taking both extremes, freedom of speech for members of minorities has no implication for the structure of government. But if there is a right to protect a minority language used by a national minority, then it is possible to argue that we do not need changes in the structure of government but you are going to need legislative protection. So, you already have implications for doing something positive.

But how can you enable a minority to protect its identity and to protect its culture if it cannot legislate for itself? In other words, in order to give effect to the rights of individual members of the minority, the minority needs to be recognized as such. This means you need to be able to deal with the minority as such. In other words, the rights that are already recognized as belonging to either members of minorities or minorities as such, can only be fulfilled , the state can only satisfy its existing obligations, if in some cases, legislative authority is given to representatives of minorities and in addition, if there is an obligation of the state, whether they like it or not, to recognize that they are dealing with minorities.

How can you enable a minority to protect its identity and to protect its culture if it cannot legislate for itself?

But that is not enough. As we have seen when it comes to the protection of human rights generally, it is not just a matter of getting states internally to do something. In the past twelve months, we have seen the impact of concerns of how the international system works, in particular in relation to the World Trade Organization and the Bretton Woods institutions. In other words, if states are to fulfill their obligation to minorities, not only do they have to recognize when they are dealing with a minority; in some cases it will mean according them legislative authority. It also means those states need to look at the structure of the international legal system to make sure that it can take on board the rights of minorities, because otherwise, states are going to be prevented from fulfilling their own human rights obligations to minorities on account of these very international structures.

Now, if that framework of analysis, all flowing from the existing legal obligations of states with regard to minority populations, is to be accepted, two things flow from it. First, there needs to be a system for recognizing which minorities qualify and the states need to be required to recognize a qualifying minority. Secondly, there is absolutely no doubt that this has implications for structured governance. It is not a right for independence, it is not a right to secession; nevertheless, there are implications for the structure of governance within quite a wide spectrum of

There needs to be a system for recognizing which minorities qualify and the states need to be required to recognize a qualifying minority.

possibilities. It may be that a group may not need to have their own assembly, but you may need to take into account the existence of the group when composing the state's assembly. It could be, if it's a bicameral system with two chambers, the equivalent of, say, the House of Representatives in the United States, or the House of Commons in England; it could be that that will be first past the post whereas the second chamber, in the case of the US Congress or again the House of Lords, could be based on regional or national representation. Another possibility would be to ensure that the actual voting system has a topping up process, so groups could be represented as such. So it's first past the post for some seats, but then there's a topping up mechanism where you can get representative positions. The experience of Israel suggests that this is not altogether to be recommended.

There is also another possibility, and that is that the group, in order to be able to fulfill its needs, needs its own assembly, that is to say, some measure of autonomy. I do not think that it could be said that all minority groups need the same type of structure in order to meet the needs that have already been recognized in international law. Some states seem to claim to want life to be tidy. I see absolutely no reason in principle why the same degree of autonomy needs to be afforded to different minority groups if their needs are different. I have no problem with the fact that Scotland has got legislative devolution and Wales has executive devolution. If that is what meets the needs of the people in those areas, then the fact that they are different from one another is likely not going to hurt. The fact that it looks at last like the French are going to do something about Corsica doesn't mean that all other groups will necessarily have to be treated in the same way. I don't see any problem with diverse arrangements.

What is the impact of this on the democratization of the United Nations in the international system? I think there are parallels between the calls of minority groups for the democratization of the UN and the calls for the Bretton Woods institutions — the IMF, the World Bank and the WTO — to take into account human rights concerns.. If the goal of the international system is to protect peace and security; then they have got to take on board the implications for the governments of the international community. It is not just a matter of implementing that goal internally; it is a matter of the international community itself, through all its institutions, promoting international peace and security. That means they have got to give meaning to minority rights internationally on the international scene, and it flows logically from the recognition of minority rights as human rights. In the case of national territorial minorities, at least, and possibly some other groups, and at least

where there are no other states that have the majority. For example, Hungry is a case in point. Hungarian minorities in other states would not necessarily come under this principle, but when you have got national territorial minorities then initially, at the very least, you need an international forum.

I think this forum needs to be institutionalized. It needs to be made into the third part of the UN structure. You've got the Security Council, which is supposed to be, in effect, the cabinet of the international system. You've got the General Assembly, which is an assembly of all recognized states. You need to have, in effect, a General Assembly of Minorities or Nations, or some other formula. It is necessary for that new international assembly of minorities, in the international sense, to actually have a role with regards to existing institutions, and it doesn't mean a change to the constitution with regard to the existing institutions. For example, I think the specialized agencies of the UN need to be required to engage with this international forum. I think there needs to be revised constitutions at least in the General Assembly, to sort out how an assembly of the nations would actually feed into the UN system, but I think it is all part of the international recognition of minority rights.

So how do you get from where we are now, which is the implementation of minority rights, with some recognition of their existence, and virtually no profile, except for indigenous peoples at the international level, to what I am talking about: effective representation of minorities within the international system? I don't think you will get there by focusing now on an Assembly of Nations. I think what you need to do first is get in place the right conceptual analysis of minority rights. You need to get the conceptual analysis of what states have already committed themselves to in the International Covenant on Civil and Political Rights, and you need to get an analysis that includes, in at least some cases, as a necessary mark of minority rights — not an optional way of doing it because you feel like it — that some minority rights can only be fulfilled by modifying current structures of governance in order to give full effect to what has already been recognized.

Now there is still a lot of conceptual work that needs to be done there, and the movement is already seriously handicapped by use of the label self-determination, because of its connotations of independence. Until something better is found, I would suggest "structures of governance rights" as a way of describing not just language rights and rights to manifest culture, but the necessary implications of those rights for government structures. So I offer "structures of governance rights" as the rights that national minorities need to be able to work with and in order to give full effect to their

> **"Structures of governamce rights" are the rights national minorities need in order to give full effect to their rights as recognized in international law.**

rights as recognized in international law. That will be the first step. When something is done along those lines, it will be time to move to an Assembly of Nations, and possibly to regional assemblies of nations. You need to insist on structural connections between those assemblies of representatives of nations and the existing international system. It will need to be plugged into the General Assembly, it will need to be plugged into specialized agencies, and you need to ensure that when

anyone is undertaking any sort of project anywhere, that they consult the appropriate mechanisms for these assemblies. If states do not give meaning to devolution or autonomy, or if they do not give international meaning to that concept, then it is their fault if you end up asking for self-determination in the traditional sense. So there is an incentive on states, I would suggest, to think in terms of governance rights.

I think it is now up to you to campaign.

Self-determination in the Context of Global Problems

Mehdi M. Imberesh

Due to my position as a professor of philosophy and history, I would like to recite from history itself. Because I was following two doctorates of history, I do believe that the issues across the face of history can't be solved by a simple way of thinking.

History to me is not the past; history to me is the existence of mankind. I don't believe in the Trinity which divides history into past, present and future. Rather, I view this as one of the problems which one should consider when dealing with history.

Having followed the recitation of the history of India provided by a delegate here and once again seen how knowledge of that history is pivotal in relation to understanding the situation of the blacks in India, we need to consider what history must mean in relation to the defining of an historical nation. Does it mean that it goes back to a type of awareness of self-identity; that it is not just a problem to deal with now? We have to go back in order to solve such kinds of problems.

For the historical nations, land is not just a material thing to be dealt with like the colonists do. The land is alive. It has special meaning, because we cannot prove our existence through action unless we have our own land. So land is history, itself. We can't deal with land as a material thing. This is a falsification of philosophy in dealing with history and land. Land has a spiritual meaning.

Most of the problems that we are dealing with now are historical problems. The Palestinian problem is not a political problem, it is an historical problem. We cannot ignore this reality. This means that the issue concerns not only ourselves, who are alive, but those who died and are buried. You cannot solve these problems just by talking and by signing agreements. We should think them over. Signing agreements is not enough. It may seem to solve the issue and bury it, but it will rise again. In order to solve the central problems, we should deal with them historically.

Now, the international community gives a lot of talk to the matter of "black" and "white" — it's very silly to talk like this. It's not my decision to be white or black, I am created as I am. So no one can try to prove that he is superior because he is white or black. It is a very silly issue which we still deal with. The same with man and woman. I did not decide to be a male, and that I am better than you because I am male. The same with East and West, South and North — this is a very silly philosophy to deal with now. So, to be united, do we need to have a United

Nations? We need to have a *united philosophy*, where we can look on each other as equal. As it stands, we have a dualism as a nation — black and white, east and west, south and north, first war, second war, third war. Far east. Near east. When I read the philosophy of all the European philosophers, I discovered this strange tendency. Unfortunately they don't understand all as one. They have to define the world as three. If mankind means I am not one, but divided into three parts — this is a false philosophy, because mankind is one, irrespective of race, color, religion. So what we need to think about is a philosophy of unity. It has to be a part of our world thinking. For most of us, our world thinking still needs to be corrected.

I come to the United Nations: does the United Nations represent the nations of the world? I don't think so, because this body was formed after the Second World War to justify the position of the victors after the Second World War. What does it mean to have permanent nations and "impermanent" nations? What is a permanent nation? Does this mean that the Arab nations are not permanent? We still want to be nations. This is discrimination. What is the Security Council? Is it the Security Council of nations, or the Security Council of the Super Powers? To have a Security Council of the nations, it will need reform.

So I know that we have people representing governments and the United Nations. I know now, out of all these, I ask them all if we are combating human beings' true problems. When it comes to representation, to representing people — I don't believe in representation. Why should we represent somebody who is present? Why should governments be formed of representatives of the people when the people are present and can represent themselves? This is a political system from the past.

I am afraid that we are withdrawing from a vast battle which requires that we should struggle with the right understanding. The issue is not, say, the issue of men controlling women and women fighting for their rights. Rather, I think in most countries, we have a situation *not* of all men controlling all women but of one man or a few controlling the whole of them. This is the problem. We are fighting a different war — we should fight together.

I understand the matter of ethnic minorities, but I think we should address the fact that today's world is the world of minorities of a different kind, those who are controlling the majorities. Those who monopolize wealth are minorities; those who monopolize knowledge are minorities. Those who monopolize weapons, they are minorities. So the minorities of the world are controlling the majorities. Of course, when we come to local areas, we can talk about minorities and majorities, but in fact the world is fighting now against those minorities who are controlling the power, the wealth and the weapons, and jeopardizing our existence.

Talking about human rights is all very well, but what about the *existence* of human beings? Our very existence is in danger. Where the existence of the human being is in danger, talking about the rights of the human being is another issue. I am not against human rights, but I think we should fight to apprehend the actuality of the existence of humankind. In Africa, they are dying of hunger, of disease, of ignorance, while we are talking about — something else.

So if the United Nations is to be united, it has to be *the united nations*. We have to be equal in order to do this.

In Pursuit of the Right to Self-determination

I think we must fight globalization. As far as I know the English language, the "tion" is to describe a situation which is normal — but it is not globalizing, it is organizing by force to make something that is not natural be natural. I want people to work to be one, but I don't want to be put before any others or have others put before me. When I say self-identity, this means that I have my history, my culture. If anyone wants to reform the world, he will have to accept the others. But we cannot be one, as Fukayama said in *The End of History and the Last Man*. What does the last man mean? It means a veto against the development of history. It means that we have no will to do, ourselves. History has been taken. Everybody has to follow the model.

> **If anyone wants to reform the world, he will have to accept the others.**

To me, to exist is to have your land, your action, awareness and will. If I don't have a will to act, this means that I am just materialized. I need to have my will to act, I need to have my land to act upon, and I would like to determine myself, not to have somebody who can shape me in any way he wants. We don't want to bring about new relations just to have open mouths to consume the trash which our supposed benefactors produce. We want to eat as we like, we want to dress as we like, we want to state ourselves as we like, otherwise we will never have a United Nations.

For those of us who want peace — peace does not have only one definition. Peace is to understand each other. Peace is not to talk in only one language — because only in my language, am I myself, and stating my ideas. Peace will take many hours, but we can come to believe that we have one destiny, one future, and when we realize this, we will be forced to work together.

Self-determination as a Means of Democratization of the United Nations & the International System

Hans Köchler

THE UNITED NATIONS ORGANIZATION AND THE QUESTION OF DEMOCRATIC LEGITIMACY

When it was founded shortly after World War II, the United Nations was not an organization representative of the nations (peoples) of the world. Contrary to the Preamble's slogan of "We the Peoples," the organization was established on the initiative of a small minority of the world's nations. At the time, a large number of peoples still had to live under the yoke of colonialism, which made the Preamble's evocation highly rhetorical, if not misleading.

As a result of the global constellation existing at the end of World War II, the United Nations Charter came to reflect the reality of the rather uneven power relations between the major powers of 1945 and the rest of mankind. The unequal power balance of the post-war period resulted mainly from the fact that so many peoples in what was later to be called the "Third World" were subjected to colonial subjugation by a few European powers, including the United Kingdom and France, major international players who co-drafted the UN Charter with the other post-war powers. The majority of today's UN member states did not yet exist when the organization was founded. Consequently, the Charter was drafted not only without their participation, but without due attention to the legitimate rights of the peoples of the then colonial territories. *Yet the same Charter, drafted by a minority of nations, is still valid in the present global constellation...* Thus, the majority of nations is bound by international rules (including regulations on the application of coercive measures) on the formulation of which it had no influence.

In Pursuit of the Right to Self-determination

The United Nations Organization is destined to operate on the basis of provisions that reflect the power balance of an earlier era, a fact which — in many instances — has effectively paralyzed its decision-making and conflict-solving capabilities.

A clear case in point is the category of "permanent membership" in the most influential body of the UN system, the Security Council. With the special veto privilege attached to it according to the provisions of Art. 27 of the Charter, this concept is a clear expression of the domination by the victors of World War II (including that era's leading colonial powers, Britain and France) over the rest of the world and of their intention to eternalize this uneven power balance by linking any Charter amendment to the requirement of their consent (Art. 108 of the Charter). This special veto right constitutes the biggest obstacle to the adaptation of the organization to the conditions of the post-Cold War era.[1]

It is the predicament of the United Nations Organization that it has been prevented from reforming its Charter along the lines of genuine transnational democracy[2] precisely because of the veto powers' self-interest in preserving the *status quo* of 1945. Particularly in regard to the composition and the decision-making procedures of the Security Council, the United Nations cannot (yet) be considered a "democratic" organization. In the present statutory framework it will be condemned to continue to operate on the basis of a "constitutional anachronism," namely the power structure of an earlier era that does not at all reflect the global realities of today.

It is a historical truth that in 1945 the majority of the nations (peoples) of the world had no chance at co-drafting — or merely influencing (on the level of international public opinion) the drafting of — a Charter, the provisions of which have been binding upon all of them up to the present time. In conformity with the iron law of power politics, the world organization was created to suit the interests of the great powers of 1945. For this reason, it can be stated without exaggeration that the United Nations Organization, in its present form, has only *limited* political legitimacy and virtually no *democratic* credibility in regard to the "peoples" of the world (or "Peoples of the United Nations," as referred to in the Charter).

It is often stated that the modern conception of self-determination originated with President Woodrow Wilson's *14 Points*, which he pronounced as the basis for a just new international order at the end of World War I.[3] This evaluation seems to be highly exaggerated, as Wilson, in his declaration of 8 January 1918, addressed the issue of decolonization merely as one of an "absolutely impartial adjustment of all colonial claims," mentioning "the interests of the populations concerned" as a factor to be given "equal weight" together with the "equitable claims of the government whose title is to be determined."[4] This can definitely not be seen as the formulation of a new principle of international law. The absence of a new universal doctrine of self-determination becomes obvious in the general context of the "14 Points," where the issue of the "freest opportunity to autonomous development" (Point X) is referred to on a rather *casuistic* basis in regard to territories of states that *lost* the war. Such a right to "autonomous development" is affirmed to the "peoples of Austria-Hungary" (Point X) and to the "nationalities ... under Turkish rule" (Point XII). However, no mention is made of a *general* right to self-determination of peoples, which would have included the national communities (peoples) living

on the territories of the United States and her allies. No doctrine of decolonization can be derived from this declaration either, as it merely juxtaposes the "interests of the populations" and the "equitable claims" of the respective colonial government.

It is consistent with this interpretation that the predecessor organization of the UN, the League of Nations, did not at all establish a policy of granting independence to the colonial peoples that were under the rule of the victors of World War I. It is not surprising either that the attempts of the indigenous peoples to establish recognition of their international status by the League of Nations remained unsuccessful.

It is an undeniable historical fact that it was the United Nations Organization that sponsored, in the post-World War II period, the large-scale decolonization process in Asia and Africa, and that helped to bring about the liberation of the peoples of South Africa and Namibia from the yoke of the *apartheid* system. The United Nations Organization provided the normative framework and the terms of legal reference that gave the post-war anti-colonial and liberation struggles their legitimacy in the eyes of the international public. However, the liberation struggles have not yet come to an end, which was implicitly admitted even by the Heads of State and Government at the UN Millennium Summit who — in their Declaration of 8 September 2000 — spoke of "the right to self-determination of peoples which remain under colonial domination and foreign occupation."[5] In regard to the latter, the question of Palestine is one of the most urgent issues of self-determination still to be settled.[6]

The *principle of self-determination* as enshrined in Art. 1 (2) of the UN Charter — the Charter explicitly speaks of the "self-determination of *peoples*"[7] — has undoubtedly advanced the decolonization process by according it the legitimacy and international legality that were indispensable for the large-scale decolonization movement in facing the realities of the global power constellation of the time.

However, the international environment at the time of the foundation of the organization was above all characterized by the major colonial powers enjoying the privileges of permanent membership in the only decision-making body of the United Nations, the Security Council. While, due to the admission of previously colonized nations as member states, the United Nations over the years became *more representative* of the peoples of the world, *its Charter has remained the same since 1945.* Minor amendments such as the enlargement of the number of members of the Security Council have not changed the overall picture. In spite of the urgent requirement of better-balanced decision-making procedures so as to adequately integrate the larger and more diverse membership, the organization has not been democratized. Indeed, the Charter constitutes an *anachronism* in today's global reality. It still lacks decision-making mechanisms that are compatible with the concept of the *sovereign equality of nations* as enshrined in Art. 2 (1). The spirit of partnership and solidarity among all member nations (states), as preached in the Charter's Preamble, has not been properly translated into the decision-making reality of the United Nations.

This anachronism becomes particularly obvious in the composition of the Security Council, where the right of veto is reserved to the permanent members, i.e. mainly to the Western power bloc. The overwhelming majority of member states

has been denied adequate participation in the only organ of the United Nations enjoying executive power (including the power of coercive military action on the basis of Chapter Seven).

It is no unfair demand, in terms of democratic values and principles, that the *reality of decolonization* (which brought about the admission of the majority of present member states since World War II) be reflected in the UN Charter itself, if the Organization wants to regain its legitimacy and credibility vis-à-vis the majority of mankind. This demand implies that the UN take account of the need to create a truly *multipolar* (not *unipolar*) international system. This will require a change in the composition of the Security Council, enlarging the number of *permanent members* beyond the group of the victors of World War II. It will further require the redefinition of the concept of permanent membership in the Security Council on the basis of *regional* membership. Permanent seats should be given only to regional entities such as the European Union, the Commonwealth of Independent States (CIS), the Organization of African Unity (OAU), the League of Arab States, ASEAN, the group of Latin American States etc. Within each region the Security Council seat could be occupied on the basis of rotation (similar to the European Union's rotation arrangements for its Presidency). Such an arrangement would effectively do away with the present over-representation of Europe in the Council (due to the individual membership of both the United Kingdom and France).

The situation would only be aggravated by the admission of Germany as a permanent member. The "upgrading" of individual countries such as Germany or Japan would make imbalances in the distribution of power within the only executive organ of the UN even greater.[8] In the non-Western regions not represented at all on the level of permanent membership, the admission on an individual basis of some "key states" will not solve the problem of democratic representation, either. Countries such as Brazil or Nigeria should also participate in a framework of regional membership and not be "designated" through permanent membership on an individual basis, as new dominating powers in their respective regions.

It is the "constitutional predicament" of the present United Nations Organization that the Charter cannot be amended without the consent of the five permanent members enjoying the veto privilege (Art. 108 of the Charter). As demonstrated by recent reform initiatives[9] presented in the General Assembly since the Security Council Summit Conference of 31 January 1992,[10] the *realities of power politics* make it virtually impossible to achieve even marginal results in the field of the badly needed democratization of international relations. The Millennium Summit organized by Secretary-General Kofi Annan in September 2000 has not changed this basic predicament.

Unless there is a fundamental change in the power equation among the present UN member states similar in magnitude to the geopolitical change brought about by

the collapse of the East bloc with the resulting end of East-West bipolarity since 1989 –, a change that would make it undesirable for the present permanent members to insist on the eternalization of their special privilege, the only realistic solution to the problem of constitutional change will be the dissolution of the present organization and its re-founding on a new constitutional basis. In such a scenario, the current member states of the UN would act as founding members of a new global inter-governmental entity and as drafters of a new Charter on the basis of partnership and equality (principles that are also stipulated in the present Charter's Preamble).

OBSTACLES TO THE REALIZATION OF SELF-DETERMINATION IN THE STATE-CENTERED FRAMEWORK OF THE UNITED NATIONS CHARTER

In modern international law, self-determination is considered a collective "peoples' right." It is generally defined as the right of a people not only to preserve its language, cultural heritage and social traditions, but also to act in a politically autonomous manner and — if the people so decides — to become independent when conditions are such that its rights would otherwise be restricted. Not all theorists of international law will agree, however, on the latter aspect of self-determination, as it is antagonistic with another basic principle of international law and of the UN Charter, namely the principle of *national sovereignty* (Art. 2 [1]).[11] In spite of the United Nations' persistent support for the decolonization process which was recently confirmed by the UN Millennium Summit,[12] the principle of self-determination has not been incorporated into the UN Charter with all the consequences that would entail for peoples' rights, but instead remains simply a general principle without precise definition.

This makes it understandable why the post-war legacy of the United Nations Organization is at the root of another major legitimacy problem of the international system as represented by the very United Nations. The concept of UN membership is defined exclusively on the basis of the nation-state as bearer of sovereignty. Apart from minor modifications mainly on the European regional level, nation-states, not peoples, are perceived to be the basic entities of international law. Only states enjoy "sovereign equality" according to Art. 2 (1) of the Charter. The principle of non-interference in the internal affairs of another state is derived from this understanding of the nation-state's sovereignty.

In contradiction to the fictitious concept of a "unified" nation-state, many of the states forming the United Nations Organization comprise *more than one national community.*. Their territory is not that of a homogenous national entity, as the concept of the nation-state presupposes. Very often, minority communities are not adequately represented or integrated into the general nation-state structures (on the level of which sovereignty vis-à-vis the outside world is being defined). On the very basis of the concept of national sovereignty and of the resulting concept of territorial integrity, those minority national communities on the territory of a nation-state (i.e. of a state constituted mainly by a national community different from their own) *are being denied the right to self-determination to create their own sovereign entity* in the form of a *state.*

In Pursuit of the Right to Self-determination

This is the case with some of the "old" European nation-states, co-founders of the United Nations, such as the United Kingdom (with the Irish, Scottish and Welsh nations on her territory), France (with, among others, the national community at the island of Corsica), and Spain (with, among others, the Basque national community). In the special case of France, even far-away national communities are artificially integrated into the French nation-state in the form of the so-called D.O.M.-T.O.M. (*départements d'outre-mer, territoires d'outre-mer*), a euphemism that serves to hide the fact that colonial rule is being upheld even at the beginning of the 21st century. A similar situation exists in the United States of America, as well as in many other vast nation-states such as the Russian Federation or Turkey and in many post-colonial states, particularly in Africa.

As recent history has proven, the denial of the right to self-determination to distinct national communities existing on the territory of often artificially-created "nation-states" constitutes one of the biggest threats to international peace, security and stability. As a result of what by some is called "imperfect decolonization," many newly independent states (whose borders were demarcated by agreements among outside powers) suffer from the problem of legitimacy, as bearers of national sovereignty vis-à-vis a multitude of ethnic communities on their territory. On the level of the respective nation-state, the denial of the right to self-determination also constitutes a challenge to *democracy* in the sense of the applicability of majority rule in such a setting of constitutional inequality.

Regrettably, the Heads of State and Government of the United Nations, in their *United Nations Millennium Declaration* of 8 September 2000, were lagging behind the standard established, though insufficiently, by Art. 1 (2) of the UN Charter. In their Declaration they explicitly confirmed, while upholding the "sovereign equality of all States," "the right to self-determination of peoples which remain under colonial domination and foreign occupation."[13] This implies, in our interpretation, that they *limit* the exercise of this right to cases of *decolonization* and of *occupation* that occurs in violation of the ban on the "use of force against the territorial integrity or political independence of any state" (Art. 2 [4] of the UN Charter).

Paragraph 4 of the Millennium Declaration demonstrates once more that the present system of international law, including the United Nations, is not able to cope with the contradiction between the *right to national self-determination* (as related to *peoples*) and the principle of *national sovereignty* (as related to the *state* as the bearer of sovereignty and exclusive subject of international law). This contradictory reality of international law originates in the tradition of an exclusively state-centered paradigm that has reached its strongest expression, in terms of power politics and a realist doctrine of international relations, in the concept of the nation-state and the related doctrine of state sovereignty.[14]

When a national community's *claiming the right of self-determination* is considered as the commission of *high treason* by the nation-state concerned, a meaningful debate about democracy and human rights (which has to be conducted free from fear) becomes impossible on the transnational level.

138

It cannot be denied that *human rights are collective rights too.* In terms of legal philosophy and modern human rights doctrine, individual and collective rights cannot be separated from each other.[15] One cannot preach human rights and at the same time ignore the right to self-determination.

THE NEED FOR A NEW PARADIGM OF INTERNATIONAL RELATIONS – OUTLINE OF A SYSTEM COMPATIBLE WITH THE RIGHT TO SELF-DETERMINATION

The normative contradiction between the principles of sovereignty and self-determination cannot be solved in the present framework of international law as represented by the United Nations Organization. A way out of the antagonism between the *power politics* of nation-states (which, in many instances, are multi-national states) and the peoples' aspirations of *self-determination* can be found only if one accepts the *imperative of Charter reform.* Such a reform will have to incorporate peoples' rights (as collective human rights) into the body of rules governing the relations among states (i.e. of general international law).

It is obvious that this "idealistic" vision cannot be realized without a major rethinking of the hitherto employed concept of the state as the exclusive actor in international relations. But there is no alternative to integrating properly defined collective rights into the set of norms of general international law if one wants to avoid major threats to international peace and security in the future. Insisting on the *status quo* may well lead to the destabilization of entire regions — with uncontrollable consequences for global peace.

On the basis of such a rethinking of the normative framework, it will be required to restructure the United Nations so as to make of it an organization that *also represents peoples and not only states.* In addition to the nation-state-based membership in the General Assembly and in the Security Council, a new concept of membership will have to be conceived that is derived from the concept of the national community (or peoples).[16] On this basis, a Second Chamber (in addition to the General Assembly) could be created with representatives of "peoples" — or national minorities — from all regions of the globe. This would allow the world organization to transcend, at least on the normative level, the hitherto impenetrable boundaries of the nation-state and to integrate the aspirations of peoples — which cannot express themselves adequately in an exclusive nation-state framework — into the United Nations system. (Those peoples or national minorities often live on the territories of several nation-states the borders of which have been created without their consent.)

> It will be required to restructure the United Nations so as to make of it an organization that *also represents peoples and not only states.*

The UN Charter in its present form allows — on the basis of Art. 22 — the creation of such a "Peoples' Assembly."[17] It would have been a sign of genuine understanding of the need to democratically reform the present international system had the Millennium Summit organized by the United Nations in September 2000 addressed this basic issue of a just and better balanced global system. A consistent

normative framework for the interplay of forces not only on the level of the states but of peoples is one of the basic elements of comprehensive United Nations reform.

Those who propagate a democratic reform of the international system — and above all of the United Nations — cannot ignore the importance of transgressing the confines of the rigid nation-state concept in favour of a new paradigm of international relations that is more consistently derived from the concept of universal human rights (comprising individual *and* collective rights). An international system that is based on the effective denial to many nations of the right to self-determination – simply because of the fact that they live on the territory of an existing nation-state – cannot be considered truly democratic. Such a system does not enjoy the legitimacy that is required to make the "international rule of law" acceptable to the multitude of peoples on the globe. It is those peoples that constitute the present nation-states and that are referred to when we speak of the "global community."

Comprehensive United Nations reform along the lines of *democratic participation of peoples* from all regions of the globe (and not only of nation-states) — with a well-defined system of checks and balances which is completely lacking in the present framework of the Charter[18] — could indeed become the catalyst for a gradual overcoming of the 19th century concept of the nation-state and for transcending the reality of power politics related to it. This concept has been at the root of a great number of conflicts, even world wars. It should be gradually transgressed ("phased out"), in such a reform process, in the direction of a global system in which each nation (people) or national community enjoys self-determination without the restrictions traditionally imposed due to the preservation of the nation-state's sovereignty. The very concept of sovereignty will have to be redefined so as to include the inalienable rights of peoples — in addition to the state's claim to be the absolute master over the peoples living on its territory.

I am well aware that such a revision of the system of international norms may imply, in certain instances, the redrawing of geographical maps and the redefining of the constitutional nature of existing states. Entities that, so far, have been defined on the basis of the category of the unified nation-state may have to be redefined in the sense of a confederate state.

I am also aware of the fact that, because of each nation-state's inherent interest in preserving its own power — which often is the power of its ruling lobbies — this "idealistic" vision of a major normative reorientation of the international system may not become reality in the near future.

However, by democratizing its own membership structure and by adapting its decision-making procedures to the requirements of (normative) equality among peoples and states as outlined above, the United Nations Organization – which sponsored the earlier process of decolonization, i.e. of emancipation of the peoples from hegemonial rule — could become the vanguard of a truly *new* international order. It could help to create a genuine *trans*-national system that — unlike the present unipolar "New World Order" — is based on the rights of peoples as basic actors of international relations.

What is needed in the present geopolitical constellation — where everything seems to depend on the overwhelming power of only one nation-state actor — is a

new paradigm of international relations based not exclusively on the *entity of the state* and its "sovereign" relations with other states, but on the *social and cultural reality* of the peoples and their inalienable right to self-determination (whether inside or outside the framework of a given nation-state).

It is not the *state* that is "eternal" and that enjoys "inalienable rights," but the *people[19]* as a collective social and cultural reality. The will of the peoples constitutes the source of political legitimacy and the normative basis of any national or international system. Only a peoples-centered, not a state-centered, framework of international law will be in conformity with the requirements of human rights and democracy as propagated in the global political discourse.

> **Only a peoples-centered, not a state-centered, framework of international law will be in conformity with the requirements of human rights and democracy as propagated in the global political discourse.**

ENDNOTES

[1] For a more comprehensive analysis of the veto privilege see the author's paper *The Voting Procedure in the United Nations Security Council. Examining a Normative Contradiction in the UN Charter and its Consequences on International Relations.* Studies in International Relations, XVII. Vienna: International Progress Organization, 1991.

[2] On the requirements of democratic reform see the Concluding Statement of the Second International Conference On A More Democratic United Nations (CAMDUN-2) in Hans Koechler (ed.), *The United Nations and the New World Order. Keynote addresses from the Second International Conference On A More Democratic United Nations.* Studies in International Relations, XVIII. Vienna: International Progress Organization, 1992.

[3] [Woodrow Wilson], *The Bases of Durable Peace / as Voiced by President Wilson.* Chicago, Ill.: Union League Club of Chicago, 1918.

[4] Point V of Wilson's "14 Points."

[5] *Draft resolution referred by the General Assembly at its fifty-fourth session,* General Assembly, Fifty-fifth session, *The Millennium Assembly of the United Nations,* Doc. A/55/L.2, 6 September 2000, Par. 4.

[6] See the author's analysis "The Palestinian People's Right of Self-determination: Basis of Peace in the Middle East," in *IKIM Journal,* Kuala Lumpur, vol. 7, n. 2, July/December 1999, pp. 45-58.

[7] Emphasis by the author.

[8] See the detailed reform proposals by the author: *The United Nations and International Democracy. The Quest for UN Reform.* Studies in International Relations, XXII. Vienna: International Progress Organization, 1997.

[9] See the proposal by General Assembly President Razali Ismail (Malaysia): *United Nations Press Release,* GA/9228 of 20 March 1997 ("Assembly President proposes increase in Security Council membership to 24 by adding 5 permanent, 4 non-permanent members").

[10] See United Nations / Security Council, *Provisional Verbatim Record of the three thousand and forty-sixth meeting,* S/PV.3046, 31 January 1992.

[11] On the modern doctrine of self-determination in international law see Antonio Cassese, *Self-determination of Peoples. A Legal Reappraisal.* 2nd ed., Cambridge etc.: Cambridge University Press, 1996; Denise Brühl-Moser, *Die Entwicklung des Selbstbestimmungsrechts der Völker unter besonderer Berücksichtigung seines innerstaatlich-demokratischen Aspekts und seiner Bedeutung für den Minderheitenschutz.* Basel etc.: Helbing & Lichtenhahn, 1994; Donald Clark (ed.), *Self-determination. International Perspectives.* Houndmills etc.: Macmillan, 1996.

[12] See Par. 4 of the Declaration of the Millennium Assembly of the United Nations.

[13] *The Millennium Assembly of the United Nations,* loc. cit., Par. 4.

[14] On the concept of sovereignty in the theory of international law see the author's analysis "The Principles of International Law and Human Rights," in *Democracy and the International Rule of Law. Propositions for an Alternative World Order.*. Vienna and New York: Springer, 1995, pp. 63-85.

[15] On the legal theory of peoples' rights see esp. Edmond Jouve, *Le droit des peuples*. Paris: Presses universitaires de France, 1986.

[16] In American usage we encounter a serious terminological difficulty and confusion in regard to the term "nation" or "national" which in one context may relate to the entity of the *state* while in another context it designates the *people* (national community or communities) forming a given state. The German terminology distinguishes more clearly between *Staat* and *Nation.*. On the issue of this distinction see the author's paper "The Concept of the Nation and the Question of Nationalism. The Traditional 'Nation State' versus a Multicultural 'Community State'," in Michael Dunne and Tiziano Bonazzi (eds.), *Citizenship and Rights in Multicultural Societies*. Keele: Keele University Press, 1996, pp. 44-51.

[17] See the Concluding Statement of the Second International Conference On A More Democratic United Nations in Hans Koechler (ed.), *The United Nations and the New World Order. Keynote addresses from the Second International Conference On A More Democratic United Nations.* Studies in International Relations, XVIII. Vienna: International Progress Organization,1992, pp. 49ff.

[18] For more details see our paper *The United Nations and International Democracy. The Quest for UN Reform.*. Studies in International Relations, XXII. Vienna: International Progress Organization, 1997.

[19] In the sense of the plural as in *peoples'* rights.

The Plight of Jammu-Kashmir

Mohammad Yasin Malik*
Guest of Honor

I am indeed grateful to IHRAAM and ICHR for inviting me to be the Guest of Honour to this first international conference on "Self-determination and the United Nations". I wished and cherished to be present at the Conference so that I would have an opportunity to meet with you and discuss the issues relating to self-determination and the predicament of our people in Jammu-Kashmir. I am sorry that I could not be with you. There are people here who did not want me to be with you.

The Government of India has not facilitated me with appropriate travel documents. This is not the first time, and I am not the first one who is once again faced with another violation of another basic human right. My other colleagues in the All Parties Hurriyat Conference (APHC) have also faced this problem. Freedom of movement and freedom of speech is a right, not a privilege.

So many of our rights have been curtailed in Kashmir that it would take me all day to go through the list. I only wish that member countries of the United Nations who have signed up to the Charter and its covenants adhered to their obligations.

Clearly, India has indicated little regard for the UN and its Charter on fundamental human rights for individuals, communities and nations. I regret that it also indicates to me that the mechanisms to check and correct such imbalances are not working and the world community, the NGOs and governments need to work hard to improve the situation. The international community has got to come to the aid of peoples and nations under foreign occupation, where repression and suppression is at its peak, and not in a chosen few places. My Kashmir is one such place which needs your urgent attention.

In Kashmir, there are over half a million armed forces of India in every street corner, in every town and city.

They used to call it heaven on earth. It has been turned into living hell by the forces of occupation over the last 50 years, and particularly over the last 10 years. They will not admit it but I can tell you that there are over half a million armed forces

* Mohammad Yasin Malik was invited to the First International Conference on the Right to Self-determination & The United Nations as Guest of Honor, but was unable to attend as he was not provided with international travelling documents by the government of India. He spoke directly to conference attendees nonetheless by means of a long distance telephone call which was transmitted into the conference hall. He is Chairman of the Jammu-Kashmir Liberation Front and Executive Member of the All Parties Hurriyat Conference.

Guest of Honor
MOHAMMAD YASIN MALIK
Chairman, Jammu-Kashmir Liberation Front
& Executive Member
All Parties Hurriyat Conference (APHC)

A P H C
The All Parties Hurriyat Conference (APHC) is dedicated
to a peaceful resolution of the Kashmir conflict
through negotiations between genuine representatives
of Kashmiris, India and Pakistan

of India in every street corner, in every town and city. This is the largest concentration of military in a small place such as Kashmir. I have seen with my own eyes, hundreds and thousands of our young men, women and children killed in the streets of Jammu-Kashmir.

Why? Because our people demand that they be allowed to exercise their fundamental human right – the right to self-determination.

As you will know, the UN Security Council passed a number of resolutions on the question of Kashmir's future recognizing the fact that Kashmir is a disputed territory and that its people only, over 12 million in population now, must decide their destiny. It is unfortunate that since these resolutions were passed, no progress has been made with regard to final disposition of the issue. And now, 50 years on, the ground situation has changed for the worse.

I believe the Kashmir issue now requires a fresh and new approach by the international community and the United Nations. India and Pakistan now have their fingers on nuclear triggers. Kashmiris have lost a whole generation — over 60,000 dead — and the death toll is rising every day.

You may be unaware that, about fifteen years ago, India hanged one of the Kashmiri sons of the soil in New Delhi's Tihar jail. His name was Maqbool Butt. His crime was that he wanted to see his people free again. He wanted his people to regain their independence. India, which claims to be the world's biggest democracy, hanged this Kashmiri leader without offering him a fair trial. There is a case still pending in the Indian courts against him. They have not even bothered to dispose of the pending case against him. I myself, and so many of my fellow countrymen, have been imprisoned for false charges so often that we cannot even remember how many times we have been locked up, and how many of us have actually been killed in custody. We are for peace, but not for peace at the cost of freedom. We want peace in our motherland with honor and dignity. Peace which assures us all the essentials of freedom and human dignity.

There is a so-called line of control across Jammu-Kashmir which divides our people and our land, not by choice but by force. Indian and Pakistani armies have faced each other for over 50 years. Believe it or not, there is also a UN Peace-Keeping Force in there somewhere, too. And yet there is not a day when innocent Kashmiris are not killed by those armed forces in the name of peace. And what do the Peace-Keeping Forces do? Not as much as I would like them to do. We are not asking the UN to send in their troops to save Kashmir as they did in Bosnia. We are asking them to help stop the indiscriminate killings, the extra-judicial murders, the rape of our women and the destruction of our people's livelihood. The use of force to impose a solution on us by any party is not the answer. The use of force to suppress our voice is not going to work, either. Our people have demonstrated that over the years and I can assure you that as long as suppression and repression continues, so will the resistance movement.

All political disputes are being resolved around the world by political dialogue. I ask you, why must the Kashmiris be forced to accept solutions imposed by the occupiers of our country? I wish to make it crystal clear to you that my organization, the JKLF, cannot see any other solution to the crisis in Kashmir. We think re-unification and complete independence for Jammu-Kashmir is the answer to the

problem, which should be determined through the exercise of the right of self-determination. Internal autonomy, maintaining the status quo, partitioning the State, all of this has been tried over the past 50 years. All these options have failed. I seek your support for this amicable solution, which will not only cater to the legitimate national interests of all our neighbors, India and Pakistan, but also safeguard the rights of all our minority communities in Jammu-Kashmir.

I assure you that no matter how long it takes, I will not betray the cause of our martyrs. With your help, we can realize the dream of our long-suppressed people sooner than later. I hope that this Conference will go some way in helping the people of Kashmir in determining their future. I also hope that the NGO community will continue its support for our just cause.

The Dalits in India: Culturally-Enforced Apartheid & Worse

Dr. Laxmi Berwa*

Before I begin my intervention, may I take this opportunity, as a Director of IHRAAM (the International Human Rights Association of American Minorities) to thank Dr.Y.N.Kly (Chair,IHRAAM), Diana Kly (Program Coordinator) and Barrister Majid Tramboo (an IHRAAM Director and Chairman of the International Council for Human Rights) for giving me this opportunity to express my views on behalf of the Dalits of India, who are the largest persecuted minority in the world.

I am delighted to meet delegates from more than 60 different groups from various countries of the world who felt that it is high time that all oppressed groups of people meet in solidarity to determine what is right for them rather than somebody else telling them.

The First International Conference on the Right to Self-determination & the United Nations, held here in Geneva, 11-13 August, 2000, provides a historical and unique opportunity to express and explore the rights to self-determination by the oppressed minorities of the world. This is an issue of an oppressor and oppressees. This conference is also occurring concurrent with the 52nd Session of the UN Sub-Commission on Human Rights here in Geneva. For the last two and half days we have heard various definitions of rights to self-determination. It is hard to come to a single definition, and it is not surprising, because this phenomenon is constantly evolving from the colonial era till today, and I am sure this is not the end of it. It may continue to evolve for the next several decades.

The Dalits of India are the largest persecuted minority in the world, comprising approximately 160-200 million, which is 50 to 70 % of total population of the United States of America.

Coming to the issues concerning the Dalits of India, who are the largest persecuted minority of the world, comprising approximately 160-200 million, which is 50 to 70 % of total population of United States of America, these numbers are simply mind boggling. Dalits have been

* Dr. Laxmi Berwa is President of the Dr. Ambedkar Memorial Trust, winner of the Dr. Ambedkar National Award, 2000, and an IHRAAM Director.

persecuted in India for at least 2000 years at the hand of dominant Indians who are popularly called Hindus, preferably so-called higher caste Hindus, who acquired this higher caste status just because they were born in that caste. And Dalits are persecuted because they were born in so-called lower castes.

As a result, Dalits for centuries have been facing oppression at the hand of so-called higher castes. Even today, the most important and powerful notion is of "Untouchability," which has the most brutal ramifications for Dalits seeking to live as decent human beings. Since India's independence from the British, a new nation was born and a new Constitution was written by the Founding Fathers of India which grants every Indian equality, liberty and fraternity. As a matter of fact, Article 17 clearly states that the practice of untouchability is abolished and punishable under the law. Subsequently many other acts have been passed to prevent this practice and the atrocities committed against Dalits, whenever they fight for their human rights.

Human Rights Watch, a well-respected agency based in New York City which monitors human rights violations throughout the world, brought out a well-documented book in 1999 on the human rights violations suffered by the Dalits of India titled *Broken People* edited by Senior Human Rights Watch Reseacher, Smita Narula.

Dalits in rural India have separate residential places away from the water wells; higher castes have separate tumblers to drink water, and any inter-caste marital affairs are met with harsh reprisals at the hand of higher castes who want to maintain the status quo. Whenever any increase in the minimum wages is asked for by the Dalits, the landed class enforces a social boycott to be practiced by all the castes in the villages. Anybody who violates a social norm of the society is gunned down; women are raped or paraded naked in the center of the villages to teach them a lesson. Dalit men and women, young or old, even children, are beheaded with machetes. Dalit houses are doused with kerosene oil and set fire; drinking water is polluted by pouring kerosene, oil or other pollutants which are not for human consumption in the wells.

Sometimes Dalits have no choice but to leave their ancestral abode. The very people, such as the police, judiciary, administration, etc., who are all supposed to protect Dalits from the criminals, sometime aid the criminals or commit crimes themselves, especially the police. We can't expect justice from a judiciary which itself is deeply prejudiced against us. There are private militias patronized by the landed class, the most notorious called RANVIR SENA, which has massacred 60 Dalits in state of Bihar. This private militia enjoys the patronage of the landed class and politicians who are there to protect the interests of the high and the mighty .

Discriminatory practices of all types have been discussed in the Committee on the Elimination of All Forms of Racial Discrimination and the Human Rights Committee, but the Indian government continues to stonewall the inquiries and implementation of suggestions in the UN meetings.

The Dalits in India: Culturally Enforced Apartheid & Worse / Berwa

On Aug 9, 2000, in this city, the UN news services reported, "India refutes Allegations of Discrimination against Dalits". This type of response by the Indian government demonstrates it is willing to make a fool of itself in front of the entire world. Even a high school student throughout the world knows about the caste based discrimination in India. Who are they kidding? India spoke out against the apartheid in South Africa but is silent on the apartheid being practiced in its own backyard! How long can India make a fool of the world? To paraphrase a Great American President — you can fool some people some of the time but you can't fool all the people all the time. How true it is.

Mr. Chairman, ladies and gentlemen, on surveying India's human rights records on Dalits, i.e. its violations of the laws of the land and the International Bill of Human Rights, India reminds me of a BIG JAIL CELL. Thus I feel that this First International Conference on the Right to Self-determination & The United Nations: From Minority Rights to Political Independence, aiming at a further democratizing of the international system, is a quite reasonable forum to address the Dalits' grievances and seek intervention from this august body.

We have been terribly disappointed by the muted response by the Indian Government; a total denial on their part is quite shocking. We will knock each and every door on this globe to contact whosoever may be sympathetic to our human rights violations. As the late Dr. Ambedkar said, "The world owes a duty to the untouchables as it does to all suppressed peoples, to break their shackles and set them free. The problem of the slaves, the Negroes and the Jews is nothing in comparison to the problem of the untouchables."

Mr. Chairman, we take this opportunity via the media of this conference to appeal to the Secretary General of the UN, Honorable Kofi Annan, to put some teeth in the UN agencies which deal with human rights and the right to self-determination, even at the cost of inviting the wrath of the UN Member nations; otherwise in my humble opinion, the UN General Assembly is no more than a Tea Party Club.

We appeal to the UN's governing bodies to appoint a Commission and a commissioner to oversee the rights to self-determination of aggrieved peoples.

I will seek everybody's help who has the genuine interest, out of full conviction, to fight for Dalit human rights, so that Dalits can live freely and as equals in the eyes of this global village.

Finally Mr.Chairman I take this opportunity to thank everybody who was sympathetic to the Dalit cause, especially the sponsors of this Historic conference,who were more than generous to me by providing even a Workshop on the Dalit issue, #4.

The Right of Self-determination in Ka Pae Aina (Hawaii)

Joshua Cooper*

INTRODUCTION

The quest to exercise the right of self-determination ignites ideas and initiatives in all peoples. The collective right of self-determination embraces the fundamental freedoms enshrined in the international declarations and conventions. Kanaka Maoli (Hawaiians) desire to live according to values and visions of our own ancestors rooted in the philosophy of *pono, lokahi* and *malama aina.*

For centuries, the right of self-determination has been undermined by foreign nations, military campaigns and multinational corporations. Kanaka Maoli have never relinquished the right of self-determination and continue the campaign with various movements rooted in a nonviolent revolution for all human rights for all.

The tradition of Indigenous Peoples participating in international institutions in international public law dates before the crafting of the United Nations Charter. The diplomacy efforts demand the recognition and respect of basic human rights. Kanaka Maoli walk in the footsteps of Indigenous Peoples' global movement for all human rights, specifically the right of self-determination.

Self-determination is one of the most contested rights constantly discussed and debated in the international arena. Its basic existence and importance is paramount to world peace.

The right of self-determination is the right that challenges dominant anddriving powers of prejudice and profit. The right of self-determination is a response to insipid racism and also a tool to preserve traditions and a dynamic process of social change inspired by the cultures of all peoples in the family of humanity. The right of self-determination is crucial to defend the basic human rights of a people and to ensure their continued evolution and existence on earth.

As Kanaka Maoli mobilize *na maka aiana* to stand up for the right of self-determination, the nations continue to contest the claims of Indigenous Peoples. The right is deemed radical, yet is a humble belief that all humanity is equal, born in dignity and deserves respect.

* Josehua Cooper is Founder/Director of Na Koa Ikaiba O Ka La Hui / Hawai'i Institute for Human Rights, Maui, Hawai'i.

HISTORY OF HAWAIIAN ISLANDS

The nation of Hawaii thrived in the family of nations. Today, it is recognized as a resort destination for the rich and famous where the Indigenous People are exotic hula wallpaper existing to serve food and fantasy. Since the 18th century, the sovereign nation-state of Hawaii had been recognized by governments around the world. For two centuries, the entity of a nation and its people have been imprisoned and in defiance of extermination. The culture and nation of Hawaiians has been challenged by the conquests of the church, imperial countries and corporate capitalism.

The Calvinist missionaries arrived to change the traditional ways of Hawaiians. Their practices were deemed primitive and backward. Along with the missionaries and the institution of the church came individuals with aspirations to rule the islands and businessmen with plans to increase profit through land exchange and a capitalist economy.

As early as 1842, the nation that now occupies Hawaii recognized its inherent sovereignty. Under the 10th U.S. President, John Tyler, the United States recognized the Kingdom of Hawaii. Before the dawning of the 20th century, the legitimate government of Hawaii would be illegally overthrown with the assistance of U.S. marines. A system of private property ownership was implemented where foreigners hold dominance over the vast majority of our sacred earth and have commodified the land, contrary to the belief system of *malama aina* (taking care of land).

While there are many significant dates and acts of defiance in the struggle for self-determination, Hawaiian history is a tragedy. Even before the overthrow of Queen Liliuokalani, the seventh King of Hawaii, David Kalakaua was forced to sign the "Bayonet Constitution" in 1887. This new imposed constitution reduced Kalakauas authority and the voting power of Hawaiians and other people of color by instituting income or property ownership qualifications for people to have voice in government with the simple act of the vote.

On 17 January 1893, Queen Liliuokalani was overthrown by businessmen masked as the 13-member Committee of Safety through the military might of U.S. Marines serving on the USS Boston. The Committee of Safety was worried that the Queen would change the constitution to reflect the basic rights of Hawaiians and challenge the monetary monopoly of the missionary descendents.

Queen Liliuokalani was a pioneer peace advocate. She avoided bloodshed and authored a Letter of Protest to preserve the nation and basic human rights of Kanaka Maoli. She wrote,

> Now to avoid any collision of armed forces and perhaps the loss of life, I do this under protest and impelled by said force, yield my authority until such time as the Government of the United States, shall upon the facts being presented to it, undo the action of its representatives and reinstate me in the authority which I claim as the constitutional sovereign of the Hawaiian Islands.

President Grover Cleveland sent James Blount, a former chairman of the House Foreign Affairs Committee, to investigate. The Georgian representative recognized

the illegality of the actions, ordering the U.S. flag to be lowered. However, Hawaii's strategic location and natural beauty sealed its fate in the manifest destiny of the United States. The next president, with advice from military ranks, recognized its potential for U.S. aspirations in the region as an imperial power. In 1898, President McKinley signed a resolution annexing Hawaii. The people of Hawaii marched in the footsteps of their Queen against the injustice. Building on her letter for the liberation of her people, a peaceful petition was signed by the Hawaiian majority determined to exercise sovereignty. Unfortunately, even though U.S. President Clinton signed the Public Law 103-150 Apology Bill recognizing the complicity of the United States in the overthrow, the injustice continues.

Colonialism continued for the rest of the century and is alive even at the dawn of this new century. As the world takes action to preserve fundamental freedoms through international institutions and instruments, the challenge of might makes right remains constant. The scales of social justice are constantly in shift. In the United Nations Charter, self-determination peppers the historic document. In four different articles, the respect for the principle of equal rights and self-determination of peoples reflects the spirit of peace. Hawaii was recognized as a colonized country and placed on the agenda of the UN Decolonization Committee. Unfortunately, in 1959, the United States violated international law with a vote that didn't allow the citizens to exercise their right of self-determination. The people weren't allowed to vote for independence as required in international law. The only two options were to remain in political limbo as a territory or become the fiftieth and final state of the USA. In the year 2000, the United States continues to deny the fundamental freedoms of the Hawaiian people. The United States Supreme Court recently decided, with the *Rice v. Cayetano* decision, to perpetuate the legacy of racism and foreign control of Hawaiian resources.

The struggle for self-determination continues at the grassroots and global level. Through direct action and diplomacy, Kanaka Maoli continue to claim the right of self-determination.

HAWAII IN INTERNATIONAL HUMAN RIGHTS LAW & THE SIGNIFICANCE OF THE RIGHT TO SELF-DETERMINATION FOR THE FUTURE OF INDIGENOUS PEOPLES AND HUMANITY

The right of self-determination continues to evolve through the processes of international human rights law. Building upon its strong showing in the UN Charter, the right of self-determination continues to gain prominence in international public law. In the twin covenants of the International Covenant on Civil and Political Rights and the International Covenant on Economic, Social and Cultural Rights, the right of self-determination reigns supreme as common article number one. The right of self-determination also appears in the Draft Declaration on the Rights of Indigenous Peoples as article three.

While most debates focus on the meaning of the first paragraph of the right of self-determination — on the right to freely determine one's political status and to freely pursue one's own economic, social and cultural development — it is also important to consider the philosophy and possibilities encased in the second paragraph focusing on the right to dispose of natural wealth and resources, and even more significant, the means of subsistence. The importance of land is at the heart of the right of self-determination. It propels the process of international human rights law to recognize earth rights, the right to a healthy environment as well as the right for Indigenous Peoples to control land in order to be able to provide basic necessities. As noted in the third paragraph, it is the seed for a moral revolution and independence for all peoples. Hawaiians and other Indigenous Peoples deserve to exercise the right of self-determination.

Taro or *kalo* is the staple of the Hawaiian diet. Military bases occupy over 25 percent of land on Oahu, the capital of Hawaii. *Kalo* must be allowed to grow again. However, water has also been diverted to maintain golf courses and tourism instead of feeding the people. Through the right of self-determination, Kanaka Maoli can put the world back in balance. Through living in harmony with the land, the people can enjoy sovereignty daily. The health of the people and the nation will be restored through the right of self-determination. It will also contribute to the emerging third generation of collective solidarity rights, reconfirming the importance of self-determination, peace and ecology.

DIRECT ACTION AND DIPLOMACY:
SEEDS FOR SELF-DETERMINATION IN HAWAII

The traditional Hawaiian relationship to land is a genealogical one with the Hawaiian people being born as a union between the Earth mother and Sky father. This philosophical premise explains the familial and reciprocal relationship of respect and nurture the Kanaka Maoli share with their sacred space known as Ka Pae Aina.

While the right to land might not be regarded as a recognized right in international law, the land represents so much more to Indigenous Peoples. The issues of religion, culture and economics are all firmly rooted in the indigenous understanding of the right to land, the environment or Earth Rights. As one indigenous representative noted,

> For many Indigenous People, land is the seat of spirituality. It is the guardian and protector of the bones of our forefathers; it is the historical record of a people, the provider of food, clothing and shelter; it represents the hope of the generation to follow... To separate the Indigenous People from the land traditionally held by us is to pronounce certain death for we will either die physically, or our mind and bodies will be altered in such a way that will mimic the foreigners' ways, adopt their language, accept their thoughts and build a foreign prison around our indigenous spirit which suffocates rather than allows for the flourishing of our spirit.

Indigenous voices around the world echo similar positions surrounding land. The indigenous worldview of the environment is beyond a parcel of land, a

resource for material wealth and a means of production. As a member of the Unrepresented Nations and Peoples Organization said, "The people and the land are one. Earth is our mother. Land is identity and the heart of indigenous culture." One scholar defined the territorial connection as a "dynamic and adaptable social phenomenon in which territory clearly provides not merely a means of economic subsistence but also sustains religious and cultural values."

Life revolves around land. Land is to be preserved, cherished and worshipped. That is why the right to environment and land as well as religious freedoms are intertwined. The political consciousness of Indigenous Peoples is connected as the issue of land weaves together the basic essentials of living and spirituality.

The Hawaiian philosophy and religion is based on the relationship to the land and can be best illustrated as *Malama Aina*, to take care of and respect the land. Living in harmony with the land is considered by the Hawaiian culture as one of the highest marks of civilized societies. In traditional Hawaii, land was shared communally and available for all to live upon and to grow food. *Aina* is the land and the meaning of this word is "that from which one eats".

The rights of Indigenous Peoples are rooted in the relationship to land. The very survival of Indigenous Peoples depends on the return of lands. The life of the land is the spiritual and cultural foundation of Kanaka Maoli and children. Hawaiians must be able to reclaim the land and reconnect with the cultural practices of the traditional methods of living within *ahupuaa*.

The islands of Hawaii and the land specifically fall in different categories under the current status as a state of the United States of America: Hawaiian Home Lands; State Ceded Lands; Federally Held Lands and Private Land Trusts, that currently serve Hawaiians as beneficiaries.

It is essential for Kanaka Maoli to be able to decide the relationship to these different types of lands as well as to be equals in efforts at reconciliation.

CONCLUSION: KANAKA MAOLI STRUGGLE FOR SELF-DETERMINATION

The philosophy and practice of living in harmony with the *Aina* still burns in the heart of the Hawaiian people after centuries of conquest of the islands and privatization of the land for profit. Hawaiians' philosophy is one of being born of the land — not the owner.

Indigenous peoples are organizing political and legal campaigns on the grassroots and global levels to secure their basic rights. Hawaiians have been able to have substantial victories to preserve the land from development although there are never clear victories.

The Public Access Shoreline Hawaii case known as PASH established that Hawaiians have rights to land and admitted that the Hawaiians prior to the arrival of the first Europeans in 1778 lived in a highly organized, self-sufficient, subsistent social system based on communal land tenure with a sophisticated language, culture and religion. In the PASH case, Mahealani Pai and his family were able to prove their connection to the land on the Big Island of Hawaii. The Pai Ohana (family) still lives and practices a traditional way of fishing and living. Because of this case, a large multinational company wasn't able to continue construction of a major resort.

The Right of Self-determination in Ka Pae Aina (Hawaii) / Cooper

The Pai Ohana were unfortunately evicted from their land to make a national park in the following year.

Another important struggle is Makua valley on the island of Oahu. The Native Hawaiians occupied the land for several years before being evicted and charged with treason. There are currently nonviolent campaigns to reclaim the land. This also highlights the issue of militarization where the sacred land is being used for target practice. Makua valley is considered a sacred space in the Hawaiian community and has unique animals and plants found nowhere else in the world.

One of the most successful strategic actions surrounds Kahoolawe, a small island off of Maui. Kahoolawe was used for bombing practice by the U.S. Navy for over three decades. One test in February 1965 was to measure possibilities for ships to survive a nuclear blast. The island was obliterated through war exercises for decades. Hawaiians held this island as a sacred space throughout their history. However, their access to it was banned.

During the 1970s, the Protect Kahoolawe Ohana (PKO) practiced civil disobedience to secure access and to reclaim the land. After two decades of actions and also political consequences, the bombing stopped and eventually the land was handed over to the state of Hawaii. Now, Hawaiians organize cultural programs on the island to reengage Indigenous Peoples with the traditions of the culture. The island, like the Hawaiian people, is not free. The funds allocated by the U.S. government to restore the land is almost spent. However, only a minimal percentage of the island is safe even to worship on. The U.S. government claims its obligations will be complete by 2003. However, the island is still a wasteland, not a place to worship.

Another important success for the recognition of indigenous rights is Public Law 103-150 passed by the U.S. Congress on the 100th anniversary of the overthrow of the Hawaiian monarchy. The U.S. admitted complicity in the illegal overthrow and also began to understand the plight of Indigenous Peoples concerning land rights. It noted, "Whereas the Native Hawaiian people are determined to preserve, develop and transmit to future generations their ancestral territory, and their cultural identity in accordance with their own spiritual and traditional beliefs, customs, practices, language and social institutions." The Apology Bill also called for resolution; however, it didn't provide a mechanism for reconciliation.

Once again, the pursuit of profit is before protection. There are no environmental protection standards for mining practices and as with many environmental practices the consequences will extend beyond a local issue concerning the Kanaka Maoli to one of global complexity as the Pacific currents will distribute the toxic elements beyond Hawaii to the other nations. The struggle for self-determination must go beyond the shores, especially for island nations that live in close connection with the oceans.

The struggle for self-determination and land rights are at the core of the indigenous global human rights movement. As a Hawaiian once stated concerning the indigenous relationship with land, "Next to shooting Indigenous Peoples, the surest way to kill us is to separate us from our part of the Earth." It is very important that international human rights mechanisms discuss and understand the holistic relationship Indigenous Peoples share with the land.

In Pursuit of the Right to Self-determination

As Ogoni Ken Saro-Wiwa noted, "The environment is man's first right." There are international agreements organized by the Indigenous Peoples that should be regarded as protecting and promoting land rights such as the Kari Oca, White Horse Falls and the Draft Declaration on the Rights of Indigenous Peoples.

Kanaka Maoli will continue to contribute to the international dialogue for indigenous rights, specifically land and its natural resources. Hawaiians will continue to author and act in accordance with the principles and rights enshrined in the indigenous documents illuminating indigenous beliefs and values such as the above mentioned international agreements. Kanaka Maoli are an important ally in the global indigenous movement to protect and promote the human rights of Indigenous Peoples. Land will continue to be a core value in the indigenous struggle for self-determination.

As *kalo* fields replace concrete and culture erodes the military control, the proverb of "the life of the land is perpetuated in righteousness" will become a reality in Hawaii. No longer will money control the direction of the islands. The *mana* will reprioritize the priorities to reflect the basic needs of the people rooted in justice and equality.

The right of self-determination is the seed to put words of wisdom into visionary actions liberating nations from the legacy of colonialism and to preserve nature in an era of globalization. The right of self-determination can provide legal language to free humanity.

Recommendations on the Issue of Reparations to African Americans

Ida Hakim*

Caucasians United for Racial Equality (CURE) would like to offer recommendations to the First International Conference on the Right to Self Determination & the United Nations on the issue of reparations as it concerns African Americans in the U.S. We hope that the Conference will deem our recommendations worthy of consideration. We are especially hopeful that our recommendation for an inclusive forum for African Americans (recommendation # 3) might be recognized as a peaceful and progressive method of examining the gravity of the lingering effects of slavery, and of examining reparations as a remedy from the victim's viewpoint.

Our organization's leader, Mr. Silis Muhammad, has a long and respected history of African-American grassroots leadership. In 1994, after years of reparations advocacy, he delivered to the United Nations a petition for reparations for African Americans under Communications Procedure 1503. Since that time he has intervened frequently at the Commission on Human Rights, the Sub-Commission on the Promotion and Protection of Human Rights and the Working Group on Minorities. His issue has been the destruction of the identity of African Americans, and the resulting fact that African Americans, collectively, have no human rights. The problems encountered in bringing the gravity of the legacies of plantation slavery to light are extreme because the destruction of identity of African Americans in the U.S. has been hidden behind the government's "melting pot" image.

African Americans did not come to America willingly, and they did not come as English-speaking Christians with an Anglo-Saxon culture. African Americans are a people who for more than 400 years have never questioned that they belong to each other as a group, and yet they have been denied the human rights that other groups enjoy: the right to speak their own language, practice their own religion and enjoy their own culture.

The African-American experience is an example for the civilized world of a holocaust wherein identity is forcibly and perpetually exterminated. With the denial of the 'mother tongue', the slaves were severed from their identity. Throughout

* Ida Hakim is President of Caucasians United for Racial Equality (CURE), an NGO in consultative (Roster) status with ECOSOC.

their history, the U.S. Government, for the benefit of the white majority, perpetuated the denial by systematically obstructing the attempts of African Americans to identify themselves. The international community well understands that human dignity is attached to identity. African Americans in the U.S. have cried out in many ways over many years for the restoration of their dignity as a people, yet their cry has been manipulated by the acts of the U.S. Government. Having been forced to assume the identity of the ruling culture, they are placed in an underling position from which there is no escape. How can they escape from a prison that many cannot even see? Only racism can be seen, and that is but a symptom of the prison. African Americans are in a grave situation. They need assistance from the United Nations.

Since collectively, African Americans enjoy no international recognition, one might wonder how charges can be brought under international law to substantiate the claim for reparations. Silis Muhammad has stated, "When we are able to argue about a violation of our human rights, this is our complaint: we are human beings, but to this date and time we are denied the human right of speaking our 'mother tongue' in violation of Article 27 of the International Covenant on Civil and Political Rights, which the United States of America has ratified." [1]

Silis Muhammad is among the first, if not the first, to bring the issue of African-American reparations to the United Nations, and be heard. He has been consistently intervening before the human rights bodies with arguments on the legal implications of the lingering effects of plantation slavery. The position of CURE is that we would not look favorably upon an offer of reparations that did not include restoration of collective human rights and international political recognition of African Americans. It is for this reason that we make the following recommendations to the First International Conference on the Right to Self Determination & The United Nations:

1. We recommend that the Conference pass a resolution declaring the lingering effects of plantation slavery a crime as related to 'mother tongue'. Such a resolution would affirm that the act of denying the slaves the right to speak the 'mother tongue' is tantamount to a permanent ongoing denial for which there is no remedy.

2. We recommend that the Conference urge the General Assembly to declare a UN decade to examine, in depth, the lingering effects of plantation slavery in the Americas.

3. We recommend that the Conference encourage the Office of the High Commissioner for Human Rights to offer UN expert and technical assistance in the organization of an inclusive forum for African-American leaders. The forum would provide an environment wherein the gravity of the current situation can be examined and the extent of damages can be determined. Within such a forum, the victims can discuss and conclude on the means of reparations most beneficial to their restoration individually and as a People.

4. We recommend that the Conference urge the United Nations and the World Conference Against Racism in particular to encourage the governments concerned to voluntarily and immediately establish tax exempt status for slave descendants; a status which will be in effect until both reparations and restoration of human rights have been achieved.

Kuiu Kwan Petition & Diplomatic Protest Concerning the State of Alaska's Initiative to Quiet Title

Rudy Al James*

Considering that a tragedy of enormous proportion threatens the Kuiu Thlingit Nation of Alaska and the Indigenous Peoples and Nations of that northern region due to an attempt by the colonial state of Alaska to permanently "Quiet Title" to submerged lands in the Alexander Archipelago through the United States Supreme Court (*Original Action 128*);

Noting that said action circumvents international law, United Nations General Assembly resolutions, covenants and accords as well as domestic local legal remedies and protocols, administrative procedures and ignores the existence of the First Peoples of Alaska who hold superior, pre-existing allodial title to their respective lands, waters and resources; and

Whereas the Kuiu Kwáan, Tenakee and Yakutat are among the Thlingit nations that never ceded sovereignty or lands to the United States;

Whereas the right of self-determination is recognised in resolution 66(i) 1946 pertaining to Article 73 of the UN Charter, and Reseolution 1469 "Cessation of Transmission of Information regarding Alaska and Hawaii" was not properly examined by the appropriate committee on decolonization;

Inasmuch as *UN summary report E/Sub.2/1999/SR.3* quotes gross violations of the human rights of the independent tribes and Indigenous Peoples of Alaska "which had been subjugated, dominated and exploited by an administering Power entrusted with bringing them to self-determination. They had not been a party to, nor had they participated in the removal of Alaska from the list of non-self governing territories in 1959. Where they had attempted to participate, they had been subjected to fines or imprisonment or both if they could not read, write or speak English; the United States military and the

* This intervention delivered by Rudy Al James, President and Spokesman for the Tribal Council of the Kuiu Thlingit Nation of Alaska and President of United Native Nations, was circulated for signature by Conference delegates in the form of a Petition & Diplomatic Protest.

transferred population had been allowed to vote, and the independent tribes and indigenous Peoples had not even been fully informed regarding their annexation by the United States of America." (Mr. Ron Barnes, Yupiaq Ambassador); and

Whereas the truth that confirms the absolute title of the Kuiu Kwáan and Tenakee and other Indigenous nations of Alaska to their lands, waters and resources lies in the United States National Archives among the correspondence introduced into the record of the Alaska Boundary Tribunal proceedings proving the U.S. knew that Russia never acquired title to SE Alaska and thus the U.S. did not acquire title to Alaska either; and

Recognising the fact that the Kuiu Kwáan have exhausted local legal remedies and have been denied protection and relief by the colonial occupying courts of the United States; and

Whereas the consequences for the Indigenous Peoples of Alaska will be disastrous to their ability to continue as Peoples, in violation of their human rights, and their rights of self-determination, and result in genocide;

Be it therefore resolved that title to lands, waters and resources cannot reside in two entities at the same time and that the United States Supreme Court does not have the authority to grant or patent title held by the Indigenous Alaskans to their lands, waters and resources; and

Be it further resolved that the undersigned call upon the Supreme Court of the United States to dismiss the colonial state of Alaska's fraudulent and frivolous lawsuit and to recognise the allodial title of the Kuiu Kwáan, Tenakee and all the traditional Indigenous Governments of the region of Alaska to their traditional lands, waters and resources;

Be it finally resolved that the state of Alaska be roundly condemned for cultural and economic genocide against the Kuiu Kwáan and the Tenakee and other Thlingit Peoples of Alaska and put an end to the legacy of colonialism and apartheid imposed upon the Indigenous Peoples of Alaska.

Signed this 13th day of August 2000-09-13

The Black Nation in North America

Marilyn Preston Killingham*

Land, independence and self-government have been objectives sought by Black people ever since they were kidnapped from Afrika and brought to this country as slaves. Many ran away and established communities in the woods, mountains and swamps, armed themselves and created bases from which they could operate and to which other slaves might flee. Others organized rebellions aimed at freeing slaves and liberating territory from which to build an independent state. To the Black people who were forced to come to this land, Black nationalism was not taken lightly. Although brutally crushed, our ancestors continued revolting. Although sold down the river, they continued to escape. Independence and self-determination was what they wanted. These Blacks were, in effect, laying bricks on a foundation which was later to become known as the Republic of New Afrika.

By 1660, the social practice and oppressive laws of the emerging Euro-American nation had made it clear that Afrikans, free or slave, were not to be permitted to join the new white nation. Despite vicious oppression, the essence of our Afrikan culture survived and bound us strongly together as a New African nation that has endured to this day.

In 1865, the 13th amendment to the U.S. Constitution recognized the freedom of Black people. Under international law, Black people had four clear options as to their political future: (1) the right to return to Afrika, as we were the victims of warfare and illegal kidnapping; (2) the right to general emigration, as our families were cruelly fragmented and scattered throughout the diaspora; (3) the right to seek admission as citizens into the United States and slave for a multi-racial democracy and (4) the right to remain on this soil, negotiate with the Native Americans and establish our nation in an independent territory, for we found ourselves on soil claimed by the U.S. in great numbers and with severed homeland ties. Clearly, this right to self-determination was available under U.S. law, because the 13th amendment simply recognized the freedom of all Blacks; it imposed no political conditions whatsoever on the newly freed slave and contained no statement of citizenship in the American community.

In varying degrees, each of these options were to be exercised by various sectors of the Black nation. At no time, however, was a national plebiscite (people's vote) held to inform our people of these options so that collectively we could make

* Marilyn Preston Killingham is former Chairperson of the Republic of New Afrika (RNA).

a choice. For over 100 years after 1865, the New Afrikan nation was kept alive by a succession of dedicated antionalists led by Henry Adams, whose movement sought independent land anywhere, by Benjamin Pap Singleton, whose movement went into Kansas, by Edwin McCabe, whose movement went into Oklahoma; by Marcus Garvey and Drew Ali and Elijah Muhammad; by Queen Mother Moore, Malcolm X and others.

Marcus Garvey once exclaimed, "Where is the Black Man's Government? Where is his president, his army, his navy, his men of big affairs?" On March 31, 1968, the seed of Garvey's prophetic vision came to fruition as a force of over 500 Black Nationalists met in a convention in Detroit, Michigan, and issued a Declaration of Independence for the Black Nation in North America, named that nation the Republic of New Afrika, identified five states in the deep south as the provisional (pre-independence) government with elected officials under the mandate to FREE THE LAND! Each year for the past 33 years, New African Nation Day (Black Nation Day) continues to be observed the last weekend in March.

The Provisional Government teaches that all Blacks, descendants of slaves in North America, are citizens of the Republic of New Afrika by birth, for we have been snatched from every region in Afrika and molded by this common history of oppression and struggle into a New Afrikan nation in the world. We are geographically separated from the continent of Afrika, but are just as Afrikan as any nation there. Blacks may choose to have dual RNA/USA citizenship or they may opt for exclusive RNA or USA citizenship. But New Afrikan citizenship is a right of birth, and the right of choice in this matter lies at the heart of the New Afrikan Independence Movement. An amendment permits naturalized RNA citizenship.

Thus, when the Provisional Government of the Republic of New Afrika was established, it set about the task of informing Black people of their rights under international law to self-determination, land and reparations. Since its existence, the Provisional Government has sharpened the theoretical basis for New Afrikan Political Science, organized national elections for officials of the government, demanded reparations from the U.S. government, defended itself against enemy attacks, sought to establish diplomatic relations with other governments and struggled for the rights of New Afrikan prisoners of war. Freedom, self-government and self-determination, the objectives sought by Blacks since our arrival on these shores, had now reached a higher stage.

WHAT WE SEEK

LAND:

Under international law, the land of our nation is all the land in America where Black people have lived for a long time, which we have worked and built upon and which we have fought to stay on. Black people have met this criteria in many areas in this country, but as part of our reparations claim, we seek the five states now known as Louisiana, Mississippi, Alabama, Georgia and South Carolina as our national territory.

REPARATIONS:

Reparations are the compensation owed or paid one nation by another nation which has damaged or harmed the first nation and its people unjustifiably. The U.S. owes New Afrikans and the New Afrikan nation billions of dollars for damage to Blacks through the murder of over 50 million Afrikans during the slave trade, during slavery and after slavery, and for social, psychological and economic damages inflicted upon Blacks throughout the past 350 years. Among other approaches, three RNA officials, under the chairmanship of Mrs. Killingham, filed a Reparations lawsuit in the U.S. Court of Federal Claims, case number 99- 195C, based on the Civil Liberties Act of 1988, as amended.

PLEBESCITE:

A plebiscite is a vote by a people to determine or clarify their national status. A plebiscite is generally held to settle a dispute as to which nation a particular people and/or territory belong. The New Afrikan population in North America has never been afforded the opportunity to determine its national destiny. We are entitled to decide, with all relevant information, whether we and our land should be an independent new Afrikan nation or a part of the United States of America. One RNA official is also involved in the request for a plebiscite for self-determination for the District of Columbia in the Civil Action No. 98-1665 in the United States District Court.

FREEDOM FOR POLITICAL PRISONERS/PRISONERS OF WAR:

Nearly 100 citizens of the Republic of New Afrika (former Black Panthers and possible members of the Black Liberation Army) have, like former prisoner Geronimo ji-Jaga Pratt, been in prison ten to 27 years! We demand their immediate release! We must also arrange the release of others (every year the U.S. imprisons thousands of young Black men and women for long sentences); they are forced to work in "prison industries" for low pay because the 13th amendment of the U.S. Constitution permits the enslavement of prisoners. The RNA demands release, education and employment of these political prisoners/ prisoners of war.

As the Black Nation in North America, we have the human right to self-determination and independence. New Afrikan nationalists understand that land is synonymous with freedom. New Afrikans are descendants of African peoples kidnapped in Africa and brought to North America against their will. According to New Afrikan political scientists, areas in the southeastern states on which Blacks are still the majority on the land (regions of connected and unconnected counties) total more than 75 thousand square miles. Collectively, New Afrikans (who have historically distinctions from their ancestors and who genetically have a unique gene pool form of experiences in North America) constitute a Black Nation.

The Right to Self-determination & Women

Ulhasini Kamble*

Before all else, You are a Wife and mother: Helman

That I no longer believe
I believe that before all else, I am human being, just as much
As you are
I should try to become one: Nora.

Both the above observations were essentially correct in the past as well as they are correct in the present as far as the woman's place in the global society is concerned.

The shock and trauma of the holocaust of World War II jolted the global statesmanship, and the UNO was born to reaffirm faith in the fundamental human rights ensuring the dignity of men and women, as well as peace and justice to nations, great and small. It is a subject of global interest, magnetized as it is, attracting intelligent studies and refusing to be stale.

Dr. Ambedkar, a dynamic leader for the cause of humanity with a penetrating perception of historical events, recalled the lessons of the French Revolution from an original angle which is pertinent to progressive analysis of the pervasive suppressive social conditions. He stated:

> The French Revolution gave rise to two principles, the principle of self-government and the principle of self-determination. The principle of self-government expresses the desire of people to rule itself rather than be ruled by others. It is called democracy. The principle of self-determination expresses the desire of the people united by common ideals and common purposes to decide without external compulsions, its political and social status.

Unfortunately after a lapse of nearly 140 years, these principles have failed to take roots.

* Ulhasini Kamble, Research-Population Department, Institute for Social and Economic Change, Bangalore, India.

The Right to Self-determination & Women / Kamble

Women and Dalits have always been victims of oppression and atrocities all over the world. Unfortunately, woman is given inferior position to that of man in the traditional setup of the social structures, religions and faiths of the various nations. Lack of education, low and undignified status, helplessness, economic and emotional dependence, restrictions on movement, and her identity as a property of the man like his other goods, has compelled her to develop either as the submissive and slavish weaker sex or as victim of oppression and atrocities with a dark future.

When in the new Millenium, we take a review of conditions, we see the practice of *sati* (immolating a widow on the pyre of her dead husband) welcomed and supported by religious leaders as a moral act; the practice of child marriage; the practice of *Devdasi* (devoting a female as an offering to God); or the practice of such offerings of women by marrying them with the Diety or the God under the cover of religion while exposing them to misery and lifelong need. This cannot be condoned. Words fail to describe the sad plight of child widows in general, as they are looked upon as ones cursed, as lifelong slaves in the family and untouchable female objects of play. The Law of Manu declared "Woman does not deserve freedom."

Are we not, as human rights activists, to take up the cause of liberation of women from the bondage of pseudo religion? The attempt to depict the true picture through the cinema by the film director, Deepa Mehta, with the actresses Shabana Azmi and Nandita Das, failed. Though the legal authorities appointed under the law of the land certified that theme for filming, the so-called protectors of religion and culture supported by the political backing of the class of dealers in Gods and culture, set on fire the set and materials at waranashi, the holy place on the banks of the world-famous sacred river, Ganges, flowing from the Himalayan hills.

Likewise, the incidence of *sati* at Village Piprala in Rajsthan created a wave of anger among human rights activists, but was ignored on account of interference in the affairs of religion.

My question is whether – religion or no religion, as a species of the human race — a woman can enjoy the freedom to develop herself and come openly before the world with her art or talents, taking support from human rights.

Human Rights & Self-determination of the Tamil People of the Island of Sri Lanka

S.V. Kirubaharan*

The Tamil Centre for Human Rights takes the floor with great appreciation to the organizers for inviting us to be a participating group in this historic conference.

INTRODUCTION

The UN Charter of 1945 supports the view that self-determination is a legal principle, and as such the right to self-determination is placed crucially in the first article of each of the two major human rights covenants, the International Covenant on Civil and Political Rights (ICCPR) and the International Covenant on Economic, Social and Cultural Rights (ICESCR). The principle and fundamental right of self-determination is firmly established in international law. It articulates the fact that every people have the right to freely determine their political status.

The Tamil people in the island of Sri Lanka have for decades been consistently denied this right. In our paper today, TCHR outlines how discrimination upon discrimination has been heaped upon the Tamil people in the island for more than fifty years, from covert to overt manipulation of Tamil homeland areas; from denial of language rights to denial of the right to existence itself. The discrimination, fanned by the flames of entrenched racial hatred, culminated periodically in brutal killings of the most chilling kind, leaving thousands upon thousands of Tamils dead – as long as seventeen years ago. The natural desire for survival and the thirst for self-expression of the right to self-determination came out of this background of persistent repression and persecution.

BRIEF HISTORICAL BACKGROUND

The Tamils have lived for several thousand years in the Northern and Eastern parts of the island, which are considered the Tamil hereditary areas. In pre-colonial days, there was a Tamil kingdom in the North East (Jaffna) and two Sinhalesse kingdoms

* S.V. Kirubaharan is General Secretary,Tamil Centre for Human Rights, France.

in the South (Kotte and Kandy). Under the Portuguese and Dutch colonial powers, the Tamil and Sinhalese areas were ruled separately. The British, who came in 1796, and captured the Kandyan Kingdom in 1815 (hitherto unconquered by the other colonial powers), fused the two main communities, the Tamils and the Sinhalese, for administrative convenience, creating the "unitary state" named Ceylon. The British had brought a million Tamils from South India to work on the plantations in the Central hill area of the island, which is outside of the Tamil homeland. Nearly three quarters of the population is Sinhalese, while the Tamils are about one fifth of the population. These two main communities have distinct cultures and languages of their own. The Sinhalese are predominantly Buddhist while the majority of Tamils are Hindu.

COLONIZATION: THE TAKING OVER OF TAMIL LAND

Sadly, the majority rule which ensued with the creation of a parliamentary system, led to the majority Sinhalese community using all its political strength as an ethnic majority to undermine and deny the rights of the Tamil people. From the 1930's, the Sinhalese-dominated governments used tactics to take the land from the Tamils, by settling armed Sinhalese families in Tamil areas, with the intention of changing the demographic pattern in those areas. This colonisation of the Tamil areas was planned and executed with methodical precision and calculated aggression. It started covertly then became overt. This whole process has been documented in detail by a distinguished adviser to the UN, who concluded in 1980 that: "Within 162 years, the Sinhalese had plundered 50% of the Tamil ancestral homeland and are still attempting to colonize more and more lands". [1]

After Independence in 1948 came a series of legislative discrimination against the Tamils which further eroded their human rights. The one million Tamils in the central hill country were immediately disenfranchised, making them stateless, and simultaneously increasing the already large majority of Sinhalese voters. In 1956, the Sinhala Only Act was passed which made Sinhala the only official language. This was in itself a watershed in the island's history, especially in the relationship between the Sinhala and Tamil people. It came as a massive blow to the Tamils in terms of their linguistic, economic, social and cultural rights. The Sinhala Only Act inevitably impacted on many areas of life such as employment, access to equal rights in the legal system and so on. To this day, Tamil detainees find themselves being forced to sign documents written in Sinhala, a language the vast majority of them do not understand.

In the seventies, there were more changes which entrenched the aforesaid discrimination and racism into the Constitution and the legislative framework of the unitary state. In 1972, Buddhism became the foremost religion of the island. The plurality of world religions — Hinduism, Islam and Christianity – and indigenous faiths, whose adherents populate the island, was totally ignored. It was insisted that the schoolchildren in all parts of the island sing the national anthem in Sinhalese, and hoist the flag designed by the majority community, which incorporates a lion symbol and a sword.

Another area of grievance was discrimination in the matter of administration of Tamil students for higher education. Admission was not done on the basis of merit. Discrimination also existed in the filling of employment opportunities in the

government sector. All these further repressive measures led to more oppression. The Sinhalization of the island paralleled the increasing importance given to Buddhism – the two went hand in hand. Feelings of being excluded and marginalized inevitably arose in the Tamil population in response to this all-encompassing racial discrim-ination.

NONVIOLENT PROTEST AND RESISTANCE CRUSHED BY POLICE AND ARMY

As part of the parliamentary and nonviolent methods of representing Tamil rights, there were pacts attempted in the fifties and sixties between the Sinhalese and Tamils, through their political leaders, aiming at setting up regional/district councils and addressing the issues of language and the colonization mentioned earlier, as they sought devolution. The Tamils were not satisfied with being under the total control of a state which so blatantly refused to redress the racism and discrimination. As we have shown earlier, the state itself actually encouraged and propagated the racism and discrimination systematically. The pacts of the 50's and 60's were broken by the forces of Sinhala racism, and the Buddhist clergy, the main antagonists, who at all costs did not want equal rights for the Tamils nor any form of power-sharing.

The Bandaranaike-Chelvanayagam pact of 1957 and the Senanyake-Chelvanayagam pact of 1965, through which the Tamils sought a solution in terms of internal self-determination, came to nothing. One cannot underestimate the power of the Sinhala majority racist vote, inflamed and encouraged by the government itself and the clergy! Bandaranaike was actually shot dead by a Buddhist monk! Today we are seeing the reaction of the Buddhist clergy to the efforts to move towards peace talks. They have been caught on film burning the Norwegian flag in front of the Royal Norwegian Embassy in Colombo; even the Norwegian Save the Children fund office has come under attack. It would appear the Buddhist clergy do not want peace but want to continue the war.

As the legislative changes from the 1950's through to the 1970's legalized and legitimized increasing discrimination in language, education, religion, culture and so on, the Tamils on the island did not sit back and accept the blatant denial of their rights. Like many people in the world, they organized dignified protests based on Satyagraha, nonviolent civil disobedience in the Gandhian manner, inspired by the belief that their nonviolent action would bring forth positive change. They did this for nearly thirty years. These protests were invariably crushed with hostile and repressive measures by the police and army on direction of the government, accompanied with anti-Tamil riots, each worse than the previous one. Between 1958 and 1983, there were seven upsurges of vicious violence against the Tamil people in the island. Sinhalese people were encouraged by the army to commit atrocities.

ROOTS OF RACISM AGAINST TAMILS

One may reasonably ask why did the Sinhalese-dominated governments and the Buddhist clergy want to take land and rights from the Tamil people? As has been well documented in many studies on self-determination, the question of de-colonisation of some countries was then followed by internal colonization by a dominant group in the country that freed itself from the former colonial power. The

Sinhalese, in their majority, actually became the rulers of Ceylon and abolished the few pitifully inadequate measures intended to protect the numerical minority which the former colonial power, Britain, had left in place.

There is, in addition, a dimension concerning religion. The Sinhala community is predominantly Buddhist. While it is widely known that Buddhism teaches the values of compassion and detachment, it is less widely known that the particular kind of Buddhism in Sri Lanka has re-interpreted a central myth, the "Mahavamsa", to mean that the island should be the conclave of Buddhism, that Sinhala Buddhists therefore have the right to take all the land away from the Tamils! Furthermore, there are also ideas that the Sinhala Buddhists are racially superior to the Tamils.

This thinking, and the action that follows from all the above, has created a formidable and chilling engine of hate. This core of religious intolerance has legitimized vehement persecution and atrocities. If this central core of racially supremacist thinking, rooted in a perverse reading of history and sacred text, is not taken into the equation, it is impossible to grasp the severity and enormity of the oppression of the Tamil people and their sufferings. This is not to say that all Sinhalese are racist towards Tamils. There exist a handful of Sinhalese who want peace and the war to stop so their sons and husbands can come home and everyone can live in peace. However, these people were and are still, through powerful censorship, denied real knowledge of what is happening, and are fed with hate propaganda by Sinhala nationalist politicians, the media and the press. A hysterical racial hatred for Tamils is whipped up in order to justify the war. Hence all Tamils become objects of hate and suspicion, and thousands are routinely arrested, detained and tortured in the South. A recent news report, based on the findings of medical research into the experiences of Tamils fleeing persecution in Sri Lanka describes the torture used by the government as medieval.

Sections of the Tamil community, at differing paces, came to feel they no longer owed allegiance to the authorities who had so cruelly denied all their rights.

THE 1977 GENERAL ELECTION: THE TAMILS FREELY EXPRESSED THEIR RIGHT TO DETERMINE THEIR OWN POLITICAL STATUS

A huge turning point came in the general election of 1977. In this general election, the Tamils overwhelmingly voted for independence, and gave the mandate for the Tamil representatives to carry this through. At this point, it was clearly recognised that the previous painstaking attempts at federal or alternative solutions had failed. The Tamil people within a nonviolent, parliamentary and democratic framework expressed their right to freely determine their political status. They expressed it loud and clear. This was the last time the Tamils freely participated in elections. Since then, the vast majority of Tamils have boycotted the elections and there has been heavy and well-documented vote-rigging on the part of the government.

In the general election of 1977, the Tamils overwhelmingly voted for independence, and gave the mandate for the Tamil representatives to carry this through.

The question then is: what happened to this free and democratic expression of the political will of the Tamil people of the island in 1977? Did the government

implement its duty to conduct itself in compliance with the principle of equal rights and self-determination of peoples? The answer unfortunately is an emphatic "no". The response of the government was to introduce the Sixth Amendment to the Constitution which prohibited peaceful advocacy of independence. It explicitly and blatantly prevents the Tamil people, who believe in self0-determination, from participating in the political process. Clearly, this destroyed any appearance of legitimacy the Sri Lankan government might have had in relation to the Tamils. The sixth Amendment is a violation of article 25 of the ICCPR which states that every citizen shall have the right to take part in public affairs without any distinction including among others, political or other opinion.

ANTI-TAMIL POGROMS & INTERNATIONAL RESPONSE

In 1981, the physical and cultural obliteration of the Tamils was sought. The Library in Jaffna was burnt to the ground. In 1983, the world saw the most horrific acts take place, and screamed out in collective horror at the brutality. There is vast documentation of the human rights atrocities which took place. A well-known picture shows a Tamil youth stripped naked, cowering with his hands over his head, while Sinhala thugs laugh at him and dance menacingly around him. Later they burned him alive. In 1983, all over the island, at least 3,000 Tamils were killed in four days, butchered in the streets. Many were burnt alive after being doused in petrol. For instance, there were cases where Sinhalese mobs ordered Tamils to read Sinhalese print out loud. If they were unable to do so, they were immediately killed. Fifty-two Tamil political prisoners were killed in the jail at Welikade. The President kept silent for four long days with not a murmur of condemnation.

The international community protested loudly and with outrage in response to what was categorised as genocide by international NGOs, some based here in Geneva. The issue was brought to the UN Human Rights Commission. The international response, however strong and effective it was in the short term in alerting the world to the stark truth of the shocking torture and extra-judicial killings, made little connection with the overall prevailing political reality, the fact that this genocide had an intrinsic connection with the deep hatred and systematic aggression aimed at denying the right to existence and denying the right of the Tamil people to freely determine their own political status.

By focussing only on the symptoms of the repressive violence and by not exposing the entrenched causes of systematic violation of basic and fundamental rights including the right to self-determination, the real issues were not adequately and fully exposed or even aired. If these issues had been exposed, a space would have been created for an objective look at the real situation in its entirety. The physical atrocities were indeed seen and condemned. The obvious psychological anguish and torment that the Tamils were subjected to was exposed too. However, the manipulative hate engine repressing the political will of the Tamils was barely understood, let alone seen, therefore it was neither named nor condemned by the international community. The Sri Lankan government's façade of a democratic government was not analysed in depth to reveal the nature of the permanent ethnic majority the Sinhalese have in parliament and the ideology at the root of the oppression of the Tamils.

After this second watershed date of 1983, genocidal acts themselves became the means of suppressing the legitimate rights of the Tamils to express openly their right to external self-determination.

THE YOUTH RESPONSE:
TAKING UP ARMS AS THE LAST RESORT

It was during the seventies when the youth were affected through their education, as explained earlier, and when the apartheid system of standardisation was introduced that they started to turn to take up arms. This can be understood as their right of last resort of rebellion against tyranny and oppression, referred to in the preamble to the Universal Declaration of Human Rights. Many of them knew the history, in detail, of the perseverance of Tamil parliamentarians in attempting to secure the rights of the Tamils. They had seen the brutal repression of the Satyagraha (nonviolent protest) of heard about it from their parents. The injustice of the infliction of pain, destruction, misery and loss of life incensed them, and they wanted to change things for the better for their oppressed community, which had exhausted all avenues of nonviolent remedy and protest. The genocidal pogroms of 1983 crystalised in the minds of many, the belief that all other ways had been tried and that the only way left to secure freedom from discrimination and oppression was through the use of arms. It is the continued, relentless pounding away at all the rights of the people through language, employment, land, religion, culture and education that eventually led to this. It is not insignificant that the UK Parliamentary Human Rights Committee states that form 1983 to the present day there is occurring in Sri Lanka a war of national liberation, in exercise of the right to self-determination of the Tamil people.

The Sri Lankan government has over the years carried out a vicious but sophisticated propaganda campaign to vilify and demonise the Tamil people internationally, using all the methods at its disposal. These include diplomatic channels, state media, and the manipulation of international news agencies. Half a million Tamils have fled from persecution in Sri Lanka, and the Sri Lankan government has installed "communications experts" in the Embassies or High Commissions of countries where there is a high density of Tamil ex-patriates and refugees active in raising awareness of the human rights issues. It is amazing how easily deceived the local media in these countries are by the Sri Lankan propaganda, to the exasperation of Tamils living locally.

Genocide

We are witnessing the most horrific phase ever of the human rights situation for the Tamil people of the island of Sri Lanka. Hospitals, churches, temples, schools, marketplaces, fishing hamlets are bombed from land, air and sea, with a huge toll on civilian life. More than 65,000 Tamil civilians have been killed by Sri Lankan armed forces. Food and medicine is denied to one million displaced people to start them, used as a weapon of war. Girls from 6 years old to women of 70 have been subjected to rape used as a weapon of war. A shocking number of Tamil women and girls have been gang-raped and murdered. All Tamils are deemed suspects and arrests of Tamils occur in thousands, the arbitrary arrests and detentions, rape, torture,

disappearances and extra-judicial killings continue. Sri Lanka has the second highest number of disappearances in the world according to the UN Working Group on Involuntary and enforced disappearances. The annihilating of the Tamil people's human rights is the government of Sri Lanka's counter attack, its punishment on the Tamil people for not being willing to accept subjugation. Ethnic cleansing is in fact taking place against the Tamils.

Ethnic cleansing is in fact taking place against the Tamils.

The UN General Assembly Resolution on Ethnic Cleansing (A/47/49) of 1992 states alarmingly "that there are still in many parts of the world manifestations of racial discrimination that are encouraged by a philosophy of racial superiority or hatred", and states that the "abhorrent practice of 'ethnic cleansing' constitutes a grave and serious violation of international humanitarian law".

Two weeks before the attacks in 1983 on the Tamil people, the then President Jayawardena stated, "I am not worried about the opinion of the Tamil people... now we cannot think of them, not about their lives or their opinion... Really, if I starve the Tamils out, the Sinhala people will be happy." Following a fact finding mission nine months after the 1983 massacres, the International Commission of Jurists wrote: "Clearly this was not a spontaneous upsurge of communal hatred... It was a series of deliberate acts, executed in accordance with a concerted plan conceived and organised well in advance." The same planned and organised annihilation of the Tamils continues today, using the full force of all Sri Lanka's armed forces, the Navy, the army, the Air force, the Special Task Force, other auxiliary sections of the Police and other mercenary groups.

Article two of the Genocide Convention describes acts committed with intent to destroy, in whole or in part, a national, ethnic, racial or religious group, as genocide. Amongst these are: "Killing members of the group", "Causing serious bodily or mental harm to members of the group" and "Deliberately inflicting on the group conditions of life to bring about its physical destruction in whole or in part". All these acts continue to happen in the island of Sri Lanka, against the Tamil people, at the hands of the armed forces of the Sri Lankan government.

Numerous war crimes have been committed by the Sri Lankan government's armed forces. Recently a Sri Lankan Navy war criminal admitted to gunning down innocent Tamil refugees in a clearly marked ICRC camp. He made this admission as he sought refugee status in Australia. It was legally established that he had committed a crime against humanity, a war crime – that his act was not isolated nor random, but part of a larger design of persecution against the Tamil people. He was on this basis denied refugee status under article 1F(a) and (b) of the 1951 Refugee Convention.

The current human rights situation actually tells us much about what the Tamil people have chosen for themselves, if we have the eyes to perceive and ears to hear. If the people were not supporting the freedom fighters, the latter could not possibly have sustained their energy. They would be like fish with no water, they would have been defeated long ago. As the people's struggle became stronger and stronger, the Tamil people see the possibility of a free future and do what they can to support their freedom struggle. There is already a de facto state of Tamil Eelam, whether it is recognised internationally or not. A penal code, social organisations,

transport, organisations of many kinds, all are formed. From 1990 to 1995, Jaffna Peninsula was a de facto state.

SRI LANKA MAINTAINS ILLUSION OF PROMOTING AND PROTECTING HUMAN RIGHTS

Western liberalism has always emphasised the promotion of individual liberties and not concentrated on group rights or the rights of peoples. This important conference is part of an ongoing concern that is convinced collective rights do matter, especially if there exists discrimination or destruction of culture and life. Successive Sinhalese governments have fed the Western system in various ways to make it appear that the rights of the Tamil people are respected. They have encouraged Tamil stooges into their administration in order to make it appear that there is no anti-Tamil discrimination. They have a Human Rights Commission (HRC) that has no power to remedy the human rights violations, and is heavily pressured by the government. Commissions for missing persons are a sham. They have tried but never convicted army personnel who have raped and murdered.

These hoaxes have maintained the illusion that the government is doing what it can to promote and protect human rights, while it is blatantly clear from documentary evidence that the contrary has been the case. The Sinhalese government has played the system well for many decades. It is significant that Sri Lanka abstained from voting in favor of the Rome Statute of the International Criminal Court. The statute includes genocide, crimes against humanity, war crimes as well as the crime of aggression, and it also provides for an independent prosecutor who may initiate proceedings and investigations.

The Government of Sri Lanka is desperate to avoid scrutiny and to ensure that its genocidal onslaught against the Tamil people is neither understood nor exposed to the outside world. Therefore it has gone to extreme measures to hide it through the following means:

• The use of censorship, control of media and dissemination of what is in effect war propaganda, locally, regionally and internationally, and the denial of free media access to the north east.

• The avoidance of inviting independent forensic experts to conduct the exhumations of the mass graves at Chemmani. Despite lists of international experts being given to the National HRC, they used Sinhalese forensic experts to carry out the exhumations!

• Despite numerous calls for independent investigations into many massacres committed by the Sri Lanka armed forces, there has not been one to date.

• The killing of human rights activists and journalists, and legislation against NGOs.

• The silencing of freedom of expression in favor of Tamil rights by repression and intimidation.

• The killing of leading human rights defender, Mr. Kumar Ponnambalam, on January 5 of this year in Colombo. He had made interventions at the Human Rights Commission here in Geneva in 1997 and 1999. He dared to protest against the violations of the Tamil people's human rights from Colombo itself, as well as in international fora all over the world.

- The use of an unhelpful vocabulary to describe Tamils and the Tamil people, evoking hostile and knee-jerk negative attitudes to the Tamil community – and simultaneously justifying requests to many countries for arms with which to exterminate the Tamil people.
- The use of Emergency Regulations and Prevention of Terrorism Act which have legitimised the arbitrary arrest, detention, disappearance and encouraged the torture of Tamils for more than two decades.

The human rights situation is dire. Genocide is occurring as described in Article two of the Genocide Convention. To point a finger at the Liberation movement and blame it for causing the violence is a complete misreading of the situation, and displays unfortunate ignorance of the real issues involved. The UN Special Rapporteur on Extrajudicial killings stated that "Effective impunity encourages political violence and is a serious destabilising element in all contexts of the Sri Lankan socio-political system. This culture of impunity has led to arbitrary killings and has contributed to the uncontrollable spiraling of violence" (E/CN.4/1998/68/Add.2). We have seen that this impunity has reached back fifty years regarding the failure of successive Sinhala governments to implement their duty to conduct themselves in compliance with the principle of equal rights and self-determination, and with their obligations under the ICCPR and the ICESCR.

THE NEED FOR INTERNATIONAL SOLIDARITY
WITH THE TAMILS – TOWARDS A JUST PEACE

Without the determined effort internationally to help implement the right of self-determination of the Tamil people, there can be no peace in that island. It is quite clear from all the aforementioned that internal self-determination is no longer an option as a solution. That time has passed long ago. The Tamil people clearly stated twenty-three years ago that they saw external self-determination as the only way forward, in exercise of their legal and fundamental rights as a people. How the implementation of the right to self-determination can be worked out is up to the leadership of the Tamil people and the government of Sri Lanka. The Tamils

Therefore the seeds of peace must be planted in a truly just solution which names the denial of these rights and recognises the right of the Tamil people to freely determine their own political status.

for many years have been calling for international assistance in this process to ensure a level playing field between the two parties to the conflict.

The roots of the war started in cruel and severe denial of fundamental rights including the right to existence of the Tamil people. Therefore the seeds of peace must be planted in a truly just solution which names the denial of these rights and recognises the right of the Tamil people to freely determine their own political status, in other words, their right to self-determination. This cannot rule out the possibility of external self-determination, as has been said publicly in recent times by senior politicians and international diplomats from different continents.

CONCLUSION

The original self-determination in Ceylon in 1947 was flawed. When the British gave independence to Ceylon in pursuance of the right of colonial self-determination, adequate protection of the rights of the Tamils should have been assured, but was not. Self-determination imposed a duty to restore the status quo prior to European colonisation which meant the restoration of the separate Tamil administration in the Tamil hereditary areas. Periodic unleashing of violence against the Tamils occurred, and more recently the incessant bombing of innocent civilians; Tamil youths were rounded up, tortured and killed routinely. Peaceful means tried by Tamil politicians met with failure after failure, and an army of occupation has been sent to the Tamil homelands to repress, rape, plunder and pillage.

The right to internal self-determination was never granted to the Tamil people. Since they have been subjected to gross and systematic human rights violations amounting to genocide, they have been left with no other alternative path than to pursue their right to external self-determination.

We congratulate the organisers of this First International Conference on the Right to Self-determination which we feel is timely and greatly needed in this new century. Also we take this opportunity to express our thanks and solidarity to all the participants. Let us join our hands and wish each other the best of luck.

ENDNOTES

[1] TCHR report on Colonisation to the 56th session of the CHR.

An Illustration of Atrocities Committed Against the Tamil Population

Deirdre McConnell*

As illustration of the ongoing violations of the human rights of the Tamils of Sri Lanka, I wish to advise the delegates of this Conference concerning a grievous event that occurred just a view days ago, a report of which is here in my hands.

"A little boy came running home around 11 a.m. and told me that soldiers had lopped off my husband's head. I ran towards the field where he was working and saw some soldiers taking a human head in a white bag. In the field, I found my husband's headless body," said Ambikapathy Santhiramohan, 20, giving evidence at the inquest into her husband" death before Acting Magistrate for Batticaloa, D.C. Chinniah, last evening at the Eravus Police station. Ambikapathy was married four months ago to Arulampalam Santhiramoham, 20, who was beheaded in reprisal Wednesday, following a firefight at Sithaandy, 24 kilometers north of Batticaloa in which two Sri Lanka army troopers were wounded.

The Acting Magistrate returned a verdict of homicide today and asked the Eravur Police to conduct investigations. Dr. S. Sukumar, District Medical Officer for Eravur, in his report at the inquest, said that the death was caused due to beheading with a sharp instrument.

He noted that there were gunshot wounds in Santhiramohan's right thigh and armpit and a knife wound on the deceased's left forehead. There was an injury on the youth's left shoulder caused after the death due to an explosion, the doctor observed.

Wanniaratchi Gamganamge Sanath Kumara, 24, a soldier from the Morokkoddanchenai Sri Lanka army camp, giving evidence at the inquest, said that he was on patrol on Wednesday and had heard gunfire near the lagoon around 11:30 a.m. The Tigers had tried to encircle his patrol thereafter and there was a firefight according to him. When he was returning to camp with his group, he had seen a body which was then handed over by them to the camp, said Sanath Kumara in his evidence at the inquest.

* Deirdre McConnell is Director, International Programme, Tamil Centre for Human Rights, Manchester, UK..

An Illustration of Atrocities Against the Tamil Population / McConnell

The next day, this information became available:

"I heard Santhiramohan pleading with the soldiers to spare his life. He was telling them he was poor and was married to a poor girl. Then there was silence. I came out of the thicket where I was hiding after some time when it appeared that the army had left the place. I found Santhiramohan's headless body lying naked in the field. I ran tohis house and told his wife that the soldiers had killed him and lopped off his head," said a boy who was herding goats by the field where a Tamil youth was beheaded by Sri Lankan army soldiers on Wednesday in the village of Sithaandy, 24 kilometers north of Batticaloa.

The boy said that Santhiramohan had fallen on the ground, hit by a bullet, when the soldiers had opened fire towards the field where many people were working at the time. The others had run for cover and hidden in the shrub nearby.

Santhiramohan's wife Ambikapathy said that she had gone to the field when the goatherd told her about her husband's murder. She had seen some soldiers taking a head in a bag and then found Santhiramohan's naked headless body. Later another group of soldiers had come to the spot and dressed his body in military fatigues and had wrapped it in oil cloth. (Civilians killed in crossfire are at times dressed thus to prove that they were Tigers.)

The soldiers had questioned Amikapathy and her mother who had also come there about the corpse, taken down notes, and then chased them away from the spot. The soldiers then took the body in an army truck to the SLA camp at Morokkoddaanchenai, three kilometers north of Sithaandy, on the main road.

Ambikathy and her mother had followed the truck to the camp and had begged soldiers on duty at the camp's entrance to give them Santhiramohan's body. The soldiers had scolded the wailing women and had tried to chase them away from the camp. But Ambikapathy and her mother had persisted, despite threats by the soldiers in the camp.

Later they were told to go and seek the body at Eravur, about ten kilometers south of Sithaandy. The acting magistrate for Batticaloa held an inquest yesterday into Santhiramohan's death at Eravur.

Ambikapathy and her mother said that they are scared that the army might harm them if they were to give further evidence on Santhiramohan's murder. "We are very poor and defenceless," said Ambikapathy's mother. Santhiramohan, 20, was the eldest in a family of three. He had stopped going to school early to fend for his poor family. Ambikapathy, who married him four months ago, however, had studied up to grade nine.

This indicates the kind of gross abuses presently endured by theTamil population in Sri Lanka.

Self-determination & the Irish Question

Francis Mackey & Joe Dillon*

THEME I: Self-determination as a form of collective restorative justice for the malformation of many multinational states created through the exercise of the now-discredited historical right to conquest & domination

The British Government's claim to be Great Britain and Northern Ireland is a malformation of the facts and has come about through conquest and domination.

We agree that National self-determination free from outside interference would be restorative justice for the injustices of Britain's domination in Irish affairs.

In support of this, we cite the various means and devices used through an 800 year period of domination, culminating in the armed suppression of Dail Eireann in 1921, the rejection of the Irish people's declared "Declaration of Independence" supported at the ballot box.

They set up two states under the transformed Government of Ireland Act by a majority vote at the Westminster Parliament. A Parliament that Dail Eireann declared "had no right to intervene in Irish affairs".

By continually denying the Irish people their rights, Britain was the instigator of the Civil War in Ireland by demanding that elected representatives to the two puppet parliaments swear an oath of allegiance to the Crown.

To vote or reject the treaty, like the Good Friday Agreement, the Irish people were not given a free choice to exercise National self-determination, and once again, this was not the will of the people but the fear of the people.

By analysing this within an Irish context, we support the view that self-determination could be a form of restorative justice for the historic injustice of domination and conquest.

THEME II: The relationship between policies of forced assimilation and racism, ethnocide & armed conflict in the context of denial of just demands for self-determination

It would be fair to say that under this theme, Ireland has suffered for centuries under these policies of forced assimilation. For example, the Irish language was outlawed and almost became extinct. Religious freedom was denied.

* Francis Mackey, Chairman of the 32 County Sovereignty Movement, Dublin, Eire, delivered interventions on Themes II and V. Joe Dillon, National Executive, 32 County Sovereignty Movement, intervened on Themes I and II.

Ownership of property was denied. Wearing national colours was denied. Our National sports were outlawed.

Since the Declaration of Independence, we have experienced: the Pogroms in the 1920s, internment without trial spanning five decades, shoot to kill policy, state collusion with loyalist death squads, Draconian laws, a non-jury court system, assassination of civil rights lawyers, gerrymandering electoral boundaries and the denial of the right to vote.

As a consequence, Britain's denial of Ireland's right to Sovereignty has led to a violation of human rights throughout the island of Ireland.

Armed resistance over the centuries was at all times based on defending the right of the Irish people to survive the attempts by the British to deny them the right to self-determination.

We believe that the Irish people will be able to achieve an end to the conflict in Ireland through democratising the UN, leading to National self-determination and hope through our participation at this conference to be part of the changes necessary to end conflict in Ireland and throughout the world.

THEME III: Self-determination through minority rights, internal autonomy or secession

All insurgency declarations, right down to the Irish Declaration of Independence in 1919, understood and guaranteed the right of minorities within the context of the right to self-determination.

Despite this, sectarian and bigoted legislation can be clearly traced to have been exercised by British imperialism based on divide and rule.

The present devolved government in the 6 counties, constituted along sectarian lines, is evidence of this continued colonial policy.

There was never a problem with the Irish people reaching an internal arrangement, either through federalism or some form of autonomy within the National right to self-determination.

There was never a problem with the Irish people reaching an internal arrangement, either through federalism or some form of autonomy within the National right to self-determination. What was preventing the Irish people getting to this point is the continued British imperialist involvement.

What was preventing the Irish people getting to this point is the continued British imperialist involvement, which fundamentally is a denial of the right to self-determination and the only cause of armed conflict on the island.

THEME V: Self-determination as a means of further democratisation of the UN & the international system

This is long overdue. Indeed, the UN since its foundation has been contradictory to its declared intention, through its charter to protect small nations and the human rights violations by some of its members.

We join in the call for an end to this situation and support the efforts being made for an end to the undemocratic right to veto by some countries.

In Pursuit of the Right to Self-determination

The apparent inability of the UN to involve itself in the Irish situation has allowed a continuance of conflict and human rights violations, bearing in mind that the British government holds a veto at the UN's Security Council, and has been allowed to argue that the situation in Ireland is an internal British problem. Which of course it is not.

Britain is an imperial power in Ireland and has continually denied the Irish people their right to sovereignty and national self-determination.

Self-determination as a means of further democratisation of the UN and the international system can only lead to ending conflict and granting our peoples their rights, a situation which will be welcomed around the world.

RESOLUTION from Delegates of the 32 County Sovereignty Movement, Ireland

• That this conference, in supporting the right to self-determination, call on the British Government to accept the sovereignty and integrity of the Irish peoples, and

• That this conference call on the Secretary-General and the UN Human Rights High Commissioner to intervene in the visa denial of our members by the United States of America and allow us to pursue our peaceful challenge at the UN.

The Future of Burma: Dictatorship, Democracy of Majority Burman, & National Self-determination of Ethnic Nationalities

Nai Ong Mon*

This article is dedicated to the Mon people, my native people, and other ethnic nationalities working for their national self-determination in Burma.

Enough has happened and enough human beings have already suffered from the oppression of military dictators in Burma. It is now mind-numbing to hear the horrible stories of crises in Burma. Thousands of ethnic minority refugees escape forced labor and human rights violations. Production of methamphetamine pills increases as the number of HIV-infected people grows. Ordinary people live in conditions below the poverty level while the ruling generals live like kings. Former drug lords are now in state-to-state level meetings while elected MPs are in prisons and the 1990 general elections' results are ignored. Teaching of the Mon language and other ethnic languages is a crime against the state and walking peacefully in a group of five is illegal. Posting a "Closed on 9-9-99" sign in front of a teashop receives a long-term imprisonment because dissident groups have called for a peaceful demonstration on 9-9-99. Thailand is now in a war against various illicit drugs produced in Burma. And Nobel Peace Laureate Aung San Suu Kyi, her party's members, and other parties' members are constantly threatened and intimidated, and so on. For those sympathetic to the victims of Burma, the task of finding a solution began a long time ago.

* Nai Ong Mon, Monland Restoration Council. Nai Ong Mon was one of Mon student activists during the 1988 nationwide pro-democracy uprising in Burma and is now exiled in the United States and working for national self-determination of the Mon people. This article reflects his personal opinions, not those of the Monland Restoration Council.

In Pursuit of the Right to Self-determination

For the majority of those finding a solution, democracy seems the one and only solution. Democracy will prevail. But, will it last? For ethnic minorities, who constitute some 45 percent of the country's nearly 50 million population, a democratic Burma that denies political equality and ethnic nationalities' rights to self-determination will not last. It will again bring Burma back to confusion, anarchy, and turmoil. The Burman often argue that now is not the right time to debate about ethnic nationalities' rights to self-determination and that it is time to debate about the way to overthrow the current military regime. They say that in a free and democratic Burma, any kind of debate will be welcome. Unfortunately, this sort of argument is not accepted any longer by the national minorities.

Minorities, on the other hand, claim that they had heard this argument before, accepted it, and trusted the Burman. In fact, they believe that it was this type of argument that brought Burman rule to their areas and led to the present situation of oppression in the country. They point out that Aung San, Burman national hero, used this same argument followed by U Nu, Burma's former Prime Minister ousted by the military coup of 1962, during his fight against Ne Win, 1962 coup's leader, from ethnic minorities' bases along Thailand-Burma border. Ethnic minorities still believe that the assassination of Aung San in 1947 created a chance for Burman to break the Panglong agreement, which their leaders signed with minority leaders in 1947 and which guaranteed the right to secession. Taking advantages of the assassination of Aung San, the Burman military forcefully dissolved a democratic constitution in 1962 and formed successive military regimes up to the present day. Also, U Nu finally gave up his fight against Ne Win, surrendered, and went back home, irritating minorities. Now and again, the Burman are attempting to make this same argument of "unite now and talk later." For minorities, the modern history of Burma repeatedly shows that they shall not entrust the fate of their people into the hands of the Burman. They also believe that the safety and prosperity of their people shall not depend on sympathy of the Burman.

More important, the conflict is often seen as a conflict between only two groups: the Burman and a few dictators, the so-called State Peace and Development Council (SPDC). An almost forgotten group in the picture is ethnic minorities. In fact, the true root of the conflict is among three groups: the ethnic minorities, who struggle for national self-determination; the Burman, who fight for democracy; and a few dictators, who strive to put the entire country into their pockets. The military regime claims to save the country from disintegration while accusing minorities of seeking separation or secession from the union. Minorities assert to fight for political equality and national self-determination while in return accusing the military of implementing "Burmanization" through ethnic cleansings. The Mon, Karen, Kachin, Chin, Arankanese, Shan, and many other ethnic nationalities have been fighting against the predominantly Burman military government long before the Burman started. Although their fight has now been over half a century, these ethnic minorities claim

that they have never demanded any right to separation or secession from the union. All they have been fighting for is political equality and national self-determination for their people. They want to progress politically shoulder-to-shoulder with Burman. They want to possess executive power, legislative power, and judicial power of their people while remaining within the union. In short, the ethnic minorities assert that they do not want to live in a country where Burman to ethnic minorities relationship is that of master to slave. "You don't want democracy?" A Burman friend asked a Karen friend in a recent meeting in Washington, D.C. "We do. But we don't want your people to rule our people."

"Can trust be built between Burman and minorities after this military is gone?" asked an American activist during a recent protest in front of the SPDC's embassy in Washington, D.C. A Mon friend answered with another question: "How many times had we built trust with Burman without success?" Many ethnic minorities believed and still believe that several agreements their founding fathers intermittently had entered with Burman were never honored. From Aung San to Panglong agreement in 1947; from U Nu to the so-called "exchanging weapons with democracy" of mass-surrender in 1958; and from Ne Win to recent ceasefire agreements, they saw no promises were honored, resulting in frustration and distrust of Burman among minorities. Ethnic minorities feel that Burman have repeatedly cheated them with such paper-agreements.

Building trust between two different groups without a trustworthy background of each group, or when both groups distrust each other, and without necessary means to obtain such trust is not an easy task, especially when the "small group" feels the "big group" has repeatedly broken promises. Besides, the powerful and predominantly Burman military, whose expenditure is almost half of the national government's budget, is seen as the biggest obstacle to the road to building trust. Also, in minority areas, Burman troops are seen as foreign occupying troops, so building trust with Burman is seen as building trust with foreigners. Minorities believe that as long as their military forces are incomparable with SPDC's forces and as long as SPDC's forces remain predominantly Burman, they cannot trust Burman. The majority of Burman will have a hard time gaining minorities' trust even after the current military regime is gone.

More than 12 years have passed since the 1988 nationwide prodemocracy uprising when thousands of lives were sacrificed for democracy. The 10th anniversary of the 1990 general elections just passed. Aung San Suu Kyi's National League for Democracy (NLD), which won a landslide victory, was not allowed to convene a parliament. Instead, the regime commemorated this anniversary with another round of arrests while refusing to enter into a genuine dialogue with elected representatives and minority leaders.

Enough has happened and enough human beings have already suffered. But the solution is still far away and invisible. For those who work for democracy in Burma, democracy will prevail. For a lasting democracy and peace, Burma still needs to begin a long process of uniting the Burman, ethnic minorities, and military dictators by consensus, not by force.

The Situations in Cyprus, Palestine, Chechnya, and Tadzhikistan

H.E. Sayyed Mohammed Musawi*

This is a very good effort to gather a good number of nationalities together in this conference, but there still are many that have no voice. I hope that many here will try to be the voice of those who have no voice, who are entitled to the right to self-determination.

The problem of those who are entitled to this right is the denial by governments that they are entitled to this right. They are being labeled by governments as people trying to be secessionists and there is a difference between to the right to self-determination and secession. We have to look at a very clear code or guideline to differentiate or distinguish between the right to self-determination and the title of secession. To me, secession is something that is wrong, but to claim the right to self-determination is not wrong at all, because it is a basic right to any people.

We have the NGOs cooperating with the UN to make it very clear that people who are entitled to this right should not be treated cruelly by governments who are trying to deny this right to them. We have good examples in Palestine where the people of Palestine have been trying to get their right to self-determination for decades, and despite all their efforts and sacrifices, they are not yet able to get it. The situation in Chechnya is another example, where the people of Chechnya are trying to get their right to self-determination, but not only the Russian troops are not understanding their beleaguered demands — the international community is also not giving appropriate support to the people of Chechnya.

In Kashmir, the situation is clear, and I am delighted that many Kashmiris are here who can express this situation. We also have the situation in Cyprus, which I feel is not a conflict between two religious groups; rather, religion is being misused by other parties to give the conflict a religious shape. We hope that things change for the betterment of the people of that area. Of course, Cyprus as you know is inhabited by both Christians and Muslims, and both of them are suffering very badly.

Then in China, I have been to Tadzhikistan, which is called now Shen-Zhen, and I have observed the sufferings of peoples in Shen-Zhen who were invaded by

* H.E. Sayyed Mohammed Musawi is President of Interfaith International.

Chinese troops about 50 years back, and have been denied their basic cultural and religious rights. The peoples of Shin-Jan can be put on the list of those who have no voice in the international community because of political reasons and because of the close ties which many western governments want to keep with China, despite the human rights situation of people in China.

To sum up: I think the problem of people or peoples who are entitled to self-determination will continue as long as the international community goes on with their policies — dealing with East Timor in a very quick way, giving them the right to self-determination, but not giving that same right to other peoples in other countries and places for reasons best known to the politicians. This is nothing but hypocrisy and double standards.

The Colonial Situation of Puerto Rico & the Struggle of the People of Vieques against the U.S. Navy

Dr. Ramon A. Nenadich*

Within the framework of Theme II, I will like to present "The Colonial Situation of Puerto Rico and the Struggle of the People of Vieques against the U.S. Navy". Puerto Rico has been a colony of the United States since 1898, when the naval forces of that country invaded our Island during the Spanish-Cuban War. For over one hundred years the U.S. Government has refused to allow self-determination and independence for the people of Puerto Rico. From 1898 to 1900 a military government was established, and during this last year Congress approved the Foraker Act, providing a civil administration for the island of Puerto Rico and its two smaller municipal islands of Vieques and Culebra. For over half a century, the government in Washington ruled on Puerto Rican affairs within a classic colonial condition. Due to this situation and the repression generated by the colonial government, an armed resistance broke out in the year of 1935. The Puerto Rican Nationalist Party, headed by Pedro Albizu Campos — a Harvard graduate — decided to face the abuses committed by the colonial government with the same weapons.

By this time, appointed Governor of Puerto Rico Blanton Winship had publicly threatened the Puerto Rican Nationalists with destruction. He ordered Colonel Francis E. Riggs, the chief of police, to physically eliminate the vanguard of the Party, formed basically by young students. In the early months of that year a police squad killed four university students in a street nearby the Campus. Albizu hit back by sending two young nationalists to kill the chief of the police. The death of Colonel Riggs was a turning point in the history of Puerto Rico. The police arrested the two youngsters and they were executed. In 1937, the colonial police killed twenty unarmed nationalists in a public demonstration. This incident is known in our history as the Ponce Massacre. As a consequence, Albizu Campos and the principal leaders of the Party were sent to Federal Prisons.

In 1940, the United States was secretly preparing its armed forces to enter the Second Great War. As the troops urgently needed training sites, the U.S. Navy

* Ramon A. Nenadich is a Professor at the University of Puerto Rico..

ordered the Government of Puerto Rico to turn over parts of the municipal islands of Vieques and Culebra. These were, at the time, two beautiful paradises located off the eastern part of the main island, and were home for many Puerto Ricans. Since that time, the U.S. Navy has established two main training areas in these small islands. In 1973 a movement of resistance broke in Culebra and the Navy was ousted from this island, but Vieques remains to this day the most important shelling and training site for the Navy worldwide.

With the constitution of the United Nations, many processes of de-colonization were completed. Puerto Rico was not included among these. Instead, the United States government managed to deceive the General Assembly by promoting superficial changes that by no means resolved the colonial situation of Puerto Rico. Because of this intent, an uprising took place in October 1950 promoted by the Nationalist Party of Puerto Rico. As a result, many people died and thousands were incarcerated, some of them for more than twenty years. At the same time, two Puerto Rican nationalists attempted to kill President Harry S. Truman at Blair House in Washington, D.C. The resistance movement was defeated, and this opened the door for the United States to impose their will over the people of Puerto Rico and, also, in the United Nations.

After controlling the nationalist movement, the U.S. Government promoted a cosmetic change in the colonial situation of the Island in order to avoid the international pressure exerted on them by many countries as well as by the United Nations. Washington decided to launch a campaign to create a "new" political status for Puerto Rico. This "new" status came to be known as the Free Associated State, and it was approved in the year 1952 by a Constitutional Convention called by then Governor Luis Munoz Marin. Resolution Number 23 of the Constitutional Convention of the People of Puerto Rico stated, among other things, the following:

> (d) Thus we reach the goal of full self-government, doing away in the principle of a pact with any colonial vestige, and we enter the times of new developments in a democratic civilization. Nothing surpass[es] in political dignity the principles of mutual consent and of a covenant freely executed.[1]

On April 22, 1952, President Harry S. Truman approved the Constitution of Puerto Rico and sent a letter to Congress recommending that this body take the same action. In this letter, Truman says: "The people of the U.S. and the people of Puerto Rico are entering into a new relationship that will serve as an inspiration to all who love freedom and hate tyranny..."[2]. Of course, tyranny is what the United States Government has maintained in Puerto Rico for over a hundred years. Although Washington tried to seek a consensus on this new colonial policy, many countries of the world did not agree with its intentions. Also, in Puerto Rico, many intellectuals and political leaders expressed their concern with the "new" political status. One of these was the former president of the Puerto Rican Independence Party, Gilberto Concepcion de Gracia. In referring in 1953 to the "new" political status of Puerto Rico, he stated the following: "[It]is a colonial statute written and deliberately conceived to deceive the People of Puerto Rico in its legitimate aspirations for

sovereignty. It was likewise intended to make the democratic world believe that our people have taken a step forward in the establishment of an autonomous government based on its own constitution…" [3]

Since the end of the Second Great War, which was fought precisely to end colonialism, a significant contradiction was created within the international legal framework for all the colonial powers. As a result of this war, all the colonial powers had to submit an annual report to the United Nations Organization explaining the advances that had been made between their states and their territories regarding self-determination and independence.

To avoid this international contradiction, in 1953, the U.S. Government managed to present Resolution 748 through which the General Assembly recognized that a new political status had been achieved between Puerto Rico and the United States. By achieving these two major goals in their colonial policy, the Free Associated State and the passage of Resolution 748, the United States has created for half a century a favorable international relations arena for their domination of Puerto Rico. But as Abraham Lincoln once said, "You cannot fool all of the people, all the time". At this very moment, the struggle of Puerto Rico for self-determination and independence is gaining momentum, as the situation in the island of Vieques manifests increasing resistance to the presence there of the U.S. naval forces.

VIEQUES AND THE STRUGGLE AGAINST
THE PRESENCE OF THE U.S. NAVY

Vieques is a municipal island located seven miles from the eastern coast of Puerto Rico and at the north west of the U.S. Virgin Islands. It is 18 miles long by 3.5 miles wide, which brings it to a square area of 51 miles. The capital of Vieques is called Isabel Segunda in honor of the Queen of Spain. By 1910, the population of Vieques was 10,425 inhabitants. In 1930, the population rose to 10,582. By the year 1960, after 20 years of the presence of the Navy, the population had declined to 7,210. According to the Federal Bureau of the Census, in 1997 there were 9,311 human beings living in Vieques.

For sixty years the naval forces of the U.S. and many other countries, especially NATO, have been using this island for different types of maneuvers and military exercises. The military activities of the U.S. Navy in Vieques go back to the Second Great War, when they expropriated 25,360 acres of land representing two thirds of the entire island. At the western coast of Vieques, the Navy has 8,000 acres which are used mainly for an ammunitions depot. The rest, which are located at the eastern part of the island, formed the shelling and training zone. As a result, the population has been restricted to a residential area of a three-mile long perimeter.

Due to the presence of the U.S. Navy in Vieques and the impact of the military training, the civil population has suffered severe damage, environmental contamination and health problems.

On April 19th, 1999 a young civilian security guard was kill by a 500-pound bomb fired from a combat jet fighter. The pilot, whose name has been kept secret by the Navy, missed the target by about one and a half miles. Since this very moment, the people of Vieques started a massive protest movement against the presence of the U.S. Navy in their territory. Although the protest movement started many years

ago, it had lain dormant for the last two decades. With this new incident, the people of Vieques and Puerto Rico were fed up with the Navy's mistreatment and harassment. For almost one year, the fishermen from Vieques, union leaders, religious leaders, university students, professors, women and many others invaded the target area and remained there until the 4th of May, 2000. On this day, more than two hundred agents from the Federal Bureau of Investigation and U.S. Court Marshals arrested over one hundred Puerto Ricans that were protesting against the presence of the U.S. Navy in Vieques.

Since then, more than 900 political prisoners have been tried for trespassing on federal property. As of August, 2000, more than one hundred of them remain in jail. Many others enter the target area every week to prevent the U.S. Navy from renewing its military practices. After I left my country, 32 women from the Vieques Women League were arrested on Monday and on Tuesday, 11 students were arrested. The resistance against the presence of the U.S. Navy is growing every day, as the governments of Puerto Rico and the United States try to deflect the people from their main objective, which is to get the naval forces out of Vieques immediately. In trying to do so, the resistance movement decided that its strategy would be based on peaceful disobedience and nonviolence.

In a Declaration of Ultimatum of the People of Vieques to the United States Navy of July 31, 1999, the people of Vieques accused the U.S. Navy of polluting their air, waters and land "and contributing significantly to the high level of cancer and other diseases related to the degradation of the environment". In this declaration, the people of Vieques also say:

We proclaim our inalienable right to build a future of peace and well-being and continue the historic and heroic struggle that for more than six decades has taken place without respite to end the abuse of the U.S. Navy in Vieques.

We reaffirm the commitment of the people of Vieques and of all Puerto Ricans to support the right of our fishermen and fisher-women to defend our sea resources.

They also hold the U.S. Navy responsible "for all the dead, wounded, ill and other victims of their military activities during six decades, and for the profound psychological damage" that has been caused to the children of Vieques. As this declaration continues, the resistance movements states:

We deplore the use of depleted uranium, napalm bombs and other chemical and toxic weapons condemned by international public opinion because of their adverse impact on health and the environment.

We demand that the United States government clean up all waste and toxic materials from the island of Vieques, as well as the decontamination of the areas used for military practice, including the removal of the bombs and ammunitions.

In Pursuit of the Right to Self-determination

Our movement, which is formed by a huge variety of political, ecological, religious, civic and community based organizations, represents the vast majority of the people of Puerto Rico and will not rest until we can fulfil our goals of getting back what belongs to our people and has been robbed from us by the United States Navy and that is our freedom.

ENDNOTES

1 Resolution No. 23 of the Constitutional Convention of Puerto Rico, 1952.

2 Antonio Fernos Isern, Estado Libre Asociado de Puerto Rico; Ed. Universidad de Puerto Rico, 1974, p. 127.

3 *Ibid.* p. 225.

Forces That Impede Resolution of Self-determination Issues

Jasdev Singh Rai*

A majority of human rights violations occur in regions where there are self-determination struggles or issues. Many are the unresolved or incomplete processes of de-colonisation. There seems to be a lack of will on the part of the international community to resolve many of these protracted conflicts and consequently reduce human rights violations. We seem to be going around in circles.

There are a number of factors that conspire against a wider discussion of the self-determination issue and resolution of many conflicts around the world. Broadly, these are:

1. Most colonial powers and particularly the British were keen to retain a market and thus trading block with regions they had colonised. It was preferable for them to hand over the regions intact as they had administered rather than encourage new States within whom they had little or no relationships and understandings. Thus the British and other colonial powers have encouraged the status quo, handed power to an elite that they could do business with and conveniently created blocks such as the Commonwealth.

2. Constitutional and Political Structures. It is interesting how the constitutions of many decolonised countries are simply continuations of the Acts that the colonial powers introduced to rule with some degree of self-governance. For instance, the Indian constitution does not draw from the cultures and values of South Asia, nor is it a new document defining the new arrangements between various peoples and communities that the decolonised region should have made. In fact, it is simply a continuation of the India Act 1935 in which self-governance was allowed with the British retaining ultimate power of decision. Now that power has been taken by the new Indian elite. The constitution is a colonial document without the spirit of independence that it should have incorporated or new starts that it should have emphasised.

3. Inadequate Political Arrangements. In most regions with self-determination struggles, there have been inadequate and insensitive political arrangements during the decolonisation process. There were no attempts to ensure that various peoples did not end up being suppressed by the newly-created majorities.

* Jasdev Singh Rai, Sikh Human Rights Group.

4. Inadequate protective measures. There were no attempts to ensure that the minorities and small groups would have been protected in the decolonised countries. No international arrangements or watchdog bodies were created to ensure that the decolonisation process was adequately accomplished with safeguards and international recourse for injustices.

5. The UN unwittingly conspires against self-determination struggles. Despite international instruments such as article 1 of the ICCPR, the general tendency of the UN bodies is to discourage a serious discussion, let alone a resolution of many just demands. This has encouraged assertion through violence as the arbiter of resolution.

6. The paradox of human rights and causes. Thus there is a paradox within the UN system. While there are several occasions to discuss human rights and attempts to improve them, there is no attempt to address the causes that lead to human rights violations.

While the UN affords opportunities to discuss human rights and attempts to improve them, there is no attempt to address the causes that lead to human rights violations.

It is suggested that there should be serious efforts to address these. Perhaps the way forward is to set up a Working Group on Self-Determination. This is unlikely to meet much support. The alternative would be to set up a Special Rapporteur on Causes of Human Rights Violations.

The Right of Self-determination & the United Nations

Mrs. Najiba Tabibi*

Let me first of all congratulate the organizers of this conference. It is a great honor for me to participate, and we wish full success to this conference as to its aims and goals on such an important topic, which is THE RIGHT OF SELF-DETERMINATION.

Human Rights states that all peoples and all nations shall have the right of self-determination. The declaration on granting independence affirms not only the political but economic rights as well. "... All people have the right to self-determination. By virtue of that right, they freely determine their political status and freely pursue their economic, social and cultural development."

It is sad today to see at the startup of the new Millennium that the right of self-determination is being violated in the name of whatever ideology and/or political and economic agenda, from Afghanistan and Kashmir to South America, Central Africa, Kurdistan and Chechnya, where men and particularly women and children are being deprived of their social, economic and educational right to live, and where sometimes the economy is at its worst.

Self-determination takes its roots from the law of change and revolution, and moves along with the expectations of the majority of mankind living in the Third World countries. The young nations of the third world who are also called the new independent states are defending with great restlessness their right of political and economic self-determination.

The process of self-determination and de-colonization moved with greater pace after the first world war – but it moved much faster during the United Nations era because the Charter advocated the Trusteeship Council for that purpose. The United Nations system as a whole was mobilized for recognizing the right of peoples and nations to self-determination. The process of self-determination moved forward since the inception of the UN, resulting in the process of decolonization; this process took shape based on a sense of legal and moral obligations for mankind.

Accordingly, the self-determination of nations, manifested in colorful flags and impressive national anthems, has done nothing to solve economic problems.

* Mrs. Najiba Tabibi is a representative of the World Islamic Call Society.

In Pursuit of the Right to Self-determination

Economic self-determination is a prerequisite for maintenance of the independence and sovereignty of newly emerging nations.

After decades of increasing world population, the economic problems of developing countries have become acute and the gap of poverty and prosperity between the developed and developing countries has widened, resulting in the failure of the World Bank and the IMF organizations. Absence of realistic negotiations aimed at restructuring international economic relations has aggravated the worldwide economic crisis. The developed countries are neglecting their humanitarian obligations and continue to maintain the status quo based on economic domination and exploitation while showing no political will for economic co-operation.

The developed countries are neglecting their humanitarian obligations and continue to maintain the status quo based on economic domination and exploitation while showing no political will for economic co-operation.

As a result, it has led to an increase in underdevelopment, malnutrition, illiteracy, poverty, hunger and disease. The continued escalation in the prices of manufactured capital goods, food products and services imported by developing countries has created a world trade gap which is having a tremendous impact on the economic and social life of those nations. Consequently, the poverty and suffering of its people and mainly of landlocked countries is increasing even further.

Mr. Chairman, we must be vigilant and resolute in our efforts not to miss any opportunity to further the interest of mankind. We must regard the whole world as a single home, living in peace and brotherhood, helping each other like members of the same family. We must contribute to the best of our ability and to the extent of our possibility to the noble cause of self-determination, individually and collectively through the United Nations.

The Rights of the Khmer Krom People in Vietnam

Vien Thach*

INTRODUCTION:

This article is written in response to recent inquiries by researchers, students, public and private organizations, who are interested in the rights issues of the Khmer Krom people in Vietnam today. The Khmer Kampuchea-Krom Federation which is the umbrella organization of the Khmer Krom organizations worldwide, would like to take this opportunity to present a very brief response to some general questions on the Khmer Krom people such as the following:

Could you tell me how the UN has helped or has not helped the Khmer Krom people in their search for human rights?

Recently, UN (United Nations) officials at Geneva have been made aware of the religious oppression of the Khmer Krom people in Vietnam, in violation of one of their major human rights.

Although the government of Vietnam has caused many difficulties for UN officials during their visit to Vietnam in October, 1998, at least the UN has observed a part of the truth for the first time in the history of the Khmer Krom people. The Khmer Krom are glad that the surface of mountains of sufferings of their people which have been accumulated layer by layer over tens of decades, has been scratched and observed for the first time by the world body.

Much more awareness and action by the world community to peacefully force the Vietnamese government to abide by international law is needed, if the Khmer Krom people are to be saved from a gradual extinction.

What exactly is the Khmer Krom looking for in terms of freedoms?

The Khmer Krom people are indigenous people of the Mekong Delta in Vietnam. They do not expect anything more than recognition of their legitimacy as a people. They are peaceful citizens of the world and they are a peaceful nation within the family of nations. Their rights have been decreed by the Charter of the United

* Vien Thach is VP of Khmer Kampuchea Krom Federation for Europe Affairs.

In Pursuit of the Right to Self-determination

Nations and by the Universal Declaration of Human Rights. They peacefully demand no more than what the norms of the world have to offer, which has been prescribed by international law. Naturally, as a member of the international community and the UN, the government of the Socialist Republic of Vietnam has the duty (if not obligation) to fully exercise those international legal instruments.

Would they like to have their own country?

In consideration of the relationship of the Khmer Krom and the Vietnamese for a duration of over 300 of years since the two people have begun interfacing, the following facts have been observed and recorded:

1) The Vietnamese have always held government powers.

2) The Khmer Krom people are allowed no chance to succeed by peaceful means and have not been able to foster a trustworthy relationship with Vietnam.

3) The Khmer Krom have suffered multiple wholesale massacres of their general population.

4) Many of the Khmer Krom leaders have been assassinated.

5) Their economic resources — land — has been robbed.

6) Their cultural characteristics as a people are gradually being tempered by forced assimilation and population transfer.

7) Their social identities in relation to foreigners who visit Vietnam are suppressed to zero.

8) There is no future for Khmer Krom children generation after generation.

9) The longevity of the Khmer Krom as a people under Vietnamese domination is in question.

Absolutely, they would like to have their own independent country and be responsible for their own future. However, one of their major objectives is "to develop peace, harmony, respect, understanding and cooperation between the Khmer Krom people and others, including the Vietnamese people". Therefore, the Khmer Krom people did not rule out other forms of self-determination

Would the Khmer Krom like to be able to govern themselves?

Definitely, with the involvement of international communities, they would like to self-govern as intermediate steps toward greater independence. The examples of the peoples of Palestine, Kosovo or East Timor could be used as typical models.

Would they like to remain citizens of Vietnam, but have equal rights in terms of having elected officials, etc.?

In 1949, in a *fait accompli*, France illegally transferred its Cochin-China colony (current south Vietnam) to Bao Dai, the emperor of Vietnam; since then, successive governments of Vietnam have forced the Khmer Krom people to be citizens of Vietnam. As a matter of fact, both France and Vietnam have betrayed their own

signatures on this transfer by not implementing their treaty in full in regard to the Khmer Krom's rights, namely the Deferre Motion. This motion has been part of the Bill of Transfer (of French Cochin-China to Vietnam) and unanimously passed by the French National Assembly, which spelled out specific rights of the Khmer Krom people.

After 50 years of imposed Vietnamese citizenship upon the Khmer Krompeople, the following question should be asked:

Did Vietnam really want to see the Khmer Krom advance as a nation within Vietnam? Or was Vietnamese citizenship imposed on the Khmer Krom used as a rationale for Vietnamese governments to exterminate the Khmer Krom people while claiming this as an internal affair? Aside from their gradual extinction, has there been anything at all that the Khmer Krom people have gained from their citizenship imposed by Vietnam?

Objectively, no favorable answers can be found to those basic questions. Therefore, with respect to international laws of citizenship, the longer Vietnamese citizenship is imposed upon the Khmer Krom people, the deeper the grave which the Vietnam government has dug to bury the Khmer Krom people as a whole.

Without real democratization, it is meaningless to have the Khmers as elected officials in Vietnam. Many Vietnamese governments in the past and present have used elected positions to mislead the Khmer Krom people. They portray Khmer Krom elected officials in many different forms and shapes to serve their purposes: to appease the Khmer Krom, to suppress the Khmer Krom. Those officials who have displayed real vision for Khmer Krom advancement and equality normally will not survive. Cosmetically, on the Khmer Krom issues, Vietnam has successfully misled the world all along.

Naturally, there is no reason why the Khmer Krom people would want to remain citizens of Vietnam. However, as to compromise, which must be built on mutual trust and respect, the Khmer Krom people are keeping all options open.

How do you think the Khmer Krom people's position in Vietnam has changed during this century?

The guiding principles of the peaceful struggles of the Khmer Krom people have been very consistent throughout history. They seek to achieve the following objectives:

1) To take appropriate measures based on the principles of nonviolence to assure the rights of the Khmer Krom people to fundamental freedoms, human dignity, and self-determination according to the Charter of the United Nations.

2) To protect the culture, religions, traditions and identity of the KhmerKrom people from assimilationist forces.

3) To advocate for the conservation of the hereditary natural resources of the Khmer Krom people such as farmland and forest in the face of illegal and deceitful deprivation.

4) To promote social, economic and intellectual development of the Khmer Krom people who live in their homeland and abroad.

5) To develop peace, harmony, respect, understanding and cooperation between the Khmer Krom people and others, including the Vietnamese people.

There have been many Khmer Krom lives sacrificed toward these beliefs, and they've always suffered vicious treatment from Vietnam as a result.

In 1841, the Khmer Krom leader Chauvay Son Kuy, a Buddhist pacifist, gave up his life and his head was cut off by the Court of Hue in exchange for preservation of the Khmer Krom's religion, rights and freedoms. This heroic deed took place during the reign of the Emperor of Vietnam, Thieu Tri. By taking down his life, Vietnam had agreed to respect the Khmer Krom's rights and freedoms.

Did Vietnam ever honor its agreements with Chauvay Son Kuy for Khmer Krom rights and freedoms?

Subsequently, many other Khmer Krom leaders have dedicated their lives for the same principles. The latest victims were Venerable Kim Toc Chuong, the Buddhist patriarch of Tra Vinh province and 21 other religious leaders, who were murdered in cold blood by the government of Vietnam in 1986.

Do you think you now have more power as a people?

Let us specifically define the term 'power'. Per Webster's New World Dictionary, the first definition of the word is the following: Power = ability to do or act. In this case, for the Khmer Krom people, the term 'power' in the question is 'the ability to control their own destiny'.

The basic components of their ability to control their own destiny are their rights and freedoms, which have been universally accepted as international standards, and defined in the Charter of the United Nations and in the Universal Declaration of Human Rights. Unfortunately, until today the Khmer Krom people in Vietnam have been denied their entitlement and their opportunity to enjoy such rights and freedoms. The government of Vietnam could advocate anything it wantsas far as rights and freedoms for people, but in reality it only provides lip service and uses such propaganda to appease the world community when seeking international aid.

As an example of the above, a recent newspaper report on March 16, 1999 about the religious rights and freedoms in Vietnam noted the following:

GENEVA, March 16 (Reuters) - The United Nations special investigator on religion on Tuesday accused Vietnam of continuing to deny people freedom of worship and called for reforms.

Abdelfattah Amor, in his report on the situation in Vietnam, said all of the religious communities there were prevented from conducting activities freely....

"Religion appears as an instrument of policy rather than a component of society, free to develop as it wishes, something which is ultimately contrary to freedom of religion or belief as governed by international law," said Amor, a former dean of the University of Tunis law faculty who visited Vietnam in October.

Evidently, in their own homeland, the Khmer Krom people's ability to determine their own future has been hindered by the Vietnamese government.

Do you feel as though the Khmer Krom are going to become assimilated into Vietnamese culture and eventually lose their identity as a people?

The eventuality of total assimilation into Vietnamese culture is a reality. It is not a threat. Khmer Krom identity as a people will be erased from the face of the earth, if immediate actions are not taken by the Khmer Krom people themselves with generous help from the international community. The following evidence has outraged the Khmer Krom people of all generations:

According to *A History of Southeast Asia*, professor D.G.E. Hall has pointed out: "The Saigon area, the Water Chen-la of the ancient Khmer Kingdom, was a tempting field for Vietnamese expansion. It had a population of only about 40,000 families so there were vast empty spaces." Obviously, there were a significant number of Khmer Krom families in the areas around Saigon before the arrival of Vietnamese settlers. How did they come to disappear? There are only a few Khmer Buddhist temples remaining in the area. Some of those temples have been confiscated by the government of Vietnam.

Originally, there were about 700 Khmer Buddhist temples all over South Vietnam or former French Cochin-China. However, under the Vietnam government's hostile policies of assimilation toward the Khmer Krom people, there were many temples destroyed as were the Khmer communities around them. As a result, the Khmer Krom people in those areas have been uprooted or completely wiped out. The number of Khmer Buddhist temples now remaining is reduced to between only 460 to 500. The Khmer Krom temples are constantly scrutinized by the agents of the Vietnam Fatherland Front (a branch of the Vietnam communist government). They dictate the religious practices as well as changing the built-in character of the Khmer to assimilate them into Vietnamese culture.

Moreover, the government of Vietnam has accomplished the complete forced assimilation and decimation of the Khmer Krom people in many provinces such as Dong Nai, Baria, Long An, Dong Thap, Sadec, Ben Tre, Vung Tau, and Ho Chi Minh city (formerly Saigon). The Khmer Krom people in the above provinces could be traced only through careful study and research.

Are there programs in place to protect your culture and to make sure your children learn who they are and where they come from?

To teach and learn the real Khmer Krom cultural heritage, who they are and where they come from, has been a crime in the past and is a crime today by the Vietnamese government's standards of treatment of the Khmer Krom people.

In Pursuit of the Right to Self-determination

Vietnamese historians did not elaborate on facts which might answer the following questions: How did Vietnam encroach on the Khmer's land? How have the Khmer Krom people and their Buddhist temples been uprooted from about 50% of the provinces of former Cochin-China? How were the 40,000 Khmer families who were once residents of Saigon squeezed out? Etc. For that reason, a very low percentage of Khmer Krom children are aware of their true heritage.

The children of the Khmer Krom, generation after generation, have been misled by Vietnam's educational systems. The Khmer language is barely surviving in the Khmer Buddhist temples. While in the public school, to appease Khmer Krom parents, the government of Vietnam has added a few hours per week of Khmer language to grade schools for Khmer children, government officials do not care about the quality of the curriculum.

The Khmer Krom people abroad are fortunate to enjoy the "REAL" freedoms from the host countries and have opportunities to teach their children the heritage and the true history of their people.

There are studies in place of how to protect Khmer culture and to make sure Khmer children learn who they are and where they come from. However due to a severe lack of resources, the Khmer Krom people could only do so much within their level of affordability. External aid is implored to help and save this unfortunate people. Generous help from any individual, any organization, and any government to educate the Khmer Krom children concerning their true values is greatly appreciated and welcomed.

What do you see happening in the near future in terms of what actions the Khmer Krom will take in order to further their goals?

The Khmer Krom intends:

1) To bring the Khmer Krom cause to the world's attention using today's communication facilities (television, radio, internet, printing, etc.)

2) To lobby the countries in which the Khmer Krom are residing, for political and material support.

3) To request world agencies and international organizations for humanitarian aid, such as medicines, vocational training, and improvement of the living standards of Khmer Krom inside the country.

4) To engage with international organizations such as UN, UNPO, IHRAAM and the ICHR for diplomatic solidarity with people and nations that share common aspirations.

Eradicating the Legacy of Slavery in U.S. Research & Policy

Joseph Wronka*

This intervention is to request that governmental bodies of the United States of America and private researchers working in tandem with these bodies, conduct research and then develop policies that are in accordance with internationally recognized human rights standards which include, inter alia, the development of a culture of informed consent (Mann, 1999); the adherence to similar ethical standards in international research as in the domestic arena (National Institutes of Health, 1999); and the incorporation of voices of oppressed groups in research and policy debates (Chapman, 1993; Mawn; 1994).

Such actions, would ultimately ensure among research participants their human "dignity" and the spirit of "brotherhood" [and sisterhood] as asserted in Article 1 of the United Nations Universal Declaration of Human Rights (UDHR), the authoritative definition of human rights standards, which are indispensable in the conducting of research and development of social policy. Also, these actions are in accordance with the United Nations International Covenant on Civil and Political Rights (ICCPR), ratified by the United States in 1992 and which further defines in part, some of the rights of the UDHR (Wronka, 1998). Article 1, for instance, speaks of the right to self-determination, the primary theme of this conference, which states in part : "All peoples have the right of self-determination. By virtue of that right they freely...pursue their economic, social and cultural development.... In no case may a people be deprived of its own means of subsistence."

Given, furthermore, that the Supremacy Clause of the United States Constitution, Article VI states in part: "All treaties made...under the authority of the United States, shall become the supreme law of the land and the judges in every state shall be bound thereby" and the ICCPR has the status of "treaty," the US should undertake every measure to ensure the implementation of these and other international human rights standards as they evolve.

*Joseph Wronka is Professor of Social Work, Springfield College and Visiting Scholar, Heller School Graduate School for Advanced Studies in Social Welfare Center for Social Change Brandeis University.

In Pursuit of the Right to Self-determination

EXAMPLES

The most obvious case was the infamous Tuskegee Study (1932-1972), where 400 African-American men infected with syphilis were monitored for 40 years, in spite of a proven cure becoming available in the 1950s (Tuskegee Syphilis, 1995). Given the recent apology of former President Clinton to the subjects of the study, it may now be generally considered a forgotten moment in US history. However, recent studies in Third World countries pertaining to the transmission of HIV appear indicative of a continuing legacy of the disregard for the dignity of the human person and spirit of brotherhood as mentioned and similar to some of the attitudes, such as a sense of superiority, that led to the slave trade in the Americas (Zinn, 1990).

Take the 1999 study by the prestigious John Hopkins School of Medicine in Uganda, South Africa, and Tanzania (Brown, 1999) which consisted of a "placebo arm" where pregnant women inflicted with HIV were randomly assigned to take inactive pills. The group assigned with the drug regimen combating HIV had a 8.6% transmission rate to the fetus; the group taking placebos had a 17.2% transmission rate, exactly double the rate!

Corneal Medical College (1999) conducted another somewhat similar study in Haiti (Bernstein, 1999) which, like slavery, violated the right to life, an obvious affront to human dignity. There, researchers offered HIV tests and HIV treatment to subjects, but denied the best treatment, considered antiretroviral therapy, to participants in order to study the progression of the disease.

CONCLUSIONS

In both instances, it appeared that participants were not entirely knowledgeable of the interventions which also seemed to "mask" research for treatment; similar practices would be acceptable in the United States, which not coincidentally has a predominantly white population, descendants of European immigrants ("illegal" perhaps, considering the presence of indigenous peoples upon their arrival); and researchers did not aggressively pursue subjects' perspectives on the research methodology and consequent policies developed, based upon their participation.

We, at this conference, therefore, applaud the US in its efforts toadvance human rights, but express our concern for the abrogation of the peoples' right to self-determination in these studies and urge the immediate end to any study that violates the human dignity of any person.

BIBLIOGRAPHY

Bernstein, N. (June 6, 1999). For subjects in Haiti study, free AIDS care has a price. New York Times, p.1, sect. 1.

Brown, D. (February 2, 1999). Short-term treatment reduces possibility of mother-child HIV transmission. Washington Post, p. A6.

Chapman, A. (1993). Securing the right to health care. Washington, DC: Association for the Advancement of Science.

Frankovits, A. (2000). "Towards a mechanism for the realization of the right to self-determination." IHRAAM preconference recommended reading. Atlanta: Clarity.

Mann, J., Gruskin, S., Grodin, M., Annas, G. (Eds.). (1999). Health and Human Rights. New York: Routldege.

Mawn, B. (1994). Women?s views on HIV screening during pregnancy and in newborns: Social

justice or travesty. (Microfilm). Ann Arbor: University of Michigan Microfilms.

National Institutes of Health, Department of Health and Human Services (1999). Clinical research guidelines. Washington, DC: Author.

Tuskeegee Syphilis Study. (1995). Board of Curators, University of Missouri. (http:// showme.missouri.edu.~socbrent/tuskegee.htm) Viewed: June 5, 2000.

Wronka, J. (1998). *Human Rights and Social Policy in the 21st Century.* Lanham, MD: University Press of America.

Zinn, H. (1990). *A People's History of the United States.* NY: Harper and Row.

Workshop I:
Peoples Seeking Political independence as the Only Feasible Way to Liberate Themselves & Fully Exercise Their Human Rights

The Right Honourable Gerald Kaufman
Moderator

Mr. Syed Nazir Gilani, Secretary-General of the Jammu Kashmir Council for Human Rights (JKCHR), UK, advised the Plenary Session that no report would be forthcoming from Workshop I as agreement among participants was not achieved.

The following resolution pertinent to the workshop was received from Barrister Majid Tramboo.

RESOLUTION

The Assembly of NGOs recognises the Kashmiris' right to self-determination and takes into consideration the International Commission of Jurists'(CJ) Mission on Kashmir that

> Both India and Pakistan should recognize and respond to the call for self-determination for the people of Jammu and Kashmir within its 1917 boundaries, inherent in the relevant United Nations resolutions. The United Nations should re-activate its role as a catalyst in this process.

And appreciates the principal dedication of All Parties Hurriyat Conference under Chapter II, Article 2 (1) of its constitution:

> To make peaceful struggle to secure for the people of the state of Jammu and Kashmir the exercise of the right of self-determination in accordance with the UN Charter and the resolutions adopted by the UN Security Council. However, the exercise of the right of self-determination shall also include the right to independence.

The Assembly confirms the findings of Human Rights Watch that:

The Indian army, Special Task Force, Border Security Force, and State-sponsored Para-Military groups and village Defence Committees – the principal government forces operating in Jammu and Kashmir – have systematically violated fundamental norms of international human rights law. Under international law, India's state-sponsored militias are state agents and therefore must abide by international human rights and humanitarian law. The government of India is ultimately responsible for their actions,

and further adds that the human rights of all Kashmiris in Jammu-Kashmir should be respected accordingly.

And urges the United Nations Human Rights Commission to take appropriate measures to secure the rights of the people engaged in their struggle for self-determination.

The Conference further recommends the establishment of a Contact Group of NGOs for the people's right to self-determination, and urges the United Nations to appoint a UN High Commissioner for Self-determination.

Workshop II:
Non-territorial or Dispersed National Minorities Seeking Some Form of Politico-legal Mechanisms within the Multi-national State

Dr. Farid I. Muhammad
Moderator

Workshop II was well attended by numerous attorneys, academicians, grass-root community activists, a medical doctor turned student of international law, an African-Canadian delegate to the Planning Group on the UN World Conference Against Racism, and other concerned ethnic minority representa-tives from Canada, Italy, India, Zanzibar and a NGO representative affiliated with UNESCO.

> **A special study conducted by IHRAAM revealed that 81% of African-Americans were in favor of having some degree of "independent control over those institutions and services that most directly affect their own communities".**

During this workshop it was noted that a special study conducted by IHRAAM revealed that 84% of African-Americans had no knowledge of the relevance of the UN and international law as applies to their unique problems and concerns as a people. However, 81% were in favor of having some degree of "independent control over those institutions and services that most directly affect their own communities", while 66% believed that "African-American voters should participate in an independent election to create a National Assembly to help monitor and represent their own collective interests".

RESOLUTIONS:
The resolutions of Workshop II were as follows:

(1) The UN Human Rights Commission, The World Conference Against Racism, along with the Special UN Working Group on Minorities, should

* Dr. Farid I. Muhammad is Chair of the Behavioral & Social Sciences Department at East-West University, Chicago, Illiois, and a Member of the IHRAAM Directorate.

take special note of the implications of the IHRAAM survey of African-American Attitudes Regarding Self-Determination, particularly as relates to the internationally binding obligations of the U.S.A.

(2) In its capacity as a NGO in consultative status with the Economic and Social Council of the UN, IHRAAM is both willing and able to collaborate with any/all local/national/international organizations in the further articulation of any future research and/or cognate activities that might be suggested by the IHRAAM survey.

(3) It is strongly recommended that similar and more comprehensive investigative studies relative to the concerns of national/ethnic minorities be conducted throughout the U.S.A. and other appropriate nations in the Americas.

(4) In light of the overwhelmingly and statistically significant indications that African-American citizens are strongly desirous of exploring options
leading to self-determination of their communities (in accordance with national/international law), it is strongly recommended that formal steps be taken to conduct a National Plebiscite or Referendum on this issue among all African-American voters, while similarly striving to establish a National Consultative Assembly which would help represent and monitor their collective concerns.

(5) Finally, as is consistent with resolutions already passed in many municipalities throughout the U.S.A. (e.g. Chicago, Washington, DC, etc.), and as has been used by other ethnic communities in America, we strongly endorse reparations (e.g. educational, money damages, ethnic studies, land, control of tax dollars, etc.) as one component of varied special measures that might be applicable to the African American Community.

RELATED PRIORITY CONCERNS:

(1) As forced immigrants and formerly enslaved ethnic minorities in the U.S.A., everyone must remain aware of and sensitive to the still lingering socio-cultural and political ills that plague the African-American Community.

(2) There should be a comprehensive review of the entire criminal justice system of the U.S.A., particularly as it relates to the grossly disproportionate treatment of African-American and other ethnic minority populations.

(3) There should be a comprehensive review of the children and family

service systems throughout the U.S.A., particularly as they relate to the African-American Community.

(4) There should be a comprehensive review of all modes of electoral reform (e.g. proportional representation, consociated democratic institutions, etc.) in light of their applicability to the African-American Community. Additonally, we recommend strong support for the plaintiffs in the equal protection lawsuit (case number 00-97) as pending before the U.S. Supreme Court.

(5) We strongly recommend that a fair trial be held for Imam Jamil Al-Amin.

(6) Lastly, we recommend that there be continued dialogue and cooperation between and among all national and ethnic minorities in the Americas.

Workshop III:
Indigenous Peoples or Minorities Seeking the Preservation, Development and Recognition of Their Cultural Rights as Pre-existing Nations or Peoples

Thlau-Goo-Yailth-Thlee (Rudy Al James)
Moderator

Participants:

Ron Barnes, Yupiaq Ambassador, Alaska; Mariana Chuquin, Quichua Ecuador; Rosa Chuquin, Quichua Ecuador; Joshua Cooper, Hawaii; Diana James, Kuiu Kwáan Alaska, IHRAAM Public Relations Director; Danyta Kennedy, Assiniboine Band Canada; David McSweeney, Ireland; Dr. Ramón Nenadich, Taino Puerto Rico; Lavina Przetiorka, First Nation Assiniboine Band Canada; Joseph Wronka, U.S.

The workshop members focused on the struggles of the Native Americans (the Indigenous Peoples and Nations) within the borders of North America, throughout Mexico, Central and South America. The workshop determined that the Irish are Indigenous to Ireland and share historic commonalities with the Indigenous Peoples of the Americas. The biggest problem confronting the groups represented at the workshop is the reluctance of new governments generally to constructively deal with the issue of internationally recognized inherent Indigenous rights of self-determination.

Workshop participants included eminent experts and scholars who presented reports and discussed pressing needs of Indigenous Peoples and nations including: Irish, Canadian First Nations, Puerto Ricans, the Quichua of Ecuador, Indigenous Peoples of Mexico, the Lakota, Dakota, Nakota Nation of the U.S. and Canada, the Alaska Thlingits and Yupiaq and the Hawaiians.

* Thlau-Goo-Yailth-Thlee (Rudy Al James) is President and Spokesman for the Tribal Council of the Kuiu Thlingit Nation of Alaska, and a Member of the IHRAAM DIrectorate.

Pressing needs of all groups represented at the workshop indicated the urgency with which the establishment of new UN mechanisms related to self-determination need to be established. The workshop endorsed Dr. Kly's call for the United Nations to be restructured to facilitate the resolution of longstanding inequities and conflicts related to the non-realization of the right of self-determination.

The Native Americans raised concerns regarding the more than 90 million Indigenous Peoples of Mexico, Central and South America, and submitted papers from Chief Richard Grass of the Lakota, Dakota, Nakota (documents related to intellectual property rights and spiritual exploitation of the Lakota Nations). Many Lakotas call their situation in the Dakotas desperate and describe reservation life as "living in Prisoner of War Camps."

Mariana Chuquin spoke eloquently of Ecuador's first peoples, and the need to recognize the depth of their ties to their lands and of the immediate need for food, clothing, medicines and a clinic for villages where many children die before reaching the age of seven. Ms. Chuquin stated that one of the reasons she came so far to attend the conference was because Mother Earth is dying, being sucked dry by exploiters who lay waste to forests, drill for oil, pollute the air and waters. Ms. Chuquin asked that the next conference be structured so that there is a balance that gives all conference attendees equal time to make presentations and not favor select groups.

David McSweeney compellingly brought home the history of the Irish genocide inflicted by the United Kingdom and related it to the genocide that occurred in Native America. He has been involved with Indigenous Peoples from North and South America and would like to see ratification of the draft Declaration on the Rights of Indigenous Peoples. He reported on the negative situation that still confronts the Irish because of the English of the United Kingdom. The Irish are working for return of their former lands and waters to Irish control. They desire independence, self-determination and sovereignty. The Irish representative requested that:

• The difficulties they are experiencing with the United Kingdom be referred to internationally as: "The Irish Question has not been resolved."

• Assistance be granted for obtaining visas for travel to the United States for the Irish members who want to be free. The US is denying travel visas to leaders of the Irish freedom movement, even though these leaders have no criminal records and vow that they are not terrorists.

Joseph Wronka profoundly suggested that the clash of civilizations that has been epitomized by the sterilization of Abenaki women in Vermont, tactics of divide and conquer regarding tribes and other economic and cultural assaults on Indians can be mitigated by true self-determination. He called upon all peoples to listen to the elders and to find humanistic ways to collaborate and work together toward self-determination for Native Americans. He warned the conference attendees to be on guard for those who "would divide and conquer."

Joshua Cooper effectively brought forth the issues confronting Native Hawaiians who are struggling for recognition of inherent rights to land, water and natural resources. He reported that a bill would soon be before Congress to recognize the Indigenous Peoples of Hawaii. Indigenous Hawaiians are seeking full recognition and implementation of the right of self-determination.

Ambassador Ron Barnes has been attending sessions of the UN sub-commissions and monitors the progress of the Draft Declaration on Indigenous Peoples. He eloquently gave an account of the human rights violations of the independent tribes of Alaska, which had been subjugated and exploited by an administering Power entrusted with bringing them to self-determination. UN summary report *E/Sub.2/1999/SR.3* quoted the Ambassador: "…nor had they [the Indigenous Peoples] participated in the removal of Alaska from the list of non-self governing territories in 1959. Where they had attempted to participate, they had been subjected to fines or imprisonment or both if they could not read, write or speak English…the United States military and the transferred population had been allowed to vote, and the independent tribes and indigenous Peoples had not even been fully informed regarding their annexation by the United States of America."

Danyta Kennedy movingly raised the issue of disproportionate incarceration, justice-related socio-economic problems and Natives killed by Canadian law enforcement authorities out of Regina, Saskatchewan, Canada. Canadian police officers transported three adult Indian males by automobile to the countryside, miles from any town, removed their shoes and warm clothes and left these three Indian men out in sub-zero cold where they froze to death. Ms. Kennedy stated that in a very real sense, this act of atrocity was an execution of the three Indian men. She noted that white police authorities are investigating their "own atrocities." The residential school system for Indians continues to affect generations of First Peoples in Canada. Some solutions offered:

• Ms. Kennedy suggested that arrested Indians should be termed "political prisoners," partly because many are taken to serve prison sentences far from their homelands where they have no visitors, family and tribal support.

• The Federal and Provincial Governments need to make more efforts to compensate for the legacy of broken lives.

• Ms. Kennedy saw a return to self-determination and implementation of traditional tribal justice systems as the answer to First Peoples' society-wide ills.

• Ms. Kennedy complained that the Indigenous Peoples were not allotted sufficient time to address the full Conference on self-determination.

Lavina Przetiorka stressed the importance of the Treaty Land Settlement of the Indigenous Peoples and the new government of Canada. She notes that the Canadian Province of Alberta is very rich because of petroleum but that the true owners, the Indians or Indigenous Peoples, are very poor! Several solutions were advised:

• Ms. Przetiorka suggested that the question of ownership of traditional tribal lands be brought to the attention of the United Nations as part of the resolution process.

• Education for First Peoples with a strong motivational cultural basis is a necessity.

• Dr. Nenadich added, "Try to re-establish with care the traditional tribal education on tribal and technical ways. Revive the old traditions and work with our spiritual values. Limit the time our students and children watch television."

• Dr. Cooper recommended that the conference create a supporting resolution with a "shadow report." He noted that Canada is ranked number one in the world for

living conditions but dramatically drops to sixty-fourth when the economic plight of the Indigenous Canadians are included in the determination process

Dr. Ramon Nenadich, a professor and Director of Natives Studies for Central America, University of Puerto Rico, provided valuable insight into the issues surrounding the island of Vieques, Puerto Rico. Vieques has been under bombardment by United States forces. Archeological sites have been destroyed and the US Navy is using armaments containing depleted uranium (DU). Indigenous Peoples are dying of cancer at unprecedented rates and DU is suspected as a causative factor to the clusters of cancer cases. Unexploded munitions leak toxins into the waters surrounding Vieques and destroy fragile reefs and eco-systems. He reported that DNA research shows that 60% of the Puerto Rican population has more than 70% Native American blood, which gives force and authority to the contention that there indeed are Indigenous Peoples in Puerto Rico. Some solutions:

- Do what is necessary to stop the United States Navy from bombarding Vieques by informing the peoples of the world and the United Nations of the harm that is being inflicted on the Indigenous Peoples of Vieques.
- Dr. Nenadich requested that letters of support be written to the US President, US Congress and the Secretary of the US Navy.
- Dr. Nenadich stated that his people would continue to enter the area forbidden to them by the US government to protest the assaults on their traditional grounds and waters.
- Dr. Nenadich objected to the fact that the Conference on Self-Determination, held in the Park Forum Hotel, in August 2000, did not give him time to make a report to the full Plenary Assembly.*

Diana James reported on the environmental degradation taking place on Alaska lands and waters, especially on traditional tribal lands and waters where the Indigenous Peoples are affected. The immigrants have clear-cut billions of board feet of the old growth forests, polluted and destroyed salmon spawning streams. Mining and petroleum industries have polluted vast areas of land, water and air endangering many game animals, birds and fishery stocks.

The right of self-determination has taken on special urgency in Alaska. The Conference on Self-Determination at the Park Forum Hotel in Geneva and the United Nations Sub-Commission on Human Rights received a Petition and Diplomatic Protest from the Kuiu Thlingit Nation protesting the current attempt of the state of Alaska to permanently *"Quiet Title"* to submerged lands in the Alexander Archipelago. Alaska and the United States government are taking the position that title to the region of Alaska resides either in the state of Alaska or the US. Despite claims made by the United States to the United Nations, the fact is that the US never purchased Alaska from Russia, nor did it deal fairly with the Indigenous residents of the region.

*At the close of the workshop sessions, Dr. Nenadich and several others who had not spoken earlier were afforded the opportunity to address the plenary session. Dr. Nenadich's intervention is included here. The intervention of Mariana Chuquin was not made available; very regrettably, it was not possible to contact her to obtain a copy. [*Eds.*]

If the immigrant state of Alaska wins the Quiet Title action, they will control all activities important to the lives of Indigenous Peoples. Access to traditional subsistence, gathering foods and medicines, fishing, hunting and materials for ceremonies, housing and clothing will be gone. There will be no place left to practice their traditional lifestyle, honor their spirituality, maintain their culture or make a living in "the usual and accustomed way." As Rudy Al James compellingly told the workshop, "If the immigrant state of Alaska and the United States government are successful in their illegal action, the Thlingits of Southeast Alaska will be relegated to the dustbin of history — a people who were, but are no more." Some solutions offered:

• Ask the Conference on Self-Determination to sign a resolution of support for the Alaska tribes and present the same to the United Nations and the US government.

• Re-open United Nations *GAR 1469*, and closely reexamine the issue of the statehood referendum for Alaska as the US government conducted it shortly after World War II.

Historical points of fact:

a) The Indigenous Peoples of Alaska were not fully informed of their international rights as guaranteed under UN Law and the US illegally chose not to bring them to a point of self-governance.

b) The only people who should have participated in the vote were Alaska's Indigenous Peoples, but those who could not write or speak the English language were not allowed to cast ballots that were counted.

c) The referendum proceeded under military occupation. The US further transported many thousands of immigrants and military personnel to vote in the referendum.

d) US agents and agencies promised an economic boom for the Indigenous Peoples if they would vote for "statehood" and join the United States of America.

e) The US government usurped the political power from Traditional Elders or Village Councils that had successfully governed the Indignous Peoples and Nations since time immemorial.

The US accomplished this by:

a) Identifying Indigenous individuals willing to renounce loyalty to their people for monetary gain who then became puppets for the alien government.

b) These "sell-out Indians" have worked with the US Bureau of Indian Affairs (BIA) with the Indian Reorganization Act (IRA) councils.

c) The US government recognizes the IRA councils as the tribal representatives and ignores the real representatives who are the Traditional Tribal Elders and/or Village Tribal Councils.

d) The IRA councils are organized with a corporate charter from the US Department of Interior and the Secretary of the Interior has

oversight control. Operating funds and salaries for IRA councils come from the US government, filtered through the BIA and finally reach the IRA councils. The IRA councils are in essence arms of the US government and they do not replace Traditional Tribal governments.

e) These non-traditional leaders do the will and bidding of the alien government which results in adverse and negative treatment of their Tribal members. Thus the US government can point to the negative work of their hired employees and say "this is what the Native Americans want".

Mr. James presented a formula for returning to traditional tribal governments in order to regain and exercise self-determination. The United Nations GARs, the US Constitution and acts of Congress such as the Indian Tribal Justice Act and Senate Congressional Resolution 76 recognize this inherent right.

Mr. James called for the Conference to endorse the re-opening of *UN GAR 1469* and support Indigenous Alaskan efforts to hold a referendum with international observers on the following issues:

- Do you, as Indigenous Peoples, still claim Allodial Title to your Traditional Lands, Waters and Resources?
- Do you, as Indigenous Peoples, want sovereignty over your own members, Traditional Lands, Waters and Resources?
- Do you, as Indigenous Peoples, want your own Traditional government and Traditional Court based upon Traditional Tribal or Village Law?
- Do you, as Indigenous Peoples, want to be independent and free from colonial or occupying governments or military forces?
- Do you, as Indigenous Peoples, want to remain under the control of the Immigrant peoples and governments?

Workshop participants determined that self-determination is an ongoing process, and the effort to achieve it will not stop until true freedom is achieved.

Workshop IV:
Minorities or Peoples Engaged in Demands for Self-determination where Special Rights Have Failed due to Entrenched Cultural Beliefs

Dr. Laxmi Berwa
Moderator

This workshop was conducted on 13 August, 2000, and attended by persons representing the African American, Kashmiri, Dalit, Irish and Tamil situations. During the workshop there was a very lively discussion from the Indian Dalits. The others were quite aghast to listen to the apartheid practices enforced against the Dalits.

Under the guidance of Dr. Kly and Mr. Tramboo, along with input from the entire group, the following resolutions were adopted:

1. This Conference strongly resolves solidarity with the Dalits. We condemn the Indian government for allowing an apartheid system to continue in India. The caste system and untouchability is discriminatory and fosters social persecution of Dalits.

2. The United Nations must make sure that its covenants are implemented in India in such a manner as to assure equal status between the Dalits and others, and respect the Universal Declaration of Human Rights.

3. We urge the UN to institute a UNDP Human Rights Development mechanism to prevent all kinds of oppression against Dalits in India.

* Dr. Laxmi Berwa is President of the Dr. Ambedark Memorial Trust, winner of the Dr. Ambedkar National Award, 2000, and a distinguished medical practitioner living in the United States.

The Right to Self-determination: Towards Mechanisms for Its Implementation

Majid Tramboo

I take this opportunity to move a specific resolution on behalf of the Conference organisers. In doing so, I would like to outline the reasons for this. With the ending of the Cold War, there has been an international expansion in the desire for democracy. Halperin and Scheffer have described this expansion in the following terms:

> The democratisation process can often resolve self-determination claims by giving rise to a political system capable of protecting and accommodating groups that would otherwise be seeking changes in political arrangements or borders. But in other cases electoral democracy may not be enough. Democracy may mean little to a minority group that is constantly outvoted. It may mean little to an indigenous people whose political culture and traditions are different from those of other groups within the state. And it may mean little to a group that feels a historical claim entitles it to greater protection [or] more political power...

Indeed, the concept of democracy and the right to self-determination are inter-related. But the words 'self-determination' immediately conjure up the notion of a territory seceding from another. It therefore becomes essential to analyse the term "self-determination".

In the aftermath of World War I, self-determination in international law evolved into an enforceable right to freedom from colonial rule. It has to be born in mind that motivation for decolonisation did not stem merely from concerns about justice but from the realisation that the instability created by peoples seeking their independence from colonial occupation could easily lead to conflict and undermine peace and security and the strategic balance between the countries of east and west.

Thus, in the Declaration on Granting of Independence to Colonial Countries and Peoples, adopted by the UN General Assembly on December 14, 1960, a first

attempt was made to link the evolution of the field of human rights to the right to self-determination. The Declaration begins with the words:

> The subjection of peoples to alien subjugation, domination and exploitation (i.e. the denial of self-determination) constitutes a denial of fundamental human rights...

No doubt this firmly establishes "self-determination" as a legal principle only as far as it concerns people under colonial rule. The words 'self-determination' appear in the UN Charter as an enunciated principle tied to the notion that "peoples have equal rights". This was subsequently incorporated into the preambles to the International Covenant on Economic, Social and Cultural Rights and the International Covenant on Civil and Political Rights.

Although international instruments do not provide a succinct definition of the contents of the right to self-determination of peoples – the Declaration of Principles of International Law Concerning Friendly Relations and Cooperation Among States stipulates that the creation of a sovereign and independent state, the free association or integration with an independent state or the acquisition of any other freely decided political status, are all means through which a people can exercise the right to self-determination.

Strictly speaking, no perfect definition has emerged. The UN appears to have recognised three types of situations in which the right to self-determination is applicable. The first is, of course, that of colonial peoples to self-determination. Next is when a state falls under the foreign domination of another power, as this is seen as a violation of the right to self-determination. The third situation covers racist domination and has only been applied in the South Africa situation.

Broadly speaking, this has developed a division of the concept of self-determination into *two* limbs. The first limb entails the right to external self-determination, i.e. the right of a people to undertake external roles such as foreign policy and defence, usually reserved for states alone, and as such, seemingly almost indistinguishable from secession. The second limb entails internal self-determination, i.e. the right of peoples or minorities to varying degrees of jurisdiction over affairs internal to the state.

The notion of internal self-determination has evolved into what seems to be an articulation of the type of rights most often demanded by national minorities. This articulation has been achieved, not so much by altering the scope or beneficiaries of the first articles of the International Covenants, but by evolution of minority rights in customary international law. Thus, looking at Article 1 of the ICCPR, which provides for self-determination and Article 27 of the ICCPR, which provides for minority rights, both these articles have evolved through customary international law. This clearly follows, that demands for minority rights are demands for self-determination.

As to external self-determination, the right to secede, in practice it is confined to populations of fixed territorial entities, such as overseas colonies, forced occupation, unrepresented peoples and nations.

Article 1 of the ICCPR stipulates that "State parties...shall promote the right in conformity with the provisions of the Charter of the United Nations." Under this

right, the ICCPR declares, peoples "freely determine their political status and freely pursue their economic, social and cultural development."

Thus, the Declaration of Principles of International Law Concerning Friendly Relations and Cooperation Among States stipulates that the creation of a sovereign and independent state, or acquisition of any other freely decided political status, the free association, are all means through which a people can exercise the right to self-determination.

Thus, a clear conclusion can be drawn that self-determination grew out of the historical traditional "practices of states". The first articles of both International Covenants and Article 27 of the ICCPR, as well as Article 55 of the UN Charter, act to codify the meanings of the right to self-determination as derived from customary International Law.

Politically speaking, Article 1, which includes the right to secession, is available for legal support to those socio-politically stronger nations or groups that, by whatever means or for whatever reasons, are able to effectively or credibly declare themselves "peoples", pursuant to Article 1 or as colonial territories.

Many of the current threats to international peace and security stem from the struggles of various minorities, indigenous populations, unrepresented peoples and nations to claim their right to self-determination. Wherever one looks, such claims are creating the sorts of tensions which have a major impact on the good relations between states. There-fore, the notion of continuing process and of popular participation is especially relevant to the human right of self-determination.

It is in this spirit and with a view to secure peace and security for humanity, and acknowledging that there is a need for the establishment of a body similar to the Decolonisation Committee but with a wider mandate to explore the realisation of all aspects of the right to self-determination, that we as Conference organisers proposed:

1. In the ongoing efforts of reconstruction of the United Nations in line with the requirements for the success of its mission, this Conference recommends the following:

a) the establishment of an office of the High Commissioner for Self-Determination; and

b) the establishment of a Self-determination Commission comprised of representatives of the United Nations member states.

2. This Conference reaffirms the importance of the right to self-determination as enshrined in the Charter of the United Nations and other international documents. The Conference further condemns all violations of this right.

3. This Conference invites the organisers of the "Second International Conference On the Right to Self-determination and the United Nations" to initiate a process by which individual cases may be comprehensively discussed and specific resolutions adopted accordingly.

CONFERENCE RESOLUTIONS*

In furtherance of the struggle to achieve world peace and development, the International Human Rights Association of American Minorities (IHRAAM), in association with the International Council for Human Rights (ICHR) held the First International Conference on the Right to Self-determination & the United Nations at the Forum Park Hotel in Geneva on August 11-13th, 2000.

The following resolutions were unanimously adopted by the Conference, and submitted to the Secretary General of the United Nations, the Office of the High Commissioner for Human Rights, and the UN Working Group on Minorities for their consideration in possible future deliberations:

1. In the ongoing efforts of reconstruction of the United Nations in line with the requirements for the success of its mission, this Conference recommends the following:

(a) The establishment of an Office of the High Commis-sioner for Self-determination; and

(b) the establishment of a Self-determination Commission comprised of representatives of United Nations member states.

2. This Conference reaffirms the importance of the right to Self-determination as enshrined in the Charter of the United Nations and other international documents. The Conference further condemns all violations of this right.

3. This Conference invites the organisers of "the Second International Conference on the Right to Self-determination and the United Nations" to initiate a process by which individual cases may be comprehensively discussed and specific resolutions adopted accordingly.

* After debate and discussion, Conference Resolutions were passed unanimously by the Conference participants. There was no dissenting vote.

Pertinent Documents

Declaration on the Granting of Independence to Colonial Countries and Peoples
Adopted by General Assembly resolution 1514 (XV) of 14 December 1960 *Available at http:// www.unhchr.ch/html/menu3/b/c_coloni.htm*

Declaration on Principles of International Law concerning Friendly Relations and Co-operation among States in accordance with the Charter of the United Nations, adopted by the General Assembly on 24 October 1970 (General Assembly resolution 2625 (XXV)). *Available at http://frontier.gibnet.gi/laws/2625.html*

Declaration on the Right to Development
Adopted by General Assembly resolution 41/128 of 4 December 1986 *Available at http:// www.unhchr.ch/html/menu3/b/74.htm*

Declaration on the Rights of Persons Belonging to National or Ethnic, Religious or Linguistic Minorities
G.A. res. 47/135, annex, 47 U.N. GAOR Supp. (No. 49) at 210, U.N. Doc. A/47/49 (1993). *Available at http://www1.umn.edu/humanrts/instree/d5drm.htm*

Draft Declaration on the Rights of Indigenous Populations
E/CN.4/SUB.2/1994/2/Add.1 (1994).*Available at http://www1.umn.edu/humanrts/instree/ declra.htm*

"Ethnic cleansing" and racial hatred
G.A. res. 47/80, 47 U.N. GAOR Supp. (No. 49) at 161, U.N. Doc. A/47/49 (1992). *Available at http://www1.umn.edu/humanrts/resolutions/47/80GA1992.html*

Report on the Linguistic Rights of Persons Belonging to National Minorities in the OSCE [Organization for Security & Cooperation in Europe] Area
Available at http://www.osce.org/inst/hcnm/docs/lingri/report.html

The Lund Recommendations on the Effective Participation of National Minorities in Public Life *Available at http://www.geocities.com/~ihraam/confoscedoc.html*

Commentary to the Declaration on the Rights of Persons Belonging to National or Ethnic, Religious and Linguistic Minorities
by Asbjorn Eide, Chair, UN Working Group on Minorities
Available at http://www.geocities.com/~ihraam/eide.html

The Hague Recommendations on the Education Rights of Minorities
Available at http://www.geocities.com/~ihraam/unhagueed.html

Vienna Convention on State Succession in Respect of Treaties
Available at http://www.un.org/law/ilc/convents.htm

Declaration on the Right and Responsibility of Individuals, Groups and Organs of Society to Promote and Protect Universally Recognized Human Rights and Fundamental Freedoms:
A/RES/53/144 *Available at http://www.unhchr.ch/huridocda/huridoca.nsf/(Symbol)/ A.RES.53.144.En?OpenDocument*

The right to self-determination of peoples (Art. 1) : 13/04/84. CCPR General comment 12. (Twenty-first session, 1984) *Available at http://www.unhchr.ch/tbs/doc.nsf/MasterFrameView/ f3c99406d528f37fc12563ed004960b4?Opendocument*

Right to self-determination : 15/03/96. CERD General recom. 21.(General Comments)
(Forty-eighth session, 1996) Available at http://www.unhchr.ch/tbs/doc.nsf/MasterFrameView/

Contributors*

Suzette Bronkhurst of the Magenta Foundation, Netherlands, is a former chief editor of a Dutch Green Party publication, and initiator and general manager of the Internet Centre Anti-Racism (I-CARE).

Erica-Irene A. Daes is a Special Rapporteur of the UN Sub-Commission on Human Rights, and former Chairperson of the Working Group on Indigenous Populations which drafted the UN Declaration on the Rights of Indigenous Peoples. She submitted a UN-commissioned Study on the Protection of the Culture and Intellectual Property of Indigenous Peoples in 1993.

Kenneth Deer is currently publisher/editor of the newspaper *The Eastern Door*, and a citizen of the Mohawk Nation at Kahnawake. He has many years of experience at the international level representing his community.

Richard Falk is Albert G. Milbank Professor of International Law and Practice at Princeton University.

André Frankovits is Executive Director of the Human Rights Council of Australia.

Marquetta L. Goodwine is Chieftess of the Gullah-Geechee Nation and editor *of The Legacy of Ibo Landing: Gullah Roots of African American Culture.* The South Carolina General Assembly will award Ms.Goodwine the 2001 Jean Laney Harris Folk Heritage Award.

Françoise Jane Hampson is an expert with the United Nations Sub-Commission. She is Professor of Law in the Human Rights Centre, University of Essex, where she teaches international humanitarian law and the law of armed conflicts.

Mehdi M. Imberesh is a Professor in the Social Sciences Faculty of Al-Fateh University, Tripoli. He started his political activities in the People's Committee of the Jamahiriyan People's Bureau in Washington, DC during the years 1979-81, was appointed in the capacity of Ameen of the Jamahiriyan People's Bureau to the Federal Republic of Germany from 1981 to 1986, and since then to the Islamic Republic of Iran.

The Right Honourable Gerald Kaufman is a member of the British Parliament and former member of the Privy Council. He was Minister of State for Industry and a Privy Counsellor of the Labour Government of 1974. He was a member of the Labour Party's Shadow Cabinet from 1980 to 1992 and presently is Member of Parliament for the Manchester constituency of Gorton.

Y. N. Kly is Chair of IHRAAM and professor of international law at the School of Human Justice of the University of Regina, Canada. He is author of numerous books and articles on minorities and societal development, two of which were

* The NGO affiliations of those presenting interventions are noted on the same page as the text of their intervention.

named Outstanding Book by the Gustavus Myers Center for the Study of Human Rights, co-sponsored by major U.S. civil rights organizations.

Dr. Hans Koechler, Head of the Philosophy Department at the University of Innsbruck, Austria and Director of the International Progress Organization, Vienna. Since 1998, Professor Koechler has served as member of the Council of Europe's Expert Group on Democratic Citizenship. As President of IPO, he dealt with the humanitarian issues of the exchange of prisoners of war between Iran and Iraq, and with the issue of Kuwaiti POWs and missing people in Iraq. Since 1972, UN Secretaries-General have acknowledged Professor Koechler's contribution to international peace in their statements.

Joseph v. Komlóssy is Vice President of the Federal Union of European Nationalities (FUEN), one of the most prestigious NGO-s, with consultative status at the Council of Europe and at the United Nations Organisation, seated at Flensburg, Germany. He is an advocate of ethnic and national minorities, a member of the Working Group on Minorities of the United Nations, regularly attending the sessions of the Comission on Human Rights. He is present at all parliamentary sessions of the Council of Europe, and participates in the work of OSCE/ODIR in Warsaw and Vienna. His presentations and interventions are guided by the principle: *"Act in time, instead of reacting too late."*

Mme. Ragnhild Nystad is Vice-President of the Sami Parliament, Norway, and also head of political affairs. She was involved in the establishment of the Sami Act (Norway) in 1987 and the Norwegian Constitutional Amendment in 1988 which gives the Sami People in Norway status as indigenous people and the right to establish their own indigenous parliament.

Karen Parker, Chief/Delegate of the International Educational Developmental/ Humanitarian Law Project at the United Nations, is an attorney specializing in human rights and humanitarian (armed conflict) law. Her annual "Armed Conflict Around the World: A Country by Country Review" is published by the Parliamentary Human Rights Group (UK) (now on Internet). Her extensive work on self-determination includes studies, Congressional testimony and Court appearances on application of self-determination to the armed struggles in Burma, Kashmir, Acheh, the Moluccas, East Timor, Tibet, Cyprus, Turkey, Western Sahara and Sri Lanka.

George Reid is Deputy Presiding Officer of the Scottish Parliament

Majid Tramboo is a Member of IHRAAM Directorate & Director, International Council for Human Rights, United Kingdom. He is a Barrister practicing in the United Kingdom.

Daniel Turp served as Canadian Member of Parliament and Bloc Quebeçois Critic for Intergovernmental Affairs from 1999-2000 and Bloc Quebeçois spokesperson for Foreign Affairs, 1997-1999. He served as a designated expert on the Belanger-Campeau Commission on the political and constitutional future of Quebec (1991), and on the Commission Studying Questions Related to the Accession of Quebec to Sovereignty, 1992.

Index